THE FOURTH EYE

MĀORI MEDIA IN AOTEAROA NEW ZEALAND

BRENDAN HOKOWHITU AND VIJAY DEVADAS, EDITORS

INDIGENOUS AMERICAS

University of Minnesota Press
Minneapolis
London

Portions of chapter 1 were previously published as "15 October 2007, Aotearoa: Race, Terror, and Sovereignty," *Sites: A Journal of Social Anthropology and Cultural Studies* 5, no. 1 (2008): 124–51.

An earlier version of chapter 12 was previously published as "*Survivor*-Styled Indigeneity in Two Reality Television Programmes from Aotearoa/New Zealand," *The Australasian Journal of Popular Culture* 1, no. 3 (2011): 297–312.

Library of Congress Cataloging-in-Publication Data
The fourth eye : Maori media in Aotearoa New Zealand / [edited by] Brendan Hokowhitu, Vijay Devadas. (Indigenous Americas)
Includes bibliographical references and index.
ISBN 978-0-8166-8103-7 (hc)
ISBN 978-0-8166-8104-4 (pb)
1. Maori (New Zealand people)—Press coverage. 2. Indigenous peoples and mass media—New Zealand. I. Hokowhitu, Brendan. II. Devadas, Vijay.
DU423.A1F67 2013
302.23089'99442093—dc23 2013030767

Published by the University of Minnesota Press
111 Third Avenue South, Suite 290
Minneapolis, MN 55401-2520
http://www.upress.umn.edu

We dedicate this collection to Merata Mita and Barry Barclay.

E koro, e kui, i tū kōrua ki te whakawātea i te huarahi. Mā ā kōrua mahi, ka kitea kāore he aha e kore e taea te whakatutuki. Kua wehe atu kōrua ki tua atu i te ārai, engari ka noho kōrua hei whetū tīahoaho hei whakamārama i te ara mō te hunga e whai ana. Nā reira, kua tāpaea tēnei pukapuka hei whakahōnore i a kōrua.

Koro, Kui, you stood up to blaze the trail. Through your work we can see that there is nothing that cannot be achieved. You have departed beyond the veil, but you remain as bright stars, illuminating the path for those who follow after you. Accordingly, this book is presented as a means of honoring you both.

Contents

Part III. Māori Television: Nation, Culture, and Identity

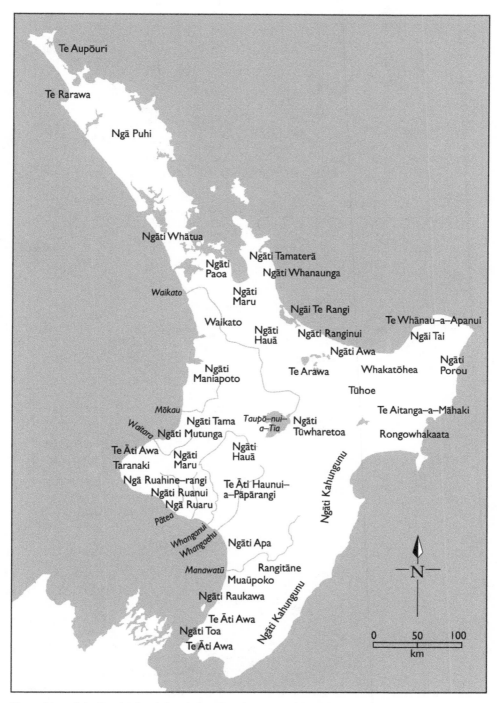

Map 1. Map of the North Island showing *iwi* boundaries. Designed by Allan Kynaston. Source: Brendan Hokowhitu et al., *Indigenous Identity and Resistance* (Dunedin: Otago University Press, 2010), 91. Reproduced courtesy of Otago University Press.

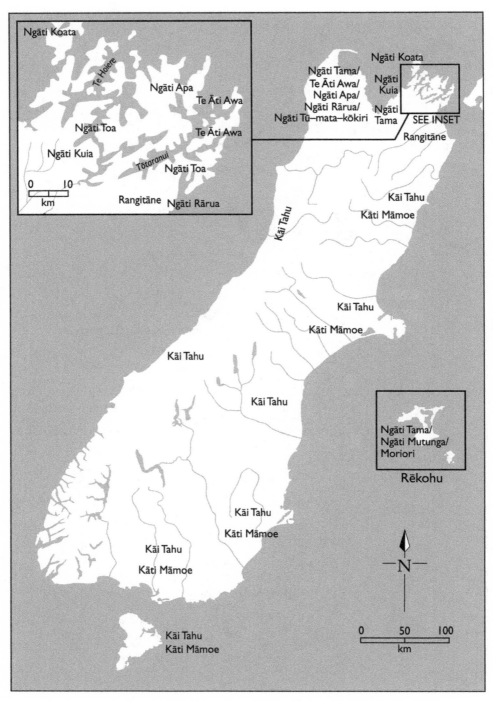

Map 2. Map of the South Island showing *iwi* boundaries. Designed by Allan Kynaston. Source: Brendan Hokowhitu et al., *Indigenous Identity and Resistance* (Dunedin: Otago University Press, 2010), 92. Reproduced courtesy of Otago University Press.

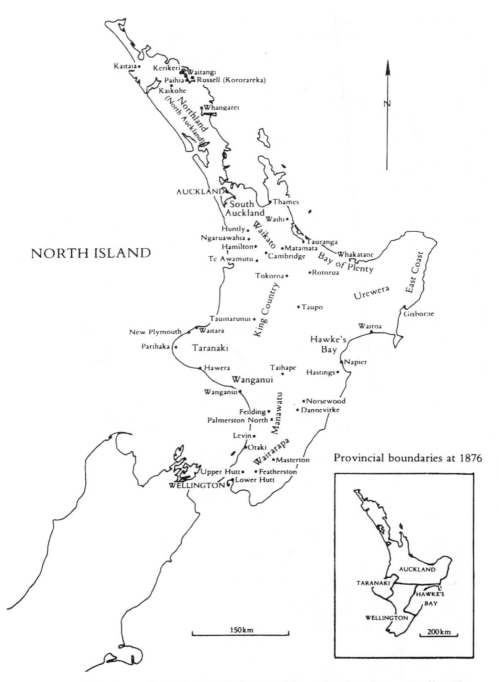

NORTH ISLAND

Kaitaia •
Kerikeri • Waitangi
Paihia • • Russell (Kororareka)
Kaikohe •
Northland
(North Auckland)
• Whangarei

AUCKLAND
South
Auckland • Thames
Waihi •
Huntly •
Ngaruawahia • Waikato
Hamilton • • Tauranga
Te Awamutu • • Matamata
• Cambridge Bay of Plenty
• Whakatane
East Coast
Tokoroa •
King Country
Urewera
• Rotorua
• Taupo
• Gisborne
Taumarunui •
New Plymouth • • Waitara
Wairoa •
Parihaka • Taranaki
Hawke's
Bay
• Hawera • Taihape • Napier
Wanganui • Hastings
Wanganui •
Manawatu
• Norsewood
• Dannevirke
Feilding •
Palmerston North •
Levin •
Wairarapa
• Otaki
• Masterton
Provincial boundaries at 1876
Upper Hutt • • Featherston
WELLINGTON • • Lower Hutt

150 km

AUCKLAND

TARANAKI

HAWKE'S
BAY

WELLINGTON

200 km

Map 3. Map of the North Island showing principal towns, cities, and regions. Source: Geoffrey Rice, ed., *The Oxford History of New Zealand*, 2d ed. (Auckland: Oxford University Press, 1981), 390. Reproduced with permission of Oxford University Press.

Provincial boundaries at 1876 (Southland 1871)

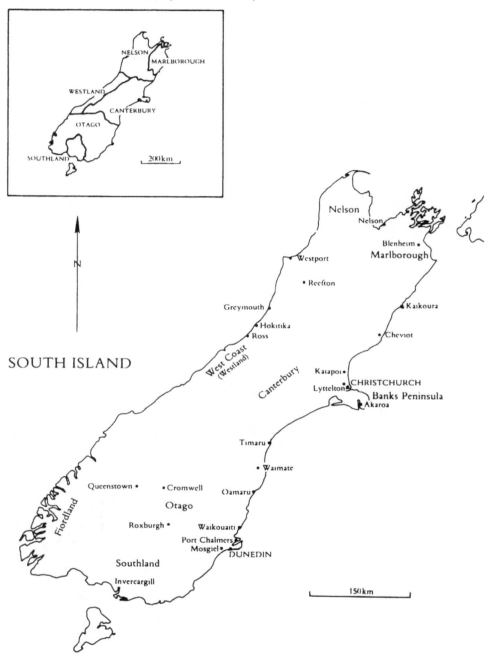

Map 4. Map of the South Island showing principal towns, cities, and regions. Source: Geoffrey Rice, ed., *The Oxford History of New Zealand*, 2d ed. (Auckland: Oxford University Press, 1981), 391. Reproduced with permission of Oxford University Press.

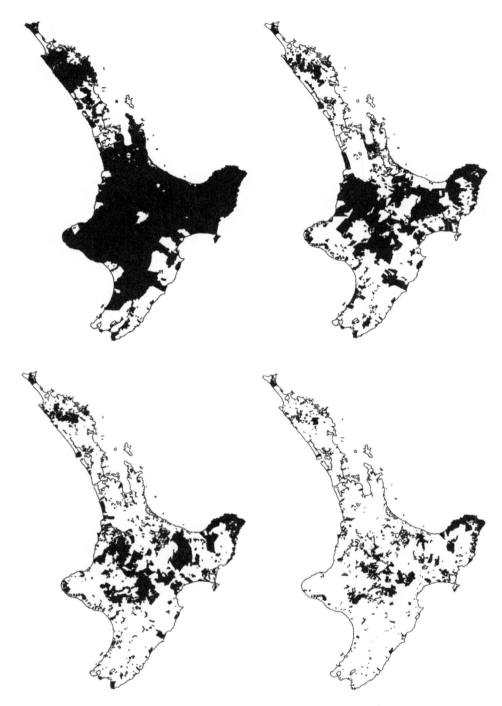

Map 5. Set of four maps of the North Island. The diminishing dark shading represents the loss of Māori land between 1860, 1890, 1910, and 1939. Source: Claudia Orange, *An Illustrated History of the Treaty of Waitangi* (Wellington: Bridget Williams Books, 2001), 318–19. Reproduced courtesy of Bridget Williams Books.

Introduction: Fourth Eye

The Indigenous Mediascape in Aotearoa New Zealand

BRENDAN HOKOWHITU AND VIJAY DEVADAS

> Our language has been brought to the very brink of extinction, more than anything
> else by the influence of monolingual broadcasting. . . . So broadcasting has an enor-
> mous responsibility in the recovery of a language it has helped to push towards
> extinction.
>
> —Derek Fox, "Honouring the Treaty: Indigenous Television in Aotearoa"

AS THE FIRST PUBLICATION OF ITS KIND on Indigenous media in Aotearoa New
Zealand (hereafter referred to as "New Zealand"),[1] this collection brings a fresh
approach to the relatively distinct fields of Media Studies and Indigenous Studies. It
contributes to both fields by drawing upon key debates, concepts, and theoretical
approaches that mark them, while suggesting that each discipline has much to offer
the other, and through this, proposes a connection between the disciplines to shore
up the possibility of articulating an Indigenous Media Studies.

The "Fourth Eye" is a term we mobilize to capture a number of complex questions,
experiences, responses, and articulations that emerge at the intersection of media cul-
ture and Indigenous lives: what are the Indigenous experiences of being the subject of
the media gaze? How does the media capture, articulate, and rearticulate the lives of
Indigenous peoples? How do Indigenous peoples use, transform, and tactically use the
media to subvert certain modalities of power relations? What postcolonial complexi-
ties reveal themselves through Indigenous media expressions?

The present collection takes the lead from Fatimah Rony's illuminating book *The
Third Eye: Race, Cinema and Ethnographic Spectacle* (1996), which traces the intimate
connections between ethnography and early cinema to show mutual affirmation and
perpetuation of racialized images of Indigenous and minority communities. Rony's
book develops upon the work of the anticolonial scholar and activist W. E. B. Du Bois,
whose notion of the "Third Eye" made use of the concept of double consciousness; the
splitting of consciousness that takes place when marginalized communities are repre-
sented by, and through, early ethnographic cinema. The splitting introduces a break, a
caesura that maintains the us/them, native/non-native divide thereby reinforcing the

marginalization, objectification, and representation of Indigenous and minority communities in racialized terms.

The first section of the present collection reaffirms both Rony and Du Bois's work. However, the concept of the "Third Eye" does not capture sufficiently the complex encounters that take place at the media-indigeneity intersection. For instance, it does not take into account the tactical use of the media by Indigenous communities or the creative potentials that are possible. In short, the "Third Eye" provides a framework for the analysis of how dominant power (in this case, via cinema) represents marginalized communities, yet fails to comprehend how these communities might challenge and transform dominant power via media technologies. That is, the ways Indigenous peoples use media biopolitically to confront conventionalized regimes of representation and to engender Indigenous sovereignty. The second and third sections of this collection engage precisely with this theme: the emergence of Indigenous media in New Zealand and the challenges it poses to a politics of identity and recognition.

For many reasons, New Zealand is in a unique position to act as a case study to illustrate and theorize the question, "What is Indigenous Media Studies?" Central to a New Zealand "way of life" is coping with the ubiquitous and mediated "bicultural drama" that plays out in all media forms. It is seen, for instance, in the over-reporting of Māori[2] dysfunction by the news media, the Indigenous themes in globally recognizable films such as *Once Were Warriors* (1994)[3] and *Whale Rider* (2002),[4] and the preeminence of Māori culture appropriated in global advertising, such as the use of *haka*[5] (dance or ceremonial performance)[6] by numerous multinational companies. Māori directors like Barry Barclay and Merata Mita (who both passed while this collection was being written, in 2008 and 2010 respectively) are also some of the most renowned Indigenous filmmakers worldwide. Additionally, the relatively recent advent of the Māori Television Service (hereafter referred to as "Māori Television"), the first ever state-funded Indigenous television network to go free to air in all households "nationally," signifies one of the most important events in Indigenous media history. In that regard, the Indigenous "mediascape" in New Zealand provides fertile ground for interrogating the growing synthesis between Indigenous and Media Studies.

This book also contributes to a field of growing international concern. It connects with contributions such as *The New Media Nation* (2010), *Circuits of Culture* (2008), *Global Indigenous Media* (2008), *Information Technology and Indigenous People* (2007), *Native on the Net* (2006), *Media Worlds* (2002), and *The Indigenous Public Sphere* (2000).[7] Other specifically contextualized works include that of Lisa Brooten (2008) on Indigenous media in Burma, Michael Christie (2008) on Australian Aboriginal communities and digital media, Terence Turner (2002) on video and the Kayapo peoples, and Doris Baltruschat (2010) on Inuit-controlled film and video production and distribution.[8] Drawing across multiple media platforms and various Indigenous communities, these contributions are preoccupied with the intricate and complex ways that Indigenous lives and media technologies intersect. Recurring themes to

have emerged in the burgeoning field include representations of Indigenous peoples in and through dominant media practices, access of Indigenous communities to media technologies, use of media by Indigenous peoples to articulate an Indigenous media aesthetic, the tactical use of the media for activism and advocacy, and the use of media for preservation and revitalization of cultural identity and community-building. To date, the field has been described as interpreting, from an Indigenous perspective, "how media enable or challenge the workings of power and the potential of activism; the enforcement of inequality and the sources of imagination; and the impact of technologies on the production of individual and collective identities."[9] These concerns are intimately connected to the advances in Māori culture and politics that have been symbiotic with the development of Indigenous media in New Zealand. In short, the present collection articulates an Indigenous media landscape that converses with issues beyond New Zealand.

For Indigenous people, the historical relationship and increasing intensification of the politics of representation has naturalized a resistance to misrepresentation while increasing the desire to control and produce their own images. As Faye Ginsburg recognizes, such a desire has coincided with "increasing availability of relatively inexpensive media technologies such as portable video cameras and VCRs, as well as more complex communication forms that have been used to facilitate regional linkages."[10] As was the case in Australia and other colonial-settler states, the binary between what it meant to be Indigenous and non-Indigenous "came increasingly to preoccupy the media, both serious journalism of record and demotic expressions of emotional affinity. Indigeneity became the site around which . . . national identity in general was narrated, disputed, and thought through."[11] Media thus has functioned as one of the most significant attendants at the space where "political time, political space, and political identity" compete to shape Indigenous realities. The present collection reflects mediated "narratives of struggle, development and transformation" that have become endemic to an Indigenous global renaissance.[12]

Defining "Indigenous" and "Indigenous Media"

The term "Indigenous" itself and its derivatives (e.g., "indigeneity") have been contested within various academic disciplines including Indigenous Studies, Cultural Studies, Postcolonial Studies, Race and Ethnic Studies, Area Studies, Anthropology, and Sociology. For instance, Jace Weaver suggests that "Indigeneity is one of the most contentiously debated concepts in postcolonial studies."[13] It has also been debated at national and international levels and has come to determine policy in institutions such as the United Nations Commission on Human Rights:

> Over a very short period, the few decades since the early 1970s, "indigenous peoples" has been transformed from a prosaic description without much significance in international law

and politics into a concept with considerable power as a basis for group mobilization, international standard-setting, transnational networks, and programmatic activity of intergovernmental and nongovernmental organizations.[14]

The landmark 2007 United Nations Declaration on the Rights of Indigenous Peoples, a culmination of "25 years of contentious negotiations over the rights of native people to protect their lands and resources, and to maintain their unique cultures and traditions,"[15] symbolically at least, recognized both the cultural and political dimensions of articulating the notion of "Indigenous." Although not a legally binding text, eleven countries abstained from voting while four countries—Australia, New Zealand, Canada, and the United States—voted against the declaration when it was passed but later recanted:[16] Australia in 2009 and the remaining three in 2010.

Undoubtedly then, common understandings of indigeneity have come to be subsumed by political dimensions, where "the concept of indigenous peoples involves those descendants of original occupants who acknowledge their distinctiveness and marginalisation, and use this politicised awareness to mobilise into action,"[17] or, as Gerald Alfred articulates, "It has been said that being born Indian is being born into politics. I believe this to be true; because being born a Mohawk of Kahnawake, I do not remember a time free from the impact of political conflict."[18] Here, the recognition of Indigenous communities challenging and resisting the constitution and hegemony of the nation-state is significantly marked, and moreover it acknowledges the possibility, and right of Indigenous peoples to call for political and constitutional autonomy, and redefine "a new social contract based on the constitutional principles of partnership, power-sharing, and self-determining autonomy."[19]

The complexities surrounding the term "Indigenous" do not preclude the need to articulate how the term is mobilized in various contexts, yet it does reinforce the hesitancy and, indeed, impossibility of a strict definition: "the concept of 'indigenous' is not capable of a precise, inclusive definition which can be applied in the same manner to all regions of the world."[20] Similarly, the African Commission on Human and Peoples' Rights stated, "no single definition can capture the characteristics of indigenous populations."[21] The term is, in other words, heterogeneous and includes a myriad of contextually based understandings, sometimes within nation-states themselves whose Indigenous communities are as diverse in language, culture, and epistemology as they are similar. Each of these communities has their own specific histories, traditions, and struggles, which are played out within particular geopolitical, social, cultural, and economic contexts. The term is also often problematically conflated with other terms such as "Native," "Indian," "Aboriginal," "tangata whenua," "First Nations," "Fourth World," and "tribal peoples." Indigeneity is also differently recognized within the politics of nation-states, ranging from a discourse of partnership in New Zealand to outright nonrecognition in China, for instance.

At the same time, the term is driven toward homogeneity by an ever-expanding global circuit of Indigenous academics preoccupied with what indigeneity has come to mean in relation to precolonization, colonization, and postcolonization, particularly within what have come to be known as "settler-states," although "invaded-states" is a more accurate coinage. Indeed, the inevitable impulsion to produce internationally recognized scholarship within Western academia has compelled many Indigenous writers to theorize their local context within theoretical frameworks that enable dialogue across colonial contexts. The global Indigenous movement can be loosely defined as a pan-Indigenous discursive formation, which unites heterogeneous narratives via comparative Indigenous methodologies and produces a universal Indigenous theory to explicate or problematize the local condition. There has been a tendency to view the production of pan-indigeneity as a positive stage in the development of Indigenous resistance. We question, however, what universal consciousness is being promoted via pan-indigeneity: How are Indigenous people being conditioned through the taxonomy of universal indigeneity, and what are the notional adhesives holding the concept of "Indigenous" together?

If we turn to some definitions, then, Roger Maaka and Augie Fleras argue that Indigenous peoples "are normally defined as living descendants of the original (pre-invasion) occupants of a territory. . . . In structural terms, most indigenous peoples occupy the status of disempowered and disposed enclaves within a larger political entity."[22] Yet, homogenous definitions are often epistemologically limited because of the ontological importance of local contexts, languages, and cultures. In reality, Indigenous scholars are often left in the unenviable position of finding common ground (i.e., "Indigenous Studies") within the ontological violence of colonialism, as Maaka and Fleras go on to point out:

> Not all indigenous peoples have been conquered; not all nations are comprised of indigenous peoples; and not all indigenous peoples can be conceived as nations. . . . Some people consider indigenous peoples as stewards holding the land for future generations. Others look on indigenous peoples as landless tribes under colonial subjugation. For still others, references to indigenous peoples implies a politicized minority demanding self-determining autonomy. . . . For yet others still, indigenous refers to any group that belongs to a territory.[23]

The importance of place, immediacy, and historical context to indigeneity itself thus makes any universalizing attempt to define the concept antithetical to its very underpinnings. Any demarcation of Indigenous peoples, therefore, must work through the domain of culture—the practices, rhythms, and ways of life that constitute a specific community.

In this collection we use both the cultural and political dimensions to articulate the notion of "Indigenous." Also, due to the collection's focus on the immediacy of media,

we determine "Indigenous" to be a strategic concept that, to remain politically viable, must adapt to the ever-shifting demands of power within the neocolonial context. Dene scholar Glen Coulthard argues that Indigenous rights have been increasingly described in the language of "recognition": "recognition of cultural distinctiveness, recognition of an inherent right to self-government, recognition of state treaty obligations, and so on . . . [is a process that] promises to reproduce the very configurations of colonial power that indigenous demands for recognition have historically sought to transcend."[24] Essentially, Coulthard argues that the progresses made toward the recognition of Indigenous rights have actually helped further assimilate Indigenous people because they have enabled the incorporation of Indigenous alterity within the neocolonial system.

It must be an assumption, therefore, that recognizable or cognizable forms of indigeneity will rapidly be subsumed by the neoliberal state. Under these conditions indigeneity must already be transforming toward a new form of sovereignty. In relation to *being* Indigenous, we thus closely align with Kevin Bruyneel's conception of indigeneity as a sovereign act:

> In resistance to this colonial rule, indigenous political actors work across American spatial and temporal boundaries, demanding rights and resources from the liberal democratic settler-state while also challenging the imposition of colonial rule on their lives. This resistance engenders a "third space of sovereignty" that resides neither simply inside nor outside the American political system but rather exists on these very boundaries exposing both the practices and the contingencies of American colonial rule.[25]

In the specific context of New Zealand, the popularity of the phrase *"tangata whenua"* (people of the land) unmistakably became increasingly significant to identity politics of the 1990s and beyond as it came to tacitly refer to globally forming notions of indigeneity and the politics therein. That is, *tangata whenua* morphed to not only mean the interconnectedness of various *whānau* (extended family), *hapū* (clan), and *iwi* (peoples) with land, it also came to refer to the increasing significance of indigeneity— of place-based politics—to Māori rights in general. *Tangata whenua* became the imagined united Indigenous polity that formed the Māori Other in partnership with the state. It is important to note here that the advancement of *"tangata whenua"* as a tool designed to nationalize Indigenous political agency was later subsumed within the prominent discourse of biculturalism in New Zealand; an extremely problematic notion not merely because it excludes all those people who are not Māori nor descendants of European settlers, but more importantly, because "biculturalism" came to tacitly refer to the incorporation of Māori culture within the dominant neocolonial system; or what Coulthard refers to as the "politics of recognition." Biculturalism, as a politics of recognition, is an important thematic to be remembered throughout this collection for it shapes the pervading discourse and, in turn, the "mediascape"[26] with

which the majority of chapters engage. The institutionalization of Māori Television, for instance, provides a prominent example of the problematics surrounding state recognition and control of Indigenous media.

In New Zealand, the mediascape, both historically and contemporarily, is molded by an anxiousness surrounding the ongoing conflict for citizenship rights within the politics of recognition (see chapter 6). Essential to this binary drama is the conterminous development of the politics of Indigenous representation and media technology. For instance, the development of the Internet and other globalized media forms has occurred simultaneously with the escalating self-interpretation of Māori as "Indigenous" within the newly forming pan-Indigenous community. The pan-Indigenous peoples' movement is "ironically an outcome of profound and, in historical terms, rapid change in the relationships between those who seek recognition as distinct peoples and the nation-states in which their territories are situated."[27] Thus, although focused on New Zealand's local context, this collection also looks at how regional and national Indigenous media is connecting with other Indigenous media circuits to form a larger transnational Indigenous media network. Conceived under the category of "Fourth World," this relatively recent media complex is described by Ella Shohat and Robert Stam as the most significant development in the global media landscape.[28]

Within the context of this book, we employ the term "Indigenous media" to first articulate the relationship between two disciplines—Media Studies and Indigenous Studies. This is a task taken up by Brendan Hokowhitu in chapter 6. The term also seeks to capture the relationship between mainstream dominant media in New Zealand and representations and stereotypes of Māori as discussed in the first part of the book. Further still, the term is used in the second and third parts of the collection to demonstrate the use, appropriation, circulation, and distribution of media by and through Māori,[29] or what Harald Prins terms the "indigenization of visual media."[30] These two parts move from a discussion of Māori as being objects of dominant image-making practices to an exploration of the emergence and struggles of Māori to take ownership of image-making technologies, including a key media initiative, the development of Māori Television.

Media, Indigeneity, and the Treaty of Waitangi

Before proceeding to discuss the three major parts that frame this book, the following provides the reader with a brief contemporary political history focusing on the preeminence of the Treaty of Waitangi (hereafter referred to as "the Treaty")[31] to Indigenous claims to media rights in New Zealand. To this extent, the Treaty and a developing urban Indigenous "third culture" have played pivotal roles in determining both the state-sponsored and Indigenous-controlled path that Indigenous media has taken.

In New Zealand, the official narrative of Indigenous urbanization is quite well known. Prior to World War II, 90 percent of Māori were rural.[32] According to the state's

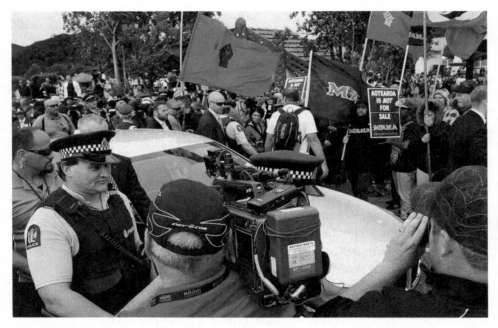

Figure I.1. Police and security personnel surround the car with New Zealand Prime Minister John Key as he leaves Hiruharama (Te Tii) Marae on February 5, 2012, at Waitangi, New Zealand. Photograph by Kenny Rodger, reproduced with permission of Getty Images.

principal adviser on state–Māori relationships, Te Puni Kōkiri (the Ministry of Māori Development):

> Māori and Pākehā societies essentially lived and worked in separately located communities until the Māori urban migration after the Second World War. . . . This urban migration was stimulated by the situation for Māori in the Depression years of the 1930s. Māori were often the first to lose work, and were paid lower unemployment benefits than Pākehā. . . . In 1956, nearly two-thirds of Māori lived in rural areas; by 2006, 84.4 percent of Māori lived in urban areas.[33]

According to Mason Durie, in the first two-thirds of the twentieth century at least, the state "actively discouraged tribal organization," which "underline[d] the significance of a new cultural identity based less on tribe than on simply being Māori."[34] Ideologically driven state intercession included the banning of speaking *te reo Māori* (the Māori language) in schools via the "Native Schools' Code" introduced in the 1870s, which, along with other government regulations over the next century, effectively meant that by 1970 it was commonly thought that the Māori language would soon be extinct without radical intervention. Similarly, the 1907 Tohunga Suppression Act banned the practices of *tohunga,* who were experts of various kinds of Māori knowledge. The state realized that *tohunga* were key adhesives to the social fabric of a Māori

epistemology. Also, the 1960s Māori Trade Training Scheme actively relocated young Māori away from their rurally based *hapū* and into manual labor training in the cities. It is apparent then that from the state's perspective, the urbanization of Māori was not merely to satiate labor needs in the city; it was ideological. The state programs to urbanize Māori were tactics that facilitated the biopolitical management of the Indigenous population. "Pepper potting," for instance, was a housing policy that encouraged assimilation by distributing Māori families within previously all-Pākehā neighborhoods.[35]

By the 1970s, it was increasingly evident that the "Māori Problem" (a phrase used to articulate the state's project of assimilating and "modernizing" the Indigenous populace) had not been resolved via assimilation. Indeed, new subjectivities of radical urban indigeneity posed the greatest threat to the nation-state. Urban Māori culture was heavily influenced by the immediate engagement with neocolonial methods of subjugation, and interaction with an increasingly politically informed academic metropolitan culture, leading to what became popularized as a process of "conscientization" and, later, "decolonization." The Indigenous rights movement in New Zealand was characterized by radical, cutting-edge, and often mediated Indigenous subjectivities that altered the political and mediated landscapes.

Importantly, radical Indigenous groups came into contact with civil rights and decolonializing discourses springing from the United States and other places. In the 1970s, Ranginui Walker referred to the "new wave" of Māori radicals as "Neo-Māori Activists" who formed groups such as the Māori Organisation on Human Rights (MOOHR), Waitangi Action Committee (WAC), *He Tauā* (literally, "a war-party"), Māori People's Liberation Movement of New Zealand, and Black Women: "The political ethos of the groups was based on the liberation struggle against racism, sexism, capitalism, and government oppression."[36] MOOHR, for instance, mediated Indigenous resistance via the newsletter *Te Hokioi*, which took the name of the Māori-language newspaper published in the 1860s by the Indigenous political movement Te Kīngitanga (the Māori King Movement, see chapter 7). The modern newsletter focused on the Treaty as a vehicle for the promotion of Indigenous rights, culture, and language.[37] The actions of groups like Ngā Tamatoa (an activist group who focused their protests on historical violations of the Treaty by the state), MOOHR, and WAC are important to note here not only because they reflect the unsettling neoformation that the postcolonial theorist Homi Bhabha had in mind,[38] but also because they located their resistance through highly mediated protests in relation to the Treaty. What was witnessed via the heavily visibilized radical urban Māori culture of the 1970s and early 1980s was a paradigmatic shift in how the nation was conceived.

In the mid-1970s the colonial narrative of "*He iwi ko tahi tātou*: Now we are one people"[39] (code for a subordinated Indigenous population within a dominant settler-colonial culture) was severely disrupted by the progressively mediated face of Indigenous resistance. The "1975 Land March," for example, began on September 13,

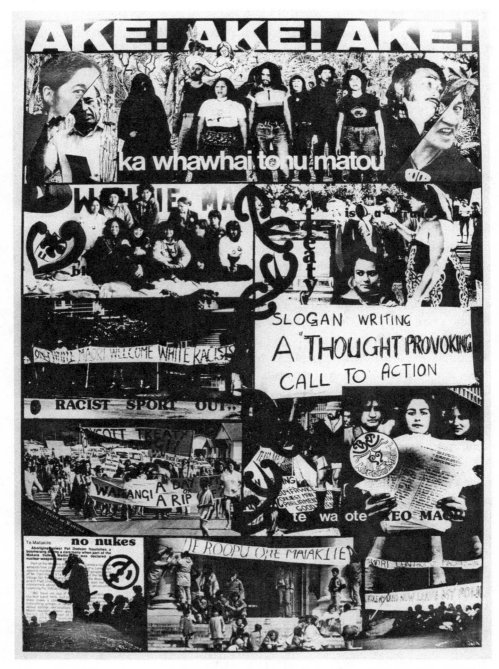

Figure I.2. Protest poster *Ake! Ake! Ake!* (Forever and ever and ever!) [1980s], Hocken Collections Uare Taoka o Hākena, University of Otago, Dunedin, ref. no. 8607737.

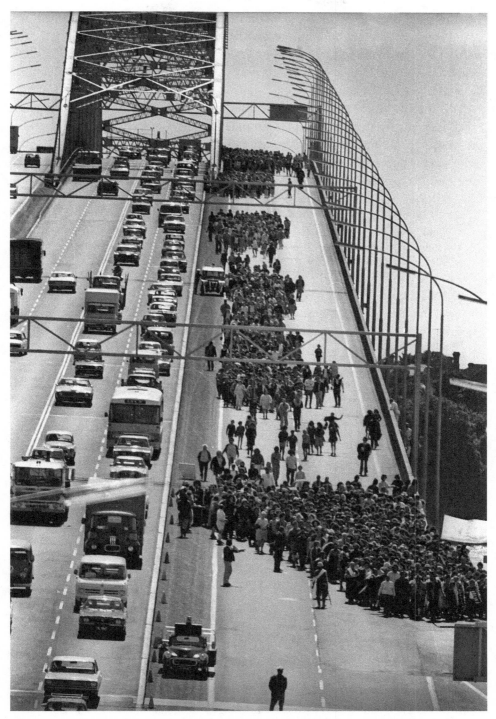

Figure I.3. Protesters in the Land March of 1975, walking over Auckland Harbour Bridge. Reproduced with permission of the *New Zealand Herald*.

1975, at Spirits Bay (in the "far north" of the country), marched the length of the North Island to the parliament buildings in Wellington, and was led by a prominent Māori woman activist, Whina Cooper. The image of the 1975 March crossing the iconic Auckland Harbour Bridge (Figure I.3) provides an enduring image of Indigenous resistance in New Zealand.

Like the 1975 Land March, the "occupation" of Bastion Point in Auckland three years later has had a lasting impact on radical Indigenous consciousness. After a prolonged period of political stasis and "being occupied," Ngāti Whātua ki Ōrākei (*iwi* from the far north who now reside in the Auckland city region) and others led by Joe Hawke[40] repossessed their lands. As a result,

> On 25 May 1978, after 506 days of occupation, 600 police officers, supported by the New Zealand Army, arrested 222 protestors for willful trespass on Crown land. The use of army and police, ordered by Prime Minister Robert Muldoon, received dramatic media attention, which reverberated through the country.[41]

The lasting image of Bastion Point is of Māori versus the state. Of note here is the documentary film of Merata Mita, *Bastion Point: Day 507*.[42] Mita and her film crew were the only media sanctioned by Ngāti Whātua ki Ōrākei to step onto

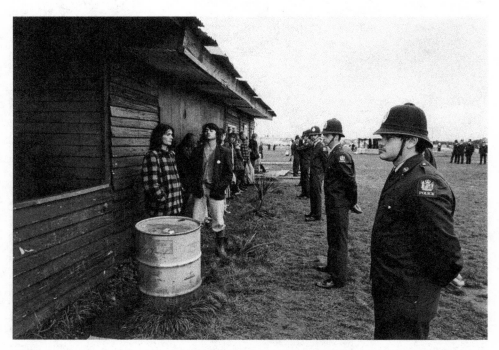

Figure I.4. Protesters and police at Bastion Point during its occupation in 1978. Photograph by Robin Morrison, reproduced with permission of the Auckland War Memorial Museum and Robin Morrison estate.

Bastion Point during the occupation, marking a significant point in the "control of the image" by Māori, and a key contribution to the corpus of what came to be conceived as "Fourth Cinema" (see the discussion below). Mita describes her subsequent documentary film of the resistance as

> the total opposite of how a television documentary is made. It has a partisan viewpoint, is short on commentary, and emphasizes the overkill aspect of the combined police/military operation. It is a style of documentary that I have never deviated from because it best expresses a Māori approach to film.[43]

The resistance to the ongoing neglect by the state toward "things Māori" eventually led (in the 1980s and 1990s) to the indoctrination of Treaty principles within state institutions such as health, education, social welfare, research, and broadcasting. Mirroring the broader Indigenous challenges, criticism of "mainstream media" galvanized around the failure of the state to promote Māori language and culture through centrally funded broadcasting. According to longtime Māori public broadcaster Derek Fox, for instance:

> The Treaty, signed in 1840 between the British Crown and the chiefs of Aotearoa guaranteed the Māori people tino rangatiratanga, or absolute authority over all their resources. . . . Like the land, the public broadcasting system is a vital present day resource, and as such Māori are legally entitled to an equal share of it.[44]

As a result of such challenges, by 1986 the Waitangi Tribunal (a state entity, established following the 1975 Treaty of Waitangi Act to assess historical grievances lodged by Māori against the state) recommended that

> It is consistent with the principles of the Treaty that the language and matters of Māori interest should have a secure place in broadcasting. . . . In the formulation of broadcasting policy regard must be had to the finding that the Treaty of Waitangi obliges the Crown to recognise and protect the Māori language.[45]

Despite the implications of the Waitangi Tribunal recommendations, state authorities failed to grasp the full intent of Māori regarding broadcasting rights. For instance, in the much-publicized Treaty Airwaves Claim, some Māori asserted Treaty rights over radio broadcasting waves in reaction to the 1989 Radio Communications Act by lodging a claim through the Waitangi Tribunal in 1990. Part of their claim read:

> Where any property or part of the universe has value as a cultural asset . . . the Crown has an obligation under the Treaty of Waitangi to recognise and guarantee Māori rangatiratanga [chiefly sovereignty] over its allocation and use for that purpose. . . . The sale of frequency management licenses under the [Radio Communications Act] without negotiating an agreement with Māori would be in breach of the Treaty.[46]

Under growing pressure from Māori then, Te Māngai Pāho (the Māori Broadcasting Funding Agency) was established under the 1993 Broadcasting Amendment Act with the mandate of "promot[ing] Māori language and Māori culture by allocating available funds, on such terms and conditions, as Te Māngai Pāho thinks fit, for broadcasting and the production of programmes to be broadcast."[47]

In 1996, a joint Māori/Crown Working Group on Broadcasting Policy was assembled to discuss the inculcation of Māori language and culture within mainstream broadcasting. The panel found that Māori content should feature "generally but not invariably in prime time" and "for reasonable periods at any one time" with the intended effect of "raising the profile/status/mana [power and authority] of Māori language and culture and enhancing their recognition as a part of everyday life . . . [and] providing a Māori view of the world, in its full complexity."[48] Similarly, a 1997 Ministry of Commerce policy report, resulting from consultation *hui* (gatherings) and submissions, found that

> the government has a responsibility to promote and protect te reo through television and radio; there should be a well-resourced, separate, Māori-owned and controlled television channel broadcast nationally, but there should be provision for regional involvement and Māori radio; Māori programming on mainstream media and in primetime is vital to promote and revitalise te reo; and public funding to develop Māori broadcasting should be distributed by a specialised agency like Te Mangai Paho.[49]

As the millennium drew to a close, however, while Māori had made remarkable headway in influencing policy, there was hardly any discernible change in practice. As Ronald Niezen points out, such a state of affairs only serves to increase Indigenous angst:

> There is a gap between the "normal" glacial pace of international legal and institutional reform and the rapid growth of Indigenous peoples' networks, the solidification of Indigenous political consciousness, and the broad base of rising expectations that accompany new powers of collective self-representation. The sense of collective injury and injustice is only made more poignant by limited political recognition and reform in the context of ongoing oppression.[50]

Central to the politics of recognition as played out via the demand by Māori to be represented in the media as "equal Treaty partners," was the emerging sense of Māori as Indigenous peoples. While *tangata whenua*[51] is not a new concept, as stated above, it became increasingly significant to identity politics of the 1990s as the term came to frame Māori agency within dominant discourses, including state policy. Yet, within the nation-state, Māori only materialized as *tangata whenua* through a discourse of partnership with the Crown. The interstitial space occurring at the interface between the neoformations of indigeneity and the grid of disciplinary coercions merely resuscitated New Zealand's "bicultural drama." That is, New Zealanders' postcolonial identity

merely provided trappings for a bicultural imaginary.[52] The "Māori Problem" morphed into "Treaty Partner," and, accordingly, both partners were produced in the bicultural imaginary through the Treaty. Aroha Harris refers to this as a "treaty consciousness."[53] For the non-Indigenous "partner," Jeffrey Sissons suggests, "post-settler belonging absolutely requires the perpetuation of an indigeneity through which new relationships to the land may be negotiated."[54] Sissons goes on to say, "Within this imagined political community settlers belong by virtue of a relationship between the Crown, which represents them, and Māori tribal leaders who represent *tangata whenua*."[55] Non-Indigenous New Zealanders on the whole, therefore, failed to come to grips with the implications of the Treaty and an increasingly educated Indigenous populace willing to strongly advocate for their sovereignty via the state's obligations to advance Māori language and culture. Thus, developments in Indigenous media remained, as Paulo Freire puts it, symptomatic of "false generosity."[56]

As outlined above, the radical intent of *tangata whenua* as a political device was quickly subsumed by a discourse of biculturalism. That is, New Zealanders in general only viewed Indigenous political agency in relation to a tokenistic conceptualization that in reality came to be referred to as "state handouts" within right-wing literature. Accordingly, Māori began to differentiate between media that reflected false generosity and Māori-controlled media. Māori lawyers and politicos Moana Jackson and Atareta Poananga, for instance, provided a "two-house model" framework that differentiated between self-determination and assimilation intent in media culture:

> The TV One programmes [i.e., state funded] Marae and Te Karere are contained within the mainstream house. . . . Both programmes attempt to portray values, language and issues related to the Māori house. . . . Within the mainstream house they occupy a "room," but the "house" is not Māori. They are still a minority within the whole industry and have to conform to the policies and practices of the mainstream house.[57]

The increasingly discursive nature of a "Treaty consciousness" led to the introduction of Māori-focused programs within the two state-sponsored television stations, such as *Te Karere* (daily news), *Eye to Eye, Marae,* and *Waka Huia* (all current affairs programs). Yet, for many Māori, the programs reflected tokenistic-based politics of recognition, as described by Jackson and Poananga above.

During this period, however, the exception to the agenda of false generosity was the development of *iwi* radio, which according to Ian Stuart has been "at the forefront of articulating Māori political aspirations in a national public sphere."[58] During the late 1980s, two *iwi* stations were trialed, *Te Upoko o Te Ika* (literally, "the head of the fish," referring to the geographical area where Wellington is situated)[59] and *Radio Ngāti Porou* (Ngāti Porou North Island East Coast *iwi*). Since the mid-1990s, *iwi* radio has grown into a consortium that numbered twenty-one affiliated stations in 2010,[60] which Stuart believes to be a critical mass capable of acting as "a unifying force for

Māori . . . creating a Māori identity, constructed by Māori."[61] In addition to this, the emergence of Māori Television in 2004 marked another significant development toward redressing the absence of Māori media in the nation.

The above demonstrates that the state's commitment to Indigenous media culture is located within the auspices of the Treaty and its bicultural aspirations. While this can be celebrated, for Māori now have access to technologies of inscription through which their culture, language, and practices can be disseminated, it must also be emphasized that within mainstream, or non-Indigenous, media culture in New Zealand, Māori continue to be represented in reductive, stereotypical fashion. The three parts of the book, which we discuss below, aim to capture this dynamism to shore up the tension between media representations of indigeneity and Indigenous self-representations through the media.

Mediated Indigeneity: Representing the Indigenous Other

Part I, "Mediated Indigeneity," elucidates the representation of Māori by non-Indigenous media. Since the publication of Edward Said's *Orientalism* in 1978,[62] the focus on the mediated representation of the "Other" has been exhaustive. Here, studies of the Other have typically focused on representations as social constructions relative to time and place that "not only do not reflect reality but, more profoundly . . . fracture, distort or quite literally *misrepresent* reality and the experiences of minorities."[63] Thus, representations of Indigenous peoples and cultures by colonial and neocolonial media are in the main seen to have little to no cognizance of the Indigenous epistemologies being represented and are, moreover, driven by imperial ideology, perverted by racialized ideologies of subjugation. In Hegelian terms, representations of Indigenous subjects by colonial and neocolonial media mirror a will to synthesize Indigenous worldviews into meanings understandable to the Western world.

In relation to New Zealand and "mainstream" television, Māori media theorist Jo Smith reiterates the above, arguing,

> As a settler society founded on a history of colonization, a dominant tendency of mainstream television is to naturalise the settler-subject in the landscape and to assert an instrumental relationship over the land via this settler-subject. . . .
>
> The nature of the conflict over what gets to count as "common" to a nation's imaginary is thus a battle over the coding of social spaces and how these spaces become an invisible part of the quotidian life of a nation.[64]

Similar to these conclusions, in the present collection, Allen Meek's chapter, "Postcolonial Trauma: Child Abuse, Genocide, and Journalism in New Zealand," discusses a series of cover stories in two prestigious New Zealand magazines, *Metro* and *North and South,* concerning the deaths of young children in Māori families. Similar to

Smith, Meek deduces that "in the context of these magazines the representations of these children's deaths were used to implicitly justify settler culture and colonial rule in Aotearoa" (see chapter 2).

The securing of settler domination over the landscape via the media is a constant presence in New Zealand and is often played out through the discourse referred to by the neocolonial media as "public sentiment." For instance, the state's decision-making regarding the 2010 negotiations of Tūhoe (*iwi* of the central North Island) claims over Te Urewera (Tūhoe ancestral lands, which after colonization became a state-governed "National Park"), was influenced by "public sentiment" as reported by the neocolonial media, which claimed there would be a "public outcry" if the National Party–led government ceded control of the National Park back to its Indigenous proprietors. Subsequently, the original agreement to return governance of Te Urewera to Tūhoe was revoked by the government, while Prime Minister John Key broke protocol "by announcing the decision publicly, saying the matter had to be cleared up following a series of media stories about the possibility of the transfer happening."[65] This event in 2010 merely follows a litany of misreporting by the neocolonial media in New Zealand.

Hodgetts et al. argue that "throughout New Zealand history when Māori have asserted rights to land and autonomy, Pākehā regulation news coverage has been partial, providing little background to grievances and dismissing Māori concerns as unreasonable and unnecessarily hostile."[66] This sentiment is highlighted by the Foreshore and Seabed Act debacle of 2004. After two decades of institutionalized biculturalism, it was increasingly clear that previous Pākehā tolerance of Māori political assertiveness was waning thin, leading to a prominent right-wing backlash that rearticulated Māori claims to Indigenous rights as "Māori favoritism" and "reverse-racism." For example, in early 2004, Don Brash, the then leader of the opposition National Party, delivered his now infamous speech on "Nationhood," which castigated the "dangerous drift towards racial separatism in New Zealand."[67] Brash promised that a National government would "remove divisive race-based features from legislation," arguing that "there can be no special privileges for any race."[68] Brash's speech rejuvenated the flailing National Party, which gained seventeen points in popularity immediately following his address; an unprecedented gain for a New Zealand political party. The growing antagonism toward Māori "favoritism" also led to reactionary politics by the then governing Labour Party; it ratified the Foreshore and Seabed Act, which disqualified the right of Māori to govern traditional preserves. Hodgetts et al. found that during the controversy the news media served to inflame, alarm, and misinform the public with regard to the issues at hand. For example, on June 21, 2003, Television One News headlines ran: "More Māori claims for large areas of the New Zealand coastline are looming after a Court of Appeal decision."[69]

More recently, on October 15, 2007, the New Zealand police under the auspices of the 2002 Suppression of Terrorism Act raided houses nationwide and arrested

seventeen Indigenous rights, environmental, and political activists, and anarchists. In the present collection, Vijay Devadas's chapter, entitled "Governing Indigenous Sovereignty: Biopolitics and the 'Terror Raids' in New Zealand," examines the media coverage of the raids on that day and subsequently until the March 2012 court decisions, across selected print and broadcast media outlets. Devadas argues that mainstream media racialized "the image of terror" through an Indigenous figure: "Iti is used to stand in for the discourse of terror as part of a larger cultural practice of visualizing identity, and testifies to the power of visual culture in the politics of reproducing notions of race, terror, and criminality" (see chapter 1).

Bruyneel argues in broad terms that the suppression of Indigenous sovereignty "can be located in economic, cultural, and political narratives that place limitations on the capacity of [Indigenous] peoples to express meaningful agency and autonomy."[70] Translated in relation to neocolonial media, misrepresentations of Indigenous peoples are enabled because Indigenous peoples are represented as unable to accurately represent themselves. Moreover, structurally the neocolonial "media complex" is arranged so that Indigenous peoples are largely silenced within the knowledge-production process. For instance, a 2006 National Survey of Journalists concluded that

> The typical New Zealand journalist is a European woman in her 30s who works as a reporter for a newspaper, holds a bachelor's degree, has less than five years experience, is paid about $40,000 a year, has no religious belief—and probably speaks French well enough to conduct an interview with Jacques Chirac.[71]

The same report found that 83 percent of those surveyed were Pākehā, with "8.5% identifying as Māori or Māori/Pākehā."[72]

The skewing of "national" media that such institutionalized underrepresentation invites is made poignant by the few content analysis studies conducted in this area. Barclay and Liu's quantitative analysis of the coverage by two urban newspapers of a prominent seventy-nine-day Indigenous land occupation at Moutoa Gardens, Whanganui, in 1995, found that

> Māori did not achieve one-half of the "amount of voice" in coverage; rather, the various Māori interests were accorded the status of a minority voice. Overall, the proportion of material quoted from Māori occupiers was less than that from any of the other groups, and Māori quotes were shorter. In terms of balance, occupiers' accounts were matched with alternative accounts more often, compared with frequency of matching for other groups.[73]

Accordingly, the general public's comprehension of events fundamentally mirrored a non-Indigenous viewpoint.

In a comparative discourse analysis of Indigenous and non-Indigenous news media, Joanne Te Awa found that mainstream news coverage typically defined Māori in "problem terms" via "conflict based coverage."[74] Te Awa also found that news from a

Māori epistemology deemphasized violence and negativity, and further that "When values such as 'cultural proximity' and 'relevance' [we]re adapted by Māori journalists working in a Māori media organisation whose audience are Māori, the news gathered is different. The focus is on Māori, problems facing Māori and often achievements by Māori."[75] It is apparent then that for Māori and Indigenous peoples in general, the mainstream news media (and increasingly advertising) has come to play a pivotal role in what Frantz Fanon referred to as "internalization."[76] Here it is important to note that the New Zealand state is the primary funder of the most prevalent media outlets in New Zealand, including Television One, Television Two, Radio New Zealand, and Māori Television. Coulthard points out that Fanon's ideas anticipated the work of Louis Althusser, "who would later argue that the reproduction of capitalist relations of production rests on the 'recognition function' of ideology, namely, the ability of a state's 'ideological apparatus' to 'interpellate' individuals as subjects of class rule."[77] The argument could then be made that in New Zealand the state-funded media outlets are part of an ideological apparatus that promotes the internalization and naturalization of derogatory representations of what it means to be Indigenous and disavows Indigenous claims to sovereignty.

Beyond misreporting of Indigenous assertions to land, the phrase "Māori news is bad news" (coined by Walker) has become synonymous with how Māori perceive mainstream news reportage of themselves. For example, the news media frequently refers to child abuse as a "Māori Problem," a discourse supported by many politicians. For instance, in 2010 the Social Development minister, Paula Bennett, addressed parliament and singled out Māori leaders as having a responsibility to rectify Māori child abuse: "I need you as respected leaders to go back to hapū, iwi and your whānau . . . and say it's time to face up to this. It's time to face up to the fact that Māori children and Māori babies are being beaten, abused and killed and it's time it stopped."[78] In response, Green Party coleader and Māori member of Parliament (MP) Metiria Tūrei argued: "Paula Bennett singles out Māori when abuse is rife through all communities. Where is her call to Pākehā leaders, to religious organisations, to the state itself for the abuses that took place in their hands?"[79] Māori historian Danny Keenan found that newspaper reportage of Māori domestic violence emphasized "predetermined ideas about Māori people and behaviour, thereby sustaining simplistic racial dichotomies."[80] In a particular child abuse case referred to by Keenan, one headline included a reference to the film *Once Were Warriors*, thereby "encouraging readers to make logical connections between the child's death and a work of fiction noted for its 'intensely negative portrayal of Māori.' "[81] As outlined above, Allen Meek's chapter in this volume examines issues of child abuse, genocide, and journalism. As with Keenan's analysis, Meek finds that "the media exploited the 'traumatic' impact of these images and narratives and potentially mobilized public opinion against Māori self-determination" (see chapter 2).

One area that has been largely under-studied, however, is the role advertising plays in appropriation of Indigenous culture. The most globally recognizable example of

mediated appropriation of Māori culture (and perhaps any Indigenous culture) is that of the *haka* entitled "Ka Mate,"[82] which is used in pre-match entertainment by New Zealand's national rugby union team, the All Blacks. The appropriation and use of Māori culture by the likes of global conglomerates such as Adidas is outlined clearly by Pākehā copyright lawyer John Hackett, who argues in relation to "Ka Mate" that "they [i.e., Māori] aren't absolutely certain who created the *haka* [i.e., "Ka Mate"]; and, there is no written contract to verify ownership, making it part of the public domain."[83] In contrast, Māori lawyer and Treaty of Waitangi claimant Māui Solomon points out the very use of a colonial legal tradition to evaluate and judge cultural and intellectual property rights (IPR) is fraught with contradictions:

> The intellectual property rights system is totally inadequate to recognize and protect Māori cultural values and cultural rights. For example, the IPR system was developed to protect private economic rights that came out of the Industrial Revolution, but when you talk about Māoritānga [Māori culture], cultural heritage rights, these are collective by nature so they don't belong to one individual, they belong to the *whānau*, the *hapū*, or the *iwi*. . . . Increasingly . . . you've got major corporates who are drawing upon Māori branding, Māori imagery, and Māori icons to promote their products. Now if they're going to do that they've got to go to Māori and make sure that they have the proper authority that they are doing the right thing, that they are using those images and icons in a culturally appropriate way. And if there is going to be a commercial return then what share of those benefits will Māori get?[84]

In this collection, Jay Scherer's chapter, "Promotional Culture and Indigenous Identity: Trading the Other," examines the discursive codes of production, the dominant cultural assumptions, and the claims of authenticity that are routinely summoned by cultural intermediaries who produce commercial images of "Ka Mate" and other Indigenous intellectual properties. The significance of Scherer's chapter lies in how it reveals the ongoing erosion of the territorial frontiers and cultural boundaries of the global advertising industry in relation to Indigenous intellectual and cultural property. Scherer notes "the value of Indigenous culture to the broader All Blacks brand: a brand that has become so popular it now exists as a vehicle for the promotion of numerous corporations" (see chapter 3).

Also looking at the broad area of advertising, Suzanne Duncan's chapter, "Consume or Be Consumed: Targeting Māori Consumers in Print Media," provides a unique insight into "ethnic marketing" from a Māori perspective. Duncan finds that the predominant postcolonial mode of ethnically targeted advertising toward Māori involves "social marketing," that is, advertising "aimed at changing behaviors and adopting new value systems that will aid in the social development of the target market." Given the state investment in social marketing toward Māori reported in her chapter, Duncan suggests such advertising reflects a neoliberal agenda, "geared towards the biopolitical management of the Indigenous body to increase productivity, via a more healthy and efficient workforce, while also ensuring that the capitalist system and the postcolonial

nation circumvent both moral and financial responsibility for the 'deviances' of the community" (see chapter 5).

The Broadcasting Standard Authority (BSA) is the state entity set up via the 1989 Broadcasting Act to assess complaints and to encourage "the development by broadcasters of codes of broadcasting practice,"[85] including advertising practices. In 2006, the New Zealand Human Rights Commission, as part of their annual race relations report, investigated the BSA's practices and found that it fielded numerous complaints regarding print, advertising, and broadcasting in relation to racism, but none were upheld. For instance,

> Radio Pacific host John Banks described Māori Television as "useless" and "one of the most disgusting apartheid TV stations in the history of the world." . . . Māori Television complained that the comments breached the prohibition against denigration contained in guideline 7(a) of the Radio Code of Broadcasting Practice. The BSA acknowledged that the host's comments were ill-informed and calculated to offend. It noted, however, that the protection of the denigration guideline extends only to a "section of the community." In the present case, the host's comments were directed primarily at the policy decision to create and fund Māori Television, and incidentally at Māori Television as a corporate entity. In the view of the BSA, Māori Television was not a "section of the community," and thus the guideline did not apply.[86]

In the same year, the BSA rejected claims of racism made against a talkback radio host, Michael Laws, concerning

> remarks made in his capacity as a radio talkback host on Radio Live, describing the late King of Tonga as a "fat brown slug." The BSA ruling stated that the King was an individual not a "section of the community." Nor did the ruling regard the comments as a breach of good taste and decency when viewed in the context of the robust nature of talkback.[87]

Given the prominence of John Banks (who is an ex–National Party minister, ex-mayor of Auckland City, and currently the leader and only MP of the neoliberal Act Party) and Michael Laws (who is also an ex–National Party MP and ex-mayor of Whanganui), it is clear from the examples above that racism is alive and kicking in New Zealand. More importantly, the first three chapters in this part demonstrate the important role that the neocolonial media complex has played in perpetuating and subjugating Indigenous sovereignty via institutionalized and nondiscursive methods.

While such interrogations are highly pertinent, they leave little room for, first, Indigenous political agency; second, for non-Indigenous people to approach an ethics of representing the Indigenous Other; and, third, the multiple positionalities of "postcolonial citizens" who view themselves beyond the colonizer/colonized, Māori/Pākehā binary. Many contemporary media analysts, for instance, increasingly describe settler nation-states as undergoing some variety of postcolonial moment, rupture, or

disjunct, typically involving interrogation of national identity in relation to the increasing politicization of Indigenous identity.

In *Australian Cinema after Mabo* (2004),[88] for example, Felicity Collins and Therese Davis argue that the recognition of the validity of Native Title in the landmark Australian High Court judgment in the *Mabo v. Queensland* case "irreversibly destabilized the way that Australians relate not only to the land but to their colonial heritage,"[89] and subsequently shaped the interrogation of postcolonial identity formation and Indigenous–settler relations in films made by Euro-Australians including *The Tracker* (2002)[90] and *Rabbit-Proof Fence* (2002).[91] As Ginsburg advocates,

> These works "backtrack" through the nation's history not in triumphalist terms, but in ways that address the legacies of grief and violence wrought by settler colonialism, a significant transformation in the country's sense of its own legacies, and a recognition that it matters whose stories are told and by whom.[92]

In New Zealand, Māori directors have tended to the "backtracking" described above, in feature films such as *Ngati* (1987)[93] and *Mauri* (1999, first produced 1988),[94] directed by Barclay and Mita respectively. Yet, films by Pākehā directors, such as *Broken Barrier* (1952, John O'Shea and Roger Mirams),[95] *To Love a Māori* (1991, first produced 1972, Rudall and Ramai Hayward),[96] and *Utu* (1983, Geoff Murphy),[97] all served to challenge postcolonial racialized constructions through themes like early-colonial warfare and interracial marriage. However, if there was such an event resembling a "postcolonial moment" in New Zealand film, it would be Māori director Lee Tamahori's *Once Were Warriors* (1994), which at the time became the most successful motion picture in New Zealand cinematic history. It was a film that, if nothing else, provided a vehicle for discussing a subversive postcolonial Māori underclass.

One of the central criticisms of *Once Were Warriors* by Māori was that while it realistically depicted urban Māori impoverishment, the undercurrent of the film, as its name suggests,

> intimates that the inherent violence of *tāne* [Māori men] was, in pre-colonial times, appropriate behavior for a noble warrior culture but has, in "modern" times, become a natural symptom of Māori urban dysfunction. The film's illustration of the implicitness of Māori male violence is never more indoctrinated than when Jake's explosive violence is repetitively heralded by the eerie wailing of a *pūrerehua* (bull-roarer); the wailing implying the stirring of the inherent savage within.[98]

Yet, nowhere in the film does the history of colonial oppression enter to offer a more accurate account of Māori penury, such as land confiscation, Treaty breaches, disease, and warfare.

In contrast to their predecessors, contemporary Pākehā directors have in the main lost their "postcolonial voice," that is, their desire to cross-examine emerging

postcolonial identities. Niki Caro's *Whale Rider* (2002), for example, typifies how Pākehā directors have, since *Utu*, shied away from interrogating settler–Indigenous relations by largely hiding postcolonial Pākehā presence:

> Like a colonial painter Caro has removed the backdrop of the colonial reality and, in so doing, purged Pākehā and other Westerners of any responsibility for the oppression of Indigenous peoples. In the simulacrum of Whangara [where *Whale Rider* was filmed], a Western audience can recognize ubiquitous human themes in an exotic locale, while the colonial process that produced the subjugation of Māori is rendered invisible.[99]

It is probable that the increasing complexity and prominence of Indigenous–non-Indigenous relations in New Zealand politics has meant that Pākehā directors have chosen to blank the canvas of settler presence when representing the Indigenous Other. This reflects the mirror opposite of other settler nation-states like Australia, whose atrocious colonial history has only since the 2000s been given any credence by mainstream politics.

One exception to this phenomenon is Pākehā director Vincent Ward, who duly tackles the emergent nature of postcolonial Māori/Pākehā identity in historically oriented feature films such as *River Queen* (2005)[100] and *Rain of the Children* (2008).[101] In the present volume, Kevin Fisher and Brendan Hokowhitu critically analyze Ward's methodology in *Rain of the Children*, paying particular attention to "remediation" filmic techniques. According to the authors, Ward's method "immediately separates his filmic practices from the likes of Caro and . . . signals an ethical approach to treating Indigenous subjectivities by non-Indigenous film-makers" (see chapter 4, "Viewing against the Grain"). However, even the growing postcolonial angst arising through revisionist filmic notions such as "backtracking" and "remediation" still tends to reflect an Enlightenment rationalism, where the central project remains the deliverance of Western subjectivities. The (historical) Indigenous subject remains the sounding board for the more enlightened postcolonial identity, and thus resides in the margins.

In stark contrast to such an approach, a radical ethics toward the mediated treatment of the Other involves, first and foremost, a reflexive praxis driven by an ethical imperative to analyze production in terms of understanding the historical tradition of Western rationalism, which "preserves the boundaries of sense for itself."[102] As Bhabha points out in relation to Said's *Orientalism*:

> Said is aware when he hints continually at a polarity or division at the very centre of Orientalism. It is, on the one hand, a topic of learning, discovery, practice; on the other, it is the site of dreams, images, fantasies, myths, obsessions and requirements. It is a static system of "synchronic essentialism," a knowledge of "signifiers of stability" such as the lexicographic and the encyclopaedic.[103]

This "synchronic" essentialization of the Other fundamentally involves the synthesis of Indigenous epistemologies within a Western regime. And this ontological imperialist project is inherently violent, as Madan Sarup argues: "in Western philosophy, when knowledge or theory tries to understand the Other, then the alterity of the Other vanishes as it becomes part of the same. In all cases it involves violence towards the Other."[104] Similarly, Robert Young states, "ontology amounts to a philosophy of power, an egotism in which the relation with the Other is accomplished through its assimilation into the self."[105]

The idea of nonsynthesis or antisynthesis as an ethical approach for the representation of Indigenous peoples by non-Indigenous appears simplistic, yet the inherent nature of synthesis to Western rationalism renders any attempt at nonsynthesis uncomfortable, unnatural, and, more than likely, unpopular. Here the full-weight of Bhabha's analysis, where "the boundaries of sense" within Western rationalism are preserved for itself, must be taken on board. If we analyze the words of celebrated ethnographic filmmaker Jean Rouch, for example, where he suggests ethnographic film has the possibility to produce "a new language which might allow us to cross the boundaries between all nations,"[106] one may see these words as "full of hope," or as reflective of a will to dilute culture so as to produce indigeneity in cognizable forms for the West.

The latter raises the question of why mediate alterity at all if understanding the Other is not at the epistemological core? Yet, such questioning can be constructed as merely preserving Western rationalism's claims to universal knowledge through free access rights to all knowledge. Repositioning the politics of representation opens up other realms for the mediation of indigeneity. For instance, Alison Griffiths suggests that, "as a discursive category, ethnographic film refers less to a set of unified significatory practices or to the anthropological method of intensive fieldwork than to the looking relations between the initiator of the gaze and the recipient."[107] While highly problematic if the "recipient" is always an Indigenous person, nevertheless, such a "politics of looking" reemphasizes the conditions of representation away from seeking truth about the Other and synthesis, and toward questions of nonsynthesis or antisynthesis.

Indigenous Media: Emergence, Struggles, and Interventions

The term "Fourth Eye" seeks to capture the politics of media representations of Indigenous peoples; the use of the media as a modality of Indigenous empowerment, sovereignty, resistance, and articulation of struggles; and the creative potentiality of an indigenized mediascape. The Fourth Eye thus captures the Indigenous politics of representation, with an emphasis on biopolitical production. This section explores the multiple, overlapping inflections on what might be considered "Indigenous media," whether that be as "anti-colonialist cultural criticism of representation,"[108] as

developmental media,[109] as an Indigenous public sphere,[110] or as "visual sovereignty."[111] Many of these notions are critically analyzed in Hokowhitu's contribution "Theorizing Indigenous Media," which examines the question, "What is Indigenous media?" through concepts such as the politics of recognition and appropriation, "Fourth Media," pan-Indigenous media, antisynthesis production, and sovereignty (see chapter 6). One of the ideas explored, for instance, is Indigenous "visual sovereignty" as lucidly discussed by Michelle Raheja in "Reading Nanook's Smile: Visual Sovereignty, Indigenous Revisions of Ethnography, and *Atanarjuat (The Fast Runner)*." In relation to the politics of appropriation Raheja argues "visual sovereignty" is

> a reading practice for thinking about the space between resistance and compliance wherein Indigenous filmmakers and actors revisit, contribute to, borrow from, critique, and reconfigure ethnographic film conventions, at the same time operating within and stretching the boundaries created by these conventions.[112]

In this collection, various other definitions of "sovereignty" are offered by Indigenous broadcasters. For example, Māori broadcaster Derek Fox, who was one of the key advocators for the development of Māori Television, contends Indigenous media sovereignty "implies 'mana whakahaere' (control), Māori are not interested in being advisers or 'colour consultants'. We are ready to make our way in this world."[113]

For many Indigenous creative artists, the neocolonial will to synthesize Indigenous knowledges within cognizable Western frames has produced a resistance that has come to ostensibly ground notions of "Fourth Media." Central to any formulation of Indigenous media is the politics of perspective, as outlined by Mita:

> It is very important to make the distinction between the way we are seen and the way we see ourselves. And the reason for this becomes very clear if you look at the films that have been made starting from 1911 in the United States, in Europe and in Aotearoa. If you look at those films made by tauiwi [white people] or by foreign eyes on us, you will see very important differences to the way they look at us and the way we see ourselves.[114]

With the creation of terms such as "Fourth Media" and "Fourth Cinema," there is a tendency to think of Indigenous-controlled media as a recent development. Importantly, Lachy Paterson's chapter in the present collection, "*Te Hokioi* and the Legitimization of the Māori Nation," pays attention to early colonial Indigenous media through analysis of *Te Hokioi* (a hōkioi was a native bird resembling a snipe, now extinct), a Māori-language newspaper published by the Indigenous political movement Te Kīngitanga in the 1860s. This was a prominent decade of Māori/Pākehā armed conflict—the time period depicted in the feature film *Utu*. As Paterson argues, "*Te Hokioi* was the first, and perhaps most radical, example of Indigenous media activism in New Zealand," enabling Te Kīngitanga "to broadcast its own developing ideology and to counter the New Zealand government's own propaganda directed at Māori" (see

chapter 7). Paterson's insightful historical analysis provides much food for thought about how Indigenous media might be conceptualized today, as the 150-year gulf since *Te Hokioi*'s publication speaks to the paradigmatic shift away from an Indigenous existentialism evident in this early Indigenous media activism.

The notion of "Fourth Cinema" is also synonymous with the work of Māori filmmaker Barry Barclay. Barclay's film *Te Rua* (1991)[115] is the subject of April Strickland's chapter, "Barry Barclay's *Te Rua:* The Unmanned Camera and Māori Political Activism," which looks at themes of Indigenous community and political activism. Of note here is Strickland's exploration of *marae* (land and buildings of genealogical significance), which in this context refers to the site of ritual encounter between *tangata whenua* and *manuhiri* (visitors) as a metaphor for Indigenous filmmaking. To explain, Strickland quotes Barclay at length (see chapter 8):

> When creating a communications marae, I think we must be conscious of that duty to offer suitable hospitality. You must not insult your guests, or let them feel they are being left on the outer. If we do not respect that most basic of marae rules, the communications marae we have striven so hard to set up will be rejected, not only by the majority culture, but by our own people—and indeed, by them first.[116]

Stephen Turner continues where Strickland leaves off by providing "Reflections on Barry Barclay and Fourth Cinema." Written soon after the passing of Barclay, this chapter provides a moving account of the importance of Barclay's thought to New Zealand in general, suggesting "the issues raised by Fourth Cinema are not simply 'film' issues. They are, more deeply, issues of law, knowledge and property . . . or what Barclay has called 'image sovereignty' " (see chapter 9).

Māori Television: Nation, Culture, and Identity

In 1996, Te Māngai Pāho funded the pilot project "Aotearoa Television," which eventually led to the advent of Māori Television in 2004. Aotearoa Television screened in Auckland for three months between the hours of 5:00 p.m. and 10:30 p.m. Accessible on a UHF frequency, it was praised for offering a range of programming with high production values aimed particularly at youth, the largest demographic sector of the contemporary Māori population. In contrast to mainstream media programming of the time, the station presented positive images of Māori, and contained cultural protocols such as closing the day's viewing with a *karakia* (prayer). However, Aotearoa Television collapsed under loss of government funding amid accusations of poor financial management; a "scandal" that gained much mainstream media coverage and notoriety in the public imagination, and in all probability stalled the actualization of Māori Television for at least half a decade.

Nevertheless, the launch of Māori Television in March 2004 marked the most significant event of Indigenous media in New Zealand's history. In a media release, the

chief executive of Māori Television, Ani Waaka, announced its arrival in relation to the "Māori Renaissance" of the 1970s,[117] suggesting a struggle lasting "30 years after the first bid to beam *te reo* and *tikanga Māori* (Māori customary lore) into New Zealand's living rooms." Māori Television's mandate demonstrates a clear developmental and nationalistic intent:

> The principal function of Māori Television is to promote te reo Māori me ngā tikanga Māori [Māori language and customary lore] through the provision of a high quality, cost-effective Māori television service in both Māori and English, that informs, educates and entertains a broad viewing audience, and, in doing so, enriches New Zealand's society, culture and heritage.[118]

As a state entity Māori Television, almost by definition, is akin with other state-funded broadcasters in the promotion of nationalism, yet with key differences. First, as Smith points out, "The 'New Zealander' envisaged by MTS [Māori Television Service] is thus a citizen of a nation state that is cognisant of Māori values, language and culture, a cognisance produced in part by the televisual mediations of MTS."[119] Indeed, one of the mandates of Māori Television was to promote Māori culture and language as part of a broader government response to the Treaty of Waitangi, including the 1987 Māori Language Act that recognized *te reo Māori* as an official language of New Zealand.

Accordingly, the evolution of an Indigenous mediascape in New Zealand has resonated through Māori Television the sentiments of the broader Māori cultural renaissance, and even broader transnational Indigenous claims to sovereignty, bound together by the key Indigenous postcolonial identity markers—land, language, culture, and community-building. Thus Chris Prentice, in her chapter "The Māori Television Service and Questions of Culture," argues that "(self-)representation or articulations of identity politics are inseparable from the wider political economy, and its onto-epistemological predicates, within which they take place." She goes on to suggest that Māori Television "is really only an epiphenomenon of a larger set of challenges for postcolonial Māori culture" (see chapter 10).

One definition of Indigenous media as "developmental" suggests that its philosophical approach is fundamentally different to that of commercial media. Stuart, for instance, argues that the functions of Māori media are primarily to revitalize Indigenous epistemology, while concomitantly unifying and educating its people: "Māori media seeks to educate people to ensure the survival of both the language and culture. The Māori media also actively seeks to promote positive images of Māori and to provide a Māori view of events and news, all roles assumed by a developmental media."[120] Stuart goes on to say that "The Māori media is building, or rebuilding, a culture, and by doing so . . . is creating a nation, but a nation separated from a state, and internal within a state."[121] Likewise, Hodgetts et al. suggest Māori media can provide "direct links within Māori communities, for nurturing a sense of community, for education,

and for fostering a shared agenda necessary for continued advocacy for social justice."[122]

In many regards then, the mandate of Māori Television, at least, reflects an "Indigenous public sphere," defined as "the highly mediated public 'space' for evolving notions of indigeneity . . . [yet] a peculiar example of a public sphere, since it preceded any 'nation' . . . it is the 'civil society' of a nation without formal borders, state institutions, or citizens."[123] However, it is clear from the discussion above that the developmental aspect of Māori Television also had in its sights non-Indigenous New Zealanders. As a starting point of her analysis of "Māori Television, Anzac Day, and Constructing 'Nationhood' " in the present collection, Sue Abel argues that Indigenous media offers Indigenous peoples the opportunity to reconfigure the national imaginary. Via viewer responses to the coverage of Anzac Day (a commemorative day for the Australian and New Zealand Army Corps) on Māori Television, Abel concludes that, presently, the national imaginary is far from being mature enough to truly interrogate its colonial history (see chapter 11).

In her comparative essay regarding the coding and recoding of the nation as it takes place on Television One versus Māori Television, Smith argues that Television One as a "territorial writing machine," "code[s] the imagined space of the nation-state according to a settler cultural compass,"[124] which serves to perpetuate the national imaginary in the shadow of a settler history. In contrast, Smith suggests that "with the broadcast of Māori programming and content on a distinctively Māori channel, the national imaginary might be forced to invoke itself in terms of a double-time."[125] Here Smith is proposing that Māori Television's "will to cultural transformation" is not so much through representation but because of "its spectral presence in the national programming schedule, a presence which inserts micro-level pauses in mainstream quotidian flows, and hence national orthodoxies, and which provide us with glimpses of our bicultural futures."[126]

Following on from her previous work, in the present collection Jo Smith and Joost de Bruin's chapter challenges the noncommercial/commercial dichotomy that is supposedly inherent to developmental Indigenous media. "Indigeneity and Cultural Belonging in *Survivor*-Styled Reality Television from New Zealand" thought-provokingly examines "the different ways in which two recent New Zealand television programs draw upon global reality television formats to articulate discourses of indigeneity and cultural belonging" (see chapter 12). Importantly, the chapter compares the discourses stemming from a mainstream program and a Māori Television program to "illuminate the specificities of local discourses of indigeneity."

Conclusion

This collection is unique in its intent to synthesize the discrete disciplines of Indigenous and Media Studies by bringing together a number of Indigenous and

non-Indigenous academics to produce a comprehensive and cogent account focused on the morphing notion of "Indigenous" through media and through the convergence of theoretical trajectories to expose the ways indigeneity is mediated. That is, it examines how media technologies produce mediated experiences informed by indigeneity or, conversely, how media representations of indigeneity filter the lens through which indigeneity is constructed. As alluded to above, the collection attends to three thematic areas that traverse various media forms and examines the construction, expression, and production of indigeneity through the reporting of Indigenous issues in commercial, non-Indigenous media; through how media has been used to engender a sense of Indigenous activism, culture, community, development, and sovereignty via the production of a politically active Indigenous voice; and, significantly, through how various Indigenous media developments should be read within a politics of recognition and a broader neocolonial system constantly attending and renegotiating threats to its stability. In initiating this collection, it is the hope of the editors (one being in Indigenous Studies and the other in Media Studies) that the synthesizing of both disciplines will enable the important area of Indigenous Media Studies to be further developed and critically enhanced.

Notes

1. Our choice to use "New Zealand" throughout the collection, bar the title, is partly based on recognition of the international audience. There are also ideological concerns that motivate our decision. All the currently employed nomenclatures are problematic. For instance, although "Aotearoa" (a Māori name meaning "Land of the Long White Cloud") is now commonly used as a translation for "New Zealand" within the imagined bicultural nation, in actuality the name originally referred to the North Island, whereas the South Island is still commonly referred to as "Te Waipounamu" ("The Land of Greenstone"). Many writers choose to refer to New Zealand as "Aotearoa/New Zealand" in recognition of the supposed bicultural nation. The problematics surrounding the conjunction include its inference that New Zealand adheres to biculturalism where, in the main, it clearly does not and, second, because it implies that there was, or is, such a thing as a homogenous group of people who could constitute a "Māori nation." Such a concept "forgets" that Māori are not one people, rather they are a confederacy of diverse peoples. However, we employ "Aotearoa New Zealand" in the title of the book, first, to acknowledge the multiple Indigenous peoples of the land now referred to as New Zealand and, second, because for many there is a subversive element to its inclusion within the nomenclature of the nation-state.
2. "Māori" is a generic word that prior to colonization meant "normal" but has come to ubiquitously and problematically represent New Zealand's Indigenous peoples.
3. Lee Tamahori (dir.), *Once Were Warriors* (Culver City, Calif.: Columbia Tristar Home Video, 1994).
4. Niki Caro (dir.), *Whale Rider* (South Yarra, Victoria, Australia: Buena Vista Home Video, 2002).
5. *"Haka"* is the generic name for all types of dance or ceremonial performance that involve movement. According to Tīmoti Sam Kāretu, while *haka* have been "erroneously defined by generations of uninformed as 'war dances,' the true 'war dances' are the *whakatū waewae*, the *tūtū ngārahu* and the *peruperu*." Tīmoti Sam Kāretu, *Haka! The Dance of a Noble People* (Auckland: Reed Books, 1993), 37.

6. In academic English texts that include Māori words and in relation to italicization, there is no normative standard, with some authors choosing to italicize all Māori words, some choosing to italicize none, and some choosing to italicize all Māori words excepting proper nouns. In the present collection, and in consultation with the publisher, the editors have chosen the last of these options. In this decision we have been mindful that nonitalicization of Māori words would signal the further assimilation of an already subjugated language into the dominant English text, yet we are also cognizant of the grammatical error of italicizing proper nouns, such as Māori place names, which do not have English equivalents.

7. Valerie Alia, *The New Media Nation* (New York: Berghahn Books, 2010); Pamela Wilson and Michelle Stewart, eds., *Global Indigenous Media: Cultures, Poetics and Politics* (Durham, N.C.: Duke University Press, 2008); Jeffrey D. Himpele, *Circuits of Culture: Media, Politics, and Indigenous Identity in the Andes* (Minneapolis: University of Minnesota Press, 2008); Laurel Evelyn Dyson, Max A. N. Hendriks, and Stephen Grant, eds., *Information Technology and Indigenous People* (Hershey, Pa.: Information Science Publishing, 2007); Kyra Landzelius, *Native on the Net* (London: Routledge, 2006); Faye Ginsburg, Lila Abu-Lughod, and Brian Larkin, eds., *Media Worlds: Anthropology on New Terrain* (Berkeley: University of California Press, 2002); John Hartley and Alan McKee, *The Indigenous Public Sphere: The Reporting and Reception of Aboriginal Issues on the Australian Media* (New York: Oxford University Press, 2000).

8. Lisa Brooten, "Media as Our Mirror: Indigenous Media of Burma (Myanmar)," in *Global Indigenous Media: Culture, Poetics and Politics*, ed. Pamela Wilson and Michelle Stewart (Durham, N.C.: Duke University Press, 2008), 111–27; Michael Christie, "Digital Tools and the Management of Australian Aboriginal Desert Knowledge," in *Global Indigenous Media: Cultures, Poetics and Politics*, ed. Pamela Wilson and Michelle Stewart (Durham, N.C.: Duke University Press, 2008), 270–86; Terence Turner, "Representation, Politics, and Cultural Imagination in Indigenous Video: General Points and Kayapo Examples," in *Media Worlds: Anthropology on New Terrain*, ed. Faye Ginsburg, Lila Abu-Lughod, and Brian Larkin (Berkeley: University of California Press, 2002), 75–89; Doris Baltruschat, "Co-producing First Nation's Narratives: The Journals of Knud Rasmussen," in *Indigenous Screen Cultures in Canada*, ed. Sigurjón Baldur Hafsteinsson and Marian Bredin (Winnipeg: University of Manitoba Press, 2010), 127–42.

9. Faye Ginsburg, Lila Abu-Lughod, and Brian Larkin, "Introduction," in Ginsburg, Abu-Lughod, and Larkin, *Media Worlds*, 3.

10. Faye Ginsburg, "The Parallax Effect: The Impact of Aboriginal Media on Ethnographic Film," *Visual Anthropology* 11, no. 2 (1995): 67.

11. John Hartley, "Television, Nation, and Indigenous Media," *Television & New Media* 5, no. 1 (2004): 12–13.

12. Kevin Bruyneel, *The Third Space of Sovereignty* (Minneapolis: University of Minnesota Press, 2007), xix. Bruyneel refers to political space as "the lived and envisioned territorial, institutional, and cultural location through which a people situates its past, present and future as a political identity. . . . [Political identity is] that which binds a group together both through its relationship to discernable power inequities—whether stronger or weaker groups—and through its collective vision of how to generate, sustain, or expand the group's capacity to determine its future" (ibid.).

13. Jace Weaver, "Indigenousness and Indigeneity," in *A Companion to Postcolonial Studies*, ed. Henry Schwarz and Sangeeta Ray (London: Blackwell, 2000), 221.

14. Benedict Kingsbury, "The Applicability of the International Legal Concept of 'Indigenous Peoples' in Asia," in *The East Asian Challenge for Human Rights*, ed. Joanne R. Bauer and Daniel Bell Daniel (Cambridge: Cambridge University Press, 1999), 336.

15. See the United Nations Declaration on the Rights of Indigenous Peoples at www.un.org/esa /socdev/unpfii/documents/DRIPS_en.pdf.

16. The 2007 announcement can be seen at http://www.un.org/apps/news/story.asp?NewsID= 37102&Cr=indigenous&Cr1=#.UVG9SVtNZjE.

17. Roger Maaka and Augie Fleras, *The Politics of Indigeneity: Challenging the State in Canada and Aotearoa New Zealand* (Dunedin, N.Z.: Otago University Press, 2005), 30.

18. Cited in Linda Tuhiwai Smith, *Decolonizing Methodologies: Research and Indigenous Peoples* (London: Zed Books, 1999), 110.

19. Maaka and Fleras, *The Politics of Indigeneity*, 31.

20. Erica-Irene Daes, *Working Paper by the Chairperson-Rapporteur, Mrs. Erica-Irene A. Daes, on the Concept of Indigenous Peoples*, United Nations Economic and Social Council, Commission on Human Rights, June 10, UN Document E/CN.4/Sub.2/AC.4/1996/2 (New York, 1996), 5, http:// www.unhchr.ch/Huridocda/Huridoca.nsf/TestFrame/2b6e0fb1e9d7db0fc1256b3a003eb999.

21. African Union, African Commission on Human and Peoples' Rights, *Advisory Opinion of the African Commission on Human and Peoples' Rights on the United Nations Declaration on the Rights of Indigenous Peoples* (Banjul, Gambia: African Commission on Human and Peoples' Rights, 2007), 3, http://www.afrimap.org/english/images/treaty/ACHPR-AdvisoryOpinion -IndigPeoples.pdf.

22. Maaka and Fleras, *The Politics of Indigeneity*, 29.

23. Ibid., 30.

24. Glen Coulthard, "Subjects of Empire: Indigenous Peoples and the 'Politics of Recognition' in Canada," *Contemporary Political Theory* 6 (2007): 437.

25. Bruyneel, *The Third Space of Sovereignty*, xvii.

26. The term "mediascape," coined by Arjun Appadurai, offers one way to describe and situate the role of electronic and print media in "global cultural flows," which are fluid and irregular as they cross global and local boundaries. For Appadurai, mediascape indexes the electronic capabilities of production and dissemination, as well as "the images of the world created by these media." Arjun Appadurai, "Disjuncture and Difference in the Global Cultural Economy," *Theory, Culture & Society* 7 (1990): 298–99.

27. Ronald Niezen, *The Rediscovered Self: Indigenous Identity and Cultural Justice* (Montreal: McGill–Queen's University Press, 2009), 22.

28. Ella Shohat and Robert Stam, *Unthinking Eurocentrism: Multiculturalism and the Media* (London: Routledge, 1994).

29. Article 16 of the United Nations Declaration on the Rights of Indigenous Peoples notes that "Indigenous peoples have the right to establish their own media in their own languages and to have access to all forms of non-indigenous media without discrimination. States shall take effective measures to ensure that State-owned media duly reflect indigenous cultural diversity. States, without prejudice to ensuring full freedom of expression, should encourage privately owned media to adequately reflect indigenous cultural diversity." See www.un.org/esa/socdev /unpfii/documents/DRIPS_en.pdf.

30. Harald Prins, "Visual Anthropology," in *A Companion to the Anthropology of American Indians*, ed. Thomas Biolsi (Malden, Mass.: Blackwell, 2004), 506–25.

31. "The Treaty of Waitangi is New Zealand's founding document. It takes its name from the place in the Bay of Islands where it was first signed, on 6 February 1840. This day is now a public holiday in New Zealand. The Treaty is an agreement, in Māori and English, that was made between the British Crown and about 540 Māori rangatira (chiefs). . . . The Treaty is a broad statement of principles on which the British and Māori made a political compact to found a nation state and

build a government in New Zealand. The Treaty has three articles. In the English version, these are that Māori ceded the sovereignty of New Zealand to Britain; Māori gave the Crown an exclusive right to buy lands they wished to sell, and, in return, they were guaranteed full rights of ownership of their lands, forests, fisheries and other possessions; and that Māori would have the rights and privileges of British subjects. The Treaty in Māori was deemed to convey the meaning of the English version, but there are important differences. Most significantly, in the Māori version the word 'sovereignty' was translated as '*kawanatanga*' (governance). Some Māori believed they gave up the government over their lands but retained the right to manage their own affairs. The English version guaranteed 'undisturbed possession' of all their 'properties', but the Māori version guaranteed '*tino rangatiratanga*' (full authority) over '*taonga*' (treasures, not necessarily those that are tangible). Māori understanding was at odds with the understanding of those negotiating the Treaty for the Crown, and as Māori society valued the spoken word, explanations at the time were probably as important as the document." http:// www.nzhistory.net.nz/politics/treaty/the-treaty-in-brief.

32. Ranginui Walker, *Ka Whawhai Tonu Mātou: Struggle without End* (Auckland: Penguin Books, 1990), 197.

33. Te Puni Kōkiri, *Historical Influences: Māori and the Economy* (Wellington: Government Printer, 2007), 7.

34. Mason Durie, *Te Mana, Te Kāwanatanga: The Politics of Māori Self-Determination* (Auckland: Oxford University Press, 1998), 55.

35. The word "Pākehā" stems from precolonial words such as "pakepakehā" and "pākehakeha" (and the like) common to certain parts of the Pacific, referring to "Imaginary beings resembling men, with fair skins." Herbert W. Williams, *A Dictionary of the Māori Language*, 7th ed. (Wellington: A. R. Shearer, Government Printer, 1975 [first published in 1844]), 252. The word has evolved to commonly refer to "New Zealander of European descent." See John Moorfield, *Te Aka: Māori-English, English-Māori Dictionary and Index* (Auckland: Pearson, 2005), 108.

36. Walker, *Ka Whawhai Tonu Mātou*, 220.

37. Ibid., 209–10.

38. Homi Bhabha, *The Location of Culture* (London: Routledge, 1994).

39. Following the signing of the Treaty of Waitangi, one of Queen Victoria's representatives, Captain William Hobson, the British consul, uttered these words of unification that have since come to symbolize, for many Māori at least, the Crown's betrayal of the Treaty's original intent.

40. Joe Hawke is a Ngāti Whātua ki Ōrākei leader who was plucked out of obscurity by Dame Whina Cooper to assist her in leading the 1975 Land March across the Auckland Harbour Bridge. Hawke became the Ngāti Whātu voice for the occupation of Bastion Point, and features prominently in Mita's film *Bastion Point: Day 507* (see note 42 below).

41. Robert Consedine and Joanna Consedine, *Healing Our History: The Challenge of the Treaty of Waitangi* (Auckland: Penguin Books, 2001), 104–5.

42. Merata Mita, Gerd Pohlmann, and Leon Narby (dirs.), *Bastion Point: Day 507* (Wellington: Awatea Films, 1980).

43. New Zealand Film Archive, *Land Wars Film Programme* (Wellington: New Zealand Film Archive, 2008), 1.

44. Cited in Jo Smith and Sue Abel, "Ka Whawhai Tonu Mātou: Indigenous Television in Aotearoa/ New Zealand," *New Zealand Journal of Media Studies* 11, no. 1 (2008): 2.

45. Cited in Donald Browne, "A Voice for Tangata Whenua: A History of the Development of Māori Electronic Media," in *Electronic Media and Indigenous People: A Voice of Our Own?*, ed. Donald Browne (Ames: University of Iowa Press, 1996), 150.

46. Ibid., 151.

47. Te Māngai Pāho website, http://www.tmp.govt.nz.

48. Peter Adds, Mia Bennett, Meegan Hall, Bernard Kernot, Marie Russell, and Tai Walker, *The Portrayal of Māori and Te Ao Māori in Broadcasting: The Foreshore and Seabed Issue* (Wellington: Broadcasting Standards Authority, 2005), 41.

49. Ibid.

50. Niezen, *The Rediscovered Self*, 41–42.

51. "Local people, hosts, Indigenous people of the land—people born of the whenua, i.e. of the placenta and of the land where the people's ancestors have lived and where their placenta are buried." http://www.maoridictionary.co.nz/index.cfm?dictionaryKeywords=tangata+whenua&search.x=-451&search.y=-172&search=search&n=1&idiom=&phrase=&proverb=&loan=.

52. Jeffrey Sissons, "Māori Tribalism and Post-Settler Nationhood in New Zealand," *Oceania* 75 (2004): 19–31.

53. Aroha Harris, *Hīkoi: Forty Years of Māori Protest* (Wellington: Huia, 2004), 27.

54. Sissons, "Māori Tribalism and Post-Settler Nationhood in New Zealand," 19.

55. Ibid.

56. Paulo Freire, *Pedagogy of the Oppressed* (New York: Herder and Herder, 1970).

57. Moana Jackson and Atareta Poananga, "Two-House Model," cited in Adds et al., *The Portrayal of Māori and Te Ao Māori in Broadcasting*, 23.

58. Ian Stuart, "The Construction of a National Māori Identity by Māori Media," *Pacific Journalism Review* 9 (2003): 52.

59. In Māori customary narratives, the North Island is referred to as Te Ika-a-Māui, the fish of Māui-tikitiki-o-Taranga; the fish was caught by the existentialist demigod Māui (as he is commonly referred to throughout the Pacific) on one of his many escapades.

60. http://www.irirangi.net/iwi-stations.aspx.

61. Stuart, "The Construction of a National Māori Identity by Māori Media," 53.

62. Edward Said, *Orientalism* (New York: Pantheon, 1978).

63. Tim Edwards, *Cultures of Masculinity* (New York: Routledge, 2006), 123.

64. Jo Smith, "Parallel Quotidian Flows: Māori Television on Air," *New Zealand Journal of Media Studies* 9, no. 2 (2006): 29.

65. Claire Trevett, "Key Refuses to Hand Over Park to Tūhoe," *New Zealand Herald*, May 11, 2010, http://www.nzherald.co.nz/nz/news/article.cfm?c_id=1&objectid=10644127.

66. Darrin Hodgetts, Alison Barnett, Andrew Duirs, Jolene Henry, and Anni Schwanen, "Māori Media Production, Civic Journalism and the Foreshore and Seabed Controversy in Auckland," *Pacific Journalism Review* 11, no. 2 (2005): 192.

67. Don Brash, "Nationhood," paper presented at the meeting of the Orewa Rotary Club, Auckland, January 27, 2004, 2.

68. Ibid., 14.

69. Cited in Adds et al., *The Portrayal of Māori and Te Ao Māori in Broadcasting*, 67.

70. Bruyneel, *The Third Space of Sovereignty*, 2.

71. Cited in Human Rights Commission, *Tūi Tūi Tuituiā: Race Relations in 2006* (Auckland: Human Rights Commission, 2006), 38–39.

72. Ibid., 39.

73. Cited in Adds et al., *The Portrayal of Māori and Te Ao Māori in Broadcasting*, 54.

74. Joanne Te Awa, "Mana News: A Case Study," *Sites* 33 (1996): 168.

75. Ibid., 171.

76. Frantz Fanon, *Black Skin, White Masks* (New York: Grove Press, 1967), 11.

77. Coulthard, "Subjects of Empire," 443.

78. Paula Bennett, cited in "Iwi Leaders Meeting," http://www.beehive.govt.nz/speech/iwi-leaders
-meeting.

79. Metiria Tūrei, cited in "Green Party: Maori Leaders Are No More Responsible for Child Abuse
than Pakeha Leaders," http://www.voxy.co.nz/politics/green-party-maori-leaders-are-no
-more-responsible-child-abuse-pakeha-leaders/5/59726.

80. Danny Keenan, "'Hine's *Once Were Warriors* Hell': The Reporting and Racialising of Child
Abuse," *Social Work Review* 12, no. 4 (2000): 5–8, cited in Adds et al., *The Portrayal of Māori and
Te Ao Māori in Broadcasting*, 48.

81. Ibid., 48.

82. While there is a vast array of *haka*, the most renowned is "Ka Mate." New Zealand's sporting
icons, the All Blacks, use "Ka Mate," which was composed in the 1820s by the famous Ngāti Toa
chief, Te Rauparaha. In brief, prior to each game and immediately following the respective
national anthems, the All Blacks form a semicircle at midfield facing their opponents. The per-
formance is an entertainment spectacle, supposedly serving as an expression of cultural iden-
tity and a motivational tool, as well as to intimidate the opposition. Kāretu points out, however,
that when "Ka Mate" was composed it was intended as a *ngeri*. *Ngeri* "are short *haka* to stiffen
the sinews, to summon up the blood, but unlike *haka taparahi* [non-warring, ceremonial haka
with set actions], have no set movements, thereby giving the performers free rein to express
themselves as they deem appropriate." He goes on to suggest "Ka Mate" has "become the most
performed, the most maligned, the most abused of all *haka*. Jumping is not a feature of either
haka taparahi or *ngeri* and it is these irritating perpetrations that lead to a lot of discord"
(Kāretu, *Haka!* 41, 68).

83. John Hackett, *Backch@t* (Wellington: Television One, June 18, 2000).

84. Māui Solomon, *Backch@t* (Wellington: Television One, June 18, 2000).

85. http://www.legislation.govt.nz/act/public/1989/0025/latest/DLM157457.html.

86. Human Rights Commission, *Tūi Tūi Tuituiā*, 41.

87. Ibid.

88. Felicity Collins and Therese Davis, *Australian Cinema after Mabo* (Cambridge: Cambridge Uni-
versity Press, 2004).

89. Faye Ginsburg, "Black Screens and Cultural Citizenship," *Visual Anthropology Review* 21, nos.
1–2 (2005): 81.

90. Rolf de Heer (dir.), *The Tracker* (Adelaide: Vertigo Productions, 2002).

91. Phillip Noye (dir.), *Rabbit-Proof Fence* (Melbourne: Bolinda, 2002).

92. Ginsburg, "Black Screens," 82.

93. Barry Barclay (dir.), *Ngati* (Wellington: Pacific Films, 1987).

94. Merata Mita (dir.), *Mauri* (Auckland: Awatea Films, 1988).

95. John O'Shea and Roger Miriams (dirs.), *Broken Barrier* (Wellington: Pacific Films, 1952).

96. "Ramai Hayward is acknowledged as a prolific pioneer filmmaker who worked in every aspect
of the industry. She was New Zealand's first Māori cinematographer; the first in the world (with
husband Rudall Hayward) to make English-language films in communist China; kuia (elder) for
the New Zealand Film Commission; patron of the international Women in Film and Television
organisation; and an actor fondly remembered as Billy T James' screen mother. She has also
been a Kingi Ihaka Award recipient; a photographer; and a successful painter and author.
Ramai—also known as Ramai Te Miha, Patricia Rongomaitara Te Miha and Patricia Miller—was
born on November 11, 1916 to a Māori mother, and a Pākehā father of Irish descent . . . Ramai
and Rudall married in 1943, and in 1946 the photographic studios were sold, financing a move

to England. Rudall's specially-made sound camera helped win the couple freelance work, and Ramai learnt how to operate camera and sound equipment. Some say she was the only professional camerawoman working in England at that time, as would be the case back home in New Zealand . . . Ramai and Rudall are acknowledged as true pioneers of New Zealand film and made many documentaries, educational and travel films in New Zealand, Britain, Australia, and China. Ramai and her husband filmed in China in 1957, working on the first English-language films made there since the beginning of Communist rule in 1949. Dressed in a piupiu, she presented Chairman Mao with a Māori feather cloak. Ramai also wrote, directed and helped shoot *Children in China,* the first of a series of children's educational films she initiated, and commanded. The series was made for the National Film Library each year over 15 years, and included the popular *Eel History Was a Mystery* (which included shots of her elderly Aunt smoking eels) and *The Arts and Crafts of Māori Children.* Argues author Deborah Shepard: 'Ramai also ensured that Hayward Films represented Maori issues in a positive light at a time when the National Film Unit was patronising in its treatment and few other film-makers were interested in the subject.' . . . Hayward has also popped up occasionally on-screen, both in documentaries and the occasional acting role, including a 1989 documentary, Riwia Brown's screen directing debut *Roimata,* and playing Billy T's domineering mother on the 1990 sitcom incarnation of The Billy T James Show. She also became a committed advocate of issues relating to Māori welfare, joining the Māori Woman's Welfare League and the Māori Artists and Writers organisation." http://www.nzonscreen.com/person/ramai-hayward/biography. See also Rudall Hayward and Ramai Hayward (dirs.), *To Love a Māori* (Auckland: Hayward Historical Film Trust, 1991).

97. Geoff Murphy (dir.), *Utu* (Auckland: Utu Productions, 1983).

98. Brendan Hokowhitu, "Tackling Māori Masculinity: A Colonial Genealogy of Savagery and Sport," *The Contemporary Pacific* 16, no. 2 (2004): 263–64.

99. Brendan Hokowhitu, "The Death of Koro Paka: 'Traditional Māori Patriarchy,'" *The Contemporary Pacific* 20, no. 1 (2008): 128.

100. Vincent Ward (dir.), *River Queen* (Moore Park, New South Wales: Twentieth Century Fox Home Entertainment, 2005).

101. Vincent Ward (dir.), *Rain of the Children* (Auckland: Vincent Ward Films/Forward Films, 2008).

102. Homi Bhabha, "The Other Question," *Screen* 24, no. 6 (1983): 24.

103. Ibid.

104. Madan Sarup, *Identity, Culture, and the Postmodern World* (Edinburgh: Edinburgh University Press, 1996), 68.

105. Robert Young, *White Mythologies,* 2nd ed. (New York: Routledge, 2004), 45.

106. Cited in Ginsburg, "Parallax Effect," 66.

107. Cited in Michelle Raheja, "Reading Nanook's Smile: Visual Sovereignty, Indigenous Revisions of Ethnography, and *Atanarjuat (The Fast Runner),*" *American Quarterly* 59, no. 4 (2007): 1179.

108. Marcia Langton, *"Well, I Heard It on the Radio and I Saw It on the Television": An Essay for the Australian Film Commission on the Politics and Aesthetics of Filmmaking by and about Aboriginal People and Things* (North Sydney: Australian Film Commission, 1993), 7.

109. Stuart, "The Construction of a National Māori Identity by Māori Media."

110. Peter Dahlgren and Colin Sparks, eds., *Communication and Citizenship: Journalism and the Public Sphere* (London: Routledge, 1991).

111. Raheja, "Reading Nanook's Smile."

112. Ibid., 1161.

113. Cited in Leonie Pihama, "Re-presenting Māori: Broadcasting and Knowledge Selection," in *Cultural and Intellectual Property Rights: Economics, Politics and Colonization,* ed. Leonie Pihama

and Cherryl W. Smith (Auckland: International Research Institute for Māori and Indigenous Education, 1997), 63.

114. Ibid.

115. Barry Barclay (dir.), *Te Rua* (Wellington: Pacific Films, 1991).

116. Cited in Strickland's chapter in this volume.

117. The Māori Renaissance refers to the revival of Māori culture, customs, arts, and language beginning in the 1970s. However, the 1970s renaissance is often referred to as the "second renaissance" due to the previous reinstitutionalization of Māori culture (significantly including the building or rebuilding of customary *wharenui,* or meeting houses) by the Māori parliamentarian Sir Āpirana Ngata beginning in the 1930s.

118. Cited in Smith and Abel, "Ka Whawhai Tonu Mātou," 47.

119. Smith, "Parallel Quotidian Flows," 28.

120. Stuart, "The Construction of a National Māori Identity by Māori Media," 46.

121. Ibid., 47.

122. Hodgetts et al., "Māori Media Production," 193–94.

123. Hartley, "Television, Nation, and Indigenous Media," 12.

124. Smith, "Parallel Quotidian Flows," 29.

125. Ibid., 31.

126. Ibid., 28.

PART I *Mediated Indigeneity:*
 Representing the Indigenous Other

1. Governing Indigenous Sovereignty

Biopolitics and the "Terror Raids" in New Zealand

VIJAY DEVADAS

ON MARCH 21, 2012, the *New Zealand Herald* reported that the jury in the trial of Tame Iti, Emily Bailey, Te Rangikaiwhiria Kemara, and Urs Signer, the four individuals charged by the Crown for allegedly belonging to an organized criminal group, was unable to come to a decision on, this, the main charge.[1] They did however decide that the four individuals were guilty on firearms charges. The report, appearing in New Zealand's largest circulating broadsheet paper, which also enjoys a high web and mobile app presence, was entitled "Urewera Verdict: Freedom, for Now." The report about the March 20 jury decision on the trial of the four individuals was accompanied with an image of Tame Iti responding to questions from reporters. Iti is quoted as saying, "It's been a waste of people's time, effort and resource: that's the Crown all over. The accusations the Crown was pushing didn't stack up." The report then goes on to cover the jubilation of the four, their *whānau* (extended family), friends, and supporters, while forewarning that "they are not out of the woods yet." It cites Iti, his decision to speak only in *te reo Māori* (the Māori language) and his rendition of the nursery rhyme "Hey Diddle Diddle." The report reminds readers of the events that led to the charges, cites the police, the lawyers, politicians from the Green Party and the Māori Party, and states that "Police Minister Anne Tolley [of the National Party] declined to comment on the verdict." This report on the decision was far more *balanced* compared with how the event was reported on October 15, 2007, when the "anti-terror" raids made headlines, nationally and internationally. However, as I will argue, the media reports five years after the raids continue to reproduce a racialized visualization of terror in New Zealand.[2]

On October 15, 2007, it was reported that the New Zealand police, including the specialist anti-terrorist unit, raided houses nationwide and arrested seventeen Indigenous rights, environmental, and political activists, and anarchists under the auspices of two Acts—the Terrorism Suppression Act (hereafter referred to as the "Terrorism Act") put in place in 2002, one year after the U.S.-led declaration of the global war on terror, and the 1983 Arms Act.[3] This was the first time the Terrorism Act was used in

New Zealand, invoked after a year-long surveillance that included bugging and intercepting conversations, tapping phones and text messages, as well as secretly videotaping the alleged suspects. As noted above, the raids made national and international news. Those arrested, however, could not be charged under the Terrorism Act because, as the Solicitor-General pointed out, "the evidence fell short of actually meeting the very technical requirements of the act."[4] In lieu of this, the government drafted the 2007 Terrorism Amendment Act, which was passed after three readings, receiving royal assent on November 19, 2007. Because those arrested could not be charged under the Terrorism Act, the police charged the accused with multiple firearms offences. On October 2008, Iti, Kemara, Bailey, Signer and Tūhoe Lambert were charged with participating in an organized criminal group. Lambert passed away in July 2011, and in September of that year firearms charges against thirteen of the accused were dropped, but charges against Iti, Kemara, Bailey, and Signer were upheld until the March 20, 2012, verdict. Two months later, on May 24, Iti and Kemara were sentenced to two and a half years imprisonment while Bailey and Signer were sentenced to nine months home detention, all on firearms charges.

In this chapter I argue that the media coverage of the raids across selected print, online, and broadcast media outlets sought to produce a racialized moral panic around terrorism.[5] Specifically, the media reportage of the event on that day connected and amplified a moral panic of "terror" around the figure of Iti, in particular, and the larger Indigenous community, exposing the operations of a racialized regime of visualizing terror characteristic of global media culture post 9/11. Media and Cultural Studies scholars such as Douglas Kellner, Goldie Osuri, and Joseph Pugliese, among others, have argued that the racialized regime of visualizing terror in the media has intensified, particularly post 9/11. Kellner, "in an analysis of the dominant discourses, frames, and representations that informed the media and public debate in the days following the September 11 attacks, show[s] how the mainstream media in the US privileged the 'clash of civilizations' model, established a binary dualism between Islamic terrorism and civilization, and largely circulated war fever and retaliatory feelings and discourses that called for and supported a form of military intervention."[6]

Similar arguments animate Osuri's and Pugliese's articles, which demonstrate the intensification of racialized and polemicized forms of media coverage of the "other," post 9/11. The point here is that what we witnessed in the media, on October 15, 2007, is part of a larger transformation in global media culture and practice that unproblematically turns to simplistic, polemic, racial, and cultural divisions to unleash "symbolic and physical violence against its designated targets."[7] At the same time, it must also be emphasized that the media practice of visualizing terror, while intensified post 9/11, has a much longer history. Edward Said's *Covering Islam*, for instance, documents the extent to which the Western media, particularly the press, invoked and perpetuated specific racial and cultural stereotypes of Islam and the Muslim world. These are stereotypes that have come to be commonly linked to the discourse of terror.[8]

Five years later, on March 12, 2012, when the *New Zealand Herald* reported a key milestone in the "anti-terror" raids, confirming the Crown decision not to retry Iti, Bailey, Kemara, and Signer, it headlined with " 'Urewera Four' will not be re-tried." What persisted, during the five years, was a media practice that simultaneously reduces and amplifies the discourse of terror in a specific way. Five years later, reports continue to name the four individuals in a particular way—as the Urewera Four—a politics of naming that continues to link terror with a specific place that is "inhabited by a number of iwi [peoples] and hapū [clan] generally known today as Tūhoe . . . notable . . . for its pronounced political and religious autonomy."[9] This is a community that never signed the Treaty of Waitangi and that has sought to retain Tūhoe sovereignty. Specifically, I argue that the politics of naming "terror" can be conceived as a biopolitical project aimed at governing Indigenous sovereignty. The media practices since 2007 have remained consistent: Indigeneity and terror are intimately connected and this demonstrates that the legitimacy and power of state sovereignty is built upon the notion of racialized sovereignty. The racialization of terror takes place both at the level of constructing race in terms of the simplistic division of people along ethnic (cultural) lines, as well as "the kind of racism that . . . is based on new paradigms from biology, on ideas of evolutionary competition and the health of the species."[10] The latter kind of racialization marks the emergence of biopower as a new technology of power that seeks to consolidate the sovereignty upon which the nation-state anchors its power and authority.

Mediating Terror

A quick survey of a sample of print and online media coverage of the October 15, 2007, "anti-terror" police raids including the *New Zealand Herald, The Age* (Australia), *The Australian,* as well as the BBC, Reuters, and Bloomberg, reveals that the headlines, choice of images, and narrative were consistent and systematic: the national and international media participated in the production of a racialized moral panic of terrorism. The BBC, for example, covered the event with the headline "NZ Police Hold 17 in Terror Raids" and the report opens in this manner: "New Zealand police have arrested 17 people and seized a number of weapons during a series of 'anti-terror' raids. More than 300 police were involved in the operation, reportedly targeting Maori sovereignty and environmental activists."[11] The report was accompanied by a file image of Iti performing a *haka* (dance or ceremonial performance) captioned: "One of those arrested was Māori rights campaigner Tame Iti." The *New Zealand Herald* reported the event as follows:

> Two hunters alerted police to the presence of armed men in camouflage in the Ureweras after stumbling into their camp, the *Herald* can reveal. Police today arrested 17 people in nationwide raids linked to alleged weapons training camps in the Bay of Plenty. The story of what the hunters saw . . . forms part of the background to an extensive investigation by 300

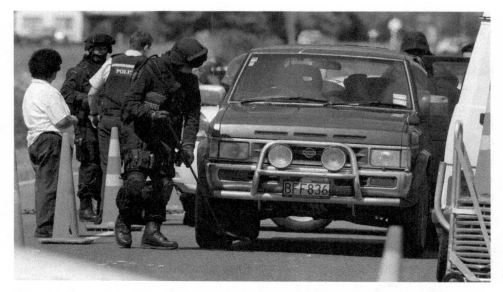

Figure 1.1. "Armed police stop vehicles at a checkpoint near the Bay of Plenty settlement of Ruātoki," *New Zealand Herald,* October 16, 2007. Photograph by Alan Gibson. Reproduced with permission of the *New Zealand Herald.*

police including the specialist police anti-terrorist unit. The raids appear to have targeted Maori, political and environmental activists and were conducted under the Suppression of Terrorism Act and Firearms Act. Police Commissioner Howard Broad said the sting was the culmination of a year-long investigation into the alleged guerrilla-style training camps. He said the raids were carried out in the interests of public safety.[12]

The image that accompanied the report is of the lockdown at Ruātoki (Figure 1.1).

Likewise, Melbourne newspaper *The Age* reported with a photo of Iti, but unlike the other cited reports, the focus here, from the beginning, was on Iti:

New Zealand police have allegedly discovered weapons training camps in a series of anti-terrorism raids under way today. Prominent Maori activist Tame Iti was among those taken in by police, his lawyer Louis Tekani told Fairfax Media. He is facing arms charges this afternoon in the Rotorua District Court.[13]

Reuters reported without an image of either the raids or Iti, but ended in this way:

New Zealand, a South Pacific nation of 4.2 million people, has no history of domestic-related terrorism, although Maori, who make up around 15 percent of the population, have at times staged high-profile demonstrations and land occupations to highlight historic grievances.[14]

The Australian reported without images but did name Iti, as did Bloomberg, which also had a section on Māori separatists, quoting then Minister of Foreign Affairs and New Zealand First Party leader Winston Peters as saying that "Maori separatist,

Figure 1.2. "Tame Iti was arrested after a dawn raid on a Bay of Plenty property," *New Zealand Herald,* October 16, 2007. Photograph by Alan Gibson. Reproduced with permission of the *New Zealand Herald.*

environmentalist and so-called peace groups were raided."[15] The next day, the *New Zealand Herald* headlined with "Tame Iti on gun and firebomb charges," with the image of Iti and the following opening paragraph:

> A line of a dozen uniformed police, two abreast, formally marched into the Rotorua District Court late yesterday afternoon and stood guard at three separate doorways inside the building—as the bail application hearing for Tame Wairere Iti, 55, and a Hamilton woman, 24, got under way.[16]

The reporting of the "anti-terror" raids in the media on that day framed "terror" in a specific way. The Indigenous body, or more precisely the face of Iti, is made to stand in for "terror." "Terror," which has no countenance, is made comprehensible through the media coverage and, within the context of New Zealand, this mediation equates "terror" with, and through, Indigenous peoples.

The media articulation of "terror" in this reduced way did not only appear in online and print media. As Sue Abel, in an analysis of national television news bulletins screened on October 15, 2007, argues, "mass media television news and Māori-produced television news gave viewers two different stories about the 'terror' raids."[17] Comparing mass-media television news, or mainstream news, on two of the main free-to-air channels (TV One and TV3) including *Te Karere* (Māori-produced news on TV One) with *Ta Kaea* on Māori Television, Abel argues that the choice of images, narrative voice over, and framing, while similar at times (such as the choice of the image of the Armed Offenders Squad on *Te Karere* and TV One), were also different in significant ways. For example, Abel argues, mainstream news articulated "the 'terror' raids in a way that seems commonsense, straightforward and neutral" while "Māori-produced bulletins *Ta Kaea* and *Te Karere* . . . offer completely different 'maps and codes', and very different explanatory contexts."[18] Further, Abel finds that "a significant Māori voice" was absent in mainstream news coverage, that mainstream news produced a discourse of fear around terror, and that Iti was used consistently as the image of terror. The framing of terror in the print, online, and broadcast media demonstrates the racialized visualization of terror through the figure of the Indigenous subject, but more significantly it sought to produce a highly racialized moral panic of terror.

A moral panic, according to Stuart Hall et al., begins with a distortion of the event, phenomenon, or discourse "*out of all proportion* to the actual threat" that relocates attention from the criminal act "to *the relation between the deviant act and the reaction of the public and the control agencies of the act.*"[19] In other words, moral panics are characterized by a discrepancy between "what is perceived and what that is a perception of,"[20] a gap between the threat itself and the reaction to the threat. Hall et al. go on to discuss the concept of moral panic in relation to the discursive construction of mugging as a street crime in Britain during the early 1970s to demonstrate how mugging is

racialized as a black problem, which then criminalizes the black community as a threat to the British way of life and white British sovereignty. As Stanley Cohen points out, there are five key actors in the production of moral panic: the folk devil, the media, rule enforcers (such as the police), politicians, and public opinion.[21]

In that sense it is arguable that the saturation of the image of Iti as the Indigenous "folk devil," and the police's and politicians' discussions of the raids, in addition to the media coverage, testify to the production of a moral panic of terror.[22] Across the spectrum of national and international media, the circulation of the image of Iti as *the* face of terror reconfigures him from campaigner for Indigenous rights and sovereignty into the figure of the terrorist. More significantly, it functions to racialize the image of terror: Iti stands in for the discourse of terror as part of a larger cultural practice of visualizing identity, and testifies to the power of visual culture in the politics of reproducing notions of race, terror, and criminality.

Iti's image, accompanied by captions such as "Maori rights campaigner,"[23] "Veteran Maori activist,"[24] and "Leading Maori activist,"[25] simultaneously links Indigenous activism and the demand for sovereignty with terrorism, conflating Indigenous sovereignty with terrorism; in short, the Indigenous terror-subject becomes a threat to state sovereignty. Furthermore, the *New Zealand Herald* report accompanied by the image of armed police checking a vehicle captioned "Armed police stop vehicles at a checkpoint near the Bay of Plenty settlement of Ruātoki," connects the discourse of "terror" to a precise settlement—Ruātoki—located in the Eastern Bay of Plenty; a particular iwi, Tūhoe (central east North Island *iwi*); and a specific place, Te Urewera, which is the traditional land and spiritual center of Tūhoe.[26] It should be recalled that while numerous people throughout the country were arrested on October 15, 2007, it was only a Māori community in Ruātoki that was laid siege to. The police did not close down a suburb of Wellington and hold children at gunpoint when arresting Valerie Morse for instance.[27]

The naming, of Ruātoki, Te Urewera, and Tūhoe, is significant for it marks a history of struggle, of nonparticipation in the Treaty principle and/or the bicultural discourse, by Tūhoe, who are

> known for its long history of resistance to colonization. . . . Today, Tūhoe have one of the highest ratios of native speakers of the Māori language (called "te reo") among tribal groups and have a strong cultural identity that is intimately linked to the land in an area that they call "Te Urewera." . . . There are about 20,000 people who claim Tūhoe ancestry, many of whom are still living in relatively isolated communities within Te Urewera.[28]

The caption emphasizes the notion of internal borders, a "checkpoint" within the nation, in Ruātoki to be precise, and articulates zones of inclusion and exclusion that demarcate between citizens in the nation, while the figure of the armed police (Cohen's

"rule enforcer")[29] highlights the significance of the raid, and legitimizes the armed operations to entrench state sovereignty within Ruātoki.[30] The print and online media reports cited all reaffirm that the police intervention was against "Maori sovereignty activists" or "Maori separatists."[31] For example, Reuters ends its report with the claim that Māori have a history of activism and "high-profile demonstrations and land occupations."[32] However, unlike the sole focus on the image of Iti and Ruātoki under siege, the report mentions that, other than Māori, police also targeted "political and environmental activists,"[33] and "so-called peace groups."[34] The media choice of images, captioning, and framing "terror" through a specific individual, community, people, and history demonstrate that the Indigenous body is now substitutable with that of the terrorist.

Fast-forward to five years later: four individuals are charged with being part of an organized criminal group but the charge is dismissed and they are now awaiting sentencing on firearms charges. These individuals are from various parts of New Zealand, there are both Māori and Pākehā (white New Zealanders) among the four. Not all of them are Tūhoe (one is a recent migrant) and not all of them come from Te Urewera or have genealogies linked to there. They are heterogeneous and different, yet mainstream media has unproblematically referred to them collectively, homogenously. Christchurch's *The Press,* for instance, refers to them as the "Urewera Four," as do the *New Zealand Herald,* the *Otago Daily Times,* and the *Dominion Post,* among others.[35] The substitution functions powerfully for it dismisses the individualities of each individual, suggesting a collective enterprise and, at the same time, connecting them to a specific place with a history of resistance and struggle. The court proceedings are framed under the heading "Urewera trial" *(Stuff News Portal, New Zealand Herald, Otago Daily Times),* the verdict as "The Urewera verdict" *(Listener, New Zealand Herald),* and the jury as the "Urewera jury" *(New Zealand Herald, Stuff News Portal).*[36] A similar pattern of framing appeared in the broadcast news and current affairs coverage. The mobilization of Te Urewera to mark the event invokes a specific place, its history, culture, peoples, and practices, to locate the 2007 "anti-terror" raids firmly in close proximity to Indigenous struggles and protests. Here "terror" is made intelligible through Te Urewera. Just as mainstream media did in 2007, this media practice of naming gives terror a countenance: an Indigenous countenance to be precise. The media practices five years after the raids, in that sense, continue the practices witnessed on October 15, 2007.[37]

One way by which we might conceive of the visual regime of racial profiling, the linking of the discourse of terror with that of Indigenous sovereignty, is through the concept of media necropower. Drawing on Achille Mbembe's notion of necropower as the "contemporary forms of subjugation of life to the power of death,"[38] Osuri examines the interview with Mamdouh Habib, "an Australian citizen, who was arrested in Pakistan just after September 11, tortured in Egypt, and subsequently spent three years imprisoned and tortured in Guantanamo Bay," broadcast on *60 Minutes*

(Australia).[39] Osuri argues that the structuring, captioning ("Under Suspicion"), and the framing of the interview, invites the viewer to "judge Habib as a possible terrorist despite Habib's recounting of his experiences of torture."[40] This is how the interview begins:

> Everyone has an opinion. Either Mamdouh Habib is a dangerous terrorist who should have been left to rot in jail or he is an innocent man persecuted because he was in the wrong place at the wrong time. It's one or the other, simple as that, if you believe the propaganda. But so far, you've not seen this mysterious Mr Habib, never heard a single word from him. . . . For the first time, your chance to judge Mamdouh Habib for yourself.[41]

The framing immediately sets up Habib in a binary: he is either a "dangerous terrorist" or an "innocent man"; it dismisses his innocence as propaganda; and "no other alternatives are put forward anywhere in the program. In fact, since the term 'dangerous terrorist' is not accompanied by any analysis or discussion, *60 Minutes* condones the solution that dangerous terrorists should rot in jail presumably without a trial."[42] In other words, *60 Minutes* put Habib to death; it kills him off and positions him, unproblematically, as a dangerous terrorist. This is the operation of media necropower, that is "contemporary media practices which reconfigure the politics of race and assimilability by making racialised bodies culturally intelligible in the current context of the war against terrorism."[43] The notion of killing or putting to death through media necropower is underpinned by Michel Foucault's account of the sovereign right to kill. As he says, "when I say 'killing' I obviously do not mean simply murder as such, but also every form of indirect murder: the fact of exposing someone to death, increasing the risk of death for some people, or quite simply, political death, expulsion, rejection, and so on."[44]

In a similar vein, it can be argued that the media coverage of the "anti-terror" raids on October 15, 2007, and the subsequent media reporting underscore the workings of necropower in the national and international media that is connected to, and part of, a larger global media practice of covering "terror" post 9/11. The coverage of the events connects disparate discourses—terror(ism), Indigenous sovereignty, Tūhoe, Te Urewera—and rearticulates terror, which has no specific cultural, ethnic, or racial countenance, into a culturally intelligible idiom. The reporting is instructive in that it demonstrates how mainstream media participates in making terror intelligible. More importantly, it is instructive in that it demonstrates the media practice of cutting up the social, setting up lines of inclusion and exclusion. As Police Commissioner Howard Broad stated, the raids were "carried out in the interests of public safety,"[45] thus demarcating the social into a public at large, who are peaceful, law-abiding citizens of the nation, and those who are violent, law-breaking noncitizens, the alleged "terrorists." The mobilization of public safety as the motive for the raids justifies the necropolitical operations of the state—the war within the nation and beyond. As Foucault aptly puts

it, "wars are no longer waged in the name of the sovereign who must be defended: they are waged on behalf of the existence of everyone."[46] And in this case, the notion of public safety becomes the justification for the violence that the state unleashes on Indigenous peoples whose lives are deemed unnecessary, not serving the common good, and who can therefore be killed so that others can live.

The examination of media reports about the "anti-terror" raids reveals that the media amplified and intensified the moral panic around terror in racialized terms: Māori "radicals" are constructed as the archetypical figures of terrorism. It also shows that the operation of the media solidifies and consolidates a system of visualizing terror as the Indigenous subjects are "put to death," in Foucault's sense. Put in another way, the "killing" of Iti, Tūhoe resistance, Ruātoki, Te Urewera, and Māori sovereignty by the media, putting them to death in the public domain, is part of a serial killing strategy that the state has employed when it feels threatened by an internal "danger."[47]

Biopolitical Control

The media coverage that I have used to exemplify the mediation of terror, I wish to argue, is closely connected to the nation-state's exercise of biopolitical control, the deployment of the technology of biopower that seeks to establish the stability of the social, to regularize and normalize the way in which the national social is imagined. According to Foucault, sovereign power operates through two technologies of power: disciplinary power, which emerged some time in the seventeenth century, and biopower, which emerged around the late eighteenth/early nineteenth centuries. Disciplinary power "centers on the body, produces individualizing effects, and manipulates the body as a source of forces that have to be rendered both useful and docile."[48] Biopower, in contrast,

> is centered not on the body but on life: a technology [of power] which brings together the mass effects characteristic of a population, which tries to control the series of random events that occur in a living mass. . . . This is a technology which aims to establish a sort of homeostasis, not by training individuals, but by achieving an overall equilibrium that protects the security of the whole from internal dangers.[49]

The two technologies of power upon which state power relies to authorize its legitimacy mark the two rights of sovereignty: the first—"to take life or let live"[50]—is constituted under the regime of disciplinary power, while the second—"to make live and to let die"[51]—is constituted under the regime of biopower.[52]

Biopower concerns the strategic management of the population by "structur[ing] the possible field of action of others."[53] It is, more crucially, a reconsideration of the constitution of sovereign power—because sovereign power recognizes that it is

dealing with populations rather than individuals, it also recognizes that it cannot sustain its power by disciplining (to take life and let live). Instead, sovereign power maintains itself through the "power of regularization . . . [of] making live and letting die."[54] This is done by "using overall mechanisms and acting in such a way as to achieve overall states of equilibration or regularity; it is, in a word, a matter of taking control of life and the biological processes of man-as-species and of ensuring that they are not disciplined, but regularized."[55] The regularization of life involves the use of multiple technologies of power that quantify, measure, objectify, and classify the forces of life in ways or relations with the aim of maximizing its value as resource.[56] This new mode of government categorizes the forces of life and determines which lives live and die, which can be killed, and which should be fostered in the name of the well-being of the population.

Conceptualized as such, it can be argued that the media practices on and about the "anti-terror" raids in New Zealand participate in the consolidation of sovereign power. It is part of a larger assemblage of power that is engaged in the management and categorization of life in general, and Indigenous life more particularly, in the name of the well-being of the population. In other words, mainstream media is complicit for it is part of a larger system of calculating, classifying, and objectifying forms of life that ensures the optimization and regularization of a general state of life. As the media reports confirm, Māori are thus produced, calculated, classified, and "put to death" as an internal danger that threatens the "overall equilibrium that protects the security of the whole."[57] The choice of Iti, who stands in for Indigenous communities and the demand for Indigenous sovereignty, and the framing of the raids through Ruātoki, Tūhoe, Te Urewera, casting these places, cultures, and communities as a "state of exception," exemplify how the media participates in a project of giving terror an Indigenous countenance and simultaneously defines a segment of the population as a problem to the rest.[58] In short, the media normalizes the national social through the marginalization and classification of Indigenous peoples through the discourse of terror.

How might we conceptualize the media practices of exposing Iti, the residents of Ruātoki, Tūhoe, Te Urewera, and the demand for Indigenous sovereignty by rightful citizens of the nation to the risk of death? Put differently, under what conditions and on what grounds did the media expose its citizens, cultures, peoples, and places to the risk of being killed? The response to this, qua Foucault, is racism. As Foucault points out, the emergence of biopower legitimized the putting to death of enemies and citizens by inscribing racism "as the basic mechanism of the State . . . [and] as a result the modern state can scarcely function without becoming involved with racism at some point, within certain limits and subject to certain conditions."[59] Foucault is not suggesting that racism emerges at the moment when biopower underpins the power of sovereignty; rather, as he emphasizes, "racism has already been in existence for a very long time. But . . . it functioned elsewhere,"[60] in that it was not inscribed as fundamental to the operations of the nation-state. The inscription of racism takes place when the

state identifies the population as a political problem and uses racism as "a way of introducing a break into the domain of life that is under power's control: the break between what must live and what must die."[61] Racism thus works to fragment the forces of life that power controls, "a way of separating out the groups that exist within a population."[62] The first function of racism is to fragment the biopolitical field. The media practices discussed herein operate similarly: the racialization of terror functions to fragment the biopolitical field to situate certain forms of "being" Māori—the demand for Indigenous sovereignty, Ruātoki, Tūhoe, and Indigenous resistance—in the zone of exclusion.

The second function of racism "allows the establishment of a positive relation of this type: 'the very fact that you let more die will allow you to live more' . . . 'if you want to live, you must take lives, you must be able to kill.' "[63] The relationship is now based on species type, and so the more inferior, abnormal species are killed, "the fewer the degenerates there will be in the species as a whole."[64] Racism thus justifies the killing of the other in the sense that the death of the other, "the bad . . . inferior race . . . is something that will make life in general healthier: healthier and purer."[65] We can see how the second function underpins the necropolitical media practices in that the racialization of terror—the racism of terror—provides the preconditions for exercising sovereign power—the right to life and death. In this context then, the media reporting is more about managing Indigenous life, Indigenous sovereignty, as a threat that must be violently dealt with in order to secure the well-being or security of the rest of the population. Let us recollect that it was precisely in the name of the population and of making it safe and secure that the police commissioner legitimized the raids.[66]

Biopolitical Challenges

Let me turn to a brief discussion of counter-responses to the mainstream media coverage: commentaries on blogs, online communities such as "October 15 Solidarity" and "Beyond Resistance," which have set up dedicated websites and social media outlets, and documentaries that circulate in the media-world are critical of the "anti-terror" raids and the prosecution.[67] These counter-voices are part of an alternative media circuit that produces a genealogy of the "anti-terror" raids that problematizes the constitution of "terror," emphasizes the violence of state power through its repressive and ideological state apparatuses, and exposes the fallacy of democracy and the closing down of resistance in New Zealand.[68] They exemplify a biopolitical challenge, that is, a politics that opposes state power as well as mainstream media power to constitute terror. They are also participating in the production of an alternative to, and a confrontation with, the normalized articulation of terror, Indigenous sovereignty, and state power.

One such alternative media instance is the documentary *Operation 8: Deep in the Forest* (2011), whose main title is the police codename for the 2007 "anti-terror" raids,

which provides a critical visualization of the "anti-terror" raids that radically reconceives terror as state terror. In his review of the film in *Crop*, Kevin Fisher suggests that the strength of the film lies precisely in its strategy of

> Utiliz[ing] very little in the way of voice-over narration, but rather through careful editing, compos[ing] an intricate mosaic of different media sources into a multi-layered dialogue among defendants, representatives of the Tūhoe people, police, ex-police, political activists, politicians, attorneys, intelligence experts and academics, that seems to revive the events surrounding Operation 8 on screen.[69]

This "intricate mosaic" that Fisher refers to is the way the film, on the one hand, links the "anti-terror" raids to the global war on terror, to a longer history of Indigenous activism, the repression of political activisms, the culture of surveillance, and police violence. On the other hand, the film's mosaic includes detailed impact statements from victims who recount the events of the day, and "the very real costs of those investigations to the lives of the defendants, as well as to legal principles concerning search and seizure and fair judicial process."[70] The film opens with recountings by those who were raided, arrested, photographed, searched, scrutinized, criminalized, and terrorized by the nationwide "anti-terror" raids on October 15, 2007. The voice of twelve-year-old Patricia Lambert recounting the police raids, the fear that gripped her and the violent police practices and interrogation, accompanied by a helicopter-shot of Te Urewera, ushers us into the world of those central to the raids but whose voices were never part of mainstream media coverage. Here, we are privy to the numerous voices, everyday people who are victims of state brutality, and another narrative of the "anti-terror" raids.

The recounting is powerful as it provides a radically different narrative of the "anti-terror" raids, emphasizing the violence of the police (in one scene, defendant Tūhoe Lambert tells us that his granddaughter was led out of the house with "a gun to her head") and challenging police claims (in another scene, Maraki Teepa informs us that his *whānau* are possum and pig hunters and as such "everyone has a 303 rifle." Guns, he insists, are not for terror activities but for sourcing food). Toward the closing of the film we come across a shed, possibly the shed the defendants had been locked up in: it is reinscribed with the powerful sentiment of a five-year-old (see Figure 1.3). This is telling for it reconfigures, recodes what took place on that day. What took place, according to the mainstream media, was a police operation against "terrorists" in the country; what took place, according to the five-year-old, a firsthand witness, was a frightful episode that left the child hungry, scared, and in tears. The "anti-terror" raids for the child were an emotive, affective, experience and the sentiment expressed in writing provides us with another way of thinking about the "anti-terror" raids. The recounting is powerful insofar as it functions to produce an alternative conception of terror and thus problematizes the mainstream media framing of terror.

Figure 1.3. Graffiti on shed marking the first anniversary of the raids, October 15, 2008, Ruātoki. Still by Errol Wright from *Operation 8* (Wellington: CUTCUTCUT Films, 2011). Reproduced with permission of Errol Wright and Abi King-Jones.

The film also engenders an alternative national social fostered though the linking of various voices to forge a community of people with multiple (activist) orientations, built around numerous issues—environment, antiwar, peace, Indigenous sovereignty, justice, land rights, Tūhoe—and from various social backgrounds committed to offering an alternative to the paradigm of power. The scene of protest that the film captures in Figure 1.4 is a visual instantiation of such a community and the call for an alternative vision of New Zealand.

What this scene captures and what the film as whole seeks to do is launch a biopolitical challenge to the visual regime of profiling terror in mainstream media, offering an alternative articulation of terror and, most crucially, imagining another vision of the national social. In that regard it seeks to voice the urgency of social emancipation and struggle against sovereign power. It is, to use the words of Michael Hardt and Antonio Negri, articulating the "making of the multitude," that is, the power of life to produce an alternative national social.[71] In *Commonwealth*, Hardt and Negri suggest that it would be remiss for us to think that Foucault's "analyses of biopower are aimed . . . at an empirical description of how power works for and through subjects."[72]

Figure 1.4. "March for Freedom" to Auckland Central Remand Prison, October 27, 2007. Still by Tia Taurere from *Operation 8* (Wellington: CUTCUTCUT Films, 2011). Reproduced with permission of Errol Wright and Abi King-Jones.

This is because Foucault does analyze the "potential for the production of alternatively different forms of power. This point [they continue] is implicit in Foucault's claim that freedom and resistance are necessary conditions for the exercise of power."[73] Hardt and Negri are suggesting that while power does seek to classify and regulate life in the name of an overall equilibrium, it cannot fully contain life or, more precisely, the power of life. Life, thus, is always already invested with biopolitical potentiality, that is, with the power to create new subjectivities and innovative forms of sociality. *Operation 8*, I wish to suggest, does this: it seeks to make the multitude and "allows us to recognize how its productive activity is also a political act of self-making."[74] It shores up the biopolitical force of the power of life, the capacity to self-make, by suturing the voice of the innumerable individuals, collectivities, and communities impacted by the "anti-terror" raids with the scenes of protest marches and meetings, alongside the surveillance of the police and undercover agents by those accused. In that regard, the complex map that the film articulates can be grasped as a biopolitical production that "intervene[s] in the circuits of the production of subjectivity, flee[s] from the apparatuses of control, and construct[s] the basis for an autonomous production" of an alternative national social that refuses to link terror with Indigenous lives.[75]

Conclusion

The events that manifested on October 15, 2007, in Aotearoa—the anti-terror raids, the differentiated policing techniques, and the media coverage—demonstrate that what took place on that day was not an exception; the racialized visualization and policing of terror perpetuates a much longer history of exploitation and oppression of the Indigenous community in this country. Reading the media practice as media necropower at work, and the arrests in terms of biopower and the power of sovereignty, I have sought to demonstrate that the media practices and arrests animate a specific sovereign function whose precondition is racism. The production of a racialized moral panic of terror needs to be conceptualized as a key sovereign investment in the management of life, or more precisely the management of Indigenous life in the name of the well-being of the population. And this investment ensures the continuation of a racialized state sovereignty.

The operations of the mainstream media around the "anti-terror" raids tell a particular tale: for an officially self-declared bicultural, postcolonial nation that champions its race relations as exemplary, the media circuit's perpetuation of a Manichean view of terror clearly demonstrates that New Zealand has not dismantled left-over colonial "processes of subject and identity formation."[76] In short, it is not quite postcolonial. The circulation of other media constructions of the event such as *Operation 8* do, however, point to the potential for an alternative media to engender a truly postcolonial social reality in which Indigenous claims for sovereignty, particularly, are recognized as autonomous.

Notes

1. G. Cumming et al., "Urewera Verdict: Freedom, for Now," *New Zealand Herald,* March 21, 2012, http://www.nzherald.co.nz/nz/news/article.cfm?c_id=1&objectid=10793480. Tame Iti, it should be emphasized, is a complex figure: he is a Tūhoe activist who has been the face of "terror" in New Zealand, post–October 15, 2007. He is, however, not just that, as detailed in note 5 below.

2. This is a condensed, updated, and expanded version of a paper previously published as "15 October 2007, Aotearoa: Race, Terror and Sovereignty," in *Sites: A Journal of Social Anthropology & Cultural Studies* 5, no. 1 (2008): 124–51. In the previous article I examined mainstream media and police practices on the day of the raids and in that regard it was a snapshot of the event. The raids' ongoing consequences continue to haunt the national imagination. The discussions from the previous article have been significantly rewritten to ensure that it connects with the argument of this chapter and the focus of this book.

3. The key elements of the Terrorism Suppression Act include the following: "the law makes it a criminal offence to take part in, finance or recruit for a terrorist organisation or terrorist act; planning a terrorist act, or making a 'credible threat', is also illegal even if it is not carried out; unlike other countries the law does not give police additional powers of arrest or detainment; the Attorney-General must give the green light to any prosecutions under the Act, but Michael Cullen has delegated this responsibility to Solicitor-General David Collins; under the Act groups can be listed as a designated terrorist entity, but so far no local groups have been

designated. Those that have been listed are United Nations designated groups." Cited from *New Zealand Herald,* "Exclusive: Hunters Alerted Police to Alleged Terror Camps," October 15, 2007, http://www.nzherald.co.nz/nz/news/article.cfm?c_id=1&objectid=10469938.

4. D. Cheng, "Terrorism Act 'Unworkable,'" *New Zealand Herald,* November 9, 2007, http://www.nzherald.co.nz/nz/news/article.cfm?c_id=1&objectid=10474950.

5. The basis for the selection of media outlets requires clarification: I have selected the following examples to shore up the point that the media participates in the production of a moral panic around terrorism that is highly racialized. At the same time, there was media coverage of the issue that did not set up the event in racialized terms. For instance, a *Sunday Star Times* report of October 21, 2007, gave considerable attention to comments by Iti's son, Toi, who "told National Radio last week his father was 'just a 55-year-old man with diabetes' who would never dream of 'blowing up innocent children at shopping malls it's not his style.'" Other comments on Iti included the following: "Iti co-hosts a boys' agony programme for emotionally distraught brothers once a week on Māori TV and then hangs about in Ponsonby cafes. He wears camouflage gear, but doesn't have the body type for special ops," from *Sunday Star Times* columnist and Canterbury University academic Rawiri Taonui. Iti's partner, Maria Steens, a social worker, "scoffs at the suggestion her partner of 10 years is a terrorist. 'I wouldn't hang out with a man who's a terrorist. If those allegations are true, I don't know when he fits it all in,' she said. Asked why Iti would be associating with environmental activists, she said: 'I guess he's as passionate as the rest of us in terms of environmental issues. Tame's friends are so broad he doesn't just hang out with Māori activists, he hangs out with all sorts of people, Māori and Pākehā.'" Numerous other friends were quoted as saying that Iti is harmless, a joke(r), or an actor, an image that has been in circulation at least since his contribution to the Parihaka exhibition at the Wellington City Gallery. This is just one example of the several ways in which the local media seemed concerned with defusing the situation, and with staging Iti as just another ordinary person, a citizen of this country, with strong convictions on issues such as environmentalism and Indigenous rights. Therefore it must be said that the coverage of the event in the media did attempt to inflect another image of Iti that differs radically from the staging of Iti in highly racialized and reductive terms as the face of terror. It is the circulation of the latter image that concerns this chapter. It must also be said that the nonracialized coverage that circulated could be seen as efforts to mask the racialized processes themselves. The full *Sunday Star Times* coverage, "Tame Iti," is available at http://www.stuff.co.nz/sunday-star-times/features/profiles/28535.

6. Douglas Kellner, "9/11, Spectacles of Terror, and Media Manipulation: A Critique of Jihadist and Bush Media Politics," *Critical Discourse Studies* 1, no. 1 (2004): 44.

7. Joseph Pugliese, "The Locus of the Non: The Racial Fault-Line of 'of Middle-Eastern Appearance,'" *borderlands e-journal* 2, no. 3, (2003), http://www.borderlands.net.au/vol2no3_2003/pugliese_non.htm; and Goldie Osuri, "Media Necropower: Australian Media Reception and the Somatechnics of Mamdouh Habib," *borderlands e-journal* 5, no. 1 (2006), http://www.borderlands.net.au/vol5no1_2006/osuri_necropower.htm.

8. Edward Said, *Covering Islam: How the Media and the Experts Determine How We See the Rest of the World* (New York: Pantheon, 1981).

9. Richard Boast, *Buying the Land, Selling the Land: Governments and Māori Land in the North Island 1865–1921* (Wellington: Victoria University Press, 2008), 202.

10. Mark Kelly, "Racism, Nationalism and Biopolitics: Foucault's Society Must Be Defended," *Contretemps* 4 (2004): 60–61.

11. The full BBC report, "NZ Police Hold 17 in Terror Raids," 2007, is available at http://news.bbc.co.uk/2/hi/asia-pacific/7044448.stm.

12. See the *New Zealand Herald*'s "Exclusive" for the full report.

13. The report at "Anti-Terror Raids in New Zealand," *The Age,* 2007, is available at http://www.theage
.com.au/news/world/antiterror-raids-in-new-zealand/2007/10/15/1192300647235.html&h=409
&w=300&sz=38&hl=en&start=1&um=1&tbnid=T-4XV5TRKIzl5M:&tbnh=125&tbnw=92&prev=/
images%3Fq%3Danti-terror%2Braids%2BNZ%26um%3D1%26hl%3Den%26client%3Dsafari
%252.

14. The Reuters report, "New Zealand Police Swoop on Weapon Training Camps," 2007, is available
at http://www.reuters.com/article/2007/10/15/idUSWEL207669.

15. The report in *The Australian* is available at "Activists Arrested in NZ Terror Raids," 2007, http://
www.theaustralian.com.au/news/activists-arrested-in-nz-terror-raids/story-e6frg6sx-1111114
646855 while the Bloomberg report by E. O'Brien, "New Zealand Anti-Terror Police Seize Weap-
ons in Raid," 2007, is available at http://www.bloomberg.com/apps/news?pid=newsarchive&
sid=aBCKchaL958M&refer=australia.

16. The report in the *New Zealand Herald* is available at http://www.nzherald.co.nz/nz/news/arti
cle.cfm?c_id=1&objectid=10470116.

17. Sue Abel, "Tūhoe and 'Terrorism' on Television News," in *Terror in Our Midst?: Searching for Ter-
rorism in Aotearoa New Zealand,* ed. Danny Keenan (Wellington: Huia Publishers, 2008), 115.

18. Ibid., 116.

19. Stuart Hall et al., *Policing the Crisis: Mugging, the State and Law and Order* (London: Macmillan
Education, 1978), 17.

20. Ibid., 29.

21. Stanley Cohen, *Folk Devils and Moral Panics: The Creation of the Mods and Rockers* (London:
MacGibbon and Kee, 1972).

22. See, for instance, the conversation cited below between key Māori political figures as reported on
Australian Broadcasting Corporation news, which further amplifies the racialized production of
moral panic. On the one hand, Pita Sharples, coleader of the Māori Party claims, rightfully, that
the terror raids were racialized; while on the other, both Parekura Horomia, then Minister for
Māori Affairs in the Labour Party–led coalition government, and Ron Mark, the New Zealand
First Party's law and order spokesperson, deny this, and in fact claim that the racialization of the
raids by Sharples was an attempt to politicize the issue instead of focusing on the raids as a mea-
sure of security. The simultaneous denial and charge (of trying to politicize the event) does not
erase the racial trope; rather, it affirms it by its denial and reconstitution (as politicization) pre-
cisely because now the "anti-terror" raids are equated as a politicization and racialization of
security. In effect, then, the discourse of the raids is always already racialized. Here is the conver-
sation reported in full: "Māori Party leader Pita Sharples says it is a sad throwback to the darkest
days in the country when colonial troopers stormed into Māori villages. 'It's saying there are
terrorists in our country, and the terrorists are Māori-centred,' he said. 'There's that and it's the
way the raids were carried out, paramilitary style, in front of children and so on just with big
guns. That's what I meant by taking us back a century.' But Māori Affairs Minister Parekura Horo-
mia says it is a homeland security, not a race issue, and that the Māori Party is rushing to judg-
ment before all the facts are disclosed. 'This is not an exercise to play the race card in, as much
as some journos and some community sectors will perceive it as such, and play it,' he said. 'Let's
be frank about it. There have been tensions over the years. [But] by crikey, our race relations are
as good as anybody's in the world, if not better.' The New Zealand First Party's law and order
spokesman, Ron Mark, says the Māori Party is attempting to politicise the police response to a
legitimate security threat. 'If the police were in possession of some of the intelligence that we
believe that they have, and they did nothing, and something happened, what would people be

saying now?' he asked. 'This is not about race. The people that have been arrested, charged and investigated are not all Māori. To suggest that it's racist is foolishness, and if I could be polite, it is mischievous.' " P. Lewis, "NZ Police under Fire over 'Racist' Raids," *ABC*, 2007, http://www.abc .net.au/news/2007-10-19/nz-police-under-fire-over-racist-raids/703668.

23. See BBC News report, "NZ Police Hold 17 in Terror Raids."

24. *New Zealand Herald*, "Exclusive."

25. *The Age*, "Anti-Terror Raids in New Zealand."

26. It should be noted that the National Party–led coalition government recently denied *kaitiaki-tanga* (exercise of guardianship) for Tūhoe over Te Urewera. This marks the nonrecognition of Te Urewera as the spiritual center of Tūhoe, and thus it remains a space of contested epistemological value. The naming of the "Urewera Four," and the mobilization of "Urewera" more generally in the coverage of the trial mark the significance of this historically contested site.

27. Here is an excerpt of Morse's firsthand account of her arrest and her comparison of this with the policing techniques in Ruātoki and South Auckland: "The raids were staged on a Monday morning starting at approximately 5 am. At 5:45 am, the Police knocked on my door. Then they nearly broke it down. When I opened it, 15 officers swarmed in, waving an 80-page search warrant in my face. When I said, 'this isn't signed,' the detective responded 'here, here's the signed copy.' Then they ransacked my room, pulling my plants out of their containers, removing the back of my refrigerator and collecting a raft of documents, photographs, electronic gear and clothing. Finally, they arrested me and told me that I was going to be charged with participating in a terrorist group. . . . Of the 17 arrested . . . 12 were Māori, many from the Tūhoe iwi (tribe). . . . In a spectacular display of force, armed, balaclava-clad police known as the 'armed offenders squad' quite literally invaded the small Tūhoe town of Ruātoki and blockaded the entire community. On an elaborate quest for terrorists and evidence, they stopped all vehicles coming in or out of the community and photographed the drivers and occupants. In the process of conducting house raids, they severely traumatized many people, including locking a woman and five children in a shed for six hours while the man of the family was questioned, taking a woman's underwear as evidence, and boarding a local school bus. In one South Auckland raid, the police held an entire family, including a 12-year-old girl, on their knees with hands behind their heads for some 5 hours, asking the young woman if she was a terrorist. This was the pattern for raids in the Māori communities. For the non-indigenous arrestees . . . the situation was starkly different. In my case, I was not even handcuffed as I was walked to the car. No white neighborhoods were blockaded, nor were white bystanders stopped and photographed as they went about their daily business that cool Monday morning in October." See Valerie Morse, "Land of the Long White Lie: The New Zealand Terror Raids," *Counterpunch*, February 19, 2008, http://www.counterpunch .org/2008/02/19/the-new-zealand-terror-raids/.

28. Ibid.

29. Cohen, *Folk Devils and Moral Panics*.

30. The armed police are a specialist wing of the police force called upon in times of extremity.

31. "Activists Arrested in NZ Terror Raids," *The Australian*; O'Brien, "New Zealand Anti-Terror Police Seize Weapons in Raid."

32. "New Zealand Police Swoop on Weapon Training Camps."

33. See BBC report "NZ Police Hold 17 in Terror Raids"; *New Zealand Herald*, "Exclusive."

34. O'Brien, "New Zealand Anti-Terror Police Seize Weapons in Raid."

35. On the use of the headline "Urewera Four," see "Urewera Four 'Training to Kill,' " *The Press*, February 15, 2012, A5; "Urewera Four: Iti Suspects Surveillance," *New Zealand Herald*, May 9, 2012, http:// www.nzherald.co.nz/nz/news/article.cfm?c_id=1&objectid=10804494; "'Urewera Four': Crown

Considers Retrial," *Otago Daily Times,* March 20, 2012, http://www.odt.co.nz/news/national /202153/urewera-four-crown-considers-retrial; "No Retrial for Urewera Four," *Dominion Post,* May 9, 2012, http://www.stuff.co.nz/dominion-post/news/6886800/No-retrial-of-Urewera-Four.

36. On the use of the headline "Urewera Trial," see "Juror's Injury Delays Urewera Trial," *Stuff News Portal,* March 16, 2012, http://www.stuff.co.nz/national/6586050/Jurors-injury-delays-Urewera -trial; "Urewera Trial: Juror Hospitalised," *New Zealand Herald,* March 16, 2012, http://www .nzherald.co.nz/nz/news/article.cfm?c_id=1&objectid=10792471; and "Urewera Trial Bill Nears $3.9m," *Otago Daily Times,* April 30, 2012, http://www.odt.co.nz/news/national/207341/ure wera-trial-bill-nears-39m. On the headline "Urewera Verdict," see T. Manhire, "The Urewera Ver- dict: What the Bloggers Are Saying," *New Zealand Listener,* March 21, 2012, http://www.listener .co.nz/commentary/the-internaut/the-urewera-verdict-what-the-bloggers-are-saying/; and "Urewera Verdict: Crown Mulls Retrial," *New Zealand Herald,* March 20, 2012, http://www .nzherald.co.nz/nz/news/article.cfm?c_id=1&objectid=10793370. On the headline "Urewera Jury," see "Urewera Jury Having 'Some Difficulty,'" *New Zealand Herald,* March 19, 2012, http:// www.nzherald.co.nz/nz/news/article.cfm?c_id=1&objectid=10793130; and "Urewera Jury Returns Decisions," *Stuff News Portal,* March 20, 2012, http://www.stuff.co.nz/national/crime/6606576 /Urewera-jury-return-decisions.

37. While there have been extensive debates across the media spectrum that have challenged, ques- tioned, scrutinized, and articulated a much more robust, problematic conception of "terror," the raids, and the state actions, I have focused on coverage that has perpetuated a reductive articulation of "terror" that connects it to Indigenous communities and the demand for sovereignty to make the point that conceptions of Indigenous lives in mainstream media remain highly problematic.

38. Achille Mbembe, "Necropolitics," translated by Libby Meintjes, *Public Culture* 15, no. 1 (2003): 39. As Mbembe writes, "this essay assumes that the ultimate expression of sovereignty resides, to a large degree, in the power and the capacity to dictate who may live and who must die. Hence, to kill or to allow to live constitute the limits of sovereignty, its fundamental attributes. To exercise sovereignty is to exercise control over mortality and to define life as the deployment and manifestation of power. One could summarize in the above terms what Michel Foucault meant by biopower: that domain of life over which power has taken control. But under what practical conditions is the right to kill, to allow to live, or to expose to death exercised? Who is the subject of this right? What does the implementation of such a right tell us about the person who is thus put to death and about the relation of enmity that sets that person against his or her murderer? Is the notion of biopower sufficient to account for the contemporary ways in which the political, under the guise of war, of resistance, or of the fight against terror, makes the murder of the enemy its primary and absolute objective? War, after all, is as much a means of achieving sover- eignty as a way of exercising the right to kill. Imagining politics as a form of war, we must ask: What place is given to life, death, and the human body (in particular the wounded or slain body)? How are they inscribed in the order of power?" (ibid., 11–12).

39. Osuri, "Media Necropower."

40. Ibid., para. 14.

41. Ibid., para. 12.

42. Ibid., para. 13.

43. Ibid., para. 1.

44. Michel Foucault, *Society Must Be Defended: Lectures at the College de France 1975–1976* (New York: Picador, 1997), 256.

45. *New Zealand Herald,* "Exclusive."

46. Foucault, *Society Must Be Defended,* 137.

47. In her book *Against Freedom*, Valerie Morse traces the response of the New Zealand government to the war on terror and locates this within a larger historical narrative. As she remarks, "colonization, systematic discrimination against Māori, racist immigration policies, support for the UK, then US wars, worker oppression, crumbs given to the masses, the illusion of democracy and media complicity, are all part of the history of this war. Like the US, the war on terrorism is nothing new in New Zealand; rather, it is the continuation of the same exploitation practiced by those in power for more than 165 years." Valerie Morse, *Against Freedom: The War on Terrorism in Everyday New Zealand Life* (Wellington: Rebel Press, 2007), 7.

48. Foucault, *Society Must Be Defended*, 249.

49. Foucault characterizes the shift in the operations of political power as a shift from anatomo-politics to biopolitics (ibid., 243).

50. Ibid., 241.

51. Ibid.

52. Disciplinary power "tries to rule a multiplicity of men to the extent that their multiplicity can and must be dissolved into individual bodies that can be kept under surveillance, trained, used, and if need be, punished" (ibid., 242). In that sense sovereignty is underpinned with taking life or letting live. Biopower, in contrast, "is not applied to man-as-body [a feature of the disciplinary regime] but to the living man, to man-as-living being, ultimately . . . to man-as-species" (ibid.). Here, biopower does not seek to individualize; rather this technology of power massifies, begins to "deal . . . with the population, with the population as political problem, as a problem that is at once scientific and political, as a biological problem and as power's problem" (ibid., 245).

53. Government, as Foucault understands it, refers to "the way in which the conduct of individuals or of groups might be directed. . . . To govern, in this sense, is to structure the possible field of action of others." Michel Foucault, *Essential Works*, vol. 3: *Power*, trans. Robert Hurley et al. (New York: New Press, 2000), 341.

54. Ibid.

55. Foucault, *Society Must Be Defended*, 246–47.

56. Sovereign power now works "to incite, reinforce, control, monitor, optimize, and organize the forces under it; a power bent on generating forces, making them grow, and ordering them." Michel Foucault, *The History of Sexuality*, vol. 1, trans. Robert Hurley (New York: Pantheon Books, 1978), 136.

57. Foucault, *Society Must Be Defended*, 249.

58. Giorgio Agamben, in *State of Exception*, trans. Kevin Attell (Chicago: University of Chicago Press, 2005), traces the concept of state of exception and its relationship to sovereignty, and suggests that the state of exception is "the dominant paradigm of government in contemporary politics" (2). Drawing on the immediacy of the global war on terror, Agamben argues that "the transformation of a provisional and exceptional measure [the creation of a state of emergency or exception] into a technique of government threatens radically to alter . . . the structure and meaning of the traditional distinction between constitutional forms [democracy and absolutism]" (2). In other words, the state of exception has become a permanent feature of democratic societies, and has been most recently mobilized in the war on terror rhetoric, specifically the USA Patriot Act, "which authorized the 'indefinite detention' and trial by 'military commissions' . . . of noncitizens suspected of involvement in terrorist activities" (3). The creation of a permanent state of exception signals not the rule of a specific law, or "a special kind of law (like the law of war); rather, . . . it is a suspension of the juridical order itself" (3, 4). The suspension of the juridical order does not then mean that the sovereignty of the nation-state, built upon a set of juridical orders and structures, is under threat. Rather, it consolidates and ensures the survival of the nation-state's sovereignty precisely

because the state of exception opens the possibility for the production and institution of law-preserving, sovereignty-affirming, measures that are outside the sphere of law. That is to say, the state of exception—"a space devoid of law, a zone of anomies, in which all legal determinants . . . are deactivated" (50)—produces the very conditions for the use of extralegal measures to ensure the survival of the sovereignty of the nation-state. This is precisely how and when "the juridico-political system transforms itself into a "killing machine" (86), where questions of citizenship and individual rights can be diminished, superseded, and rejected in the process of claiming this extension of power by a government. The state of exception thus provides the very conditions for the brutalization of individual and collective rights and liberty.

59. Foucault, *Society Must Be Defended*, 249.

60. Ibid.

61. Ibid.

62. Ibid., 255.

63. Ibid.

64. Ibid.

65. Ibid.

66. Let me add that while I have been discussing racism as the precondition for state sovereignty with reference to how the Māori community, particularly those demanding Indigenous sovereignty, have been arrested and represented through Foucault's notion of biopower, it does not follow that racism can be simply conceived in cultural or ethnic terms, although this is done in the media practices. Such a view cannot explain why the state targeted political activists, anarchists, and environmentalists whether they were Māori or not. In other words, their cultural location had no bearing on the state's decision. These collectivities were nevertheless arrested, exposed to the sovereign right to live and to kill, because of the racism of the state. And here racism must be grasped "as a way of introducing a break into the domain of life that is under power's control" (Foucault, *Society Must Be Defended*, 254). The anarchist, political activists, and environmentalists were those figures that were engineered as interrupting the domain of life (and state sovereignty) and hence had to be arrested to make the rest of the population safe and secure.

67. For further information on the "15 October Solidarity" and "Beyond Resistance" collectives, see http://october15thsolidarity.info/ and http://beyondresistance.wordpress.com, respectively.

68. I use the term "alternative media," following Nick Couldry and James Curran, to encompass both "media production that challenges, at least implicitly, actual concentrations of media power, whatever form those concentrations may take in different locations" and media forms that contest and challenge "established power blocs with a view to wider social emancipation." Errol Wright and Abi King-James (dirs.), *Operation 8: Deep in the Forest* (Wellington: CUTCUTCUT Films, 2011). See Nick Couldry and James Curran, "The Paradox of Media Power," in *Contesting Media Power: Alternative Media in a Networked World*, ed. Nick Couldry and James Curran (Oxford: Rowman and Littlefield, 2003), 7.

69. Kevin Fisher, "Operation 8: State of Exception," *Crop* 2 (June–July 2011): 30.

70. Ibid., 31.

71. Michael Hardt and Antonio Negri, *Commonwealth* (Cambridge, Mass.: Harvard University Press, 2009), 173.

72. Ibid., 59.

73. Ibid.

74. Ibid., 175.

75. Ibid., 172.

76. Ali Rattansi, "Postcolonialism and Its Discontents," *Economy and Society* 26, no. 4 (1997): 482.

2. *Postcolonial Trauma*

Child Abuse, Genocide, and Journalism in New Zealand

ALLEN MEEK

In New Zealand, as in many other nations, the notion of a collective experience of trauma has allowed different understandings of history, identity, and social policy to be articulated and contested. When the then Labour Party member of Parliament (MP) and associate minister of health (now coleader of the Māori Party) Tāriana Tūria proposed in August 2000 that Māori suffered from "Post Colonial Traumatic Stress Disorder"[1] she intervened in a complex set of discourses surrounding the Treaty of Waitangi (see Introduction), child abuse, and the ongoing legacies of colonial violence. The use of the word "holocaust" in Tūria's comments, and in documents produced by the Waitangi Tribunal, briefly (and belatedly) introduced international debates about genocide into this local context. Yet, Tūria's propositions about trauma and history in New Zealand, which invited initial hostility, appear to have since been absorbed into a general silence.

Tūria's comments need to be seen in the context of events that led to her departure from the Labour-led coalition government, particularly the foreshore and seabed controversy.[2] Tūria's opposition to Helen Clark (then prime minister and leader of the Labour Party) over this issue resulted in her dismissal from cabinet, her resignation from the Labour Party, and the formation in 2008 of the Māori Party. The specific association of Māori with high levels of child abuse in New Zealand forms part of a more general backlash by the dominant culture against Māori struggles for sovereignty. The horrific details of such abuse, when amplified by color photography and lurid journalistic description, became occasions for postsettler society to dramatize its guilt and anxiety about poverty and violence among Māori.[3] Urban family dysfunction was made a symptom of the failure of Māori to conform to moral standards and the rule of law. Mainstream media constructed child abuse as a cultural trauma that Tūria then resituated as part of a larger colonial history.

The following discussion will consider some of the events that led to the brief controversy surrounding Tūria's proposal. In particular, I discuss a series of cover stories in the prestigious New Zealand magazines *Metro* and *North and South* concerning the deaths of young children in Māori families. Such stories have been prominent in New

Zealand media over the past fifteen years. One high-profile case attracting intense media coverage was the deaths of the three-month-old twins Chris and Cru Kāhui in June 2006. The trial and acquittal of the twins' father, Chris Kāhui, in 2008 led to public outcries concerning the failure of the justice system and a "conspiracy of silence" on the part of the dead children's *whānau* (extended family).[4] Media commentary on such cases has tended to reproduce two major ideological, or discursive, positions: a neoliberal emphasis on individual responsibility and a state welfarist demand for greater intervention in the physical abuse of children. Both positions potentially conflict with government policies of biculturalism, which recognize the important role of Māori social structures and cultural values in the provision of social welfare. But when Tūria gave a speech to the New Zealand Psychological Society proposing that domestic violence among Māori needed to be understood with respect to the long-term impact of colonization, the child abuse debate escalated briefly into a broader argument regarding the nation's history.

The traumatic experience of a child, including horrific physical abuse by its adult caregivers leading to death, can become understood as a trauma in a cultural or historical sense through its representation in news media and public debate. The specific media coverage of domestic violence that I will discuss in this chapter included explicit photographs of the victims' bodies and graphic descriptions of the abuse that they suffered leading to their deaths. What was at stake in this potent mix of image and narrative? Why was media coverage focused so exclusively on Māori?[5] Who did these bodies properly belong to and who should mourn their deaths, the citizens of New Zealand or Māori as a sovereign people? Journalists David McLoughlin, Deborah Coddington, Bill Ralston, and Geraldine Johns argued vigorously and evoked emotionally charged scenarios in order to claim victims, such as Jordan Ashby, Delcelia Witika, James Whakaruru, and Tangaroa Matiu as members of the national family, all the while laying blame on their caregivers, *whānau,* and neighbors for failing to take responsibility for the children while they were alive. In this way the media exploited the "traumatic" impact of these images and narratives and potentially mobilized public opinion against Māori self-determination. But, for Tūria, violence within Māori communities could not be separated from the loss of *mana* (power and authority) resulting from confiscation and occupation of Māori lands by the colonial state and settler society. She argued that only public acknowledgment of the violence of this historical appropriation would allow understanding of the ongoing violence at a personalized, individual level. For Tūria, colonization was a trauma collectively experienced by Māori giving rise to an ongoing historical struggle over its effects. However, this heated debate appeared to subside as quickly as it rose up, giving way to a focus on parliamentary reform regarding the use of physical force to discipline any child.

The following discussion will consider the representation of child abuse and death in the New Zealand media as part of a complex range of ideological positions. While some of these stories also received substantial coverage in New Zealand newspapers,

the series of cover stories in *Metro* and *North and South* were often based on extensive research; they provided detailed accounts of individual case histories and articulated political and moral positions on the various issues raised by child abuse in New Zealand. The purpose of this chapter is not so much to uphold one of these positions over another as to attempt to understand what was at stake for different groups in the traumatic deaths of these Māori children. In his famous theses "On the Concept of History," Walter Benjamin proposed that the critical historian must appropriate images of the past that are in danger of being used by dominant formations of power. According to Benjamin's dramatic formulation *"even the dead* will not be safe" unless we attempt to learn from these images.[6] In the spirit of Benjamin's comments, I argue that in the context of these magazines, the representations of these children's deaths were used to implicitly justify settler culture and colonial rule in New Zealand. Following the publication of these pictures and stories there ensued a struggle over the meanings of these deaths in public debate. This chapter seeks to keep this debate alive through a critical meditation on the larger historical significance of these representations of violence and loss.

Postcolonial Trauma

The violent abuse of a child can lead to physical and psychological trauma. The death of a child as the result of violence within the family can also lead to the psychological traumatization of the immediate family group and extended family. Media coverage of such events can serve to generalize, thus claiming that the larger community also experiences some form of trauma. Through its representation, physical trauma can become the subject of public discourses that lay claim to traumatic experiences on behalf of particular communities such as ethnic groups or entire nations. I will use the term "postcolonial trauma" in this chapter to designate the ways that specific violent events enter a mediated or discursive space where they take on a larger significance in postcolonial societies.[7] Kevin Bruyneel has argued, in the U.S. context, that the ongoing resistance of Indigenous peoples to colonial power engenders what he calls a "third space of sovereignty": "a supplemental space, inassimilable to the institutions and discourse of the modern liberal democratic settler state and nation."[8] The New Zealand welfare system has served as an important site for the assimilation of Māori social structures and cultural practices into the institutional governance of the state. The particular crisis provoked by child abuse can be called a "postcolonial trauma" in the sense that it evokes images and stories of violence and suffering that cannot be fully assimilated into the narrative of the liberal democratic nation. The debates surrounding these child deaths suggest that the violence of colonization is unfinished, not "settled" but rather unacknowledged in the dominant narratives of nation-building.

In New Zealand, as in Australia, the history of colonization creates problems for formulating and sustaining a popular myth of national identity. In both countries the

myth of "brave white masculinity" exemplified by the Australia and New Zealand Army Corps (ANZAC) soldiers in the World Wars remains the predominant myth of nationhood.[9] The use of the word "holocaust" by Indigenous peoples has challenged such "heroic" constructions of modern war because of its common association with the "Nazi Final Solution." Writing in the *Listener*[10] while residing in Germany, expatriate Philip Temple observed that the establishment of the Holocaust Memorial in Berlin raised the question of how we should understand historical responsibility for colonial violence in New Zealand. In a similar mode Ross Gibson has adapted Margarete and Alexander Mitscherlich's famous analysis of postwar German society's failure to confront the Nazi past, and suggested that many Australians have also yet to acknowledge or confront the genocidal dimensions of colonization:

> The histories of most nations founded on violence suggest that an inability or refusal to acknowledge the past will produce evermore confusing or distressing symptoms in the body politic. In the wishful shelter of ignorance or amnesia, an abiding melancholy tends to creep into the populace. Or equally disabling, the society can succumb to a paranoid urge to expunge all dissenting persons or memories.[11]

But how accurately does such a scenario fit New Zealand? Had not Prime Minister Jenny Shipley already apologized in 1998 to the Kāi Tahu (South Island *iwi*) peoples for breaches of the Treaty of Waitangi?[12] Yet, a speech given by the then opposition National Party leader Don Brash in 2004, in which he promised an end to "race-based funding"[13] and that attracted widespread approval in subsequent opinion polls, suggested that many New Zealanders were eager to "move on" from what are seen as the historical wrongs of colonization. Brash had promised to accelerate settlement of all Treaty claims, and this also appeared to have popular support.

Perhaps these developments can be seen as symptomatic of what Paul Gilroy has called "postcolonial melancholia": the inability to work through the historical legacies of colonialism and the changing face of collective identity in postcolonial societies. For the melancholic, the traumatic past always threatens to disrupt attempts to establish and maintain a sense of a bounded, coherent identity. In national narratives, such disturbing events can include the collective experience of war, genocide, or mass displacement of populations. In postcolonial societies this traumatic past can encompass not only the Indigenous population's experience of colonization, but also the colonizers' experience of emigration and settlement. The traumatic impact of such events is often compounded by the silence that surrounds them, the refusal to acknowledge their occurrence or that their effects endure in the present, or the victims' shame that prevents them discussing the distressing aspects of the past more openly. Rather than being assigned a place in an accepted narrative, such events become part of the unfinished business of recalling, working through, and contesting historical experience.

Different groups within the nation-state also compete for recognition in their representation of the past, in ways often related to broader issues of grievance and legal reparation, restitution, and narratives of reconciliation. For these reasons there is a specific danger that trauma becomes a way of constituting the Indigenous subject as victim, thereby attributing a collective psychic process where a specific analysis of social, political, and economic determinants may be more useful. Kimberly Wedeven Segall has argued that in postcolonial contexts trauma can come to mean the performance of victimization by postcolonized peoples.[14] Yet, she also notes that the idea of trauma can usefully complicate Enlightenment narratives of reason, progress, and law insofar as trauma draws attention to what is unresolved, haunting, and disruptive.[15] In the following sections, I argue that representations of child abuse in New Zealand media have become a site where the violence of colonization is articulated as a historical trauma. In the mainstream media this trauma is understood in terms of the civilizing mission of the parent culture. However, a number of Indigenous voices have challenged these assumptions by proposing that trauma be understood as a consequence of colonial violence.

Representing Child Abuse

Child abuse receives attention from news media in cases that are particularly shocking and emotionally harrowing, but it also forms part of the broader social problem of domestic violence. In her study of representations of domestic violence, Nancy Bearns explains that media stories tend to focus on victims, but this "does little to develop public understanding of the moral context of violence and may impede social change that could prevent violence."[16] Bearns argues that various magazine genres frame this issue differently: women's magazines tend to frame domestic violence in terms of individuals trapped in abusive relationships;[17] men's and conservative political magazines tend to use an antifeminist frame to discredit claims about male abuse;[18] while liberal political magazines tend to use a social justice frame and look for progressive solutions to social problems.[19] Bearns uses examples from U.S. media, but in the New Zealand context the frames are somewhat altered, taking into account both the different ethnoscape and much more limited range of publications. The articles that I will discuss present a mix of different ideological frames on child abuse that include elements of antifeminist arguments and an emphasis on individual responsibility, along with some propositions about progressive social change. There is a consistent tendency in all of these articles to hold Māori accountable for child abuse.

North and South and *Metro* are "glossies" published by ACP Media, which also publishes magazines on motoring, fashion, cooking, design, real estate, and other areas of popular consumption. *Metro* is categorized as a lifestyle magazine aimed primarily at Auckland-based readers. *North and South* is characterized by an emphasis on quality, and often award-winning, journalism.[20] In this section, I discuss a series of

articles that appeared in these magazines between 1994 and 2007 in terms of their implicit ideological positions. According to a neoliberal agenda, child abuse should be understood as a failure of individual responsibility and family values rather than as endemic to poverty, unemployment, and/or longer histories of violence. Thus, a number of the articles consistently express concern that the mother of the dead child was presented in court as traumatized and the victim of violent abuse, representing this as an example of feminist ideology distorting the process of justice and evading moral accountability. The argument carried over into a rejection of any notion of postcolonial trauma insofar as it would displace individual responsibility by claiming that the perpetrator of violence is an historical victim. Neoliberals have often tended to evoke images of Māori as failing to achieve the ideal of the nuclear family. On the other hand, left-liberals find abhorrent the right-wing tradition of associating poverty with race and therefore often avoid the question of cultural and social structures and their relation to poverty. Both neoliberals and left-liberals also argue for more flexible and proactive forms of intervention by social services. The result of this debate, as a cross-purposes consensus, has been legal reform prohibiting parents from using physical force on children. However, the position advanced by Tūria and other Māori voices rejected both neoliberal moralizing and state welfarist paternalism and emphasized Māori initiatives as the best way to address problems of violence in Māori communities.

Yet, it is Māori communities that often take the blame for child abuse in journalism. In a 1994 *North and South* cover story entitled "Killing Our Kids," David McLoughlin wrote of the "anguish" and "outrage" of the public at the deaths of young Māori children at the hands of their caregivers, while castigating the Department of Social Welfare for failing to rescue the children and "keeping at-risk kids within their whanau come hell or high slaughter."[21] The title of this article implies that the children are "ours," that is, the nation's, as opposed to any Māori community's. The article begins by focusing on the case of Jordan Ashby, a three-year-old who "was killed on March 24 by Philip Rakete, 22, the cannabis-addled, layabout partner of his mother."[22] While Jordan's biological father was Pākehā (white New Zealander), his mother was a member of a "large, extended Maori whanau" who were "warm and supportive"[23] yet failed to save Jordan from death at Rakete's hands. The article lists the names of several other child victims of 1993 and various other statistics on New Zealand child abuse dating from the late 1970s to late 1980s. These statistics claim disproportionately high rates of physical abuse by Māori and Pacific Islanders, but do not establish anything conclusive about the ethnicity of those children who have died of abuse.[24] The article also criticizes the effects of the 1989 Children, Young Persons and Their Family Act:

> While supposedly meant to protect children, the legislation emphasises the rights of families, whanau, iwi, hapu and family groups. It assumes that children belong to families and must be left in their care, despite the fact some families are noted for violence and abuse extending over several generations.[25]

The article goes on to explore different perspectives on the dilemmas of family or foster care and the necessity and difficulties of state intervention in domestic violence.

While McLoughlin's article implies a failure of bicultural policy in social services, Finlay Macdonald, in a 1996 article for *Metro*, linked high rates of child abuse to new forms of poverty emerging in New Zealand, and ultimately to neoliberal economic policies.[26] He also linked some of the most influential voices of neoliberal economic thought with a long tradition of explaining poverty in terms of racial and cultural difference.[27] Macdonald cites Sir Roger Douglas, the minister of finance in the 1984 Labour government and notorious architect of New Zealand's neoliberal market reforms of the 1980s, who evoked images of child abuse and domestic violence in Māori families in order to argue that family values, rather than poverty or unemployment, are the basis for quality of life.[28] However, Macdonald's essay does not provide any analysis of the relation between ethnicity and poverty in New Zealand, or of the impact that ethnic social structures and cultural traditions may have on perceptions of economic failure. This emphasis on economic hardship rather than ethnic community appears to be typical of the left-liberal approach to these issues.

However, rather than consider the historical and social reasons for child abuse, journalists overall tended to look for particular individuals or groups to blame. In November 1998, *North and South* featured an article on the death of two-year-old Delcelia Witika, whose mother and stepfather were jailed for child abuse leading to death. The article describes the mother, Tania Witika, as "the adopted daughter of a dysfunctional South Auckland Maori family" and the father as "a Samoan-Pakeha teenage lay-about."[29] Providing a detailed account of the physical abuse of Delcelia, the writer berates the child's extended family for failing to notify the police or Social Welfare. The child died alone in her home while her parents were captured on video the same evening at a party with friends.[30] Regardless, the principle concern of the article was the case made in court that Tania Witika was herself a victim of violent abuse and suffered from post-traumatic stress disorder.[31] In this account, there is a strong emphasis on personal responsibility, suggesting that the portrayal of Tania Witika as a victim is a perversion of justice. By implication the article suggests that this distortion of responsibility is also largely the result of feminist ideology.[32]

Deborah Coddington (who would later serve as an MP for the neoliberal ACT Party) pursued these issues further in her February 2000 *North and South* article on the violent abuse leading to the death of four-year-old James Whakaruru. The article includes photographs of the dead child, his naked body covered in bruises from extensive beating. In this case, blame falls heavily on the failure of social services to protect the child after evidence of sustained physical abuse. Again the mother, extended family, and neighbors of the child are held accountable for not seeking help,[33] yet the article fails to consider the possible reasons for the alienation of these individuals from police, state services, or employers. Coddington concludes her article by reflecting on the introduction of laws prohibiting the use of physical force against children.[34] This

article, like its precursors in *North and South,* revealed a disturbing tendency to represent individuals in ways that recalled the oldest colonial stereotypes of the lazy, ignorant native or wild savage. The implication is that Māori have failed to become integrated into the national community, as evidenced by their refusal to properly interact with government institutions and public services. With the exception of Macdonald's article, attempts to argue that the perpetrators of this abuse are themselves victims of social disadvantage and domestic violence are viewed with skepticism. The result is that the deaths of these innocent children are constructed as a trauma for the nation rather than for the specific families and communities directly impacted by these terrible events.

The "h" Word

The tendency in mainstream media to chastise Māori for violent child abuse was challenged in August 2000 by Tāriana Tūria. Tūria delivered a speech to the New Zealand Psychological Society (NZPsS) Annual Conference in which she asked psychologists to consider the historical impact of colonization when dealing with Māori patients. Speaking in Parliament earlier the same week, Tūria had attempted to link domestic violence with colonization.[35] In her speech to the NZPsS, Tūria compared the impact of colonization to post-traumatic stress disorder and referred to colonization as "the holocaust suffered by indigenous people."[36] Tūria linked Māori social structures to the "guardianship and occupation of land" and spoke of the alienation of these structures by government policy and law. Citing Native American psychologist Eduardo Duran as a precedent, Tūria sought to explain domestic violence in terms of self-hatred among Māori due to the internalization of negative images produced by the dominant colonial culture. She also cited the research of renowned New Zealand anthropologist Dame Anne Salmond, which found that in precontact Māori society, violence toward children was less common than in European societies of the same period.[37] Tūria then proposed that healing for Māori could only begin with the public acknowledgment of "the holocaust suffered by many Māori tribes during the Land Wars"[38] and the continuing settlement of Treaty of Waitangi claims.

The notion of post-traumatic stress disorder was initially developed in the case of U.S. soldiers returning from Vietnam, but has since become more prominent in the treatment of survivors of both child abuse and the Jewish Holocaust. When Tūria used the "h" word it was without an initial capital, and she clearly emphasized that she had no wish to enter a "our holocaust was worse than your holocaust debate."[39] Prime Minister Helen Clark's response, that Tūria's use of the word "holocaust" was inappropriate, revealed a need to silence those accounts of colonization. Yet, while the prime minister demanded from Tūria a public apology, the "h" word had already been referenced by the Waitangi Tribunal to describe the forcible confiscation of lands in the Taranaki during the Land Wars.[40] Thus, the New Zealand government's official com-

mitment to the Treaty of Waitangi had already opened a space for a public acknow-
ledgment of colonial genocide.

The public debates around Tūria's references to trauma and the Holocaust made
local news but were also representative of larger international trends. Trauma theory
has emerged in recent years as a significant intervention in academic debates about
historical representation.[41] Debates about historical trauma in the public sphere and
mass media have also given rise to transnational alliances through which new com-
munities of political interest have emerged. The use of the term "holocaust" by Indig-
enous peoples to describe the effects of colonization is one such example. While the
use of this term is no doubt intended to provoke controversy and renewed attention to
the political struggles of Indigenous peoples, it has often given rise instead to debates
about exclusivist and relativist uses of the term "holocaust" itself. Yet, whether the
term "holocaust" is truly appropriate to describe the history of European colonialism
in New Zealand or elsewhere, or whether colonization can be validly compared to the
Nazi Final Solution, is less important than considering the broader implications of his-
torical experience as it is rearticulated in new institutional, public, and mediated con-
texts. The use of "postcolonial trauma" in New Zealand inflects a counter-narrative
that challenges dominant versions of history in this postcolonial nation. In particular,
the use of the term "holocaust" challenged the pedagogical relation of the colonizer
and colonized, leading to the reassertion of colonial dominance when it was
"explained" that Tūria's use of this term was inappropriate and could not be sanc-
tioned in the public domain.

Mana magazine, the New Zealand "glossy" devoted to Māori interests (see also
chapter 5), included a transcript of Tūria's controversial speech. In the same issue,
Māori commentator and lawyer Moana Jackson criticized moralistic and paternalistic
responses to the violent abuse of Māori children. Jackson noted the failure of the
media to acknowledge attempts by Māori to address this problem within their com-
munities along with the failure of government to adequately support and fund these
initiatives. Like Tūria, Jackson expressed regret at the association of Māori society with
violence and also challenged the nation to confront its own violent history of coloniza-
tion and oppression of Māori. But Tūria's speech would prompt further response in
subsequent media coverage of child abuse. In his editorial for *Metro* in October 2000,
Bill Ralston dedicated that issue to the memory of three-year-old Tangaroa Matiu,
another Māori child who died as a result of sustained physical abuse. As Ralston saw it,
"Tangaroa Matiu was not, as associate Māori affairs minister Tāriana Tūria would have
it, a victim of colonization. He was murdered by a sadist and allowed to die by an
uncaring family."[42]

Ralston also referred to failures in Māori social structures and accused Tūria and
Salmond of indulging in a myth of a Māori golden age and a "naive, antiquated
view of the Noble Savage." Rather, asserted Ralston, the "cruel fact of history is that
pre-European Māori life was often brutal and harsh." It was also an "undemocratic,

slave-owning, ritualistically cannibalistic society."[43] Ralston proposed that the solution to violence against children is individual responsibility rather than a bogus psychology that would seek to transform the perpetrator of violence into an historical victim. Ralston's position was further elaborated in an article by Geraldine Johns in the same issue of *Metro*, detailing the violent abuse leading to the death of Tangaroa Matiu. After Ralston's editorial, Johns's account of the child's death reads like an allegory of Ralston's view of life in precontact Māori society. The article describes the "fathomless savagery"[44] of the violence unleashed on the child. As with similar media reportage, it was argued in court that the mother suffered from Battered Woman's Syndrome. This question was pursued further in a September 2003 *North and South* article on abusive mothers where the notion of Battered Woman's Syndrome was again discredited.

Ralston's editorial drew out the larger historical implications of the stereotypes often employed in these articles. The academic world also responded to Tūria's speech. In 2003, David MacDonald published an essay in the *Journal of Genocide Research* considering Tūria's controversial proposals. The title of this essay "Daring to Compare: The Debate about a Māori 'holocaust' in New Zealand" already seems to indicate a certain complicity with the dominant media interpretation. Tūria, writes MacDonald, "equated Māori experiences with those of European Jews,"[45] yet, in her speech Tūria had explicitly rejected the whole question of comparison, and commented that the suffering of Māori had not received the same attention as victims of the Final Solution or Vietnam veterans. While MacDonald insisted that Tūria was claiming "moral equivalence"[46] between the Final Solution and colonization in New Zealand, there was in fact no insistence by Tūria on equivalence but rather on an extension of compassion, understanding, and healing. Tūria had sought to rearticulate Māori colonial trauma in the globalized context of the Indigenous holocaust.

MacDonald provided the historical background to Tūria's position and explained that while the Māori Renaissance of the 1970s and 1980s (see Introduction) was strongly influenced by the political style and rhetoric of the African American Black Power movement, more recent political interventions were influenced by Native American Indigenous activists who took up the word "holocaust." Māori and Native American peoples share a colonial history leading to the drastic decline of their populations.[47] The 1990s saw the beginning of references to genocide in the claims before the Waitangi Tribunal, leading it to use the term "holocaust" in the 1996 *Taranaki Report*[48] and the phrase "threat of extermination." MacDonald identified an underlying problem in the "conflation of holocaust with genocide"[49] and also argued that the Māori experience of colonization was significantly different from that of Aboriginal Australians and Native Americans.[50] He concluded, "While much violence, land theft, trickery, and forced assimilation can indeed be proven in the case of Māori, there is no record of genocide being committed and certainly no proof of intent to exterminate Māori as a people."[51] On the contrary however, Tūria's speech had used the terms

"genocide" and "holocaust" in order to claim the Māori experience of colonization as part of a global process of invasion, conquest, and destruction of Indigenous societies.

Although the Holocaust has come to be increasingly represented and discussed as the iconic catastrophe of modernity, the challenges posed to historical understanding by its traumatic effects should not obscure our attention to the continuing consequences of genocide and practices of colonial and neocolonial domination. On this point, Bill Ashcroft has emphasized the transformative processes by which colonized peoples have responded to the forms of domination continued in postcolonial nation-states,[52] and explains what he understands as postcolonial resistance in the following way: "fractures open up within discourse at the boundaries of its determination where the 'rules of exclusion' and 'rules of inclusion' are negotiated."[53] Arguments about the singularity of the Jewish Holocaust can become a means of surrounding one discourse with legitimacy while excluding other—and MacDonald's argument is not free of these tendencies. Indigenous peoples, including Native American, Aboriginal, and Māori activists, have all made use of the "h" word to describe the impact of colonization, yet the discourses that surround the Jewish Holocaust can be said to be "dominant" in Western intellectual and cultural production. Ashcroft reminds us, however, that the contested question of genocide opens fractures within the discourses surrounding the Jewish Holocaust, allowing new spaces of articulation to open up for those who wish to speak of the victims of colonial domination and violence. To challenge the rules of inclusion and exclusion is to turn the inside out and the outside in with regard to the postcolonial nation's discourses of legitimacy. To speak of the historical experience of Indigenous peoples as holocaustal is to occupy in a rhetorical sense what has become a Western intellectual and cultural sacred space. Yet this rhetorical claim need not diminish the Jewish Holocaust in any way.

The Lost Child

Meanwhile, what haunted the debate around holocaust exclusivism and relativism in New Zealand were media images and stories of several children who had died as a result of abuse in Māori homes. To what degree was it coincidental, opportunistic, or strategic that arguments about the long-term effects of colonization in New Zealand should be linked to instances of child abuse? If it is made to appear that an idea such as postcolonial trauma is being used to excuse child abuse in some way, then public outrage is not a surprising response. While Tūria's comments never made such an argument directly, the relation between domestic and historical trauma does remain a vexed one. In their 1995 book *Native American Postcolonial Psychology*, Eduardo and Bonnie Duran argue that the widespread health problems and high rates of alcoholism, suicide, and educational failure that plague Native American communities need to be understood in terms of the transgenerational effects of colonization and

genocide. The Durans reject the universalist assumptions embedded in dominant forms of psychological research and argue that the specific historical experience of Indigenous peoples must inform therapeutic practice. They extend Frantz Fanon's famous analysis of black self-hatred as internalized oppression, interpreting child abuse and domestic violence as "a venting of anger toward someone that is helpless and as a reminding of the perpetrator of himself" while the "root of the anger is toward the oppressor."[54]

On this point there is also an important link to be made with the Australian government's *Bringing Them Home: Report of the National Inquiry into the Separation of Aboriginal and Torres Strait Islander Children from Their Families* (1997),[55] in which it was found "that the policy of forcible separation constituted genocide within the meaning of the term in international law."[56] In New Zealand, the trial by media of Māori families as perpetrators of domestic violence and abuse also had the problematic implication that guardianship by the state was no longer a viable option. The 1948 United Nations Genocide Convention defined one of the features of genocide as "forcibly transferring children of the group to another group." The condemnation in New Zealand media of Māori families failed to acknowledge the

> range of social, cultural and economic reasons which make Indigenous children and young people more susceptible to both child protection intervention and criminalisation by the juvenile justice system. These include high levels of unemployment, poverty, ill-health, homelessness and poor educational outcomes. They arise from the intergenerational effects of earlier assimilationist policies, as well as being the direct outcome of dispossession and marginalisation.[57]

In this context it can be argued that the mediated stereotyping of Māori as child abusers constitutes a displacement of the genocidal features of colonization, including ongoing effects of social disadvantage. To portray Māori caregivers in the media as child abusers is to displace the nation's collective responsibility for the socioeconomic legacies and continuing impact of colonization. These cases also provoke a crisis of welfarist ideology, as state intervention could imply further destabilizing of Māori families with long-term genocidal consequences. These disjunctures in dominant political discourses such as neoliberal individualism and state welfarism define the parameters inside which Tūria's comments were received and that they were intended to disrupt and question.

The role of the child in these representations of violence also has a long history. Ashcroft explains how the figure of the child is a prominent colonial trope: "As a child, the colonial subject is both inherently evil and potentially good, thus submerging the moral conflict of colonial occupation and locating the child of empire in a naturalization of the 'parent's' own contradictory impulses for exploitation and nurture."[58] In the case of domestic violence in Indigenous families, the abused child becomes a site of

redemptive potential under the care of the parent society at the same time as Indigenous groups are blamed for neglect and failure. However, as the forcible separation of the child from its family has become more problematic in public discourse, the onus falls ever more directly on the Indigenous family itself to assume responsibility.

Ashcroft also argues that one of the ways that the contradictions underlying the construction of the colonial subject as child are overcome is through "the transfer of the disciplinary regime of education to the colonial subject."[59] In the public response to Tūria's comments we can see a manifestation of this pedagogical impulse. On the one hand, it needed to be "explained" to Tūria that her use of "h" word was historically inaccurate and culturally insensitive. On the other, it needed to be demonstrated once again that Māori were inadequate as caregivers within the family. In both responses it was implied that Māori were not fully integrated as adult subjects into New Zealand's public discourses or into the nuclear family and suburban society. At the same time, previous state interventions in the Māori family have been revealed as deeply problematic. These contradictions were manifest in the title of Coddington's article for *North and South*, "Disciplined to Death," which described the killing of James Whakaruru. The projection of the pedagogical relation as perverse and violent in the Māori home again suggests a displacement of colonial and statist forms of domination and control. In these public responses to child abuse we can read the failure of both neoliberal and welfarist discourses to address the larger historical forces that shape the societal problem of domestic and racial violence.

Beyond the hypocritical claim to public grieving was a deeply colonial impulse underlying these mediated responses to Tūria's comments and to the deaths of these children. Moreover, in these responses we can read a more fundamental failure of the dominant narratives of nationhood. The pedagogical relation of colonizer and colonized is intended to resolve the contradiction between liberal (and neoliberal) individualism and the exploitation of the colony in the global system. The moralizing emphasis on individual responsibility displaces any historical responsibility for colonial violence. The move by Indigenous peoples to demand recognition of, and reparation for, the genocidal consequences of colonialism also demands that we reject this pedagogical model of colonial domination.

Postscript

In 2004, Tāriana Tūria and Pita Sharples became coleaders of the newly formed Māori Party. In the face of Brash's popular attack on "race-based funding," the Māori Party argued for both more government funding and Māori autonomy in running community programs "enabling rangatiratanga, or self-determining status, promised under Article Two of the Treaty of Waitangi."[60] In May 2006 *North and South* featured another cover story on the problem of child abuse, citing the statistic that of "27 OECD countries New Zealand is rated third highest for child homicide through maltreatment."[61]

The article also notes that the Green Party MP Sue Bradford introduced a bill to Parliament "to repeal Section 59 of the Crimes Act, which allows parents to use 'reasonable force' in disciplining their children."[62] A year later, *North and South* again ran a cover story on child abuse, this time focused specifically on Bradford's bill. The discussion focused on a comparison with other countries, including the Netherlands, Sweden, and Ireland, who had recently outlawed the use of "reasonable force" against children. With discussion focused on law reform, the vexed questions of ethnicity and community responsibility disappeared from the public discussion in the media, along with the debates about postcolonial trauma.

Bradford's bill, which many in the media continue to refer to as the "anti-smacking law," was passed but is seen as unpopular with voters. John Key's National government (elected in 2008 and reelected in 2011) has been characterized by tax cuts that benefit the wealthy, leading to a widening gap between rich and poor. In 2009, Christine Rankin, a prominent and outspoken opponent of Bradford's bill, was appointed to the Families Commission. In her August 2010 address to *iwi* leaders, Minister for Social Development Paula Bennett claimed to be "haunted by our neglected and abused children,"[63] once again invoking this trauma in a specifically Māori context. In response, coleader of the Green Party Metiria Tūrei accused Bennett of failing to address Pākehā responsibility for this problem.[64] The voice of Tūria, now in a coalition agreement with the National government, was no longer featured in this dispute. The appearance in July 2011 of the government's Green Paper for Vulnerable Children was greeted by derision by those who saw it as a cynical gesture in an election year while spending cuts on social services and welfare benefits continued. Perhaps the most notable proposal in the Green Paper is mandatory reporting of signs of child abuse by teachers and health professionals, along with greater access to information for police. As in Australia, the right-wing response to child abuse in Indigenous communities is surveillance and punishment with no acknowledgment of social inequalities or injustice.

The ongoing construction of child abuse as a "Māori problem" by politicians and media disregards the social and political contexts of domestic violence—poverty, criminalization, and other forms of disadvantage—and instead invokes the colonial stereotype of the native child who has failed to grow into a full national citizen. This construction is itself abusive insofar as it denies the continued impoverishment of Māori by the social and economic order while blaming them for their violent "nature." There is a systematic violence at work that justifies further cuts in welfare, higher levels of incarceration, and greater powers of state surveillance. Tūria's claims about postcolonial trauma, quickly silenced in public discourse, should continue to reverberate for us if we choose to acknowledge the historical violence of colonization, its perpetuation by political policy and media representation, and the long-term devastation it has unleashed on Indigenous peoples.

Notes

1. Tūria gave her speech to the New Zealand Psychological Conference at Waikato University on August 29, 2000. These passages from her speech contain the references to Post Traumatic Stress Disorder, the Holocaust, the Treaty of Waitangi, colonialism, and domestic violence: "I know that psychology has accepted the relevance of Post Traumatic Stress Disorder. I understand that much of the research done in this area has focussed on the trauma suffered by the Jewish survivors of the holocaust of World War II. I also understand the same has been done with the Vietnam veterans. What seems to not have received similar attention is the holocaust suffered by Indigenous people including Maori as a result of colonial contact and behaviour. The Treaty of Waitangi Tribunal made such a reference in its Taranaki Report of 1996 and I recollect what appeared to be a 'but our holocaust was worse than your holocaust' debate. A debate I must add, I do not wish to enter. The psychologists, Emeritus Professor James and Professor Jane Ritchie, likewise link colonisation with violence. The Native American psychologist Eduardo Duran suggests, in referring to Native Americans, that the colonial oppression since colonial contact needs to be articulated, acknowledged and understood. Professor Mason Durie identifies the onset of colonisation and the subsequent alienation and theft of the land as the beginning of Maori health issues that manifest themselves today—issues that have, as a result of intergenerational systematic abuse, become culturally endemic. Since the first colonial contact much effort has been invested in attempts at individualising Maori with the introduction of numerous assimiliationist policies and laws to alienate Maori from their social structures which were linked to the guardianship and occupation of the land. A consequence of colonial oppression has been the internalisation by Maori of the images the oppressor has of them. . . . I know the psychological consequences of the internalisation of negative images is for people to take for themselves the illusion of the oppressor's power while they are in a situation of helplessness and despair leading to self hatred and, for many, suicide. The externalisation of the self-hatred on the other hand, is seen with the number of Maori who are convicted of crimes of violence and the very high number of Maori women and children who are the victims of violence." The complete text is available at http://www.nzherald.co.nz/nz/news/article.cfm?c_id=!&objectid=149643.

2. This controversy concerns the claim to ownership of the foreshore and seabed by Māori under the terms of the Treaty of Waitangi. Tūria supported the claim that the foreshore and seabed be defined as customary Māori land. Public resistance to this claim led then prime minister Helen Clark to legislate for state ownership. In 2004, the New Zealand Parliament passed the Foreshore and Seabed Act, which gave full ownership to the Crown. In 2011, the National Party government passed the Marine and Coastal Area Act, which repealed the 2004 Act and allowed the right to make property claims through the courts. While the new Act was supported by the Māori Party, this led to a further schism within that party resulting in the departure of MP Hone Harawira and the subsequent formation, under his leadership, of the Mana Party.

3. After some discussion the author and the editors agreed that it was not acceptable to reproduce the photographs that accompanied these texts about the deaths of Māori children. It is common in New Zealand for newspaper and magazine articles and editorials on these cases to reproduce photographs of the deceased children and of those accused of their abuse or murder. The most shocking example is Deborah Coddington's article for *North and South* in February 2000, which included large photographs of the deceased victim's naked body. This chapter argues that this use of photography incorporates the shock and trauma of child abuse into a symbolic violence against Māori in national media and public discourse. The author and editors agreed that out of respect for the dead children and their families, these images would not be reproduced in this collection.

4. See "Editorial and Letters," *Listener,* June 7, 2008, 5–6.

5. Some relevant statistics cited in these articles included the following: in the year ending June 30, 2003, the Department of Child, Youth and Family Services recorded "6519 substantiated abuse cases and 2540 of those were Māori" (V. Larson, "Some Mothers Don't Have It," *North and South,* September 2003, 32); "New Zealand children are killed at the rate of one every five weeks"(ibid., 39); of "27 OECD countries New Zealand is rated third highest for child homicide through maltreatment"(J. Chamberlain, "Our Shame," *North and South,* May 2006: 45).

6. Walter Benjamin, *Selected Writings,* vol. 4: *1938–1940,* ed. Howard Eiland and Michael W. Jennings, trans. Edmund Jephcott et al. (Cambridge, Mass.: Harvard University Press, 1995), 391.

7. By using the term "postcolonial" I do not wish to suggest that the process of colonization is over or of merely historical significance.

8. Kevin Bruyneel, *The Third Space of Sovereignty: The Postcolonial Politics of US-Indigenous Relations* (Minneapolis: University of Minnesota Press, 2007), xvii.

9. Paula Hamilton, "Sale of the Century? Memory and Historical Consciousness in Australia," in *Contested Pasts: The Politics of Memory,* ed. Katherine Hodgkin and Susannah Radstone (London: Routledge, 2003), 140.

10. The *New Zealand Listener* (1939–) is the country's only national weekly that includes television and radio program listings along with in-depth articles on current affairs, entertainment, lifestyle, and other topics.

11. Ross Gibson, *Seven Versions of an Australian Badland* (Brisbane, Australia: University of Queensland Press, 2002), 158–59.

12. "The Crown's Apology to Ngai Tahu," *Dominion,* November 28, 1998, 2.

13. Joanne Black, "Let Us Be Our Own Solution," *Listener,* May 7, 2005, 14.

14. Kimberly Segall, "Postcolonial Performatives of Victimization," *Public Culture* 14, no. 3 (2002): 617–19.

15. Ibid., 618–19.

16. Nancy Bearns, *Framing the Victim: Domestic Violence, Media, and Social Problems* (New York: Aldine de Gruyter, 2004), 3.

17. Ibid., 57.

18. Ibid., 105.

19. Ibid., 130.

20. See the ACP Media website, http://www.acpmedia.co.nz.

21. David McLoughlin, "Killing Our Kids," *North and South,* April 1994, 43.

22. Ibid., 44.

23. Ibid., 46.

24. Ibid., 45.

25. Ibid., 48.

26. Finlay Macdonald, "Bad Times," *Metro,* December 1996, 84.

27. Ibid., 85–87.

28. Ibid., 87.

29. David McLoughlin, "The Rehabilitation of Tania Witika," *North and South,* November 1998, 36.

30. Ibid., 36–37.

31. Ibid., 37.

32. Ibid., 38.

33. Deborah Coddington, "Disciplined to Death," *North and South,* February 2000, 33–34.

34. Ibid., 43.

35. Tāriana Tūria, "A Stress Disorder," *Mana Magazine,* no. 36 (October–November 2000): 64.

36. Ibid., 64.
37. Ibid., 65.
38. Ibid.
39. Ibid., 64.
40. Bruce Ansley, "Tariana Turia Does Not Talk to Bruce Ansley," *Listener,* September 16, 2000, 13.
41. See for example Cathy Caruth, ed., *Trauma: Explorations in Memory* (Baltimore: Johns Hopkins University Press, 1995); Dominick LaCapra, *History and Memory after Auschwitz* (Ithaca, N.Y.: Cornell University Press, 1998); Jill Bennett and Rosanne Kennedy (eds.), *World Memory: Personal Trajectories in Global Time* (Houndmills, U.K.: Palgrave, 2003); Elizabeth Ann Kaplan, *Trauma Culture: The Politics of Terror and Loss in Media and Literature* (Brunswick, N.J.: Rutgers University Press, 2005).
42. Bill Ralston, "Editorial," *Metro,* October 2000, 9.
43. Ibid.
44. Geraldine Johns, "Tangaroa's Story," *Metro,* October 2000, 49.
45. David MacDonald, "Daring to Compare: The Debate about a Māori 'holocaust' in New Zealand," *Journal of Genocide Research* 5, no. 3 (2003): 386.
46. Ibid., 387.
47. Chadwick Allen, *Blood Narrative: Indigenous Identity in American Indian and Māori Literary and Activist Texts* (Durham, N.C.: Duke University Press, 2002), 2.
48. New Zealand Waitangi Tribunal, *The Taranaki Report: Kaupapa Tuatahi* (Wellington: GP Publications, 1996).
49. MacDonald, "Daring to Compare," 389.
50. Ibid., 383.
51. Ibid., 398.
52. Bill Ashcroft, *On Post-Colonial Futures: Transformations of Colonial Culture* (London: Continuum, 2001), 1.
53. Ibid., 112.
54. Eduardo Duran and Bonnie Duran, *Native American Postcolonial Psychology* (Albany: State University of New York Press, 1995), 29.
55. Human Rights and Equal Opportunity Commission, *Bringing Them Home: Report of the National Inquiry into the Separation of Aboriginal and Torres Strait Islander Children from their Families* (Canberra: Australian Government Publication Service, 1997).
56. Chris Cunneen and Terry Libesman, "Postcolonial Trauma: The Contemporary Removal of Indigenous Children and Young People from their Families in Australia," *Australian Journal of Social Issues* 35, no. 2 (2000): 100.
57. Ibid., 102.
58. Ashcroft, *On Post-Colonial Futures,* 36.
59. Ibid., 47.
60. Black, "Let Us Be Our Own Solution," 14.
61. Chamberlain, "Our Shame," 45.
62. Ibid., 46.
63. Paula Bennett, cited in "Iwi Leaders Meeting," http://www.scoop.co.nz/stories/PA1008/S00335/bennett-iwi-leaders-meeting.htm.
64. Metiria Tūrei, cited in "Turei Angered over Abuse Comments," tvnz.co.nz.

3. *Promotional Culture and Indigenous Identity*
Trading the Other

JAY SCHERER

IN 2007, Italian truck manufacturer Iveco, a multinational corporation with little or no connection to the sport of rugby union (or to New Zealand for that matter), became the official global sponsor of the All Blacks. Having won over 75 percent of all rugby matches that they have played since 1903, and having most recently won the 2011 Rugby World Cup—a tournament that was hosted by New Zealand, and, incidentally, relied heavily on elements of Māori culture for promotional purposes—the All Blacks remain the most dominant sports team in the world. Germane to this chapter, the national sport of rugby and the All Blacks are ubiquitous elements of national popular culture and continue to be widely understood and mythologized as central signifiers of dominant understandings of New Zealand identity. With a few glaring exceptions,[1] the All Blacks have been comprised of Māori, Pākehā (white New Zealanders), and, more recently, players of Pacific descent.[2] In this respect, the team's unparalleled sporting successes have provided numerous moments for Māori and Pākehā alike to imagine important points of connection and to celebrate the nation's bicultural identity, most notably through the team's long-standing tradition of performing the "Ka Mate" *haka* (performing art chanted with actions; hereafter referred to as "Ka Mate") prior to each test match.[3]

Since being propelled into the professional era in 1995, the national sport of rugby and the All Blacks have been steadily incorporated into a global promotional culture as the New Zealand Rugby Union (NZRU) and its corporate "partners" (including Iveco and, as of 2012, the multinational insurance corporation, American International Group [AIG]) aggressively pursue new revenue streams via merchandizing, corporate public relations, and cross-marketing on a world scale.[4] It is the uniqueness of the All Blacks (their legendary black jerseys, rich history, and dominance in world rugby) that forms the basis for the NZRU—as the game's governing body—to exclusively extract monopoly rents[5] from various corporate sponsors seeking to appear distinct in their own pursuit of capital accumulation. A corollary of the exponential increase in the global marketing of the All Blacks, however, has been the intensive commodification of Māori culture and "Ka Mate," which now exist as desirable "circuits of promotion."[6]

Figure 3.1. (L–R) Richard Kāhui, John Afoa, Stephen Donald, Richie McCaw, and Keven Mealamu perform the *haka* "Ka Mate" prior to the Scotland versus New Zealand All Blacks rugby match at Murrayfield on October 8, 2008, in Edinburgh. Photograph by Ross Land. Reproduced with permission of Getty Images.

For example, to anoint their sponsorship of the All Blacks, Iveco released three versions of a televised advertisement that aired in Italy, Spain, Great Britain, and New Zealand and featured several All Blacks of Māori and Pacific descent performing "Ka Mate" to equate the power of the All Blacks with the Iveco Stralis (a heavy-duty truck). As the CEO of Iveco explained,

> Iveco and the All Blacks are built the same way . . . the overwhelming way they play and how they put pressure on their opponents. It's also something we pride ourselves on in relation to our latest-generation engines, which out-power all the others, in every category.[7]

Revealing the ongoing erosion of the territorial frontiers and cultural boundaries of the global advertising industry, the Iveco All Blacks campaign, which so heavily commodified "Ka Mate" and Māori culture, was developed and produced by the Italian-based Domino advertising agency. Beyond this, what is important to reemphasize here is the centrality of select aspects of Indigenous culture to what the executives at the NZRU now simply call the All Blacks "brand." This is a brand that is now so popular that it recursively promotes numerous corporations at once (including Adidas, AIG, Coca-Cola, Ford, Steinlager, and Mastercard, among others), through mutually reinforcing public texts that commonly feature "Ka Mate."

The questions that inevitably follow from these developments are many. First, given the sheer growth of the number of sponsors of the All Blacks who utilize elements of Indigenous culture, are Māori afforded similar commercial benefits as those

accrued by various corporations and the NZRU? Second, do these organizations have a broader commitment to Māori culture beyond the commercial/promotional sphere? Or, are the NZRU and its corporate sponsors simply reproducing the long-standing and lucrative practice[8] of what Indigenous theorist Linda Tuhiwai Smith refers to as "trading the Other"?[9] Indeed, for the geographer David Harvey, the expansion of these commercial practices is little more than "accumulation by dispossession":[10] the hallmark of a new imperialism encapsulated in the "marked growth in international interest in 'cultural heritage tourism' and the use of Māori imagery, symbols and designs by a growing number of corporations seeking to gain an edge over competitors by associating their products and services with the 'trendy' and exotic Indigenous brand."[11]

While the broad conditions of cultural and economic globalization have been extensively theorized,[12] there has been little engagement with the various marketing and advertising executives who promote and normalize the commodification of Indigenous culture.[13] It is imperative to engage these cultural intermediaries[14] because of their increasing salience as authorities in shaping consumerist dispositions and their role in consolidating and normalizing the power of the NZRU to accrue monopoly rents from various corporations like Adidas and Iveco that seek to use "Ka Mate" in their advertising product. Moreover, these advertising executives are, like their counterparts in the broader media industry in New Zealand, predominantly affluent Pākehā males[15] who now wield considerable influence over the representation of Māori culture in the global economy.

Consequently, in this chapter I examine the discursive codes of production and the various claims of authenticity and national tradition that are routinely summoned by the cultural intermediaries who produce and regulate the commercial images of Māori culture on behalf of the NZRU and its sponsors. I will argue that the majority of these claims do little more than conceal the grounds upon which the NZRU can continue to extract sizable sponsorship monies from corporations that seek to profit from their commercial association with the All Blacks and "Ka Mate." Moreover, despite declarations of respect for Indigenous culture and the initiation of forms of consultation with some constituencies of Māori, the resulting advertising texts are often little more than racialized spectacles of consumption that produce a specific regime of truth/knowledge about Māori for global audiences. Building on these issues, I then discuss the resulting disjunctures between Western values of exchange, private property, and intellectual property rights, and Māori understandings of history, ownership, and community in relation to debates over who "owns" "Ka Mate," and, in turn, who can profit from Māori culture. This is a reminder that monopoly claims under economic and cultural globalization are as much an "effect of discourse" as they are an outcome of material struggles over various intellectual property rights including a very recent Treaty of Waitangi (see the Introduction to this book) settlement between the Crown and a number of *iwi* (peoples) that has important implications for the commercial use of "Ka Mate."

The Power Relations and "Cultures" of Production

I begin this section by simply noting that the NZRU has deployed a variety of discursive frameworks to downplay the commercial appropriation of "Ka Mate" and Māori culture. Most of these arguments, in fact, take their cue from taken-for-granted understandings of "Ka Mate" as a noncommodified and incomparable symbol of the nation's bicultural identity. As we shall see below, when taken to their logical conclusion, these arguments suggest that "Ka Mate" is no longer distinctly Māori but now simply part of the collective heritage of all New Zealanders and representative of a "whole way of life": a popular assertion that continues to have a substantive impact on the intellectual property rights claims discussed later in this chapter. Here are two instances of such assertions: "I don't think anyone thinks the haka is performed for commercial purposes. If it was ever reduced to that I'm reasonably sure we wouldn't want to perform it"[16]; and "It's not commercial property."[17]

As the above quotes from former NZRU CEO David Rutherford illustrate, the union has publicly argued that, given its unique cultural qualities and heritage status (unlike other products like shirts, shoes, or rugby), "Ka Mate" remains immune to commodification. Rutherford was, in fact, responding to a story[18] which claimed that Māori rugby administrators from the Whakapūmautanga Board (the NZRU's Māori advisory board) were considering charging the NZRU and its sponsor Adidas $NZD1.5 million for the use of Māori imagery including "Ka Mate" in Adidas's "Black" advertising campaign.[19] In his response above,[20] Rutherford alludes to the importance of the language of originality and a host of other discursive shifts that do little more than gloss over the power of the NZRU to extract monopoly rent from corporate sponsors seeking to use "Ka Mate" for commercial purposes. This remains, importantly, a discursive tactic that also works to obfuscate any potential intellectual property rights issues between the NZRU and Māori (i.e., if "Ka Mate" is so distinct and culturally important that it cannot be bought or sold, then there is simply no need to question who owns it or who can profit from it).

Of course, it is precisely the uniqueness of "Ka Mate" that allows the NZRU to derive monopoly rents from corporate sponsors that seek to capitalize through an association with the All Blacks and the team's cultural traditions and long-standing rituals. The NZRU has, most recently, shifted its discursive strategy and now concedes that "Ka Mate" is for sale, but merely as an element of the broader All Blacks brand. Still, this uneasy accommodation does little to conceal the NZRU's expansive promotion and exploitation of "Ka Mate" as part of a commercially oriented and spectacle-driven sporting practice. As the NZRU's marketing and sponsorship manager argued:

> I think the All Blacks brand is made up of so many different components and stories. The Ka Mate haka is a key component of New Zealand history and the history of the All

Blacks, but it is only one component. I sincerely doubt it is the reason that corporations are attracted to the All Blacks, and certainly it is not a core reason out of our current sponsorship group. I mean, if the All Blacks did the haka well but lost every game I don't think they would be with us.[21]

The executive is certainly correct to point to the long-standing success and dominance of the All Blacks as the key drawcard for corporate sponsorship. It seems unreasonable, though, to deny the fact "Ka Mate" now exists as a valuable commodity sign that has been remarkably appropriated as the core element of innumerable advertisements for corporations seeking access to the New Zealand market, and, indeed, the broader global bazaar.[22] For example, in 1999, Adidas released a black-and-white television commercial entitled "Black" that was based entirely around a "Ka Mate" spectacle.[23] According to industry documents, the commercial was produced by advertising agency Saatchi & Saatchi to solely articulate the Adidas brand with "the most powerful and awe-inspiring properties of the All Blacks: the '*haka*' (native Māori war challenge); the raw power/intensity of the game they play—and the powerful colour of black."[24] The commercial featured numerous aspects of Māori culture, including several images of Māori warriors performing "Ka Mate" in unison with the All Blacks.

Although the commercial aired in New Zealand, it was designed as a "primal, scary ad"[25] to reach Adidas's company-wide global target market of fourteen- to twenty-five-year-olds in over seventy countries. "Ka Mate" was not just a component of Adidas's campaign, but the actual "campaign hero" and "core 'thematic' driver for the entire global marketing campaign communication."[26] For example, the commercial's images of the Māori warrior and other aspects of Indigenous culture were also "cut and pasted" into Adidas's online marketing campaign entitled "Beat Rugby."[27] Meanwhile, the NZRU has also made "Ka Mate" available for purchase as a ring tone for mobile phones on allblacks.com.[28] Clearly, in an era of digital capitalism, "Ka Mate" and Māori culture have been continually repackaged and marketed by the NZRU to fully exploit as many ancillary revenue streams as possible. Notably, the NZRU has aggressively pursued these sources of income simply because, in the global economy, its own monopoly position has been increasingly undermined by deep-pocketed clubs in France and England (and indeed other competing codes) that continue to target the best New Zealand players in the professional era.

In light of these developments, various cultural intermediaries have attempted to justify the commodification of "Ka Mate" by suggesting that it is now simply a generic symbol of the All Blacks and New Zealand identity, as opposed to a unique element of Māori culture derived from a specific *iwi*. For example, with respect to producing Adidas's "Black" campaign, Saatchi & Saatchi's creative director and Adidas's marketing manager both noted that they did not hesitate to use "Ka Mate" in commercials because of its historical association with the All Blacks and New Zealand identity. A similar sentiment was expressed by the NZRU's marketing and sponsorship manager who stated that "Ka Mate," in fact, now belonged to all New Zealanders:

> We get rung up the whole time if we will approve the use of the haka, and our answer to
> that is we don't own the haka, we have no right to approve the haka, the haka is unique to
> New Zealand, and not just unique to Māori, unique to New Zealand and New Zealand
> Māori.[29]

This is clearly a self-serving argument in light of the NZRU's intensive commodifica-
tion of "Ka Mate." Indeed, the NZRU strictly guards its role as the "final arbitrator" of the
All Blacks brand to preserve its monopoly position, and, as noted above, acknowledges
that "Ka Mate" is, at the very least, a critical component of the broader brand. It can be
suggested that the NZRU's marketing and sponsorship manager's comments illumi-
nate the extent to which "Ka Mate," a residual cultural element,[30] has been naturalized
as a dominant cultural symbol of the national imaginary that mythically unites Māori
and Pākehā in postcolonial New Zealand via the All Blacks.[31] It is these taken-for-
granted understandings of "boutique multiculturalism,"[32] incidentally, that subtly jus-
tify the ongoing commodification of "Ka Mate" and Māori culture as matters of eco-
nomic and cultural common sense in a market-driven society. That is, if all New
Zealanders own "Ka Mate" as a collective signifier (or if it exists as part of the All Blacks
brand) instead of being an element of Indigenous culture with long-standing links to a
specific *iwi*, it too can be pillaged for commercial purposes. Moreover, when affluent
advertising executives and other Pākehā claim that "Ka Mate" and Indigenous imagery
are part of the All Blacks history or "our" common culture, they are not only dramatiz-
ing their cultural preferences, they are also often being incredibly selective as to when
they identify with and embrace Māori culture: an issue that I will return to in my
conclusion.

 Despite all of this discursive shifting and swaying, it is important to note that each
of these cultural intermediaries was well aware that the commodification of Māori cul-
ture was highly contentious. These developments are an inevitable corollary of a resur-
gence of Māori resistance against neoliberal practices and various historical challenges
against the conversion of elements of Indigenous culture into exclusive private prop-
erty rights. It is within this context that Māori have struggled for "control over how their
taonga [prized possessions] (including, in this context, language, designs, symbols and
knowledge) are used, for what purposes they are used, and by whom are they used."[33]

 In light of this contestation—and contradicting the aforementioned claim that the
NZRU could not approve the commercial use of "Ka Mate"—the NZRU marketing and
sponsorship manager also noted that the union has initiated a commercial *approval*
process and now consults with individuals on the Māori Rugby board with respect to
any commercial activity that features "Ka Mate." Referring specifically to Adidas's
"Black" campaign, he also noted that "Ka Mate" was always treated with "respect" in
any commercial production:

> I can assure you that anything that ourselves or our sponsors have done in a Māori environ-
> ment and as an example in 1999 the "Black" campaign was based around the haka in a team

environment, it wasn't acting as an example, the haka is something that needs a different type of respect . . . it's not something that you act. Every time someone does the haka it is for *real* and Māori [are] consulted on such things.[34]

Adidas's marketing manager used strikingly similar words and noted that, unlike other organizations, Adidas had at least consulted with Māori over the use of the "Ka Mate" *haka* out of respect:

> One word and that's respect, it's very important. . . . The All Blacks have been doing the haka for years and it's part of it. It's like anything, you take sport out of it and you know, it's like political issues and land issues or anything like that and it's just about respect. . . . You know you respect the iwi and the Māori and the tradition of the culture and the haka. So it does come into it, when we are talking about the creative side of things we do factor it in. Hey, some creatives don't involve cultural activity or anything like that.[35]

In perhaps the most extreme example of this trend, a cultural intermediary at Saatchi & Saatchi went to great lengths to inform me that, when producing "Black," the advertising agency not only consulted with the NZRU and Adidas, but also flew in Māori experts from Rotorua and Gisborne (two North Island towns) to perform "Ka Mate" and to ensure respectful and "real" representations of Māori culture.[36] Māori were also consulted on the use of weapons and the warriors who featured in the commercial wore authentic Māori attire. The advertising agency, meanwhile, endeavored to transform the commercial set into a *marae* (land and buildings that Māori affiliate with genealogically), and went to considerable lengths to welcome people on the set in an "appropriate manner."[37]

Despite the claims of respect by various marketing executives and the businessmen who run rugby, it is worth questioning whether these interest groups are committed to Māori culture, the creation of respectful commercial images, and Māori ownership of Indigenous cultural symbols. For example, to augment the commercial spectacle of "Black," the cultural intermediaries at Saatchi & Saatchi layered the advertising text with a range of sound and visual effects, and also added a simulated *moko* (tattoo) to the main warrior. The technical manipulation of skin color has, as Paul Gilroy notes, clearly added a "conspicuous premium on today's planetary traffic in the imagery of blackness" that "supplies the signature of a corporate multiculturalism."[38] Building on Gilroy's argument, it can be suggested that these types of marketing strategies represent a new stage in the types of cultural liberties that are being taken by advertisers who are increasingly deploying simulated *moko* to augment their commercial productions. Here it is worth noting that numerous cultural intermediaries now consider visual spectacle to be an increasingly important signifier of what qualifies as "good advertising."[39] These types of spectacular advertisements allow corporations to "capture" media-savvy and discerning audiences (the audience commodity

that advertising agencies claim to sell to their client companies), but they also bestow credibility, distinction, and awards—the ultimate accolade in the advertising industry—upon the cultural intermediaries who create them.[40]

The fabricated *moko* that featured so prominently in the Adidas commercial was, however, greeted with derision from some Māori, thus illuminating the inevitable limitations of advertising consultation processes and the claims of corporate interest groups who strive to be "real" and "authentic" while operating according to non-Māori cultural understandings and frameworks of knowledge. For example, after the release of "Black," attorney Māui Solomon argued that it was inappropriate for elements of Indigenous culture to have been haphazardly simulated and inserted into commercial productions that were controlled by non-Māori, and constituted by Western understandings of intellectual property that subsume communal identity under categories of possessive individualism:

> The tā moko is not just the individual lines on the face, it tells a whole story of that person's heritage, of the marae of the tribe . . . it's part of that collective right. . . . The person carries all of that mana [power and authority], all of that heritage, all of that tradition. So, it is wrong for me to go and try and copyright an ancestor figure that's been carved on a tree because I've got a company and I want to use it on a logo because that belongs to my collective, it belongs to my *iwi*.[41]

Solomon's criticism of the simulated *moko* also astutely captures the schizophrenic conditions of late capitalism, and the breakdown in the signifying chain that constitutes meaning; in this instance the simulation of a *moko* that never actually existed, and now only exists as "phantom content"[42] in a commercial for Adidas.

These issues raise other key questions. For example, who exactly is to be consulted over the use of Indigenous imagery for a commercial that merely sutures together various identities and "all the styles of the past"?[43] At what point do consultations occur during production processes that endeavor to convey an "authentic" Indigenous identity through the "glossy qualities of the image"?[44] Whose aesthetic interpretation of Indigenous culture counts? Given that these commercial images are simulations of a past that never existed, are these consultations merely token gestures so that commercial interest groups and the NZRU can appear to be politically correct as they accumulate wealth via the appropriation/dispossession of preexisting elements of Indigenous culture? Or, do Māori and other Indigenous groups have the final say in terms of the commercial use of cultural imagery and how they are represented so as not to reproduce a stereotypical discourse of racial primitivism?[45] And, importantly, given the poverty of many Indigenous communities—the residue of colonization and the more recent transfer of public assets to private interests under neoliberalism (both instances of accumulation by dispossession)—who profits from the commodification of Indigenous culture besides a transnational corporation and a small segment of the local bourgeoisie?

Consuming "Ka Mate" and the Politics of Intellectual Property Rights

The benefits of these commercial products are, of course, far from widely distributed. It is somewhat unsurprising, then, that award-winning commercials like "Black"—a commercial that emphasized the uniqueness and "authenticity" of "Ka Mate" for Adidas—have angered many Māori and Pākehā and spurred resistance to the ongoing commodification and exploitation of Indigenous culture for the economic benefit of others. In relation to these developments, it should also be noted that there have also been substantial concerns over the commercial misrepresentation of "Ka Mate" and Indigenous culture. For example, a number of commentators criticized the pseudo-historical depthlessness and superficiality of "Black," and its representation of "Ka Mate" as a "blunt instrument of aggression"[46] and as a war dance.[47] These issues have not been lost on some high profile ex–All Blacks, including Anton Oliver and Byron Kelleher, who have recently lamented that, given its extensive commodification, "Ka Mate" now exists as little more than a publicity stunt, and has lost its *mana*.[48] Indeed, the obvious contradiction here is that, as "Ka Mate" has become more and more mar-ketable, it has also become less unique and less "special": a trend that may eventually erase any monopoly advantages for the NZRU as it continues to leverage "Ka Mate" for various sponsors of the All Blacks.

Meanwhile, the following editorial in a local newspaper indicted Adidas's exploita-tion of "Ka Mate," while lambasting the valorization of Indigenous identity by some Pākehā as hypocritical in light of a resurgence of right-wing politics in New Zealand:

> German company Adidas is cashing in most on the trend with a monochrome television advertisement featuring the All Blacks haka, a Māori warrior, and lots of that colour. Even the haka is done under the lights at night to heighten the black effect. . . . It is a total sell-out of a proud tradition . . . which is a shame because the haka is increasingly a key part of New Zea-land's identity . . . and Pākehās usually lead the way. . . . Few Pākehā identify themselves closely with Māori culture and some are unnerved by the Māori renaissance being brought about through [increased Māori representation in Parliament] and Treaty settlements. But when it's time to celebrate this country's distinctiveness and pride, we all tend to turn to the haka.[49]

These comments are noteworthy on any number of levels. First, they point to the selective incorporations of elements of Māori culture as national symbols, while other aspects of Indigenous identity are shunned or marginalized by some Pākehā altogether. For example, Don Brash, ex-leader of the National Party and author of the infamous Orewa speech,[50] once criticized the use of *pōwhiri* (a Māori welcoming cer-emony) at official state functions as being an uncivilized and inappropriate way to greet foreign dignitaries.[51] Second, and related to this latter point, the comments also encompass a broad critique of inequitable race relations in New Zealand, and the cor-porate and state policies that sustain them. Finally, what is also operating behind these

declarations of public anger is a valuable set of critical ideas, including the under-
standing that some areas of life are contaminated when they are driven purely by the
logic of economic growth, and that some cultural practices need to be afforded protec-
tion, and, beyond this, ought not to be for sale to the highest corporate bidder.

It is precisely these types of critical questions that have produced a renewed sense
of urgency to ensure the legal protection and identification of Māori cultural and intel-
lectual property rights in the context of a much larger historical struggle—a struggle
without end, to use Ranginui Walker's words[52]—against accumulation by disposses-
sion. For example, in June 2000, following the release of Adidas's "Black" commercial,
it became public knowledge that members of Ngāti Toa (a lower North Island *iwi*) had
formally applied to trademark Te Rauparaha's "Ka Mate" "to protect it as identifiable
cultural property . . . that belongs to the collective group of its origins."[53] The initiation
of these types of legal proceedings, in fact, speaks to the pressures facing many Indig-
enous groups around the world to articulate their political concerns in a manner and
language that power understands: a difficult task given the conceptual limitations and
colonial foundations of Western concepts of private property.[54] Here it is important to
note that the main intention of Ngāti Toa, who regards "Ka Mate" as a gift to the nation,
was to assert the tribal origins of "Ka Mate" and protect it from unauthorized commer-
cial exploitation rather than profit from its use.[55] Indeed, Ngāti Toa confirmed that if its
application succeeded, it would continue to allow the All Blacks to perform "Ka Mate,"
but wanted to be consulted with respect to further commercial activities. This is a key
point because, while some Māori were involved with the production of "Black," mem-
bers of Ngāti Toa were not consulted by the NZRU, Saatchi & Saatchi, or Adidas.

Predictably, the trademark application produced heated dialogue including the
typical arguments leveled by many on the right who claim that these types of initia-
tives are little more than attempts by Māori to "cash in." These sentiments have been
fanned by speculative media reports like the one noted in the previous section, which
suggested that Māori rugby administrators from the Whakapūmautanga Board were
seeking substantive reimbursement from the NZRU and Adidas for the commercial
use of "Ka Mate." Clearly, though, Ngāti Toa's attempts to trademark "Ka Mate" are not
related to establishing monopoly rights of private property though commercial law
(e.g., like those pursued by pharmaceutical companies seeking to establish property
rights over genetic material). Beyond this, at least two competing arguments have
emerged over the "Ka Mate" trademark debate. Intellectual property lawyers have
suggested that it is simply impossible to trademark "Ka Mate" because, unlike con-
temporary trademarked brands used to differentiate products, "Ka Mate" exists as a
song, chant, or a challenge.[56] On the other hand, some patent lawyers have argued
that the trademark application is appropriate because the All Blacks are now an inter-
national business and the *haka* is a distinct part of their performance and "product."
However, these lawyers have also conceded that "Māori notions of 'ownership' of a
taonga . . . such as the *haka* find no easy niche in our existing legislation, for example

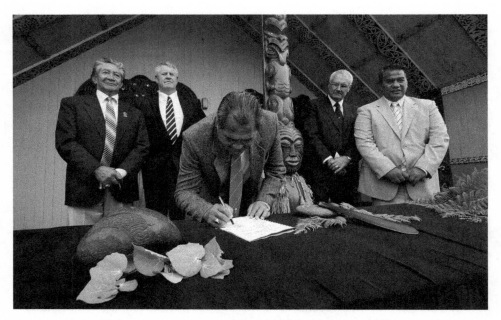

Figure 3.2. Mathew Solomon signs the agreement while (L–R) Ariki Wineera, Steve Tew, Mike Eagle, and Taku Parai look on during a signing ceremony to announce the agreement between Ngāti Toa and the New Zealand Rugby Union at Takapuwahia Marae on March 17, 2011, in Porirua, New Zealand. Photograph by Hagen Hopkins. Reproduced with permission of Getty Images.

copyright or trademarks."[57] This last comment is exceedingly important in the context of debates over intellectual property rights of Indigenous cultures, and the inadequacy of the Western intellectual property rights system to protect and identify Māori culture and cultural rights as embodied in the Treaty of Waitangi.

These issues initially plagued Ngāti Toa's trademark application, and by September 2004, reports had emerged that the *iwi*'s bid to trademark "Ka Mate" was on the verge of failing due to lack of proof that the claimants had maintained control over its use and because "Ka Mate" "may now simply belong to everyone."[58] Following this report, in July 2006, Ngāti Toa's claim was turned down by the Intellectual Property Office of New Zealand, which concluded that "Ka Mate" no longer represented a particular *iwi* but all of New Zealand. Nevertheless, the publicity generated by these issues galvanized other initiatives relating to intellectual property rights and Māori culture, including the Wai 262 claim that was filed by representatives of *iwi* groups in 1991.[59]

Unsurprisingly, Māori continues to vigilantly police the commercial exploitation of "Ka Mate," and other cultural lore by local and global corporations. In 2001, for example, Lego withdrew its "Bionicle" range of toys based on Māori culture and knowledge following objections from three Māori tribes represented by Māui Solomon. Lego had actually copyrighted specific Indigenous words. After sending a representative to New Zealand, Lego is now planning to work with Māori to draft guidelines on how

to use customary knowledge. Other transnational corporations including Sony, TechnoMarine, Ford, Fischer Skis, among others, have used Māori designs, names, and imagery to market their brands and products.[60] In perhaps the most extreme example, in 2002 a German company registered a trademark over the Māori and Polynesian name "Moana" and legally threatened Moana Maniapoto, a New Zealand and Māori performing artist, "for daring to use her own name, Moana, on a CD of the same name, which was for sale in Europe."[61] In a similar vein, *haka* have been exploited by corporations including Williams Lawson's Whisky (owned by Bacardi-Martini), Italian car company Fiat, and most unceremoniously by Vodka Reef in a commercial where bikini-clad women perform a *haka* and encourage consumers to drink the beverage and "go native."

The debates over intellectual property rights and Indigenous culture have, however, culminated in several significant victories for Māori. In February 2009, a substantial and broad Treaty deal officially recognized the cultural significance of "Ka Mate" for Ngāti Toa, and finally acknowledged its authorship by Te Rauparaha. Once again, it is important to note that Ngāti Toa have no intentions of charging royalties or vetoing any performances of "Ka Mate" by ordinary New Zealanders, including the All Blacks, but want to prevent further misappropriation and any culturally inappropriate use of that specific *haka*. The most significant development, though, occurred in 2012, when Ngāti Toa won a $NZD70.6 million Treaty of Waitangi settlement that officially recognized Te Rauparaha as the composer of "Ka Mate."[62] As a result of this ruling, Ngāti Toa must be recognized and identified in any commercial use of the "Ka Mate," a development that may force the NZRU to acknowledge the *iwi*'s ownership of "Ka Mate" (a move that the NZRU has been reluctant to do), and introduce a more robust consultation process with respect to its commercial use.

Conclusion

In summing up, I want to return to a point raised in the introduction to this chapter about the multifaceted commercial value of "Ka Mate" in the vortex of signs in contemporary global promotional culture. For example, Iveco's sponsorship of the All Blacks has seemingly extended well beyond a simple "partnership" between the NZRU and a transnational corporation. More specifically, in 2007, various aspects of Māori culture, including "Ka Mate," were central to the Notte Bianca (an annual all-night cultural festival) hosted in Rome to promote not only Iveco, but also the All Blacks and New Zealand as a "brand state"[63] in the context of uneven geographic development and the intense competition for mobile capital and tourists. An Iveco press release noted:

> Iveco and New Zealand's Embassy in Rome will lead the public all the way to New Zealand, accompanied by the Haka dance that will introduce the Māori cultural identity. . . . In the

collective ritual of the Haka dance, Iveco will join the Māori people in confirming the values (Commitment, Reliability, Performance and Team Spirit) that it shares with the New Zealand rugby team, the All Blacks. . . . During the Haka dance, the streets of Rome will become a marae, the traditional open-air space in which social ceremonies are held. The shouts and foot-stamping will reaffirm the endurance of the Māori cultural heritage; watching this spectacle . . . onlookers will witness an identity and values whose power remains undiminished even in today's world.[64]

These developments, of course, speak to the continued commercial value of elements of Māori culture (now articulated as "collective symbolic capital") for a host of interest groups (including the state) that seek to capture monopoly rent within an expansive global promotional culture.[65]

I have also noted, though, that the commodification of "Ka Mate" and Indigenous culture in late capitalism—the expansion of the long-standing historical practice of "trading the Other"—has not developed without resistance. In this respect, a number of oppositional groups have brought a sense of cultural form and "legitimate practice" from other places in the social formation—places represented by other classes, and, most obviously, differing ethnic groups—to challenge the preferred meanings, structures, and disciplines of advertising specifically, and the culture and economic pressures of globalization, more generally. As noted earlier, these groups have questioned whether dominant interests like the NZRU, Adidas, and the bourgeois state are sincerely committed to Māori culture and the resolution of long-standing inequalities in New Zealand. Or, to paraphrase bell hooks,[66] is Indigenous culture now primarily thought of along promotional lines, as a "product" or the spice and seasoning of various branding initiatives to be sold to potential investors, consumers, and affluent tourists around the world?

For example, despite the NZRU's relentless promotion of "Ka Mate" and its extraction of monopoly rents, it has been quick to abandon other, less profitable, long-term associations with Māori culture. Here I am referring to the NZRU's decision to discard the Māori rugby team for the 2009 international season as a cost-saving measure. Of course, prior to this decision the Māori rugby team had been radically transformed by the NZRU into a "farm" team to support the development of future All Blacks, and even the "maintenance" of former All Blacks like Christian Cullen.[67] For much of their history, the Māori rugby team bestowed honor for the Māori community because of their success against the best international teams in the world, and also because the team existed as a powerful site for the affirmation, and indeed celebration, of Māori culture. However, in the context of late capitalism, it appears that the meanings and traditions of the Māori rugby team—like so many other elements of Indigenous culture—threaten to be subsumed by the language and discourse of promotion and reduced to the marketing of nostalgia.

Notes

1. The NZRU capitulated to the South African Rugby Board and sent white-only All Black teams to South Africa in 1928, 1949, and 1960. Beyond these examples, there have been rare moments such as the bitterly divisive 1981 South African Springbok tour of New Zealand, where the hegemonic currency of rugby and the All Blacks has been temporarily devalued.

2. While New Zealand rugby continues to incorporate the athletic labor of a growing number of Pacific rugby players in the professional era, the dominant bicultural understanding of the nation's identity may work, at times, to denigrate these athletes as "others" or "immigrants." See Andrew Grainger, "From Immigrant to Overstayer: Samoan Identity, Rugby, and Cultural Politics of Race and Nation in Aotearoa/New Zealand," *Journal of Sport and Social Issues* 30, no. 1 (2006): 45–61.

3. There are many types of *haka*, which is the generic name for all forms of dance or ceremonial performances involving movement within Māori culture (Wira Gardiner, *Haka: A Living Tradition* [Auckland: Hodder Moa Beckett, 2001]). However, globally, the most visible is the "Ka Mate" *haka* which is performed by the All Blacks prior to international rugby matches. The "Ka Mate" was composed by Chief Te Rauparaha while fleeing and seeking the protection of chief Te Wharerangi after being ambushed by warriors of Ngāti Te Aho who were seeking revenge for earlier killings. Te Wharerangi hid Te Rauparaha in a kumara pit while Te Wharerangi's wife, Te Rangikoaea, sat over its entrance. The warriors pursuing Te Rauparaha soon arrived and began performing chants to locate and paralyze their victim. However, their chants were neutralized by the genitals of Te Rangikoaea. While hiding, Te Rauparaha contemplates his fate and the conversation between his pursuers and Te Wharerangi. He whispers to himself: "Aha ha. Ka mate, ka mate. Ka ora, ka ora. Ka mate, ka mate," or "I die, I die. I live, I live. I die, I die." Following the departure of his pursuers, Te Rauparaha exclaims: "Ka ora, ka ora. Tenei te tangata puhurupuhuru nana nei I tiki mai whakawhiti te ra," or "I live, I live. For this is the hairy person who has fetched the sun and caused it to shine again." As he takes his first steps out of the pit he exclaims: "Hupana, kaupane; Whiti te ra": "Spring up the terrace; the sun shines" (translated by Kāretu, *Haka*). Tīmoti Sam Kāretu, *Haka! The Dance of a Noble People* (Auckland: Reed Books, 1993).

4. Wayne Hope, "Whose All Blacks?," *Media Culture & Society* 24, no. 2 (2002): 235–53; Jay Scherer and Steve Jackson, *Globalization, Sport, and Corporate Nationalism: The New Cultural Economy of the New Zealand All Blacks* (Oxford: Peter Lang, 2010).

5. David Harvey, "The Art of Rent: Globalization, Monopoly and the Commodification of Culture," in *Socialist Register 2002*, ed. Leo Panitch and Colin Keys (London: The Merlin Press, 2001), 93–110.

6. David Whitson, "Circuits of Promotion: Media Marketing and the Globalization of Sport," in *Mediasport*, ed. Lawrence Wenner (London: Routledge, 1998), 57–72.

7. "Iveco Becomes New All Blacks Global Sponsor," allblacks.com website, https://www.allblacks.com/index.cfm?layout=displayNews&newsArticle=5324.

8. The commercial trading of the Other clearly has deep roots in colonialism and conquest in a variety of contexts. For example, in the United States, the remarkable abundance of American Indian and Polynesian imagery, and the ubiquity of black servants in the advertising and marketing of consumer goods at the turn of the twentieth century was a powerful site for cultural producers to mark their own civilization (Rosemary Coombe, *The Cultural Life of Intellectual Properties: Authorship, Appropriation and the Law* [Durham, N.C.: Duke University Press, 1998]).

9. Linda Tuhiwai Smith, *Decolonizing Methodologies* (Dunedin, N.Z.: Otago University Press, 1999).

10. David Harvey, *The New Imperialism* (Oxford: Oxford University Press, 2003).

11. Māui Solomon, "A Long Wait for Justice," in *Resistance: An Indigenous Response to Neoliberalism,* ed. Maria Bargh (Wellington: Huia Publishers, 2007), 80.

12. David Harvey, *The Condition of Postmodernity* (Oxford: Blackwell Publishers, 1990); Fredric Jameson, *Postmodernism, or the Cultural Logic of Late Capitalism* (London: Verso, 1991).

13. I draw heavily from interviews conducted with the marketing and sponsorship manager of the NZRU, Adidas's marketing manager, and advertising creative at Saatchi & Saatchi.

14. Pierre Bourdieu, *Distinction: A Social Critique of the Judgement of Taste* (London: Routledge, 1984).

15. Claudia Bell, "All We Need to Know because TV Tells Us So," in *New Zealand Television,* ed. John Farnsworth and Ian Hutchison (Palmerston North, N.Z.: Dunmore, 2002), 21–30.

16. "We Won't Pay to Do the Haka—Union," *Dominion,* June 12, 2000, 32.

17. J. Milne, "Tribe Applies for Trademark on All Blacks Haka," *Dominion,* June 13, 2000, 1.

18. Neil Reid, "$1.5m for Haka," *Sunday Star Times,* June 11, 2000, 1.

19. The "Ka Mate" *haka* fee plan was eventually denied by Whakapūmautanga chairman Tom Mulligan.

20. For example, even prior to the NZRU's embracement of full professionalism in 1995, "Ka Mate" featured prominently in its "Stand by Me" commercial that was released in 1987 (Nick Perry, *The Dominion of Signs* [Auckland: Auckland University Press, 1994]). Indeed, "Ka Mate" was initially promoted as part of the broader racialized commercial spectacle of early overseas rugby tours and remains part of the overall mystique of the All Black brand.

21. Personal communication.

22. Jay Scherer and Steve Jackson, "Cultural Studies and the Circuit of Culture: Advertising, Promotional Culture, and the New Zealand All Blacks," *Cultural Studies—Critical Methodologies* 8, no. 4 (2008): 507–26.

23. "Black" opens with a shot of bubbling thermal hot springs common to Rotorua: a popular tourist destination in New Zealand. The black-and-white images are accompanied by an eerie audio and drumbeat, signifying an impending and potentially fearful event. In the first scene a *tekoteko* (a carved figure), which represents a well-known or significant ancestor of an *iwi* or *hapū* (clan), is visible at the side of the thermal pool. The commercial immediately cuts to a misty image of five advancing Māori warriors, presumably a *tauā* (hostile expedition or army) given the presence of *taiaha* (a weapon of hard wood having one end carved in the shape of a tongue with a face on each side and adorned with a fillet of hair or feathers, the other being a flat, smooth blade) and *patu* (club used as a weapon). The commercial then cuts to a close-up frame of the All Blacks running: the image is cropped to show only the players' legs and the ever-present Adidas logo on their socks. The viewers are presumably supposed to associate the initial image of the advancing Māori warriors with the following image of the All Blacks running to engage the opposition. The commercial shifts to a Māori warrior with full facial *moko,* dressed only in a *piupiu* (grass skirt) and holding a *taiaha.* The warrior screams in rhythm with the opening line of the "Ka Mate" *haka* as the commercial switches to an image of 1999 New Zealand captain Taine Randell leading the All Blacks in "Ka Mate." The commercial continues with interwoven shots of Randell and the Māori warrior as they progress through the *haka.* Such an aesthetic is clearly designed to equate the past chief/warrior leading the *haka* and his warriors into battle with the then Māori captain of the All Blacks leading his team into their sporting battle/contest. The commercial quickly cuts to an aerial shot of Eden Park in Auckland and the capacity crowd, zooming in on the All Blacks as they join Randell in performing the *haka* in front of the opposing Australian Wallabies. We are then shown a pastiche of images from the rugby match featuring mostly high impact collisions and tackles that are dramatized with sound effects. Intertwined

with these images are shots of the Māori warrior performing the *haka* in rhythm with the All Blacks, with an emphasis placed on Randell and Kees Meeuws: both are of Māori descent and, especially Meeuws, embody extremely muscular and hypermasculine rugby players. With the final line of the *haka*, the players jump in the air in unison while the commercial focuses on blond-haired All Black icon Jeff Wilson. The commercial then cuts to a black image with the Adidas slogan "forever sport" displayed and then quickly to two shots of Randell and Meeuws glaring intensely at the opposition following the completion of the *haka*. The commercial concludes with a final image of the Adidas logo.

24. Adidas, "The Adidas 1999/2000 All Blacks Sponsorship," unpublished manuscript, Wellington, 2000–2001.

25. "Primal Team," *AdMedia*, October 1999, 22.

26. Adidas, "The Adidas 1999/2000 All Blacks Sponsorship."

27. Jay Scherer, "Globalization, Promotional Culture and the Production/Consumption of Online Games: Engaging Adidas's Beat Rugby Campaign," *New Media and Society* 9, no. 3 (2007): 475–96.

28. Jay Scherer and Steve Jackson, "Producing allblacks.com: Cultural Intermediaries and the Policing of Electronic Spaces of Sporting Consumption," *Sociology of Sport Journal* 25 (2008): 243–62.

29. Personal communication.

30. Raymond Williams, *Marxism and Literature* (Oxford: Oxford University Press, 1977).

31. Lynne Star, "'Blacks Are Back': Ethnicity, Male Bodies, Exhibitionary Order," in *Masculinities in Aotearoa/New Zealand,* ed. Robin Law, Hugh Campbell, and John Dolan (Palmerston North, N.Z.: Dunmore Press, 1999), 229–50. It is also important to note that many Māori are divided over the place and acceptability of "Ka Mate" in contemporary New Zealand society. For example, members of the South Island *iwi,* Kāi Tahu, consider "Ka Mate" to be deeply offensive because Te Rauparaha and his armies slaughtered their ancestors. Gardiner recounts a recent story of one individual from a North Island university group who mistakenly performed "Ka Mate" while staying overnight at a Kāi Tahu *marae.* As soon as he began all the Kāi Tahu leaders stood up and said: "E tau! E tau!" ("Sit down! Sit down!") (Gardiner, *Haka,* 63).

32. Stanley Fish, "Boutique Multiculturalism, or Why Liberals Are Incapable of Thinking about Hate Speech," *Critical Inquiry* 23, no. 2 (1997): 378–86.

33. Solomon, "A Long Wait for Justice," 80–81.

34. Personal communication; emphasis added.

35. Personal communication.

36. Saatchi & Saatchi held auditions for the warriors; the main warrior was a policeman from Rotorua and a member of the Rotorua Māori culture group Ngāti Rangiwewehi.

37. Personal communication.

38. Paul Gilroy, *Against Race* (Cambridge, Mass.: Harvard University Press, 2001), 21.

39. Robert Goldman and Stephen Papson, *Sign Wars: The Cluttered Landscape of Advertising* (New York: Guilford Press, 1996).

40. Jay Scherer and Steve Jackson, "Sports Advertising, Cultural Production and Corporate Nationalism at the Global-Local Nexus: Branding the New Zealand All Blacks," *Sport in Society* 10, no. 2 (2007): 268–84.

41. Solomon cited in Steve Jackson and Brendan Hokowhitu, "Sport, Tribes, and Technology," *Journal of Sport and Social Issues* 26, no. 2 (2002): 136.

42. Jean Baudrillard, *Simulations* (New York: Semiotext(e), 1983), 80.

43. Jameson, *Postmodernism,* 18.

44. Ibid,, 19.

45. Brendan Hokowhitu, "Tackling Māori Masculinity: A Colonial Genealogy of Savagery and Sport," *The Contemporary Pacific* 16, no. 2 (2004): 259–84; Brendan Hokowhitu, "Early Māori Rugby and the Formation of Traditional Māori Masculinity," *Sporting Traditions* 21, no. 2 (2005): 75–95; Melanie Wall, "Stereotypical Construction of the Māori 'Race' in the Media," *New Zealand Geographer* 53, no. 2 (1997): 40–45.

46. C. Laidlaw, "Haka in Danger of Being Devalued," *New Zealand Herald,* October 2, 1999, S1.

47. T. Anga, "Meet the Man behind the Moko," *Waikato Times,* September 11, 1999, 1; L. Salas, "An End to Adverts," *Dominion,* November 4, 1999, 8.

48. This was, in fact, one of the reasons why the All Blacks introduced the "Kapa o Pango" (line—as in rank—of blacks) *haka* (composed by Derek Lardelli of Ngāti Porou) in 2005. The new *haka,* however, was not without controversy, especially because it featured a movement that was interpreted by many observers as a "throat slitting" gesture. For Lardelli, though, the new *haka* was not a war challenge and the controversial gesture was intended to signify drawing of *hauora,* the breath of life into the heart and lungs. Still, for some, including *Sydney Morning Herald* columnist Paul Sheehan, the All Blacks performance of "Kapa o Pango" was simply a reminder that the "Maoris [*sic*] once engaged in unspeakable conduct." It is, ironically, this misinterpretation of "Kapa o Pango" as too "savage" for public consumption that may prevent it from being incorporated as a national symbol and further commodified. See "Australian: Throat Slitting Haka Has No Place," http://www.stuff.co.nz/sport/rugby/5818998/Australian-Throat-slitting-haka-has-no-place.

49. "Black Is Our New Black," *Waikato Times,* September 18, 1999, 6.

50. A speech on nationhood delivered by Brash at a meeting of the Ōrewa Rotary Club, Auckland, in January 2004 (see the Introduction to this book).

51. P. Crewdson, "Too Much Culture, Says Brash," http://www.nzherald.co.nz/nz/news/article.cfm?c_id=1&objectid=10343937.

52. Ranginui Walker, *Ka Whawhai Tonu Mātou: Struggle without End* (Auckland: Penguin Books, 1990).

53. Milne, "Tribe Applies for Trademark on All Black Haka," 1.

54. Rosemary Coombe, *The Cultural Life of Intellectual Properties* (Durham, N.C.: Duke University Press, 1998).

55. B. Ruth, "Ngati Toa's Haka a Gift to Nation Says Kaumatua," *Evening Post,* June 13, 2000, 3. These are exceedingly complex issues, and divisions exist within Ngāti Toa over the claim. As Matiu Rei, executive director of the Ngāti Toa *iwi* authority Te Rūnanga o Toa Rangatira, noted: "Even within Ngāti Toa there is dissent over whether it would belong to the descendents of Te Rauparaha or the tribe as a whole. Not everybody (in the tribe) is a descendent of Te Rauparaha" (T. Ross, "Bid to Trademark Ka Mate Looks Set to Fail," *Sunday Star Times,* September 12, 2004, A1).

56. J. Milne, "All Black Haka Trademark Move 'Could Succeed,'" *Dominion,* June 15, 2000, 3.

57. Ibid.

58. Ross, "Bid to Trademark Ka Mate Looks Set to Fail."

59. Including Ngāti Kurī, Te Rarawa, Ngāti Wai, Ngāti Porou, Ngāti Kahungunu, and Ngāti Koata. Solomon, "A Long Wait for Justice." In short, the claimants sought *tino rangatiratanga* (self-determination) with respect to Indigenous flora and fauna, Ngāti symbols and designs, and their use and development within and outside the commercial sphere.

60. Solomon, "A Long Wait for Justice."

61. Ibid., 81.

62. "Ngāti Toa Settlement Gives Islands, Haka Right," http://www.stuff.co.nz/national/politics/7580015/Ngati-Toa-settlement-gives-islands-haka-right.

63. Peter van Ham, "The Rise of the Brand State: The Postmodern Politics of Image and Reputation," *Foreign Affairs* 80, no. 5 (2001): 2.

64. "Iveco and the Māori Haka Dance during Rome's All-Night Event," Iveco website, http://web .iveco.com/en-us/press-room/release/Pages/IvecoandtheMaoriHakadanceduringRome%E2 %80%99sall-nightevents.aspx.

65. See Andrew Wernick, *Promotional Culture: Advertising, Ideology and Symbolic Expression* (London: Sage, 1991).

66. bell hooks, *Black Looks: Race and Representation* (Boston: South End Press, 1992).

67. Brendan Hokowhitu and Jay Scherer, "The Māori All Blacks and the Decentering of the White Subject: Hyperrace, Sport, and the Cultural Logic of Late Capitalism," *Sociology of Sport Journal* 25 (2008): 187–205.

4. *Viewing against the Grain*

Postcolonial Remediation in *Rain of the Children*

KEVIN FISHER AND BRENDAN HOKOWHITU

IN THE CONTEMPORARY POSTCOLONIAL ENVIRONMENT, any non-Indigenous filmmaker who undertakes the task of engaging with Indigenous material must reconcile their methods with Homi Bhabha's description of the construction of the colonized by the colonizer as "a site of dreams, images, fantasies, myths, obsessions and requirements."[1] Often, as in the case of Pākehā (white New Zealander) filmmaker Vincent Ward's *Rain of the Children* (2008),[2] this takes shape as an ethical imperative to reflexively fold a critical interrogation of the filmmaker's own practices of representing the Other into the body of the film.

While Bhabha recognizes that encounters with the colonized "destabilize and interrogate notions of cultural identity" and can thus "challenge the notion of the absolute hegemony of the colonizing power,"[3] the prevailing tendency in films on Indigenous subjects produced by non-Indigenous filmmakers is toward the production of a kind of third culture that acknowledges and incorporates this tension, but ultimately in the attempt to stabilize the unstable by drawing the incomprehensibility of Indigenous *difference* within understandable conventions of representation and narrative. Against the grain of what might be called this neocolonialist paradigm, we will analyze *Rain of the Children* as an earnest—if at times inconsistent—attempt to self-consciously defy rather than satiate the imagined oppressive discursive repository that Bhabha articulates.

This chapter will explore how *Rain of the Children* foregrounds Ward's remediation (re-viewing and re-narrating) of his earlier film, *In Spring One Plants Alone* (1980),[4] shot when he was just twenty years old and documenting his relationship with an elderly Tūhoe (Central North Island *iwi*) woman, Puhi (who died in 1980) and her adult son, Niki with whom Ward lived intermittently for two years in the remote rural areas of Te Urewera. Of central importance is how Ward relates his own story of making his original film to the Indigenous story and hidden history that he inadvertently reopens, without at first comprehending, and then methodically reconstructs through interviews with Tūhoe elders and elaborate historical reenactments.

One of the predominant criticisms of films with Indigenous subject material (in New Zealand at least), is that while they often refract the post-colonial *facticity* of

Indigenous lives, such as social degeneracy (*Once Were Warriors*, 1994)[5] and cultural decay (*Whale Rider*, 2002),[6] the genealogy of colonization inherent to the "cultural degeneracy" theme remains untold. The global audience, particularly in the case of *Whale Rider*, is left to celebrate the "enlightenment" of a backward paternalistic culture through feminized empowerment.[7] Although, like *Whale Rider*, *Rain of the Children* draws attention to generational and gender conflicts, it does so within the context of the disruptive effects of colonization, not as a means to bypass or supervene them. Rather, the path to understanding the enigma at the center of *Rain of the Children* must pass through the experience of colonization and state violence. Through remediated layerings of his own earlier films, reenactments, archival photos and film, and interviews, Ward recomplicates the colonial history that Niki Caro oversimplifies in *Whale Rider* through its reduction to frames cognizable to the Western episteme.

Implicit in Ward's filmmaking is a methodology that signals an ethical approach to treating Indigenous subjectivities by non-Indigenous filmmakers. Significantly, he seeks advice from a number of important Tūhoe *kaumātua* (elders) such as Te Wharehuia Milroy and Pou Temara, other community leaders, and people with close familial ties to Puhi and Niki. In demonstrating how their counsel instructs Ward's reexamination of his earlier film, he does not merely pay lip service to "native informants" in the manner of Caro, for example, who in part established the "authenticity" of *Whale Rider* via the supposed backing of the local Māori community.[8] Instead, Ward casts himself as a sort of nomadic interpreter[9] who walks between the Indigenous and non-Indigenous worlds. Yet, in foregrounding the ethical possibilities of Ward's methods, we also critically analyze the extent to which Ward expresses his awareness of certain

Figure 4.1. Tūhoe historian Pou Temara. Still from *Rain of the Children* (Auckland: Vincent Ward Films/Forward Films, 2008). Reproduced with permission of Vincent Ward.

limits to his treatment of Indigenous *difference*. For while Ward challenges the naive "cherished beliefs" of his younger self, it is also apparent that at the same time he cannot completely divest himself of them.

Practices of Remediation: Immediacy and Hypermediacy

Remediation describes the reconstitution of one media form within another. In their book *Remediation: Understanding New Media*, Jay David Bolter and Richard Grusin articulate the process as an historical dialectic of succession and replacement.[10] For example, perspective painting was remediated within photography (which automated its principles), the theatre was remediated within cinema, and, in our contemporary era, photography and cinema are being remediated within digital media.[11] Examples from *Rain of the Children* include the remediation of Ward's original 16mm documentary and archival photography within a 35mm film format that was then, subsequently, digitally transferred, as well as the compositing of filmed footage with computer graphic simulations.

Bolter and Grusin analyze remediation as historically driven by a double (and reciprocating) logic of "immediacy" and "hypermediacy." Immediacy relates to the teleological drive of media to become a more transparent and direct revelation of reality, to effectively disappear in the very act of mediation they enable. For instance, although

Figure 4.2. Transparent remediation in the digital compositing of Rua Kēnana's settlement. Still from *Rain of the Children* (Auckland: Vincent Ward Films/Forward Films, 2008). Reproduced with permission of Vincent Ward.

digital "restorations" of analogue film footage add another layer of mediation to the original, they do so in the service of achieving greater transparency through the removal of physical blemishes that would draw attention to the material opacity of the original film stock as well as any computer-generated "artifacts" that would foreground the process of digitization. For example, immediacy in *Rain of the Children* is evident in Ward's compositing of computer-generated simulations of the Tūhoe prophet Rua Kēnana's settlement[12] with filmed footage of Maunga-pōhatu in which the differences between sources are made indiscernible, producing the illusion of a transparent window onto a reality that is, in fact, a layered synthesis of different media forms.

Hypermediacy, by contrast, foregrounds the different layers of media present within a work. Consider, for example, how Ward marks off the footage of his original 16mm film by preserving the differential appearance of its film stock (its grain and saturated colors) against that of the 35mm and digitally generated footage of *Rain of the Children*. In this way, the spectator no longer simply looks *through* its mediation, like a transparent window, but also *at* its texture and materiality rendered partially opaque within its remediated context.

Although Bolter and Grusin argue that "the two twin logics of remediation have a long history, . . . a genealogy that dates back at least to the Renaissance and the invention of linear perspective," a history one might add that also coincides with that of European colonial expansion, they restrict their analysis to "current media in North America."[13] Regardless of whether this is considered a merely pragmatic decision on the part of the authors in the interest of scope, it still serves to obscure the role that practices of remediation have played (and still do play) within Indigenous cultures and in the formation of colonial and postcolonial subjectivities. For while Bolter and Grusin argue that "we are in an unusual position to appreciate remediation because of the rapid development of new digital media and the nearly as rapid response of traditional media,"[14] they are also insistent that these "new digital media are not external agents that come to disrupt an unsuspecting culture. They emerge from within cultural contexts, and they refashion other media, which are embedded in the same or similar contexts."[15] It is precisely this assumption that we wish to contest by asserting that Māori and other Indigenous subjects of colonization have occupied an equally "unusual position" to experience processes of remediation through the reception of their own images, cultural artifacts, and practices as reconstituted through Western technologies of representation, principally still photography and cinema—technologies that have functioned integrally within the apparatus of colonization and neocolonization today.[16]

Remediation within an Indigenous Context

In her article "The Soul and the Image," the late Māori filmmaker and theorist Merata Mita describes the Māori experience of photographs taken of themselves by Europeans in terms akin to remediation, but in a manner that challenges the cultural monologism

presumed by Bolter and Grusin. As Mita observes: "The first photographs in the nineteenth century introduced Māori people to the captured images of themselves."[17] Extending her analysis to the later developments of moving images, Mita elaborates:

> From those first years it became obvious that the camera was an instrument in alien hands—a Pakeha instrument, and in the light of past and present history another reason for mistrust. It is clear that as early as 1930, the screen was already colonized and had itself become a powerful colonizing influence, as Western perspectives and stereotypes were imposed on indigenous peoples.[18]

What Mita's comments demonstrate is that from the earliest contact with Western representations of themselves, Māori have experienced these images in a state of hypermediacy. And yet, by her account, Māori peoples' acute awareness of the hypermediation of the photographic image was also inextricably tied to an appreciation of its immediacy. This reciprocity between the terms reflects Bolter and Grusin's point that "in every manifestation, hypermediacy . . . (in sometimes subtle and sometimes obvious ways) reminds us of our desire for immediacy."[19] In Mita's analysis, the remediation of Pākehā-produced still and moving images within Māori culture hinges upon the desire for a type of immediacy that Bolter and Grusin's analysis could not anticipate. Specifically, the immediacy of still and moving photographic images does not function merely to create a transparent window onto *empirical reality,* but more profoundly serves to open a window onto an Indigenous spiritual reality, what she describes as a "window to the soul." Mita elaborates:

> We have acknowledged, from that time to this, that the camera has power of a mystical quality . . . the reproduced likeness had *mana,* and the introduction of those first frozen portraits added a new dimension to our remembrances and provided what was thought to be a window to the soul. Therefore a sacred aspect was accorded those images . . . [and] photographs of loved ones adorn the walls of meeting houses and surround funeral biers.[20]

Indeed, as Mita's work indicates, it was this unique understanding that Māori had of the "immediacy" of the photographic and cinematic image of themselves that made the experience of its hypermediacy, as "an instrument in alien hands," so pronounced and problematic.

While we do not have the space to provide an in-depth explanation of essentialized notions of Māori culture such as "*mauri*" (life principle) and "*wairua*" (spirit, soul), images of people, and especially images of *ngā mate* (those who have passed) resonated through an incorporeal realm. That is, images, like everything else within an essentialized Māori epistemology, transcended physical matter and, by the same stroke, empiricist reduction. Yet, in recognition of their differential understanding of the photograph's immediacy, Māori and other Indigenous and marginalized groups have increasingly introduced a hypermediated opacity within the viewing of images of

themselves, thus opening a space to question the source of these images and the power relations inherent in their production. Given that postcolonial Māori traditions included third cultural photographic and cinematic representations (e.g., inclusion of still photos at *tangihanga*/funeral rites), the pronouncement of hypermediacy has become critical for Māori in the process of asserting their sovereignty over image production, preservation, and exhibition, as elaborated upon by Mita.

The complexity of *Rain of the Children* as a postcolonial text can be addressed in the way it utilizes strategies of hypermediacy to generate a dialogue between divergent understandings of immediacy characteristic of incommensurable cultural epistemes. Consider, for example, the double function of archival photography as remediated within the historical reenactments. On one hand, the photographic record anchors the facticity of the reenactments, and thus operates within a Western juridical understanding of the analogue photograph as empirical evidence. For instance, following reenactment of a police raid on Rua Kēnana's settlement conducted under false pretences, the film cuts to an archival photograph and the camera moves to examine its details as Ward narrates: "The policeman in the background is holding a revolver. That shows the women are under armed guard. In court, the police denied ever doing this; not realizing this photo would come to light years later, and Puhi is at the center of this photo." The photograph simultaneously verifies Puhi's presence within these events and questions the reliability of official accounts. This in turn, establishes the rhetorical grounds for the reenactment, narrated by Tūhoe historians and relatives of those affected as *contre-histoire*.

On the other hand, photographs of the event function on an entirely different plane of immediacy as a source of spiritual reconnection with the past in the manner previously described. After displaying an archival photo of Rua Kēnana's arrest, a friend of Puhi's narrates an event from much later in Puhi's life: "I showed her the photograph of Kēnana's arrest on that day. She burst into tears. She crumpled it and held it to her chest and started to talk—and she talked how she remembered the bullets." The film then cuts back to the reenactment as a young Puhi stands transfixed with bullets whizzing just over her head. Reenactment, in this case, conjures specific sense memories of being caught in the crossfire of both visible and invisible threats—a memory that also carries greater metaphoric implications for understanding the *mākutu* (referred to by Ward as "the curse") central to the film. The audiovisual representation of the flying bullets also uncannily anticipates Niki's later description of the *mākutu*, recounted by the actress Rena Owen, as "like silent bullets." The oblique connection between the actual bullets of the state police and the supernatural "silent bullets" indicates the complicated genealogy of the *mākutu* within the experience of disease, death, and misfortune that Ward reconstructs as a direct result of colonial state violence. As we shall see, this collision between empirical and spiritual immediacy carries over into the film's treatment of the *mākutu* as a confrontation of incommensurable epistemes.

Hypermediation of the Self

The function of hypermediacy goes beyond the visible qualities of the image alone. It can also be expressed through the reflexive figuration of certain conditions of media production conventionally excluded from visibility in the interest of transparent immediacy. As Bolter and Grusin observe, "immediacy is promoted by removing the programmer/creator from the image . . . [and] by involving the viewer more intimately in the image."[21] While other "Māori subject films" such as *Whale Rider* purge the presence of Pākehā to foster the illusion of ethnographic objectivity and spectatorial intimacy/immediacy within a pure Māori world and story, Ward reverses this logic by making his own Pākehā subjectivity audible and visible, both as the forty-eight-year-old spectator/filmmaker, and twenty-one-year-old documentarian. The first excerpt from *In Spring One Plants Alone* to appear within *Rain of the Children*—a close-up of Puhi reciting *karakia* (prayers) in hushed tones—is accompanied by Ward's voice-over: "this footage is 30 years old. Puhi was 80 and I was 21 when I shot this." Ward contrasts the *gravitas* of Puhi's presence with his own almost maudlin narcissism, juxtaposing excerpts from *In Spring One Plants Alone* with filmed self-portraits (almost like Warhol's *Screen Tests*) from the same period. He narrates in voice-over:

> This is me when I made the film. I was 21, young, naive, inexperienced. I laugh when I see myself now—so serious. This person who I hardly recognize looks kind of funny to me now. I wanted to experience everything, something, anything. Go out from my little pocket, my little world, and explore.

Hypermediacy, in this instance, cultivates a different way of viewing the earlier material, characterized by a hermeneutics of suspicion toward his younger self.

> I don't know that I'd trust my younger self—well, I wouldn't. I was alone, the only white guy, the only Pākehā in the whole area, didn't speak Māori, didn't know anyone. And I definitely didn't have any idea what I was getting myself into. Maybe that's why you took me in, because I was so vulnerable.

The hypermediated visibility of Ward as image-maker and narrator thus draws attention to his fallibility and vulnerability within a world whose episteme defies his understanding.

The Remediation of the Other

Ward's self-construction as an unreliable narrator can be read as a backhanded ploy to assert objectivity through the denial of agency, and at the same time exchanging the inherent dangers of trusting the Western gaze with an appeal for concern regarding his own personal safety. However, it could also be countered that Ward is critically

aligning the audience's desire for historical objectivity and truth with his own imma-
ture anthropological and romantic intent, a judgment he also seems to project onto
the non-Indigenous audience largely ignorant of its own colonial history (as the
younger Ward himself was when filming the original footage). This appears to be sup-
ported by the way Ward cedes the mantle of narrational authority to the multiplicity of
Indigenous voices that the film subsequently invokes, opening up a polyphonic tex-
tual space in which those who have shared in Puhi's life and the history that surrounds
it can dialogue. As Bolter and Grusin observe, "Where immediacy suggests a unified
space, hypermediacy offers a heterogenous space, in which representation is con-
ceived of not as a window on to the world, but rather as 'windowed' itself—with win-
dows that open on to other representations or other media."[22] In the context of Ward's
methods, hypermediation holds significant possibilities for an ethics surrounding
filmic treatment of the Indigenous Other, primarily because it confronts the existence
of variant epistemologies while resisting their synthesis. The untotalizable reality envi-
sioned requires the audience to move beyond an empirically guided approach to
understanding the Other by first shifting their expectation toward "unknowing,"
beyond the will to a universalized humanity.

This commitment is tested, though in a productive sense, by Ward's treatment of
the *mākutu*. The idea of the curse runs thematically throughout the film, referring not
only to Puhi's plight but also to the general succumbing of Indigenous people to colo-
nial disease. The film's exploration of the *mākutu* focuses on its causes and means
of transmission, as well as the interpretation of the experiences associated with its
affliction. Ward describes how disease became a tacit means of genocide within colo-
nization. He points out that because even medical science at that time could not
explain why Māori were so much more susceptible to diseases introduced by Pākehā,
Māori tended to interpret the phenomena as "punishment for some sin." In the case of
Rua Kēnana, his understanding of the supernatural was already a synergistic product
of the colonial encounter with Western religion. Kēnana deduced that the Tūhoe peo-
ple had been failed both by their own religion and by New Testament Christianity, nei-
ther of which had offered salvation from disease and oppression. He thus turned to the
Old Testament story of the Israelites' exile and return to the promised land and grafted
it onto preexisting Tūhoe beliefs, constructing his followers as the new Israelites, and
their return to the sacred Tūhoe mountain, Maunga-pōhatu, as deliverance from exo-
dus. The narrative constructed by Kēnana and his followers is one of the most extraor-
dinary stories of third culture created by Indigenous leaders navigating New Zealand's
early postcolonial landscape.[23]

The young Puhi, as a favorite of Kēnana's, is chosen to marry his son Whatu. How-
ever, when Puhi's first child is born with "problems" (which the film does not disclose),
mākutu is suspected. After she gives birth to two more children, Whatu abandons her
for another wife. Following his murder, Puhi is married-off by Kēnana to his associ-
ate Kahukura, an older man whom Puhi does not love. She gives birth to ten more

children, and revolts against her situation by publicly humiliating her second hus-
band. Disease strikes, and Puhi is hardest hit—six of her children die, and her other
four children are taken from her as preventive action against the suspected *mākutu*.
Ward suggests: "It must have seemed to Puhi that everyone she touched died. With so
many believing in her curse, it only reinforced her own belief." Indeed, it is because of
Puhi's fear of the curse that she clings so protectively to her son Niki, born to her by a
third husband later in life, who also dies while Niki is just a young boy.

There is a subtle but detectable element of condescension in Ward's speculation
regarding Puhi's thought processes. Underlying his comments is the presumption that
the *mākutu* is a superstitious misconstrual of a fundamentally empirical/scientific
reality. Yet Ward's narration becomes subsumed within a broader hypermediated field
that takes a decidedly more ambivalent stance toward the physical and metaphysical
etiology of the *mākutu*. For example, in an inversion of Ward's ascription of cause/
effect, Tūhoe interviewed promote an understanding of *mākutu* operating beneath
and through the mechanisms of disease. Correspondingly, reenactments that address
what could be understood as empirical precipitating factors of Niki's disorder in child-
hood: his discovery of his father's dead body, witnessing its exhumation by police for
autopsy, suffering a head injury following his fall from a horse, and witnessing the
"body tree"[24] are hypermediated by multiple layers of narration that draw them into
question. As one Tūhoe contributor elaborates:

> When you talk about *patupaiarehe* [fairies], we're talking about in Niki's case having a mental
> illness. We're talking about a person who hallucinates and hears voices. That's when he was
> getting sick from a Westernized perspective of the illness. But from a Māori perspective of the
> illness, he would actually see those things as being real, and so it would be cross-spoken with
> the elders who would understand that *patupaiarehe*, or fairies as such, were real things.

From this perspective Niki's condition results not from seeing things that aren't empir-
ically real, but in his inability to reconcile (to cross-speak) empirical and nonempirical
orders of existence.

Through mechanisms of hypermediacy Ward not only overcomes his immature,
younger self, but the film itself (by Othering its own site of narration) transcends the
mature Ward's skepticism. The narrator is thus made unreliable not just once but
twice, and as the film progresses the possible reality of the *mākutu* increasingly defies
Western terms of containment, affecting both the audiovisual field of the film and
Ward's own consciousness. In the first instance, the suggestion that the lattice of coin-
cidence surrounding the *mākutu* might indicate the operation of some malevolent
force behind "natural phenomena" is expressed through remediated footage from *In
Spring One Plants Alone* through the addition of subtle sound effects not present in the
original film. In one key sequence, Niki lies on his bed in the darkness, visible only in
shadows, while the twenty-one-year-old Ward (sitting at his bedside) inquires about

his time spent in a mental hospital. Niki becomes defensive: "Look, there's a lot of bad things being done to me around here and you don't have to ask me that. . . . Not only to me but my mother. We're both getting it." At the very moment that Niki finishes speaking, as if on cue, gunshots ring out. The moment is punctuated in the sound-scape by a low and unsettling cello note, just before Niki emerges from his state of shock and urges Ward to "Ring the cops!" Once again we encounter the hypermedia-tion of a double immediacy resonant with Mita's description of photographic means of representation. On one hand, Niki's plea to "Ring the cops!" refers to an empirical danger: "cunts shooting guns up the road." But on the other hand, the *co-incidence* of the gunfire with the content of the conversation raises the threat to a higher power (figuratively and literally), as the association of the *mākutu* with invisible bullets is marked once again.

Exhuming Ghosts

There is also a way in which Ward's *mode* of narration (in some cases) suggest an atti-tude toward his own images at variance to the Western episteme he espouses. For example, from quite early on in the film through to the final shot, Ward *talks to* Puhi through his images. That is, he not only speaks of Puhi in the third person, telling her story, but also frequently addresses Puhi's image in the second person. Perhaps the most profound instance of this occurs when Ward transitions from his initial com-mentary on *In Spring One Plants Alone* to the elaborate re-creation and reenactment of her life story. Notably, this is also the first time that Ward mentions the *mākutu*.

This scene is preceded by a shot from *In Spring One Plants Alone* of Puhi outside her house crouched by a bucket of water; her incantations audible in hushed tones. The film cuts to a shot of Ward's face framed within the front left portion of the image against a dark background. Behind him, and to the right, the face of the actress who plays the middle-aged Puhi (Rena Owen) is visible but partially shrouded within the darkened space. It is at first unclear whether he is standing in front of a static photo-graph of the woman, or whether she is actually present in the space behind him. Ward addresses the spectator:

> It was as if there was something coming down on them, something she was frightened of, and it wasn't just his [Niki's] health. And when I came back and started talking to local people, they told me it was a curse; that she believed in a curse. It didn't matter whether I believed in it or not, I knew that she, now (at least what I've come to understand), that she believed in it.

Ward pauses and turns toward the face behind him. The camera moves in upon the woman's face until Ward is out of frame. Her eyes blink: this is not a still photo. The image flickers, revealing that it is a cinematic image rear-projected on a screen. Ward

Figure 4.3. Ward's "conjuring" or "resurrection" of Puhi (played by Rena Owen). Still from *Rain of the Children* (Auckland: Vincent Ward Films/Forward Films, 2008). Reproduced with permission of Vincent Ward.

addresses and entreats the image: "So now I have to conjure you up, in the different phases of your life. Go back, and find out your story. Would you tell me your story?" The shot cross-dissolves to a black-and-white still photograph of Puhi at roughly the same age as the actress in the previous shot. A voice speaks in monotone, as if from beyond the grave, as the camera slowly zooms in on Puhi's face: "I was born 1898 . . ."

Ward's comparison of his cinematic re-creation of Puhi's story to "conjuring," combined with his direct address to the deceased woman through her screen image, recalls Mita's account of how the moving image amplifies the paradoxical power of the still photograph. As Mita explains:

> Old films are highly prized because they retain the images of the ancestors. They not only retain them, they are also able, under the right conditions, to bring those images to life in front of *us* on the screen, and this can be repeated over and over again with each screening. Nothing else has this power, not books or tape recordings or statutes, or written historical records. . . . It is not uncommon for archival screenings to be complemented by an appreciative living soundtrack of laughter, exclamations of recognition, crying, calling out, and greetings. . . . Because what the audience sees are *resurrections* taking place, a past lives again, wisdom is shared and something from the heart and spirit responds to that short but inspiring on-screen journey from darkness to light.[25]

The extraordinary claim that what the audience sees are "resurrections" underscores the spiritual significance of the cinematic image's immediacy within the nonempirical episteme at play. Likewise Ward's appeal to the screened image of Puhi (played by Owen) expresses a spectral conjuring through the medium(ship) of cinema. Moreover, Puhi's disembodied narration reinforces this sense of her manifestation not merely as image, but as a spiritual and authorial presence; closer to what Mita describes as "soul." Indeed, it could be argued that through his interaction with images of Puhi (from the earlier film, from photographs, and from re-creations), Ward resituates himself, and by extension his audience, within what Mita describes an Indigenous mode of spectatorship.

However, a less ingratiating reading could argue that Ward's attempt to transcend hypermediacy in the pursuit of a spiritual immediacy toward the deceased Puhi performs a type of metaphysical colonization. For one thing, it seems problematic that Puhi's spirit is compelled to speak in the language of the colonizer for the edification of an English-speaking audience. Another related problem is the way in which the film literalizes within its own fiction a process of reception that by Mita's accounts only takes place within the cultural specificity of an Indigenous audience. As such the film could be accused of appropriating and simulating the culture to make its experience of the film universally accessible to a Western audience. One striking example occurs late in *Rain of the Children* when Ward returns to Puhi's now abandoned farmhouse for the first time in thirty years. As Ward walks through the house, the film cuts seamlessly between the footage of its current state of dereliction and footage from the earlier film in which Puhi still visibly and audibly inhabits the space. Ward's narration promotes the experience of the remediated footage as that of a haunting: "I could still sense your presence in the house. You died, but your spirit cannot rest." Ward thereby attributes to himself and extends to the spectator a sort of extrasensory perception of Puhi's nonempirical presence, akin to the Indigenous means of knowing associated with Niki. Yet, it is Ward's presence throughout the scene that is most eerie of all, as he literally haunts his old footage in a manner not dissimilar to the "spectral colonization"[26] of Whoopi Goldberg by Patrick Swayze (playing a dead white man) in *Ghost* (1990).[27] This critique takes shape within the film's more general resemblance to an archaeological quest. Images of Ward riding up Maunga-pōhatu on horseback to retrace Puhi's steps, or standing outside her now abandoned house, re-create, perhaps unwittingly, the sense of Indigenous history as something awaiting rediscovery by non-Indigenous investigators and Western media.

Yet, the degree to which Ward becomes guilty of some form of neocolonial phantasmagoria must also be considered in the context of the way the composited footage once again hypermediates the older Ward's ways of viewing with those of his younger self—a relationship expressed through another bit of more subtle cinematic conjury. In the scene described above, a shot from *In Spring One Plants Alone* follows behind

Puhi as she walks down the entrance hall toward the open doorway of her house. The film cuts to an establishing shot of the same doorway from outside in the yard. A shadowy figure moves in the hall precisely where Puhi stood in the previous shot, but instead the older Ward emerges in her place. The sequence slips between immediacy and hypermediacy, from a transparent window to the past to the foregrounding of Ward's revisiting and re-viewing. He speaks to the camera: "I remember the very last shot we filmed, I was watching you from here. You were chopping wood." The film cuts again to a reverse shot looking out from the doorway. In the yard Puhi sits with her head bent over in an expression of grief, striking at a piece of wood with a hand ax as Niki stands just beyond, his back turned to both her and the camera. Ward thus interpolates himself into the mise-en-scène of his original film as a means to draw attention to the doubled viewing position he occupies in relation to his younger self. As he observes, "Looking at the footage now, I realize you were chopping the wood against the grain. You weren't even trying to chop the wood; you were so worried about Niki." In the context of this revelation, Ward's hypermediation of his original footage enacts an analogous practice of viewing "against the grain," which he extends to the spectator.

It is also worth noting that Ward was initially reluctant to appear in the film, and his change of mind was due, at least in some part, to the counsel of Tūhoe elders who impressed upon him the responsibility conferred by Puhi's recognition of him as *mokopuna* (grandchild). In relationship to both Puhi and the Tūhoe community, Ward was an outsider who had, to some degree, been taken in. As Tūhoe elder Matu Te Pou explains, "She saw Vince as one of her own, but of a special nature; probably because of the color of his skin [she] thought of him as a *tūrehu* or *patupaiarehe* [light-skinned fairy folk] and obviously his relationship with Niki."[28] Curiously, both Niki and Ward can be understood as performing parallel functions of extending Puhi's vision, though in different directions and within different realms. On one hand, as interviews within the film reveal, Puhi hoped that Niki's "gift," his ability to see the other world and the *patupaiarehe*, would also allow him to make contact with her dead children. Ward's filmmaking, on the other hand, enabled her to spiritually reconnect with her living community and with a broader world. As Tūhoe elder Danny Hillman Rua observes, "I believe that what she got out of Vince was this project now, this story about her on a screen." Thus, beyond whatever "use" to which Ward might be accused of subjecting Puhi, she reciprocally, and quite self-consciously "used" Ward and the film for her own spiritual and cultural ends.

When reflecting on why Puhi's spirit can now finally rest as a result of her story being told, Matu Te Pou comments: "More importantly, I think because it was told by her *mokopuna*, and held in memory with her *mokopuna*. It's their families, their *mokopuna*'s and Vince's *taonga*, of which we as Tūhoe have a choice to share in with them." His description of the film as *"taonga"* (communal treasure) resonates with Mita's account of film as resurrection, and hence as intergenerational spiritual inheritance. One of the significant ways in which the broader Tūhoe community also

chose to "share in it" was by performing many of the roles within the reenactments of Puhi's life and of their history. The place of reenactments in documentary practice has long been contested, which is probably why Ward refers to *Rain of the Children* as a "dramatic work" while he designates *In Spring One Plants Alone* as a documentary.[29] However, against the backdrop of Mita's analysis, *Rain of the Children* promotes an understanding of reenactment grounded more in its ability to re-create a cultural memory than its approximation of some criteria of empirical correspondence to "objective" reality.

More importantly for Puhi, the reenactment of her life by the Tūhoe community is also tantamount to the restoration of her person. The film is about death and trauma, but itself works as a sort of remedy, which in the words of the Tūhoe elders, "restores Puhi's *mana*." Within this light, the cumulative effect of processes of remediation operating throughout the film exemplify what Bolter and Grusin identify as the less frequently emphasized meaning of remediation as healing and reform: "The word derives ultimately from the Latin *remederi*—'to heal, to restore to health' . . . [and] can also imply reform in a social or political sense."[30] Both senses are certainly operative in the film and can be traced among its various participants. Thus, although Ward's strategy could be construed as a pretext for collapsing difference it can alternately be read as an earnest attempt at an Other-centered ethics insofar as he allows himself and his film to "become an instrument in alien hands," thereby reversing Mita's description of the typical colonial function of the cinematic image by lending oneself to the representation of the Other on the Other's own terms.

Conclusion

Through practices of remediation Ward claims to "see the old film with fresh eyes." In one sense, this new way of seeing is driven by Ward's desire to deal with his own personal loss, and yet he also acknowledges an unbridgeable impasse between self and Other. At the end of the film, Ward addresses Puhi one last time: "I made this film about you, Puhi, because I wanted to understand you and try to find out who you were. But maybe you can never really know someone, and maybe that's alright, because in the making of this film I feel can finally say 'good-bye.'" In another sense, Ward's reconnection of the personal and the political (in terms of his own autobiography) can be read as a remedy to Mita's contention that Pākehā have long misunderstood and trivialized the spiritual profundity of their own representational technologies, not only with regards to the distortions and caricatures of Māori that she catalogs, but also in relation to Pākehā self-representations that express, with few exceptions, a displaced inability to confront their own victimization through colonization, exemplified in characters who are condemned perpetually to experience the political conditions of their oppression in terms of personal alienation—and epitomized in the Pākehā archetype of the "man alone."[31] In this respect, Ward's journey of re-viewing *In Spring*

One Plants Alone might be redescribed as a remediation of his younger self, when he was "naive. . . . alone . . . [and] didn't know anyone," within the frame of a more mature ability to understand his own identity as a product of, and as indebted to, his encounter with the Other.

Notes

1. Homi Bhabha, "The Other Question," *Screen* 24, no. 6 (1983): 24.
2. Vincent Ward, *Rain of the Children* (New Zealand: Rialto Distribution, 2008).
3. Stuart Sim, ed., *The Routledge Companion to Postmodernism* (London: Routledge, 2001).
4. Vincent Ward (dir.), *In Spring One Plants Alone* (Wellington: Vincent Ward Film Productions, 1980).
5. Lee Tamahori (dir.), *Once Were Warriors* (Culver City, Calif.: Columbia Tristar Home Video, 1995).
6. Niki Caro (dir.), *Whale Rider* (South Yarra, Victoria, Australia: Buena Vista Home Video, 2002).
7. See Brendan Hokowhitu, "The Death of Koro Paka: 'Traditional Māori Patriarchy,'" *The Contemporary Pacific* 20, no. 1 (2008): 115–41.
8. For further reading see Brendan Hokowhitu, "Understanding Whangara: *Whale Rider* as Simulacrum," *New Zealand Journal of Media Studies* 10, no. 2 (2007): 53–70.
9. Gilles Deleuze and Felix Guattari, *A Thousand Plateaus: Capitalism and Schizophrenia* (Minneapolis: University of Minnesota Press, 1987).
10. Jay David Bolter and Richard Grusin, *Remediation: Understanding New Media* (Cambridge, Mass.: MIT Press, 1999).
11. There is no reason that remediation cannot work in reverse, and it often does within the fine arts where, as in the case of artist Chuck Close, a painting is done of a photograph, or even of a digital image. See William J. Mitchell, *The Reconfigured Eye: Visual Truth in the Post Photographic Era* (Cambridge, Mass.: MIT Press, 1992), 132.
12. In the first decade of the twentieth century, the enforced colonial encroachment into Tūhoe lands and deepening tribal structural crises brought about by displacement and disease gave rise to the Tūhoe prophet Rua Kēnana Hepetipa, commonly referred to as Rua Kēnana who "like Moses came down from Maungapohatu, the sacred mountain of Tuhoe, and announced his divine mission. . . . In 1906 [he persuaded his followers] to sell their possessions and give up material goods as Christ had done with his disciples" (Ranginui Walker, *Ka Whawhai Tonu Mātou: Struggle without End* [Auckland: Penguin Books, 1990, 182]). The group's capital endeavors eventually led to the development of Hiruhārama Hou, "Rua's New Jerusalem and City of God at Maungapohatu" (ibid.).
13. Bolter and Grusin, *Remediation,* 18.
14. Ibid., 4.
15. Ibid., 16.
16. Sam Edwards, "Cinematic Imperialism and Maori Cultural Identity," *Illusions* 10 (1989): 17–21.
17. Merata Mita, "The Soul and the Image," in *Film in Aotearoa New Zealand,* ed. Jonathan Dennis and Jan Bieringa (Wellington: Victoria University Press, 1996), 36.
18. Ibid., 43.
19. Bolter and Grusin, *Remediation,* 30–31.
20. Mita, "The Soul and the Image," 36.
21. Bolter and Grusin, *Remediation,* 25.
22. Ibid., 34.

23. See John Cullen and Mark Derby, *The Prophet and the Policeman: The Story of Rua Kenana* (Nelson, N.Z.: Craig Potton, 2009).

24. Here the "body tree" refers to trees where the bodies of the dead were hung; after some time, the bones would be collected. Tree cavities were also used for storing bones. Thus, while such trees were not horrifying, as depicted in *Rain of the Children,* they were nonetheless highly *tapu.* That is, they were sacred and probably people were forbidden to be in their vicinity unless properly sanctioned under correct *tikanga* (customary lore).

25. Mita, "The Soul and the Image," 50–51; emphasis added.

26. Val Hill and Peter Every, "Postmodernism and the Cinema," in *The Routledge Companion to Postmodernism,* ed. Stuart Sim (London: Routledge, 2001), 108.

27. Jerry Zucker (dir.), *Ghost* (Los Angeles: Paramount Pictures, 1990).

28. "In Māori tradition patupaiarehe, also known as tūrehu and pakepakehā, were fairy-like creatures of the forests and mountain tops. Although they had some human attributes, patupaiarehe were regarded not as people but as supernatural beings (he iwi atua). They were seldom seen, and an air of mystery and secrecy still surrounds them. In most traditions, those who encountered patupaiarehe were able to understand their language. But in one account they were unintelligible" (Martin Wikaira, cited in "Story: Patupaiarehe," http://www.teara.govt.nz/en/patupaiarehe/page-1).

29. Interview with Vincent Ward in *Rain of the Children.*

30. Bolter and Grusin, *Remediation,* 56–57.

31. The one notable exception cited by Mita is Jane Campion's *An Angel at My Table* (Auckland: Hibiscus Films, 1990).

5. *Consume or Be Consumed*

Targeting Māori Consumers in Print Media

SUZANNE DUNCAN

> Throughout the world Indigenous populations have had to reckon with the forces of "progress" and "national" unification. The results have been both destructive and inventive. Many traditions, languages, cosmologies, and values are lost, some literally murdered; but much has simultaneously been invented and revived in complex, oppositional contexts. . . . Something more ambiguous and historically complex has occurred, requiring that we perceive both the end of certain orders of diversity and the creation or translation of others.
>
> —James Clifford, *The Predicament of Culture*

ADVERTISING IS A PERVASIVE DISCOURSE that has been recognized as permeating every aspect of symbolic expression.[1] By progressing the political and economic interests of business and of governments, advertising has also psychologically, sociologically, and culturally impacted people en masse.[2] Advertising's significant impact on Indigenous communities has come about due to the privilege it has been afforded because of its perceived "development" potential that, in turn, has led to the destruction and reinvention of cultures and identities.

Marketing communication relies heavily on visual representation to produce meaning. Representation is used to create an image of the product or service by linking brands to an identity of their own. These representations often replace an actual experience, that is, representations can entice people into believing they have knowledge of something that they have no experience of, which, in turn, influences future experience. The "distorted mirror"[3] refers to the professional selection of behaviors and values that supposedly reflect culture, yet in truth may not reflect reality at all and are selected precisely to achieve the best results for business. This can be seen in the overuse of stereotyped symbolism. Stereotypes occur in advertising because they enable understanding, that is, they simplify and decrease the amount of information transmitted to the consumer in order for them to understand the message. The inadvertent effects of the use of social stereotypes is the reinforcing of preconceived ideas, dehumanization of interpersonal relationships, encouragement of simplistic social analyses, and the propagation of ageism, sexism, and/or racism.[4]

As a postcolonial example, from the early 1900s to the 1930s, cigarette manufacturers in New Zealand targeted Māori smokers through campaigns that associated their product with Māori culture.[5] "Loyal's Burley Blend Roll Your Own Smoking Tobacco," for example, "was packaged in a red, black and white tin, which featured the image of a *tekoteko* [carved figurehead] beside a cigarette."[6] The colors and imagery are closely associated with Māori art and carving, and served to target smoking to Māori consumers. Likewise, the "Māori Brand of Impregnated Safety Matches" targeted their audience via Māori imagery that included the head of a Māori male with a full-facial *moko* (tattoo).[7] Such cultural appropriation resembles what Ngāhuia Te Awekotuku argues is a "deliberate, and . . . promiscuous plundering of Māori motifs—design, forms, myths."[8]

Over a century later, the advertisement (Figure 5.1) reflects a promotion by Auahi Kore (i.e., "smoke-free"), a program developed by the New Zealand Health Sponsorship Council predominantly aimed at Māori.[9] Similar to the cigarette manufacturers cited earlier, Auahi Kore uses Māori imagery and language to target a Māori audience with their message. The figures depicted are distinctly and highly recognizable contemporary Māori symbols, such as the *tiki* (stylized figure) and *kōwhaiwhai* (scroll ornamentation) patterns.[10] The main text's English translation reads: "Strengthening the family, strengthening the clan, strengthening the people in a Smokefree world." The text at the bottom translates as: "A strong bloodline is a Smokefree one." Significantly, the advert through both imagery and text appeals to the notion of *whakapapa* (genealogy), which is central to Māori epistemic beliefs and embodied in the contemporary expression, "I belong, therefore I am."[11] The advert's reference to *whakapapa* thus signifies a genealogical moral obligation and responsibility for Māori smokers to quit.

The smoking-related examples above speak to what James Clifford refers to as the "destructive and inventive" results of colonization. Sardonically, in this case, the initial use of Māori cultural motifs to sell cigarettes to Māori has in part led to the destructive acculturation of smoking into postcolonial Māori communities and subsequent health issues. However, in contemporary society, reinvented Māori motifs are now being creatively used to produce a healthier populace. This chapter is less concerned with the destructive appropriation of Indigenous culture through advertising, a subject that has come to dominate the nexus between Indigenous studies and marketing;[12] rather I focus on "the end of certain orders of diversity; and the creation or translation of others," as Clifford puts it.

The chapter analyses print media advertising in New Zealand in relation to an "ethnic market," specifically the "Māori market" and the development of the contemporary consumer identity that has reconfigured the meaning and value of citizenship.[13] The study of advertising discourse has helped produce understandings surrounding notions of belonging, citizenship, and cultural hierarchies. It could be said, for instance, that who does and does not belong to a group can be understood in terms of collective ideals displayed in advertising.[14] Using case studies of the most significant print magazines targeting a Māori audience in the last sixty years, this

Figure 5.1. Auahi Kore advertisement, *Mana Magazine*, no. 84 (October–November 2008): 33. Reproduced courtesy of the Auahi Kore organization.

chapter provides a partial history of "marketing"[15] to Māori via print media advertising, framing the discussion through the relatively new area of study, "ethnic marketing." Advertisements are also analyzed in terms of themes, trends, and attitudes. The chapter concludes by exploring the contemporary context via an analysis of the preeminent "glossy" Māori magazine, *Mana*.

Ethnic Marketing

Market segmentation is the cornerstone of marketing theory and refers to the process of dividing the total possible market of a product into smaller homogenous groups,[16] that is, of "dividing a market into direct groups of buyers who might require separate products or marketing mixes."[17] Although not new in practice, "ethnic marketing"[18] has a relatively recent history in marketing theory. Sonny Nwankwo and Andrew Lindridge described it as being in an "embryonic stage" in their article on marketing to ethnic minorities in the United Kingdom in 1998.[19]

Since 1998, ethnic marketing has developed as an approach rooted in the belief that a consumer's ethnic uniqueness extends to their buying behavior.[20] Using "ethnicity"[21] as a market variable, however, is problematic because of the difficulty in finding discrete data that indicates meaningful ethnic segmentation as opposed to demographic market segmentation,[22] which is often employed due to its ease of availability in population statistics and censuses. Dennis Cahill, a critic of ethnic marketing, suggests the morphing nature of ethnicity makes its market segmentation viability dubious. Due to assimilation and acculturation, ethnicities erode as people move away from old neighborhoods, for example, or marry people of different ethnicities and have children.[23] By proxy, Cahill's analysis would suggest that in the postcolonial context ethnic marketing to Indigenous groups is pointless due to rapid assimilation into the dominant settler culture. Significantly, very little ethnic marketing literature has addressed Indigenous consumers and such a conclusion therefore remains tenuous. The overwhelming majority of literature has focused on the "ethnic minority consumer," and has concentrated on immigrant groups, such as Latino culture in the United States. Geng Cui's literature review of ethnic marketing demonstrated an increase in ethnic marketing, particularly when the ethnic group in question was highly visible.[24]

In New Zealand, the nexus between Māori Studies and marketing has focused primarily on the appropriation of Māori culture, particularly in tourism.[25] Another form of literature stems from government reports and social organization accounts, which typically explore efforts to socially market to Māori by groups such as the Health Sponsorship Council, as in the Smokefree campaign illustrated above. To date, however, discussions of commercial ethnic marketing to Māori are almost absent, barring the work of Jayne Krisjanous and Matene Love.

According to Krisjanous and Love, mainstream marketing has paid little attention to targeting Māori consumers due to the assumption that Māori remain among the lowest-income earners in New Zealand and, as a consequence, purchase few goods

beyond essentials.[26] The common stereotype of the Māori sot as unintelligent and capricious portends the assumption that Māori discretionary spending (i.e., the range of spending beyond essential purchases) is contemporaneous with poor decision-making, such as purchasing alcohol and tobacco.[27] Further, Māori are overrepresented in the "commercially unattractive" statistics,[28] which help normalize the view that Māori are citizens who seldom contribute positively to society. Dialogically, therefore, the pursuit of "progress" as defined by capitalist economic development is seen as beyond the Māori consumer and, in turn, products such as new technologies do not feature in ethnic marketing.

Social Marketing and Māori

While the Māori consumer has, for the most part, been ignored, there are many contemporary and historical examples of Māori-targeted advertising, which might be termed "social marketing," as seen in the *Te Ao Hou* case study discussed below and examples from early newspapers. Social marketing is aimed at changing behaviors and adopting new value systems that will aid in the social development of the target market. Philip Kotler and Gerald Zaltman define social marketing as the "design, implementation and control of programs calculated to influence the acceptability of social ideas and involving considerations of product planning, pricing, communication, distribution, and marketing research."[29] Social marketing is thus predominantly concerned with influencing the target audience to change their behavior, whether that be in terms of health, education, the environment, community betterment, or numerous other "social concerns."[30]

As a tool of the state, there is no question that the statistics validate social marketing to Māori. Māori remain overrepresented in the worst figures, particularly in the areas of crime and health. An example of this is life expectancy: between 2005 and 2007 the life expectancy for Māori women was 7.9 years less than non-Māori and for Māori men it was 8.6 years less than non-Māori.[31] Issues such as smoking, alcohol, and drug abuse are key focuses for many Māori organizations. Māori women are more than twice as likely to smoke as the rest of the New Zealand population.[32] Education is still an issue, with 56 percent of Māori leaving high school without achieving NCEA Level 2 in 2007–2008.[33] Yet, the concentrated effort to "fix" Māori through social marketing also tends to reinforce stereotypes and reify a victim mentality.

In a more critical reading of social marketing toward Māori, Kirihimete Moxon argues that the overconcentration of Māori within social marketing adverts that tell Māori to " 'stop smoking', 'stop drinking', 'get an education', 'get a job', 'be fire wise', 'stop domestic violence' "[34] cumulatively perpetuate stereotypes of Māori cultural incapacity and uphold a neoliberal agenda by focusing blame on Indigenous individuals while "ignor[ing] cultural, political and social barriers that inhibit Māori."[35] Here, "neoliberal agenda" refers to the social marketing taglines being geared toward the biopolitical management of the Indigenous body to increase productivity via a

more healthy and efficient workforce, while also ensuring that the capitalist system and the postcolonial nation circumvent both moral and financial responsibility for the "deviances" of the community.

The remainder of this chapter traces the targeting of Māori by print media advertising, including the prevalent social marketing campaigns that largely reflect the biopolitical manipulation of Māori as outlined here. The sections that follow investigate advertising targeted at Māori within three news magazines, *Te Ao Hou*, *Tu Tangata*, and *Mana Magazine*. The first two of these analyses are presented as historical case studies, while the third explores the contemporary context.

Māori News Magazines: 1950s to Today

CASE STUDY ONE: *TE AO HOU*

The news magazine *Te Ao Hou* was printed from 1952 to 1976 by the government Department of Māori Affairs.[36] Altogether, seventy-six issues of *Te Ao Hou* were produced at a rate of three issues per year. The aim of the magazine was to keep Māori in touch with their rural communities as they ventured into *te ao hou*, or "the new world," as Māori became urbanized. The content of *Te Ao Hou* "ranged from agricultural stories, recipes and articles to wood carvings and other crafts to bilingual presentations of legends and poems."[37]

Te Ao Hou was published during the time when urbanization of Māori was part of, and crucial to, the state policy to assimilate Māori. Urbanization was seen as one way that Māori social structures and collectives could be broken down to produce the Indigenous nuclear family.[38] During the mid-1950s, the Māori population was approximately 135,000. The "urban drift" saw many Māori move from their rural homes to urban settlements. In 1926, only 3,457 Māori were recorded as living in urban areas. In 1951, however, this had increased to 16,010, and in 1956, the urban population of Māori had reached 21,645.[39] Notably, this figure triples to approximately 60,000 from the mid-1950s to the mid-1960s. This period in Māori history has been written about by many academics and commentators, who attribute the motivation of such swift urbanization to neocolonial phenomena such as the state-driven ideological campaign to assimilate Māori into dominant settler culture. As Ranginui Walker outlines, in the 1960s the Department of Māori Affairs formulated a relocation program that "exhorted rural families to leave the subsistence economy of the 'pipi beds' [shellfish beds] by finding them employment and accommodation in urban centres."[40] The urban drift is commonly understood to have led to Māori-language decline, and the loss of Māori culture and identity, specifically due to the breaking down of Māori social stratifications such as *hapū* and *iwi*, as Māori moved away from the rural hinterlands and into the "nuclear family" of the cities.[41]

In the sample surveyed for this research, *Te Ao Hou* had approximately one advertisement per five pages. The most significant feature of the advertising was the high number of product and service advertisements compared to the number of social

advertisements. Also, both categories featured advertisements that used Māori language as the main medium of communication. One product that was consistently advertised in all but one of the magazines analyzed was Wrigley's Chewing Gum, which typically employed the Māori language to sell the product. The wording in one advertisement, "He Pai Mahau, He Pai Hei Ngau," which translates as "It is good for you, It's good to chew," suggests that chewing their product will "brighten your teeth" and that it "Aids your digestion."[42] The accompanying cartoon character is not obviously characterized as belonging to any particular ethnic group.[43] The placement of such advertising in a government-sponsored magazine would suggest that a model of health, which simulated whiteness, was central to the state civilizing project of its Indigenous populace. The advertisement is being used as a tool of assimilation. Similar Wrigley's advertising campaigns in the United States targeted African Americans and were designed to imply that "blacks' buying motivations simply mirrored those of whites."[44]

The second example (Figure 5.2) relates to social marketing and particularly water safety. The advertisement is completely in the Māori language, describing the high statistics of Māori children that drown every year. It specifically details the number of Māori children that have drowned in the particular year the advertisement featured, in this case 1957. The text asks parents to be vigilant when their children are near the water to ensure their safety. It also states that all waters are dangerous, referring to the sea, rivers, and lakes. The use of detailed Māori language as the main medium for communication indicates that at this time there were still a large number of Māori-language speakers, particularly of parenting age. The image used also clearly depicts the children swimming as Māori. Again, this example of social marketing, while overtly paternalistic, demonstrates the state's historical impulse to civilize its Indigenous citizenry in the sense that the natural world was depicted as innately dangerous.

The final example from *Te Ao Hou* (Figure 5.3) is a recruitment advertisement for nurse aids that could also be classified as social marketing, given the state's investment in Māori health. At the time the state had a vested interest in elevating Māori recruitment into the nursing workforce as a way to combat the poor health of Māori people that was an accompaniment of colonization. The advertisement is written in English and features a cartoon woman telling the reader that "NATURALLY you'll want to be a NURSE"; there is also an image of a young European girl dressed up as a nurse. Although this advertisement appears to be a generic and national female recruitment campaign, due to the apparent lack of Māori language or imagery, it is interesting to analyze because of its placement within a Māori media outlet. Analysis of the copy and discourse uncovers a paternalistic and patronizing message. While it states that "NATURALLY you'll want to be a NURSE" it goes on to say "and there is a place for you as a NURSING AID." Nursing aids did not require qualifications or formal training; rather they assisted qualified nurses. Combined with the image of a young girl dressed up as, presumably, a nurse aid, the message to Māori women was: while you may want to be a

Figure 5.2. Water safety advertisement, *Te Ao Hou*, no. 20 (November 1957): back cover. Reproduced with permission of Te Puni Kōkiri.

Figure 5.3. Nurse aid recruitment advertisement, *Te Ao Hou*, no. 19 (August 1957): inside back cover. Reproduced with permission of Te Puni Kōkiri.

nurse your "place" is as a nurse aid. Further to that, you are a "child" compared to the nurses that you will be assisting. Moreover, the advertisement signifies the state's biopolitical desire to control and monitor its Indigenous citizenry via trained Māori health professionals. When read against the 1907 Tohunga Suppression Act, which outlawed the practices of *tohunga* (experts in various forms of Māori philosophy and practices), such social marketing indicated the Indigenous body was increasingly viewed as a state-owned enterprise.[45]

The social marketing within the three examples above demonstrates assimilatory intent. That is, the goal was to devalue Māori-centered value systems by replacing them with European lifestyles, social values, and gender roles as the ideal and desired way of living. The advertisements contained in the *Te Ao Hou* issues do not use any Māori imagery yet clearly they were advertising to Māori because they were in a Māori magazine and many used the Māori language, yet the lack of Māori values or beliefs indicates their biopolitical and civilizing intent.

Such advertisements, particularly those in *Te Ao Hou*, reflect Anne McClintock's "commodity racism," which she states is "distinct from scientific racism in its capacity to expand beyond the literate, propertied elite through the marketing of commodity spectacle."[46] Through the use of images and "things" to penetrate cultural systems, mass imperial marketing allowed for "messages of racism [to] subtly spread across classes and races."[47] McClintock's analysis focuses on soap as a commodity that perpetuated Victorian values and British nationalism through advertising. Throughout *Te Ao Hou* there are a number of commodities that also can be viewed "as a cheap and portable domestic commodity" that could "persuasively mediate the Victorian poetics of racial hygiene and imperial progress."[48]

Wrigley's Chewing Gum, for example, which highlights the "brightening" and essentially whitening of teeth, also signifies the "civilization" and biopolitical control of Māori. While it appears that the advertisements were part of wider national campaigns targeting both Māori and non-Māori, those adverts that targeted Māori specifically were only ever about "social concerns" and thus stemmed from the underlying discourse of social control and assimilation, whereas Pākehā (white New Zealanders), as fully human, were subject to the full gamut of advertising. Moreover, the nursing recruitment advertisement shows a white child "playing nurse." The desired behaviors are not just those that encourage health service aspirations; Māori are to become the white figures represented in the advertisements and create a new identity as a white citizen.

CASE STUDY TWO: *TU TANGATA*

Tu Tangata was a news magazine produced between 1981 and 1987 by the government Department of Māori Affairs. The content of the magazine was similar to the news stories of *Te Ao Hou*, with articles about current events and issues occurring in Māori society and also short literary pieces by Māori authors. The magazine

is interesting to analyze as its publications occur immediately following the most prominent period of radical Māori protest, with events such as the 1975 Land March, the 1978 occupations of Bastion Point, and other significant iconic moments in Māori postcolonial resistance (see Introduction). Moreover, it was a period where the realization of Māori cultural renaissance was coming into fruition, especially through the revitalization of the Māori language and *tikanga* (Māori customary lore). In a global context, Māori were riding the wave of political protest and amplifying the minority voice that had traveled around the world since the American Civil Rights Movement. The name of the magazine itself is reflective of the political and social climate, with *Tu Tangata* meaning "people standing tall."

Examples of advertising in *Tu Tangata* are limited. Overall, advertising in the magazine was centered on products and services such as books and Māori-language courses, although awareness campaigns such as that by the New Zealand Human Rights Commission featured consistently throughout the issues sampled. This campaign was aimed at increasing the awareness about equal opportunity and outlines the legislation that governs discrimination in New Zealand and the areas in which it applies. The 1980s was a period when many Māori asserted their sovereignty and rights as the Indigenous people of New Zealand. As is already outlined, the events of the 1970s provided a fertile ground for fostering Māori resistance, including the Crown's recognition of its duties under the Treaty of Waitangi, which included institutional reform. Again, the inclusion of the 1977 Human Rights Commission Act within a government-sponsored magazine for an Indigenous population strongly indicates the infiltration of Indigenous rights discourses into at least some government institutions.

A specific example of product advertising is that of an Indigenous-themed novel. Throughout the issues sampled, there are various versions of advertisements from Penguin Books promoting the work of Māori authors. The advertisement promoting the novel *Potiki* by renowned Māori author Patricia Grace is typical. The advertisement simply shows an image of the book, with the title and author's name and a short summary. The advertising is representative of an increase in Māori-written and Māori-themed literature, which is also reflective of the Māori Renaissance period.

In the advertisements that did feature in *Tu Tangata,* English is the main medium of communication, while the use of the Māori language and Māori imagery had largely been culled in comparison to its predecessor, *Te Ao Hou*. This reflects the decline Māori culture had suffered due to colonization leading up to the publication of *Tu Tangata.* A noticeable feature of the *Tu Tangata* issues selected in this research is the overwhelming lack of advertising, with a mere 1 percent of physical space devoted to it in some issues. Given the impetus of the Māori Renaissance that arguably peaked in the late 1970s, the scarcity of Māori-targeted advertising conflicts with Cui's study in the U.S. context, which found increased advertising when a minority group's visibility became more pronounced, as was the case for African Americans during and

Figure 5.4. Book advertisement, *Tu Tangata,* no. 29 (April–May 1986): 45. Reproduced with permission from Penguin Group (NZ).

following the Civil Rights Movement.[49] Yet, the millions of African Americans, in comparison to the approximately 200,000 Māori living at this time, demonstrates the practicalities of accountability.

Tu Tangata appears during what is referred to as the "Accountability Era" of advertising,[50] a period when advertising was held accountable to product demand. The lack of advertising may simply suggest that businesses held little confidence that advertising in *Tu Tangata* would convert to sales, due in part to the poor socioeconomic status of Māori. The dearth of advertising also reflects the absence of a Māori consumer identity, mirroring the lack of Māori financial resources symptomatic of the neoliberal

reform instigated by the 1984 Labour government. In summary, the prominent decline of Māori-targeted advertising during the period of *Tu Tangata* signifies a disinvestment in overtly state-sponsored biopolitical control of Māori. While token institutionalized recognition of Māori culture resulted from the high period of Indigenous resistance of the 1970s, in the mind of the state, the civilization, assimilation, and urbanization of Māori was largely complete and hence Māori social marketing became essentially obsolete, in the Accountability Era at least.

CASE STUDY THREE: *MANA* AND THE CONTEMPORARY CONTEXT

This section explores the contemporary practice of Māori print advertising through the most recognized "glossy" Indigenous-themed magazine in New Zealand, *Mana Magazine* (hereafter referred to as *Mana*). *Mana* was established in 1992 and remains a highly successful magazine today. A privately owned magazine, *Mana* is New Zealand's leading Māori lifestyle and current affairs periodical and is published bimonthly. The current editor of *Mana*, Derek Fox, states that the magazine's aim is to "provide a window on Māoridom [Māori society] for people to look through to see what we're up to."[51] It is important to note that the appearance of *Mana* is markedly different to its government-funded predecessors, *Te Ao Hou* and *Tu Tangata*. It has a glossy cover, is printed in color, and its appearance, cost, and marketing make it the Māori equivalent to high-end mainstream New Zealand magazines such as *North and South* and *Metro* (see chapter 2).

The nature of *Mana* indicates a target audience that has a higher level of disposable income and reflects an increasing "Māori middle class." While the impact of the global recession has not been completely accounted for yet, from 2003 to 2008 Māori personal income increased by 36 percent.[52] In 2008, an ACNielsen survey showed that *Mana* readership was approximately 136,000; an increase of 14,000 readers over the previous twelve months' readership of 122,000, demonstrating *Mana's* improving saleability. A majority of the readers are Māori, while 40 percent ticked both the Māori and Pākehā ethnicity boxes when completing the survey.[53] The magazine's glossy appearance and general subject matter indicates that the publishers aspire to affirm Māori success stories, target a higher-end Māori audience and, by association, project a new Māori consumer identity.

Since *Tu Tangata* was published in the 1980s, statistics demonstrate a relatively recent increase in economic activities by Māori. Māori have assets in lands, fisheries, and forestry (e.g., *iwi* conglomerates), and are increasingly participating in business.[54] A recent document published by the Māori Economic Taskforce and prepared by Business and Economic Research Limited (BERL) estimated the Māori asset base to be worth approximately NZD$36.9 billion.[55] There have also been a raft of social improvements symbiotic with an increasing awareness of a Māori consumer identity. Māori forms of tertiary education have been established such as Te Whare Wānanga o Aotearoa, Te Wānanga o Raukawa, and Te Whare Wānanga o Awanuiārangi, leading to an

Figure 5.5. Front cover, *Mana Magazine*, no. 94 (June–July 2010). Reproduced with permission of photographer Aaron Smale.

increase in tertiary-educated Māori. New media streams such as Māori Television have been launched, and industries such as tourism have (not unproblematically) employed Māori imagery, symbols, and cultural icons to attract the global market. To some degree, Māori culture has become "mainstream."

To this effect, there is an emerging Māori middle class who are educated and, as a consequence, have higher salaries and more disposable income.[56] Yet, in the main, the New Zealand media tends to focus on Māori deprivation and crime and still insists on painting a picture of Māori as either "saints or sinners." Meanwhile, the burgeoning Māori middle class, apparently neither highly desirable or highly undesirable, remains invisible to most sectors of society, business in particular.[57] Ata Te Kanawa, a Māori business women, states, "I often have to battle with marketing graduates straight out of university who don't get it; who don't think we're credible consumers. . . . It's like they think we are all tragic."[58]

Including the Auahi Kore example provided in the introduction to this chapter, three advertisements have been selected from the sampled issues of *Mana*. Each advertisement represents three major themes of advertising featured in the magazine. The first, as already discussed, is a social marketing advertisement for the Smokefree organization. The second is an advertisement for tertiary education in the advertorial style that dominates this category. The final example advertises Designer Headstones.

The editorial-style advertisement is for the New Zealand tertiary provider, the University of Otago. University of Otago advertisements have become a regular feature in *Mana*, typically located on the inside front cover. Taking two full pages, this coveted advertising space has high visibility as it gains the reader's immediate attention. The advertisement featured here is typical of similar advertising by other tertiary institutions in *Mana*. The advertorial style, in its profiling of either students or members of

Figure 5.6. University of Otago advertisement, *Mana Magazine*, no. 85 (December–January 2008–9): inside front cover. Reproduced courtesy of the University of Otago.

staff, replicates the form of an article and, as a consequence, could be mistaken for an article. This is especially so for *Mana* because the advertisements closely resemble the main feature reportage of the magazine, which typically relay life-narratives of successful Māori.

The *Mana* advertisement profiles student Sam Taylor. The "article" presents his journey at the University of Otago and celebrates his successes. His story ends with introducing his *whakapapa* (genealogy) and *iwi* affiliation. Below the "article" there is an image of Sir Peter "Te Rangihīroa" Buck, believed to be the first Māori medical graduate and the first Māori to graduate from the University of Otago.[59] The advertisement thus establishes a clear lineage between the university's history of graduating Māori leaders and contemporary students. There is then a statement relating to Māori scholarships that are available. The advertisement does not use Māori imagery or language to target its audience. The image of Buck, the student's *iwi* affiliations, and the mention of Māori scholarships are the only references to things Māori. The concentration of tertiary-education advertising within *Mana* signifies that the targeted audience are educated Māori, but also that the genealogy of social marketing to Māori continues to be fostered.

The second *Mana* example is a commercial advertisement (Figure 5.7). While there are a number of products and services advertised in *Mana*, they are generally for other forms of media, such as Māori Television and *iwi* radio stations. This advertisement, for Designer Headstones, is one of the few advertising tangible consumer goods. The images show headstones that have Māori-inspired designs and information is provided regarding the company's ethos. While it is a simple advertisement, the use of Māori designs clearly demonstrates the desired target market. While it does not overtly link to Māori understandings of death and the high level of importance placed on *tangihanga* (the funeral process) and *hura kōhatu* (unveiling of the headstone), its existence as an advertisement does create this connection. This advertisement represents the small proportion of businesses that view Māori as legitimate consumers and have made the effort to target Māori appropriately.

The examples of advertising in *Mana* presented in this chapter provide a sample of the high level of advertising that makes up between 28 and 45 percent of the total magazine content in the issues analyzed. The sheer number of advertisements is a dramatic increase from the previous case studies, which may simply reflect that the survival and success of *Mana*, like any privately owned venture, is determined by its profitability. *Te Ao Hou* and *Tu Tangata* were both published out of the Department of Māori Affairs and therefore government-funded, meaning ideology took priority over profit. That is, advertisements were selected by the Department of Māori Affairs that befittingly represented desired behaviors and attitudes.

Yet, oddly, the social versus commercial marketing–oriented advertisements in *Mana*, as in their government-funded predecessors, tend to dominate. Approximately 58 percent of all advertising in *Mana* can be categorized as social marketing, with

Figure 5.7. Designer Headstones advertisement, *Mana Magazine*, no. 86 (February–March 2009): 11. Reproduced with permission of Richard Cornell, Designer Headstones.

products and services making up 25 percent, with the remainder relating to advertising of events such as Matariki (the Māori New Year). A majority of advertising income for *Mana* stems from government-funded organizations such as Auahi Kore and tertiary institutions. In a sense then, although the advent of *Mana* represents a growing "Māori middle class," the messages within the social marketing advertising tend to reify the notion of Māori as a "problem," in need of direction and propping up. Such an ideology has been a premise of New Zealand's colonial and postcolonial history and can be traced back to the civilizing discourses of the nineteenth century. This is despite Māori proportionately exceeding other ethnic groups in tertiary education. For example, in 2008, 19.1 percent of Māori aged fifteen years or over were enrolled in tertiary institutions of all forms, from polytechnics to *wānanga*.[60] Reflecting these figures, social marketing is the cornerstone of advertising in *Mana* and is well developed in terms of the use of language, imagery, and linkage to Māori concepts, which demonstrates a conscious and Māori-informed effort to target Māori. Thus, while the very concept of a "glossy" Indigenous magazine reflects a change in class structures, the predominant messages within the magazine reestablish the kinds of social marketing signs instituted by the government in earlier magazines.

Conclusion: Targeting Māori

This chapter has explored Māori-targeted print media advertising in New Zealand. The case studies presented from *Te Ao Hou, Tu Tangata,* and *Mana* demonstrate

various trends in advertising, most of which reflect the social and political issues of their respective times. Significantly, they show that social marketing, or desire to change behaviors, remained the predominant discourse. It is suggested that the continued social marketing focus of advertising targeting Māori reflects the general discourse within New Zealand, as bolstered and supported by statistics and other media outlets, such as the news media, which infer Māori culture and people remain in a social crisis. The "invented" Māori identity that has been portrayed by advertising is one of an undesirable, impoverished, uneducated and socially deficient consumer and therefore citizen. It should be remembered that the "Māori problem" discourse has served to underpin the state treatment of Māori since the early colonial period and in so doing has laid the blame for the failure of the state to accommodate authentic recognition of Māori culture and the failure of Māori within the state system at the feet of Māori themselves.

Yet, contrary to such a discourse is evidence that demonstrates an increased economic involvement by Māori. Māori have assets in lands, fisheries, and forestry, and an increased participation in tertiary education and business.[61] Despite this, ethical concerns present in ethnic marketing are still present, particularly in the case of Māori, whereby inadvertent stereotypes are perpetuated through constant social marketing highlighting Māori social deficits. The irony of Māori-targeted social marketing in regards to smoking as presented at the beginning of this chapter is that the state is now trying to reverse the effects of early tobacco advertising and yet its social marketing, unintentionally, is perpetuating a subtler form of a negative Māori stereotype. Globally, advertising asserts the need for people to consume and with that consumption and so-called contribution to the economy can come the rights and privileges of citizenship. The more you are seen to consume, the more desirable a consumer and therefore citizen you become. For Māori, the impact of colonization has left them with social issues which, in advertising, continue to be perpetuated, advertently or inadvertently. Consumption is the price you pay for citizenship.

Notes

1. Richard W. Pollay and Katherine Gallagher, "Advertising and Cultural Values: Reflections in the Distorted Mirror," *International Journal of Advertising* 9, no. 4 (1990): 359–72.
2. Ibid.
3. Pollay suggests that advertising is a "distorted mirror" that models and reinforces only the lifestyles, attitudes, and behaviors that serves the sellers' interests. He further states that a culture will change to fit the persistently reflected philosophies asserted in advertising. See Richard W. Pollay, "The Distorted Mirror: Reflections in the Unintended Consequences of Advertising," *Journal of Marketing* 50, no. 1 (1986): 18–36.
4. Ibid., 23.
5. John Broughton, *Puffing Up a Storm: Ka Pai Te Torori!* (Dunedin, N.Z.: Te Roopu Rangahau Hauora Māori o Ngāi Tahu, 1996).

6. Vanessa Oxley, "The Impact of Becoming or Wanting to Become Smokefree for Māori" (master's research report, University of Otago, Dunedin, N.Z., 2004), 9–10.

7. Ibid., 10.

8. Cited in Charis Brown, "Cultural Appropriation: Use of Minority Culture within a Commercial Environment" (master's research report, University of Otago, Dunedin, N.Z., 2005), 26.

9. The Health Sponsorship Council is a New Zealand government agency that promotes healthy lifestyles and develops and delivers the Auahi Kore programs and brand. See http://www.aua hikore.org.nz.

10. Meeting houses or *whare tipuna* are the carved (usually) buildings that are the centerpieces of *marae* (meeting places). The patterns and symbols used in the carved meeting houses reflect genealogical connections for those associated with that meeting house to their ancestors and the customary narratives of that place.

11. Michael King, *Te Ao Hurihuri: The World Moves On* (Wellington: Hick, Smith & Sons, 1975), 5.

12. For further readings in this area see Carter Meyer and Diana Royer, *Selling the Indian: Commercializing and Appropriating American Indian Cultures* (Tucson: University of Arizona Press, 2001).

13. Arlene Davila, *Latinos, Inc.: The Marketing and Making of a People* (Berkeley: University of California Press, 2001).

14. Ibid.

15. Here marketing is referred to as a social and managerial process that is used by individuals and groups to obtain what they need and want by creating and exchanging products and value with others. See Philip Kotler, Linden Brown, Adam Stewart, and Gary Armstrong, *Marketing* (Frenchs Forest, New South Wales: Pearson Prentice Hall, 2004), 8.

16. Michael J. Etzel, Bruce J. Walker, and William J. Stanton, *Marketing*, 14th ed. (Boston: McGraw-Hill/Irwin, 2007), 142.

17. Kotler et al., *Marketing*, 107.

18. In general, marketing researchers have conceived of ethnicity in relation to racial group membership and on the basis of commonly shared features. See Ahmad Jamal, "Marketing in a Multicultural World: The Interplay of Marketing, Ethnicity and Consumption," *European Journal of Marketing* 37, nos. 11–12 (2003): 1601. This definition implies stability, due to the biological determinism that underpins the notion of "race." Further, this connection infers that ethnicity is linked to genetics. Such definitions lean toward an objectivist perspective, which suggests that ethnic groups can be identified by aspects such as surnames, country of origin, paternal ancestry, or area of residence. See Guilherme D. Pires and John Stanton, "Ethnic Marketing Research and Practice: A Framework for Analysing the Gap," in *Australia and New Zealand Marketing Academy Conference Proceedings and Refereed Papers* (Dunedin, N.Z., 2007), 1215. Other marketing definitions of ethnicity, however, move away from fixed objectivist notions. For instance, one definition recognizes ethnicity as having three defining characteristics: perception by others that the group is unique; perception by members of the group that they are unique; and that the group has some internally consistent behavior. See Guilherme D. Pires and John Stanton, *Ethnic Marketing: Accepting the Challenge of Cultural Diversity* (London: Thomson Learning, 2005), 7.

19. Sonny Nwankwo and Andrew Lindridge, "Marketing to Ethnic Minorities in Britain," *Journal of Marketing Practice* 4, no. 7 (1998): 200.

20. Pires and Stanton, *Ethnic Marketing*, 3; Guilherme D. Pires and John Stanton, "Marketing Services to Ethnic Consumers in Culturally Diverse Markets: Issues and Implications," *Journal of Services Marketing* 14, no. 7 (2000): 607.

21. Phil Cohen maps the history and evolution of the term "ethnicity" along with its bedfellows "race" and "nation." See Phil Cohen, ed., *New Ethnicities, Old Racisms?* (London: Zed Books, 1999). He claims that for the postwar Western intelligentsia the three terms were all considered negative and thenceforth marginalized as inappropriate social descriptors. "Ethnicity" was "a throwback to forms of culture and consciousness that modernity had long since relegated to the margins of history" (ibid., 1). Similarly, "race" was pushed to the periphery because of its negative usage via fascism. The racist theories of intelligence and eugenics, which were central to World War II, meant it was not acceptable to use the term "race" in official discourse (ibid.). After the Cold War and the surge of decolonization throughout the world, connotations surrounding the term "ethnicity" changed and it became recognized as a permeable and open-ended descriptor of identity. More recently, minority groups have taken the negative stereotypes created by dominant society and turned them into "badges of pride." "Ethnicity" was no longer "negative" but instead became "soul food" and "race" was given a "new rationality." See Satyananda J. Gabriel, *Racism, Culture, Markets* (London: Routledge, 1994; cited in Cohen, *New Ethnicities, Old Racisms?*, 2). In the 1980s, a new theoretical paradigm including the notion of "new ethnicities" was introduced by Stuart Hall. Hall theorized that identities had moved away from their roots in singular histories of race and nation and toward the insistence that ethnicities were invented and modern (Gabriel, *Racism, Culture, Markets,* 5–7).

22. In a literature review conducted by Geng Cui on scholarly studies of ethnic minorities in marketing publications, three stages of development in research in this area were discovered. The first stage, the thematic stage, showed that researchers focused on identifying research questions and seeking evidence in advertising. Issues such as the lack of representation of ethnic minorities in advertising and the belief that ethnic minorities were underserved by marketing were generally at the forefront. The next stage was the problematic stage, where researchers shifted to identify problematic practices in marketing to minorities and their causes. Problems such as the heterogeneous nature of ethnic groups and the debate about the necessity for separate advertising for different ethnic groups were researched during this stage. The final stage was the practical stage. This stage saw researchers seeking practical solutions to some of the existing problems in this area of research. See Geng Cui, "Marketing to Ethnic Minorities: A Historical Journey," *Journal of Macromarketing* 21, no. 1 (2001): 23–31. Cui's review has led to theories being developed such as the cultural distinctiveness theory developed in Rohit Deshpande and Douglas Stayman, "A Tale of Two Cities: Distinctiveness Theory and Advertising Effectiveness," *Journal of Marketing Research* 31, no. 1 (1994): 56–64. This theory suggests that an ethnic minority will respond positively when a spokesperson of their own ethnic background is used in advertising.

23. Dennis Cahill, *Lifestyle Market Segmentation* (New York: Haworth Press, 2006), 60.

24. Cui, "Marketing to Ethnic Minorities."

25. See Irena Ateljevic, "Representing New Zealand: Tourism Imagery and Ideology," *Annals of Tourism Research* 29, no. 3 (2002): 648–67; Maggie Asplet, "Cultural Designs in New Zealand Souvenir Clothing: The Question of Authenticity," *Tourism Management* 21, no. 3 (1996): 307–12; and Jeffrey Sissons, "The Systemisation of Tradition: Maori Culture as Strategic Resource," *Oceania* 64, no. 2 (1993): 97–116.

26. Jayne Krisjanous and Matene Love, "Effective Marketing to Māori," in *The New Zealand Marketing Environment*, ed. M. Rod (Boston: McGraw-Hill, 2005), 32.

27. Ibid.

28. Commercially unattractive statistics include low personal and household incomes, disproportionately poor health, and high levels of incarceration. For example, the Māori median weekly income is NZD$500 compared to NZD$537 for the total population.

29. Philip Kotler and Gerald Zaltman, "Social Marketing: An Approach to Planned Social Change," *Journal of Marketing* 35, no. 3 (1971): 5.

30. Philip Kotler, Ned Roberto, and Nancy Lee, *Social Marketing: Improving the Quality of Life* (Thousand Oaks, Calif.: Sage, 2002), 5.

31. Te Puni Kokiri, *Hauora Māori: Māori Health*, 2009 [online], http://www.tpk.govt.nz/en/in-print /our-publications/fact-sheets/maori-health/.

32. Ibid.

33. NCEA Level 2 is the equivalent of the U.K. sixth form, or U.S. eleventh grade (junior year) of high school.

34. Kirihimete Moxon, "It's about Advertising": Understanding Māori Focused 'Self-Help' Advertisements and the Perpetuation of Stereotypes" (master's research report, University of Otago, Dunedin, N.Z., 2005), 8.

35. Ibid., 10.

36. This department is now named "Te Puni Kōkiri, the Ministry of Māori Development." Te Puni Kōkiri, like its predecessor the Department of Māori Affairs, "is the Crown's principal adviser on Crown-Māori relationships [which] also guide[s] Māori public policy by advising Government on policy affecting Māori wellbeing and development. Te Puni Kōkiri means a group moving forward together. As the name implies, [it] seek[s] to harness the collective talents of Māori to produce a stronger New Zealand." See the Te Puni Kōkiri website, http://www.tpk.govt.nz/en/.

37. Ministry of Culture and Heritage website, http://www.nzhistory.net.nz/media/photo/te-ao-hou.

38. For more information about the effects of Māori urbanization see M. C. Woods, "Integrating the Nation: Gendering Māori Urbanisation and Integration 1942–1969" (PhD thesis, University of Canterbury, Christchurch, N.Z., 2002).

39. Department of Statistics, *New Zealand Census 1956* (Wellington: Government Press, 1956): 6.

40. Ranginui Walker, *Ka Whawhai Tonu Mātou: Struggle without End* (Auckland: Penguin Books, 1990), 197.

41. See ibid.

42. *Te Ao Hou*, no. 13 (December 1955), 4, http://teaohou.natlib.govt.nz/journals/teaohou/issue /Mao13TeA.html.

43. Ibid.

44. Jason Chambers, *Madison Avenue and the Color Line: African Americans in the Advertising Industry* (Philadelphia: Pennsylvania University Press, 2007).

45. J. R. Rosenfeld, *Island Broken in Two Halves: Land and Renewal Movements among the Maori of New Zealand* (University Park: Pennsylvania State University Press, 2010), 192.

46. Anne McClintock, "Soft-Soaping Empire: Commodity Racism and Imperial Advertising," in *The Visual Culture Reader*, ed. Nicholas Mirzoeff (London: Routledge, 2002), 508.

47. Alissa Goddard, "Consumption as Lifestyle: The Use of Western Lifestyle as a Status Symbol in Multinational Corporations' Advertising in India," *ISP Collection,* Paper 811 (2009), 17.

48. McClintock, "Soft-Soaping Empire," 507.

49. Cui, "Marketing to Ethnic Minorities," 23–31.

50. Sandra E. Moriarty, Nancy Mitchell, and William Wells, *Advertising: Principles and Practice* (Upper Saddle River, N.J.: Pearson Prentice Hall, 2009).

51. "More People Reading Mana Magazine, " *Mana Magazine* press release, http://www.scoop.co .nz/stories/BU0805/S00546.htm.

52. Te Puni Kokiri, *Whakawhiwhinga Whaiaro a Ngāi Māori: Māori Personal Income*, 2009 [online], http://www.tpk.govt.nz/en/in-print/our-publications/fact-sheets/maori-personal-income/.

53. "More People Reading Mana Magazine."

54. E. Light, "Market to Māori. Key Mistakes: Key Remedies," *Marketing* 18, no. 6 (1999): 1.

55. Ganesh Nana, Fiona Stokes, and Wilma Molano, *The Asset Base, Income, Expenditure and GDP of the 2010 Māori Economy* (Wellington: BERL, 2011).

56. C. Courtney and J. Wane, "Māori in the Middle," *North and South*, no. 267 (2008): 36.

57. Ibid.

58. Ibid., 38.

59. Sir Peter Buck, also known as Te Rangihīroa, was a prominent Māori scholar from the early 1900s until his death in 1951. Upon graduating from the University of Otago, he dedicated much of his life to public health and also politics. He was a medical officer for the First Māori Infantry in World War I. He spent twenty-five years studying in the Pacific and published many notable scientific articles, monographs, and books on Polynesian culture. Beaglehole 1966, Te Ara website, http://www.teara.govt.nz/en/biographies/3b54/buck-peter-henry.

60. Ministry of Education, *Participation Rates*, 2008 [online], http://www.educationcounts.govt.nz/publications/ece/2551/34702/part-3---tertiary.

61. Light, "Market to Māori," 1.

PART II *Indigenous Media: Emergence,*
Struggles, and Interventions

6. *Theorizing Indigenous Media*

BRENDAN HOKOWHITU

[Māori] are aware of how negatively we are portrayed in television, in film and in newspapers . . . [and] are becoming increasingly aware that at some stage in this media game, we must take control of our own image . . . only when we do that, only when we have some measure of self-determination about how we appear in the media will the truth be told about us. Only when we have control of our image will we be able to put on the screen the very positive images that are ourselves, that are us.

—Merata Mita, "The Value of the Image," cited in
Leonie Pihama, "Re-Presenting Maori"

IN ARIZONA IN THE MID-1960S, Sol Worth and John Adair carried out a unique project, which later led to their 1972 book *Through Navajo Eyes: An Exploration in Film Communication and Anthropology.*[1] The project was revolutionary. First, it veered away from the traditions of Western rationalism and anthropology by acknowledging that the Navajo might see the world differently than Western eyes, signifying a multi-lensed reality. Second, the researchers "put the means of production and representation into the hands of indigenous people . . . teaching filmmaking to young Navajo students without the conventions of western production and editing, to see if their films would reflect a distinctively Navajo film worldview."[2] Worth and Adair's vision is outlined in the opening paragraphs of their book:

Our object in the summer of 1966 was to determine whether we could teach people with a culture different from ours to make motion pictures depicting their culture and themselves as they saw fit. We assumed that if such people would use motion pictures in their own way, they would use them in a patterned rather than a random fashion, and that the particular patterns they used would reflect their culture and their particular cognitive style.[3]

While the importance of *Through Navajo Eyes* is hardly recognized in New Zealand, many of the underpinning ideas and problematics that the project's unique approach brings to bear can be seen resurfacing as Indigenous people have attempted to define Indigenous media. For instance, central to the above quote is the thesis that if

Indigenous people control media technology then, in this case, the filmic production will reflect the "patterns" and "cognitive style" of Indigenous epistemic knowledge.

The development of Indigenous-controlled media has largely occurred because Indigenous peoples have witnessed their misrepresentation and nonrecognition by others. In defining "the politics of recognition" in relation to what he refers to as "subaltern groups," Charles Taylor suggests that

> identity is partly shaped by recognition or its absence, often by the *mis*recognition of others, and so a person or group of people can suffer real damage, real distortion, if the people or society around them mirror back a confining or demeaning or contemptible picture of themselves. Nonrecognition or misrecognition can inflict harm, can be a form of oppression, imprisoning someone in a false, distorted, and reduced mode of being.[4]

As the Introduction to this collection points out, in New Zealand, Indigenous claims to distinctive rights have occurred simultaneously with the development of Indigenous media. A significant moment for New Zealand Indigenous media occurred in 2003 when the host of the annual Treaty of Waitangi celebrations, Ngā Puhi (a northern North Island *iwi*), banned mainstream media journalists from attending the annual pre-celebration gatherings because historically public sentiment had been so heavily

Figure 6.1. Keith Hawke, Waka Attewell, and Barry Barclay filming *Tangata Whenua* (Wellington: Pacific Films, 1974) at the Ngāti Porou Marae, Tikitiki, East Cape, April 25, 1974. Image courtesy of photographer Rick Spurway.

influenced by the news media's misrepresentation of these events. As Sue Abel points out, "Mainstream media had over the years continually overlooked what went on for several days at Waitangi, focusing instead on what was often merely a few moments of conflict."[5] The actions of Ngā Puhi at once recognized their historical misrecognition in mainstream media, while also creating the conditions for a space of self-realization.

Robert Young suggests the oppressive process of colonization in and of itself has initiated a "distinctive postcolonial epistemology and ontology."[6] Here, Young is suggesting that resistance to colonization itself has produced a postcolonial consciousness within Indigenous peoples, which in turn has led to Indigenous claims to distinctive rights. Indigenous media has largely been initiated as this consciousness burgeoned from the late 1960s onwards. Jane Dunbar in her analyses of the quality of critical news journalism in New Zealand finds that Māori news journalists created "parallel institutions to counter the monocultural depiction of their reality in mainstream."[7] Joanne Te Awa likewise finds that "'bad news,' stereotypical representation, invisibility and poor recruitment strategies [was] partly behind the growth of separate Maori media."[8] Thus, the actions of Māori news media reflect Merata Mita's call to "control our own image."

Yet, can controlling our own image be that straightforward? In *Postcolonial Cultures*, Simon Featherstone lays the groundwork for interpreting popular culture, including media, through some critical problematics that postcolonial theory is attempting to address. For instance, he asks:

> "Can the Subaltern Speak?" . . . Spivak's answer to her own question is a qualified "no." A primary condition of subalternity, she argues, is, in fact, a lack of position of speaking. For subalterns, the condition of being postcolonial is one of being relentlessly constituted in the discourses of power that control their situation and that lie beyond their agency . . . a warning about the limitations of the intellectual endeavour of postcolonialism, and a challenge towards its transformation and the creation of the space for that speaking and self-realisation.[9]

Gayatri Spivak's belief that the subaltern is "relentlessly constituted in the discourses of power" inherently relates to Indigenous politics of recognition and politics of appropriation, which this chapter will explicate. As a focus, this chapter unpacks the question "What is Indigenous media?" and, in doing so, locates Indigenous media within some of the key debates currently occurring in Indigenous studies.

Politics of Appropriation

For the purposes of this chapter, the politics of appropriation refers to the problematics surrounding the uptake of media technologies by Indigenous peoples, specifically in relation to decolonization. As Mita argues,

> I can unite the technical complexity of film with a traditional Māori philosophy that gives me a sense of certainty, an unfragmented view of society, and an orientation towards people

rather than institutions. This gives me the passion and intensity . . . it means I'm just not
motivated. I'm driven.[10]

Media analyst Jo Smith questions the emancipatory potential for Māori culture when
employing media composite of "the very tools (print and audiovisual media) that
have contributed to its marginalisation in New Zealand society," asking "what are
the transformative potentials of [the Māori Television Service] on air?"[11] Also in rela-
tion to the advent of the Māori Television Service (hereafter "Māori Television"), Ian
Stuart suggests, "Maori media are acting more like the mainstream media in that
they run public debates, reporters challenge and question leaders and hold up some
decisions and ideas to public scrutiny."[12] It is possible Stuart is arguing that the prac-
tices of Māori Television, as a state-incorporated entity, merely reflects the ideology
of their sponsors.

Yet, are Stuart's criticisms merely false expectations based on the presumption
that Indigenous media must be antithetical to mainstream media? For Ronald
Niezen, "a corollary of this attitude towards aboriginal cultures is suspicion, rejec-
tion or misjudgement of their adaptation to conditions of modernity."[13] As Faye
Ginsburg notes in relation to the auto-ethnographic filmmaker, "anthropologists
have been known to question the so-called authenticity of an indigenous person's
identity because he or she was using a camera."[14] Ginsburg goes on to quote Kayapo
video-maker Mokuka: "Just because I hold a white man's camera, that doesn't mean
I am not a Kayapo. . . . If you were to hold one of our head-dresses, would that make
you an Indian?"[15]

Underpinning Mokuka's sarcasm is a critique of the prevalent discourse that sug-
gests "those aboriginal societies that stray too far from the path of Palaeolithic values
and technology are unworthy of rights and respect due to distinct societies."[16] The
point seems almost as ludicrous as the tourist who arrives in New Zealand expecting
Māori to be running around in grass skirts, yet it reflects a serious issue given that
Indigenous peoples lose their right to legal claims when they become inauthentic, that
is, when their claims to legal distinctiveness are devalued if interpreted to be inau-
thentic and hybridized. It is important that the discussions surrounding Indigenous
media and the politics of appropriation move beyond binary notions of modernity
and tradition, however, for clearly there is no credence in the claim that the use of
available media technologies by Indigenous groups somehow makes Indigenous peo-
ples less authentic or traditional.

It is also important to dispel the mistaken notion that either Indigenous culture is
colonized by media technologies or that media technologies are completely revamped
and used for the processes of decolonization. The relationship is significantly more
complex then such a binary allows for. A more productive way to conceive of this rela-
tionship is through the notions of hybridity and appropriation. The politics of appro-
priation, in this sense, constitute "the relationship between those who have the

authority to fix the meaning of a sign and those who seek to appropriate signifiers for their own ends through transforming the signified to create other meanings, alternative identities, and new forums for recognition."[17]

Pertinent here is Michel de Certeau's *The Practice of Everyday Life,* in which the political is reconstituted to include practices of cultural appropriation.[18] For example, the indigenization of media suggests the interaction of Indigenous people with their postcolonial environment produces political instruments out of those previously imperial tools. Cheung Siu-woo argues that "the appropriation of imposed symbolisms by marginalized groups to be unavoidable";[19] in other words, tactics of appropriation "always invoke and transform fields of power."[20] Thus, critical Indigenous media as defined here can contain those instruments of subordination that have been transformed to hold new political resonance and aid integrating Indigenous sovereignty into the social field.

In short, the politics of appropriation in conjunction with notions of hybridity suggest that the appropriation of mediated signs, methods, and even genres by Indigenous communities can enable new Indigenous frames of resistance to arise. Through her notion of "visual sovereignty," for instance, Michelle Raheja suggests that the appropriation of film by Indigenous groups makes possible an alternative reality that contravenes typical filmic methodology. Raheja argues that in *Atanarjuat: The Fast Runner* (2000),[21] for example, a significant alterity occurs through "pacing and attention to landscape"[22] including "slow pans of the landscape, the quotidian actions of the characters as they find and prepare food, and shots of things such as feet crunching through the snow."[23] The approach "take[s] the non-Inuit audience hostage, successfully forcing us to alter our consumption of visual images to an Inuit pace, one that is slower and more attentive to the play of light on a grouping of rocks or the place where the snow meets the ocean."[24]

In New Zealand, Indigenous peoples have also employed similar tactics of appropriation. For instance, *iwi* (peoples) radio brings a definitively Indigenous style to broadcasting that is community-based and particular to *iwi* mores. These include scheduling, pacing, the use of collective address, and the use of *karakia* (spiritual recitations), *waiata* (songs), and *whakataukī* (proverbs). Likewise, while Māori Television employs genres and formats borrowed from mainstream commercial television (e.g., news, sports, lifestyle programs, reality TV, documentaries), the product is a hybrid televisual text, which departs from the discursive regiments that govern mainstream commercial television. The presentation of the weather, for instance, in the typical format following the news, becomes indigenized by using a map that "renames the nation" employing Māori place names. Such "renaming" may be considered tokenistic, yet to literally view "the nation" through Indigenous mapping on a daily basis is epistemic. In many ways, Māori Television's use of media technologies reflects what Lisa Parks in her book, *Cultures in Orbit: Satellites and the Televisual,* refers to as "territorial reclamation and cultural survival."[25]

Parks's attention to "survival" is important to consider in any theorization regarding Indigenous media. That is, Indigenous communities more than others face socioeconomic hardship that barely figures into "culturalist" accounts of Indigenous media. Here, Featherstone suggests, "the 'real' in this case is the already-existing economic, social, and cultural plight of [Indigenous] people,"[26] their existential material reality that is seldom accounted for in culturalist *re*visioning. As this chapter goes on to explicate below, Indigenous existentialism is an important concept to analyze through Indigenous media because not only does it foreground the "everyday" facticity of the Indigenous condition, it also suggests a movement away from the politics of recognition toward Indigenous responsibility and choice, so that "survival" becomes less about being determined by others, and more about making choices that benefit Indigenous communities.

Moreover, while academics (myself included)[27] criticize the infiltration of non-Indigenous media into Indigenous communities, at times there are significant socioeconomic benefits for those Indigenous communities involved. In commenting on the 1922 film *Nanook of the North,* Raheja is "hesitant to disregard the complicated collaborative nature of the film's production,"[28] specifically, community involvement "as technicians, camera operators, film developers, and production consultants."[29] Likewise, Ginsburg makes clear the socioeconomic benefits of Indigenous-owned media companies. For instance, the 75 percent Inuit-owned Igloolik Isuma Productions, Inc. is "Canada's first Inuit independent production company"[30] and provides "more than 100 Igloolik Inuit, from the young to the elderly" with employment "as actors, hairdressers, and technicians, as well as costume makers, language experts, and hunters who provided food, bringing more than $1.5 million into a local economy that suffers from a 60 percent unemployment rate."[31] Essentially then, the facticity of Indigenous communities must be a pivotal concern when analyzing the merits of media.

To conclude this section, I refer to Kimber Charles Pearce's work, which defines "generic appropriation" as "the making over and setting apart as one's own the substantive stylistic, and situational characteristics of a recurrent rhetorical form."[32] She discusses generic appropriation in relation to how late 1960s radical feminists mimicked the manifestos of patriarchal groups. Pearce argues that

> radical feminists appropriated the generic elements of the manifesto as a form of historicism that challenged the authority of male history and guided feminist action in response to that history. . . . The radical feminists' appropriation of the manifesto form demonstrates how rhetors may transform a genre into one of a different symbolic action with a new rhetorical purpose. However, in some ways, generic appropriation constrained radical feminists' rhetoric to the prior discourse of the patriarchy to which they were opposed.[33]

At the heart of Pearce's perception is what Siu-woo calls the "the Janus faced quality of appropriation,"[34] which also lies at the center of Spivak's question above. For Indigenous media the tension reverberates around the question, "How can Indigenous people produce media that does not merely answer the call of imperial rationalism?"

That is, represent the Indigenous Other within frames understandable to Western cognition. This line of questioning leads to the broader analyses of the politics of recognition, a core problematic within current Indigenous Studies, and one I suggest should underpin Indigenous Media Studies.

Politics of Recognition

In relation to this chapter, the politics of recognition resemble the politics of appropriation because their central problematic asks, "What is at stake in locating Indigenous epistemes within Western frames, whether those frames be Western media technology in terms of appropriation, or the rhetoric of colonial compensation in terms of recognition?" For the purposes of this chapter, the politics of recognition refers to the systemic problematics surrounding the production of Indigenous media via state-funded "Indigenous media" entities. Specifically, this means the way that Indigenous groups are afforded recognition via the state's accommodation of Indigenous media practices and the subsequent discursive appropriation of Indigenous culture. The advent of Māori Television in 2004 provides an example for discussion because it represents an Indigenous media outlet driven by a Māori desire to be provided with state funding, originally contested through the Treaty of Waitangi via the language of compensation for historical wrongs and, in particular, the denigration of Māori culture and language. Accordingly, the manifesto produced specifies Māori Television's role in the revival of culture and language.

In the quote below, Dene scholar Glen Coulthard neatly outlines the language of recognition that has become central to the interface between Indigenous groups and various postcolonial states.

> Over the last 30 years, the self-determination efforts and objectives of Indigenous peoples . . . have increasingly been cast in the language of "recognition"—recognition of cultural distinctiveness, recognition of an inherent right to self-government, recognition of state treaty obligations, and so on . . . [a process that] promises to reproduce the very configurations of colonial power that Indigenous demands for recognition have historically sought to transcend.[35]

The language of recognition reveals "the condition of being postcolonial," "of being relentlessly constituted in the discourses of power." In New Zealand, the creation of Māori as a "Treaty Partner," for instance, reflects the operationalization of a liberal pluralism underpinned by the delegation of resources to a select few Indigenous "brokers" who are supposed to and, to varying degrees do, represent discrete Indigenous groups. In turn, Māori and Māori culture are accommodated, recognized, imagined, and, partially at least, institutionalized within the nation-state.

The institutionalization, or what Will Kymlicka refers to as the "incorporation,"[36] of Māori Television within the state-funded national broadcaster calls into question

Figure 6.2. Advertisement for Māori Television, *Mana Magazine,* no. 100 (June–July 2011): back cover. Reproduced with permission of Māori Television.

what is at stake for both sides within a mutually dependent Indigenous–state relationship. That is, what are the conscious and unconscious conditions of the pact? Spivak would argue that the voice Māori Television produces will ultimately be reconstituted to resemble a "re-orientalized" Indigenous identity, particularly because it is an entity funded by the state and thus by definition demands both discursive and nondiscursive synthesis of indigeneity within Western forms of knowing. In other words, state

compensation for historical wrongs is repaid in kind by the biopolitical production of a recognizable Treaty Partner. The state, whether tacitly or otherwise, fundamentally expects their "sovereign governance" over all their subjects to remain intact and thus the terms of recognition produced means the "foundation of the colonial relationship remains relatively undisturbed."[37] Indigenous media with radical intent, that is, Indigenous media that desires Indigenous sovereignty or the disruption of state governance cannot, I suggest, exist within this relationship of mutual recognition. Accordingly, central to one definition of Indigenous media is independence of will, the freedom and responsibility to represent oneself. The cost of such a definition would undoubtedly be, as things stand in New Zealand at least, nonrecognition and, therefore, a lack or loss of state funding.

If one accepts that state-incorporated Indigenous media has the possibility of biopolitical production, the question becomes, "To what extent can a culture change beyond the juridical construction of 'Indigenous' before it loses its rights to indigeneity?" Critical to the politics of recognition are the notions of tradition and authenticity that haunt discourses of indigeneity, and the degree to which the production of Indigenous culture resembles a pacified version of radical Indigenous alterity. While the reimbursement of language and "culture" has been central to the mutual dependency of the Treaty partners in New Zealand and to the Māori cultural renaissance in general, seldom have Māori academics (and Indigenous academics in general) problematized what they mean by "culture."

The question of culture is central to the politics of recognition, for as Spivak argues, the biopolitical production of postcolonial indigeneity merely reflects a "reorientalization," while the eventualities of Indigenous resistance movements have in many cases produced unhealthy and prolonged cultural essentializations, which have led to an Indigenous form of necropolitics.[38] Black activist Cornel West argues that "Third World authoritarian bureaucratic elites deploy essentialist rhetorics about 'homogenous national communities' and 'positive images' in order to repress and regiment their diverse and heterogeneous populations."[39] Along similar lines, Homi Bhabha's criticism of Edward Said focuses on his monolithic construction of power in the colonies. Bhabha's criticism of Said in relation to representation is particularly important to Indigenous media and the politics of recognition:

> There is always in Said, the suggestion that colonial power and discourse is possessed entirely by the colonizer, which is a historical and theoretical simplification. The terms in which Said's Orientalism is unified—the intentionality and unidirectionality of colonial power— also unify the subject of colonial enunciation. This is a result of Said's inadequate attention to representation as a concept that articulates the historical and fantasy (as the scene of desire) in the production of the "political" effects of discourse.[40]

Here, Bhabha is signaling that more complex analyses of the subject of colonial enunciation move beyond the colonizer/colonized binary. The definition of Indigenous subjectivity (i.e., what representation of indigeneity is assigned the voice of authenticity)

and, subsequently, to the rights to postcolonial grieving, treaty claims, and privilege is related to the processes of "ethnic formalization," particularly through the concepts of authenticity, tradition, and culture.

In relation to state-funded Indigenous media, there are very real impacts of the "political effects of discourse," where a handful of Indigenous people are chosen to govern and to determine, for instance, programming. This relationship between state broadcasting and those "Indigenous elites" incorporated with responsibility is important to interrogate. Kevin Bruyneel, for example, is correct in establishing that the "third space of indigenous sovereignty,"[41] as he calls it, exposes the contingencies of colonial rule. One of these contingencies must be how individual Indigenous people negotiate sovereignty on behalf of others. Given a "lobbying divide,"[42] there are merely a few Indigenous elites able to mediate the production of Indigenous knowledge within Western frames, resulting in the production of certain Indigenous subjectivities while others are left to die[43] (see chapter 1), which in some instances must involve complicity to exclude the realities of those Indigenous subjectivities who have been most disenfranchised by colonization. Thus, what role does Māori Television play in the biopolitical reproduction of heterogeneous Indigenous populations? The production of "Māori culture" as a unitary form of Indigenous subjectivity is legitimized by the series of discourses that animate its reality, "like an organism with its own needs, its own internal force and its own capacity for survival."[44] Māori Television as a state-funded broadcaster is merely one chamber of the organism serving to "produce" Māori as a "strategic possibility" that enables disparate statements to be perceived as natural accumulations.

On the flip side of the above arguments is the concern that such theorization hastens Indigenous people to discard those political notions of culture at the forefront of Indigenous rights, "the very identities, narratives and analytical tools that had charged a long history of popular anti-colonial struggles."[45] Spivak's notion of "strategic essentialism" is important in the figuring of any Indigenous media, yet it is more important to ask, "When do such essentialisms stop being strategic and become inhibitive?" For example, when does the notion of "tradition" as framed through Indigenous media serve to rejuvenate and when does it serve to restrain? Here Māori academic Paul Meredith suggests "tradition," within the context of ethnic formalization, "is not only utilised as a normative guide but also to establish and sustain a citizenship which is structured around subordinate/dominant power relations and inclusive/exclusive membership."[46] In sum, what is the cost of recognition? In the act of desiring recognition, what choices do Indigenous peoples lose? Or simply do we lose choices? That is, while Indigenous groups may gain, for instance, short-term economic gains via neocolonial political structures, the cost of such gains is autonomy; the right to construct Indigenous identity as Indigenous peoples deem appropriate. Will choices of political recognition through state bodies especially (which inherently relocate Indigenous groups within the colonizer/colonized binary) actually lead to outcomes of

self-definition, choice, and responsibility? The remainder of this chapter examines how Indigenous media has been defined thus far in light of these questions.

What Is Indigenous Media?

PAN-INDIGENOUS MEDIA

There has been a tendency to view the production of pan-indigeneity in general and in particular relation to media as a positive stage in the development of Indigenous resistance. Yet, what universal consciousness is being promoted via pan-Indigenous media? How are Indigenous people increasingly being mediated through the generalizing idea of indigeneity, and what are the conceptual adhesives holding such an oxymoronic embryo together? More generally and in relation to the question of Indigenous rights, Niezen asks,

> "who is the subject of rights?" Indigenous peoples have . . . drawn new cultural boundaries, redefined themselves as nations, and, by implication, redefined the foundation of belonging for their individual members not only as kinship or shared culture but also as distinct citizenship, as belonging to a distinct regime of rights, entitlements, and obligations.[47]

With regard to the central problem of determining what Indigenous media is, it is therefore pertinent to locate the problematic within the relatively new discipline of "Indigenous Studies." Media scholars have for some time problematized media through notions of race and postcoloniality, and, consequently, the project of comprehending "Indigenous media" via conventional Cultural Studies methodologies may appear mundane. Yet, as the previous section highlights, when Indigenous media is viewed through those germane problematics current in Indigenous Studies, the inquiry takes on different meaning and provides new analyses.

First and foremost, as Niezen points out, the transnational politicization of "Indigenous" is a fairly recent development that requires redefinition of cultural boundaries. The politics of recognition for Indigenous people are undoubtedly related to what might be generally defined as a pan-Indigenous movement underpinned by decolonization. That is, as a direct result of the conscientization process stemming from the American Civil Rights Movement and the subsequent highly mediated Indigenous rights protest campaigns, settler colonial states have to varying degrees been coerced over the last forty years to recognize the distinctive rights of their Indigenous populations. At the same time, Indigenous scholars and practitioners have turned to methods and practices of "decolonization" that have in turn led to the advent of *decolonial theory.*

Decolonial theory has developed as *re*scholarship where alternative knowledges are *re*inserted into text so that Indigenous people can deconstruct occidental history to produce counter-histories. For instance, in her widely read text, *Decolonizing*

Methodologies, Māori scholar Linda Smith argues, "Transforming our colonized views of our own history (as written by the West) . . . requires us to revisit, site by site, our history under Western eyes. This in turn requires a theory or approach, which helps us to engage with, understand and then act upon history."[48] Prominent media theorists have likewise often interpreted Indigenous media in terms of *re*interpretation and *re*insertion of Indigenous culture into the fabric of a nation. Ginsburg notes the establishment of a burgeoning global Indigenous media network has opened the possibility for Indigenous communities to

> reenvision their current realities and possible futures, from the revival of local cultural practices, to the insertion of their histories into national imaginaries, to the creation of new transnational arenas that link indigenous makers around the globe in a common effort to make their concerns visible to the world.[49]

Prominent at the interface between Indigenous Studies and Indigenous media, therefore, is the increasing sense of a pan-indigeneity or a globalized Indigenous conscientization underpinned by the notion of *re*interpretation.

While the growing global Indigenous community has its benefits, such as the sharing and development of ideas, and the formation of transnational entities to arbitrate with organizations such as the United Nations, pan-Indigenous media is not unproblematic. Pan-indigeneity demands political recognition of the transnational Indigenous movement, yet at the same time a requirement of "indigeneity" is cultural distinctiveness. Given a pan-Indigenous collective consciousness must operate beyond the local, there is a tendency to gravitate to unifying concepts that in their own way debilitate native alterity. Niezen argues,

> Media representation of a culture, often an adjunct to legal lobbying, calls for the most essential qualities of that culture to be defined and displayed. . . . [Yet] seeking recognition as a distinct community of rights holders paradoxically entails taking up strategies that are globally uniform and, in some ways, corrosive of distinctiveness.[50]

As is the case with Indigenous Studies in general, pan-Indigenous Media Studies is epistemologically limited because of the ontological importance of local contexts, languages, and cultures. Such inattention to the local Indigenous condition inherently devalues the very concept of indigeneity because of its tethering to place.

Here the Internet deserves thorough attention because of the role it plays as the "public sphere" of pan-Indigenous media. The notion of the public sphere is defined via Jürgen Habermas,[51] whereby the development of media technology can in and of itself create a new public consciousness. For Indigenous people, the Internet has in part enabled a universal discourse where a transnational language of anticolonial struggle has come to inform *local* Indigenous self-determination and resistance paths. Here Niezen's message is clear:

To address the consequences of displacement and denial, to have a stabilizing effect on selfhood, memory is expressed in the form of the publicly exhibited artefact. . . . The internet's expressions of self as contemporary artefacts, as truths in themselves, without undue concern with their possible corruptions of the science of history . . . the historical artefacts, or "memories" most implicated with new possibilities for fabrication are, at the same time, the best evidence we have of the longings and constructed virtualities of collective selfhood.[52]

In other words, Niezen is suggesting that the Internet has, for some Indigenous peoples, become a site of collective memory, a monument where the ontological violence of colonization constructs a collective Indigenous selfhood that not only reflects the desire for recognition of such historical trauma, but also produces and reproduces such a consciousness.

Pan-Indigenous media advocates are in the unenviable position of finding common ground within the ontological historical violence of colonialism, where colonial oppression becomes "the common denominator."[53] This is no small issue, for as an Indigenous consciousness becomes globalized via Indigenous media, an uber-oppressed/oppressor dialectic must not take center stage, although it is probable that it already has. Such decontextualized conditioning of victimhood through universalizing taxonomies will almost certainly detract from the responsibility of Indigenous communities to find their own cogent paths toward metaphysical and material well-being. Indigenous communities' access to new technologies is relevant to the endemic nature of the "new Indigenous political."

FOURTH MEDIA: MEDIATED INDIGENOUS SOVEREIGNTY

Ella Shohat and Robert Stam in *Unthinking Eurocentrism: Multiculturalism and the Media* developed the concept of Fourth World Media as an analytical device to situate global Indigenous media circuits.[54] The notion of "Fourth World" was coined in appropriation of the emancipatory potential of Third World critique, which stemmed out of neocolonial Asia, Africa, and Latin America. Fourth World Media (hereafter referred to as "Fourth Media") on the other hand has come to refer to media controlled by Indigenous peoples in settler-colonial states, such as New Zealand, Australia, Canada, Taiwan, and the United States.

The idea of sovereignty is important to the developing definition of Fourth Media. Mediated Indigenous sovereignty is defined here as the determination of Indigenous peoples to represent and perceive their epistemic knowledge through the media as they deem appropriate, meaningful, relevant, and valid. Bruyneel's conceptualization of a "third space" of Indigenous sovereignty is helpful here in drawing a distinction between Third Media and Fourth Media,[55] where the former relates most prominently with neocolonialism[56] and the latter with postcolonialism. In quoting Spivak's definition of postcoloniality as "the failure of decolonization," Bruyneel suggests "the clear

dividing line between self-other, us-them, and indigenous-American is the exact sort of boundary imposition postcolonial indigenous politics works against, because these dualisms serve the constitutive interests of the dominant polity."[57] The emergence of a Fourth Media has occurred alongside broader political Indigenous movements for self-determination and tribal sovereignty, or what Bruyneel calls "postcolonial nationhood":

> The claim to postcolonial nationhood adhered fully to neither a civil rights framework for defining equality nor a third world decolonization framework for defining anti-colonial sovereignty. Instead it located itself across the boundaries and through the gaps of colonial imposition, in the third space.[58]

Definitions of Fourth Media have seldom followed this track however. Indeed, the underpinnings of Fourth Media remain tellingly vague, reflecting the similarly fuzzy notions of "Indigenous Studies." Constant with general theories of decolonization, Fourth Media has tended to focus on those appropriations of the media principally geared in the direction of cultural knowledge production, of *re*writing history from an Indigenous perspective discursively veiled by colonial media. Ginsburg, for instance, in relation to Indigenous filmmaking in Australia, argues the process has been a struggle led by "Indigenous media activists" and that has lasted over two decades. She defines the effort as one of indigenizing the "blank screen": "to reverse that erasure of Aboriginal subjects in public life . . . by making representations about Black lives visible and audible on the film and television screens of Australia and beyond."[59]

Similarly, Māori scholars Jo Smith and Sue Abel argue in relation to Māori Television that Indigenous media offers the opportunity not to color the nation-scape with brown-tinted glasses but "to bring to light hither-to unseen visions of Aotearoa/NZ; to see with 'iwi eyes' the shape and contour of the nation's scape."[60] From an Indigenous urban perspective, a memorable moment in New Zealand cinema occurs in the opening scene of *Once Were Warriors* (1994),[61] where the billboard image of clean, green New Zealand is contrasted against an industrialized urban scene; the reality for the majority of Indigenous New Zealanders:

> The camera movement that begins *Once Were Warriors* is not about the substitution of image for image, of New Zealand for another. Instead, it presents itself as something of an optical illusion and ironic revelation that enacts several binary oppositions: billboard tableau versus moving cinematic image; fabricated primeval nature versus real urban present.[62]

Thus, from the above examples one prominent definition of Fourth Media includes *re*-righting (writing) the erasure of indigeneity from the mediated public sphere and, in doing so, reshaping the vision of the postcolonial nation.

Another prominent definition of Fourth Media prioritizes genealogy and simultaneously alienates non-Indigenous media as "not of this place." Here the preeminent Māori "Fourth Cinema" theorist, the late Barry Barclay, elaborates: "The First Cinema Camera sits firmly on the deck of the ship. It sits there by definition. The Camera Ashore, the Fourth Cinema Camera, is the one held by the people for whom "ashore" is their ancestral home."[63] Similarly, Raheja defines Fourth Media as having "its roots in specific indigenous aesthetics with their attendant focus on a particular geographical space, discrete cultural practices, social activist texts, notions of temporality that do not delink the past from the present or future, and spiritual traditions."[64] Fourth media, as defined by both Barclay and Raheja, is thus firmly located "ashore" via ancestral and metaphysical connection to place, yet inherently also positioned in an antagonistic dialectic with "First Media."

The Lacanian- and Freudian-influenced work of Laura Mulvey attempts to deconstruct the phallocentrism and patriarchal unconscious inherent to Hollywood film production by suggesting feminist-oriented filmic strategies coalesce to disrupt the voyeuristic and fetishist male gaze. While fundamentally different, Mulvey's "to-be-looked-at-ness"[65] analysis can be appropriated by Indigenous Media Studies because of the elementary power of the "First World" camera to visually code Indigenous people via exoticizing and epidermalizing processes, in the creation of a "tradition of exhibitionism." Thus, another definition of Fourth Media contains strategies to unravel and disrupt the way unconscious colonial structures function to locate Indigenous and non-Indigenous peoples within a naturalized binary. Here Raheja's construction of "visual sovereignty" is insightful:

> I explore what it means for indigenous people "to laugh at the camera" as a tactic of what I call "visual sovereignty," to confront the spectator with the often absurd assumptions that circulate around visual representations of Native Americans, while also flagging their involvement and, to some degree, complicity in these often disempowering structures of cinematic dominance and stereotype.[66]

Raheja argues that in the case of *Atanarjuat* the film "forc[es] viewers to reconsider mass-mediated images of the Arctic."[67] The film's opening scenes, which depict "a lone man standing on the snow-packed tundra with his howling dogs,"[68] reflects stereotypical images of Inuit primitivity and isolation in specific reference to *Nanook of the North.*[69] The image is undercut by the next scene, which "takes place inside a spacious qaggiq (large igloo), where a dozen or so adults and children are contemplating a visitor, referred to as an 'up North stranger.' "[70]

In returning to Bruyneel's "Third Space," with Raheja's "visual sovereignty" and the politics of appropriation all in mind, a developing definition of Fourth Media defies classification via "anticolonial" binaries; rather it resides within the colonial state and

garners its power largely from its indefinability. Fourth Media here is an accomplice with colonial technologies yet resistant to colonial definitions of "nation" and, indeed, underscored by a desire to unravel the unconscious imperialism of colonial media. Here Ginsburg suggests that a "third space" of filmic production has opened up for Indigenous Australians: "these more recent forms of cultural production have offered a different kind of intervention, creating new sites for the recognition of the cultural citizenship of a range of Indigenous Australians, from remote settlements to urban neighbourhoods."[71] Ginsburg makes the distinction between those films "that have focused on land rights, ritual, oral histories, language maintenance, and local sports events."[72] In this "third space" of filmic production,

> These newer films speak to other, multiple legacies of settler colonialism that have shaped Aboriginal lives, but that are less clearly marked in public discourse. These works reject an easy division between remote, traditional people and deracinated urban Aboriginals . . . [offering a filmic space] for a sector whose experience has been rendered largely invisible in the Australian imaginary: mixed race, urban and rural Indigenous subjects, historically removed from contact with their traditional forebears, those for whom history—until quite recently—and the reflective screens of public media have been, so to speak, black.[73]

Ginsburg is effectively referring to an Indigenous media that moves beyond the identity production at the interstitial space of the politics of recognition to signify the importance of shifting the camera away from those biopolitical subjectivities that are recognizable and toward Indigenous subjects "less clearly marked."

New Zealand filmmaker Taika Waititi draws attention to such indefinability when he quips, "Let's just say I'm a filmmaker who is Māori. . . . Why can't I just be a guy who writes stories and puts them in a film? Why can't I be a tall filmmaker? Or a black-haired filmmaker?[74] Waititi's dis-logic (i.e., will to frame himself outside "common sense" discourse) presents a postmodern indigeneity that unpacks the naturalness of making the simplistic connection between a Māori who makes film and "a Māori filmmaker." Inherently, Waititi recognizes that the label "Māori filmmaker" is political, and with predecessors such as Mita and Barclay, the association is valid. Waititi thus attempts to move himself beyond the politics of recognition that would like to register him as "Māori" within the Māori/Pākehā (white New Zealander) binary. Mediated Indigenous sovereignty or Fourth Media can, therefore, be defined as a site where a reflexive challenge to representation takes place, where definition of the settler nation is brought into crisis through mediated representation of the conflict (and at times resolution) that signifies the Indigenous/non-Indigenous binary, and where the pre-eminence and centrality of "place" to Indigenous epistemic knowledge unpacks the naturalized claims to rights discursively and genealogically afforded via imperial conquer.

Radical Indigenous Media

Read contemporarily, Frantz Fanon makes it clear why Spivak suggests postcolonialism is the failure of decolonization:

> This struggle for freedom does not give back to the national culture its former values and shapes; this struggle which aims at a fundamentally different set of relations between men cannot leave intact either the form or the content of the people's culture. After the conflict there is not only the disappearance of colonialism but also the disappearance of the colonized man.[75]

In this context, those attempting to define "Indigenous media" and Indigenous media practitioners must also contend with Fanon's challenge: How does Indigenous media fundamentally alter national culture? Coulthard argues that the

> dialectical progression to reciprocity in relations of recognition is frequently undermined in the colonial setting by the fact that, unlike the subjugated slave in . . . Hegel's Phenomenology, many colonized societies no longer have to struggle for their freedom and independence. It is often negotiated, achieved through constitutional amendment, or simply "declared" by the settler-state and bestowed upon the Indigenous population in the form of political rights. Whatever the method, in these circumstances the colonized, "steeped in the inessentiality of servitude" are "set free by [the] master."[76]

One emerging criticism of postcolonial Indigenous subjectivities, therefore, is that the forms of indigeneity produced, far from challenging the settler-colonial narrative, have in fact reified it.

Similarly, it could be said that Indigenous media thus far has largely failed to radically challenge the postcolonial system. For instance, far from being the beacon of Indigenous alterity, the state-funded Māori Television may merely resemble being "set free by the master." Certainly then, Indigenous media must be reflective on how it mediates recourses to "rights" and represents claims to recognition via essentialized notions of culture, tradition, and authenticity. *Remembering*, that is, the search and desire for classical Indigenous culture, was necessitated by the cultural insecurity and unprincipled, immoral, unethical, anarchical cultural void left in colonization's wake. Unmistakably then, a sense of loss and a desire for origin was colonization's etch on the Indigenous psyche. The question then becomes to what extent various Indigenous media reify this etch or, conversely, move toward deeply challenging colonization's "relentless constitution" of indigeneity.

Kobena Mercer, in an essay entitled "Diasporic Culture and the Dialogic Imagination," suggests that black British Film, for instance, rather than expressing "some lost origin or some uncontaminated essence in black film-language," should be "a critical 'voice' that promotes consciousness of the collision of cultures and histories that

constitute our very conditions of existence."[77] Mercer's call mirrors that of West, who argues that

> The main aim now is not simply access to representation in order to produce positive images of homogeneous communities—though broader access remains a practical and political problem. Nor is the primary goal here that of contesting stereotypes though contestation remains a significant though limited venture. Following the model of the Black diaspora traditions of music, athletics, and rhetoric, Black cultural workers must constitute and sustain discursive and institutional networks that deconstruct earlier modern Black strategies for identity formation, demystify power relations that incorporate class, patriarchal, and homophobic biases, and construct more multivalent and multidimensional responses that articulate the complexity and diversity of Black practices in the modern and postmodern world.[78]

Criticism of this approach is offered by Paul Gilroy, who refers to it as "premature pluralism"[79] and "a postmodern evasion of the need to give historical specificity and complexity to the term *black*, seen as linked racial formations, counter histories, and cultures of resistance."[80] Similarly, Arif Dirlik argues that postcolonialism has had a tendency to undermine effective anticolonial praxis by unraveling "the traditional tools of a radical analysis of the postcolonial condition—history, causality, identity— and installing instead concepts that are much more amenable to the forces of global capitalism—the now canonic theoretical repertoire of hybridity, diaspora and anti-essentialism."[81]

In quite a unique way of interpreting the problematic, here is Young's critique of postcolonial theory. He argues, "despite its espousal of subaltern resistance, [postcolonial theory] scarcely values subaltern resistance that does not operate according to its own secular terms."[82] For Indigenous media, this critique involves the politics of appropriation and recognition, as already discussed, in that it asks how Indigenous media does things differently: How does Indigenous media not merely reify a Western episteme through brown-tinted glasses? In particular, how does Indigenous media move beyond the confines of Western rationalism to produce texts that resist synthesis into codes of Othering, and the will to generalize and universalize knowledge? How does it produce texts that value, for instance, Indigenous metaphysicality in its untranslated form, where Indigenous culture "may remain incommensurable"[83] and "without the kinds of explanatory apparatuses that typically accompany ethnographic films"?[84]

Raheja argues in terms of "visual sovereignty" that Indigenous filmmakers in particular through new media technologies can construct meaning in relation to self-determination and self-representation and thus "frame more imaginative renderings of Native American intellectual and cultural paradigms, such as the presentation of the spiritual and dream world, than are often possible in official political contexts."[85] The recently deceased Mita also discusses the possibilities of media in relation to Indigenous metaphysicality. She suggests that nothing holds the kind of power that old footage of *tīpuna* (ancestors) does, "particularly in the tribal areas to which the film material is especially relevant."[86] Mita claims that film provides the opportunity

for a metaphysical experience "because what the audience sees are *resurrections* taking place, a past life lives again, wisdom is shared and something from the heart and spirit responds to that short but inspiring on-screen journey from darkness to light" (see also chapter 4).[87] To return to Young's point then, the problem with postcolonial critique is that it has thus far failed to imagine how Indigenous peoples might interpret media and appropriate it to the advantage of their own epistemic perspective.

Conclusion

Perhaps a more constructive way to frame this ongoing essentialist/nonessentialist debate that plagues postcolonial theory in general is to reanalyze it through Indigenous sovereignty, where Indigenous sovereignty refers to the way Indigenous peoples choose to represent their worlds. Whether that be through hybrid or essentialist notions of culture, both forms should remain critical to strategic decolonization and fluid epistemologies. Rather than focusing on the detrimental effects of diluting essentialized Indigenous culture versus the necropolitics that occur as Indigenous cultures are produced to be "authentic," the key is to concentrate on the choice and responsibility of Indigenous communities to represent themselves as they see fit, flanked by processes of critical self-reflexivity.

The key, then, for various Indigenous media producers within a frame of choice and responsibility is to find balance between rejecting those forms of representation that pander to Western rationalism's desire to recognize and synthesize, yet do not isolate those Indigenous peoples who are located at the interstitial sites between "Indigenous" and "Western"; to create media that reflects a particular Indigenous epistemology, yet to be wary of the traditionalizing process that seems to inherently occur in postcolonial Indigenous communities, where other forms of indigeneity are discarded as "inauthentic." Finally, they need to recognize that Indigenous media described here may not sit well within the established codes of media practice, for if the partial goal of Indigenous media in general is "decolonization" then this process necessitates uncomfortability, unsettling, and disruption. The balance here is a difficult one to maintain, for it requires Indigenous communities to decipher the politics of recognition that intimately occur at the negotiation space between funders of Indigenous media and Indigenous communities.

While acknowledging that neocultures are an implicit production of colonization, it is imperative that notions of self-critique and responsibility underpin these new cultural spaces, as well as a will to investigate what is being included and thus excluded under the name of "indigeneity"; for typically those excluded are those who have been most displaced by colonial rule. As I see it, any definition of Indigenous sovereignty must be underpinned by the notion of Indigenous existentialism. Primarily, Indigenous existentialism focuses our historical remembrances upon the paths of political resistance and forms of third culture that have been produced so that we understand the production of Indigenous identities as outcomes of the choices Indigenous people

have made, and Indigenous responsibility. For instance, in New Zealand, both Māori and non-Māori tend to think that Māori Television is the panacea to *mis*representation and self-determined Indigenous representation. In reality, while Māori Television remains a state-funded entity those involved need to be vigilantly self-critical, especially in terms of the biopolitical production of Māori subjectivities and the necropolitics their media affects.

Notes

1. Sol Worth and John Adair, *Through Navajo Eyes: An Exploration in Film Communication and Anthropology* (Bloomington: Indiana University Press, 1972).
2. Faye Ginsburg, "The Parallax Effect: The Impact of Aboriginal Media on Ethnographic Film," *Visual Anthropology* 11, no. 2 (1995): 67.
3. Worth and Adair, *Through Navajo Eyes*, 11.
4. Charles Taylor, "The Politics of Recognition," in *New Contexts of Canadian Criticism*, ed. Ajay Heble, Donna Pennee Palmateer, and J. R. Tim Struthers (Toronto: Broadview, 1997), 98.
5. Sue Abel, "The Public's Right to Know: Television News Coverage of the Ngāpuhi Media Ban," *New Zealand Journal of Media Studies* 9, no. 2 (2006): 17.
6. Cited in Glen Coulthard, "Subjects of Empire: Indigenous Peoples and the 'Politics of Recognition' in Canada," *Contemporary Political Theory* 6 (2007): 454.
7. Cited in Peter Adds, Maia Bennett, Meegan Hall, Bernard Kernot, Marie Russell, and Tai Walker, *The Portrayal of Maori and Te Ao Maori in Broadcasting: The Foreshore and Seabed Issue* (Wellington: Broadcasting Standards Authority, 2005), 42.
8. Joanne Te Awa, "Mana News: A Case Study," *Sites* 33 (1996): 168.
9. Simon Featherstone, *Postcolonial Cultures* (Jackson: University Press of Mississippi, 2005), 10.
10. Cited in Joseph Bristowe, "Indigenising the Screen: Screenplay and Critical Analysis for The Prophet" (master's thesis, University of Waikato, N.Z., 2009), 24.
11. Jo Smith, "Parallel Quotidian Flows: Maori Television on Air," *New Zealand Journal of Media Studies* 9, no. 2 (2006): 28.
12. Ian Stuart, "The Maori Public Sphere," *Pacific Journalism Review* 11, no. 1 (2005): 22.
13. Ronald Niezen, *The Rediscovered Self: Indigenous Identity and Cultural Justice* (Montreal: McGill–Queen's University Press, 2009), 85.
14. Ginsburg, "The Parallax Effect," 68.
15. Ibid.
16. Niezen, *The Rediscovered Self*, 86.
17. Cheung Siu-woo, "Miao Identities: Indigenism and the Politics of Appropriation in Southwest China during the Republican Period," *Asian Ethnicity* 4, no. 1 (2003): 90.
18. Michel de Certeau, *The Practice of Everyday Life*, trans. Steven Rendall (Berkeley: University of California Press, 1984).
19. Cheung Siu-woo, "Miao Identities," 90.
20. Ibid.
21. Zacharias Kunuk, *Atanarjuat: The Fast Runner* (Igloolik, Nunavut, Canada: Igloolik Isuma Productions, 2000).
22. Michelle Raheja, "Reading Nanook's Smile: Visual Sovereignty, Indigenous Revisions of Ethnography, and *Atanarjuat (The Fast Runner)*," *American Quarterly* 59, no. 4 (2007): 1177.
23. Ibid., 1177–78.

24. Ibid., 1178.

25. Lisa Parks, *Cultures in Orbit: Satellites and the Televisual* (Durham, N.C.: Duke University Press, 2005), 48.

26. Featherstone, *Postcolonial Cultures,* 20–21.

27. See, for instance, Brendan Hokowhitu, "The Death of Koro Paka: 'Traditional Māori Patriarchy,' " *The Contemporary Pacific* 20, no. 1 (2008): 115–41.

28. Raheja, "Reading Nanook's Smile," 1161.

29. Ginsburg cited in Raheja, "Reading Nanook's Smile," 1162.

30. Isuma.tv website, http://www.isuma.tv/lo/en/isuma-productions/about.

31. Cited in Raheja, "Reading Nanook's Smile," 1166.

32. Kimber Charles Pearce, "The Radical Feminist Manifesto as Generic Appropriation: Gender, Genre, and Second Wave Resistance," *Southern Communication Journal* 64, no. 4 (1999): 307.

33. Ibid.

34. Cheung Siu-woo, "Miao Identities," 90.

35. Coulthard, "Subjects of Empire," 437.

36. Cited in ibid., 450.

37. Ibid., 451.

38. Achille Mbembe, "Necropolitics," trans. Libby Meintjes, *Public Culture* 15, no. 1 (2003): 11–40.

39. Cornel West, "The New Cultural Politics of Difference," in *The Cultural Studies Reader,* ed. Simon During (London: Routledge, 1993), 212.

40. Homi Bhabha, "The Other Question," *Screen* 24, no. 6 (1983): 24–25.

41. Kevin Bruyneel, *The Third Space of Sovereignty* (Minneapolis: University of Minnesota Press, 2007).

42. Niezen, *The Rediscovered Self,* 10–11.

43. There are various meanings of sovereignty, but I use the word in a Foucauldian sense: "It is the power to 'make live' and 'let' die" (Michel Foucault, *Society Must be Defended: Lectures at the Collège de France 1975–1976* [New York: Picador], 2003, 241), that is, it is the power to produce authentic Indigenous subjectivities and de-authenticate others. Foucault argues that "From the nineteenth century until the present day, we have . . . a legislation, a discourse, and an organization of public right articulated around the principle of the sovereignty of the social body and the delegation of individual sovereignty to the state; and we also have a tight grid of disciplinary coercions that actually guarantees the cohesion of that social body" (ibid., 37). Essentially, Foucault would suggest here that Indigenous subjectivities have been made to live and allowed to die via the juridification of subjectivity (i.e,. via juridical law formalized by the state) and disciplinary coercions that in a much less direct way function to regulate difference via the idea of normative culture.

44. Michel Foucault, *The Archaeology of Knowledge* (London: Routledge, 2002), 39.

45. Featherstone, *Postcolonial Cultures,* 18.

46. Paul Meredith, "Urban Maori as 'New Citizens': The Quest for Recognition and Resources," paper presented at the Revisioning Citizenship in New Zealand Conference, February 22–24, 2000, Hamilton, N.Z., 16.

47. Niezen, *The Rediscovered Self,* 40.

48. Linda Smith, *Decolonizing Methodologies: Research and Indigenous Peoples* (London: Zed Books, 1999), 34.

49. Faye Ginsburg, "Embedded Aesthetics: Creating a Discursive Space for Indigenous Media," in *Critical Cultural Policy Studies: A Reader,* ed. Justin Lewis and Toby Miller (Oxford: Blackwell, 2003), 97.

50. Niezen, *The Rediscovered Self*, 40–41.

51. Jürgen Habermas, *The Structural Transformation of the Public Sphere: An Inquiry into a Category of Bourgeois Society*, trans. Thomas Burger (Cambridge: Polity Press, 1989).

52. Ibid., 47.

53. Ibid., 54.

54. Ella Shohat and Robert Stam, *Unthinking Eurocentrism: Multiculturalism and the Media* (1994; repr., London: Routledge, 2002).

55. Bruyneel, *Third Space.*

56. Here the distinction is made between neocolonialism and postcolonialism. Neocolonialism specifically refers to those nation-states where the Indigenous population have been reasserted into state leadership, however the residue of colonialism remains nondiscursively powerful. For instance, while a state may be governed by Indigenous leadership, neoliberal multinational companies remain to effectively govern by controlling the nation's capital and resources. Post-colonialism here relates to the framing of both discursive and nondiscursive power structures within settler-colonial states. There are exceptions to these definitions. For instance, much post-colonial literature stems from India.

57. Bruyneel, *Third Space,* 144–45.

58. Ibid., 124.

59. Faye Ginsburg, "Black Screens and Cultural Citizenship," *Visual Anthropology Review* 21, no. 1 (2005): 81.

60. Jo Smith and Sue Abel, "Ka Whawhai Tonu Mātou: Indigenous Television in Aotearoa/New Zealand," *New Zealand Journal of Media Studies* 11, no. 1 (2008): 52.

61. Lee Tamahori (dir.), *Once Were Warriors* (Culver City, Calif.: Columbia Tristar Home Video, 1994).

62. Gregory Waller, "Embodying the Urban Maori Warrior," in *Places through the Body,* ed. Heidi Nast and Steve Pile (London: Routledge, 1998), 338.

63. Barry Barclay, "Celebrating Fourth Cinema," *Illusions* 53 (Winter 2003): 10.

64. Raheja, "Reading Nanook's Smile," 1167.

65. Cited in Tim Edwards, *Cultures of Masculinity* (London: Routledge, 2006), 117.

66. Raheja, "Reading Nanook's Smile," 1160.

67. Ibid., 1161.

68. Ibid., 1174.

69. Robert Flaherty (dir.), *Nanook of the North* (New York: Pathé Pictures/Kino Video, 1998 [1922]).

70. Ibid.

71. Ginsburg, "Black Screens," 83.

72. Ibid.

73. Ibid.

74. Cited in Ocean Mercier, "Close Encounters of the Māori Kind—Talking Interaction in the Films of Taika Waititi," *New Zealand Journal of Media Studies* 10, no. 2 (2007): 38.

75. Frantz Fanon, "On National Culture," in *Perspectives on Africa: A Reader in Culture, History and Representation,* 2nd ed., ed. Roy Grinker, Stephen Lubkemann, and Christopher Steiner (Oxford: Blackwell, 2010), 496.

76. Coulthard, "Subjects of Empire," 449.

77. Cited in James Clifford, "Further Inflections: Toward Ethnographies of the Future," *Cultural Anthropology* 9, no. 3 (1994): 319.

78. West, "The New Cultural Politics," 212.

79. Cited in Clifford, "Further Inflections," 319.

80. Ibid.

81. Cited in Featherstone, *Postcolonial Cultures,* 13.

82. Robert Young, *Postcolonialism: An Historical Introduction* (Oxford: Blackwell, 2001), 338.

83. Raheja, "Reading Nanook's Smile," 1175.

84. Ibid., 1176.

85. Ibid., 1165.

86. Merata Mita, "The Soul and the Image," in *Film in Aotearoa New Zealand,* ed. Jonathan Dennis and Jan Bieringa (Wellington: Victoria University Press, 1992), 50.

87. Ibid., 51.

7. Te Hokioi *and the Legitimization of the Māori Nation*

LACHY PATERSON

IN 1861, two central North Island Māori chiefs from the Waikato, Wiremu Toetoe and Te Hemara Rerehau, returned from a sojourn in Vienna where they were guests of the Austro-Hungarian authorities. While there they worked for nine months at a printing establishment and, on their departure, received the gift of a printing press from the Austro-Hungarian emperor.[1] Later, this press allowed the Kīngitanga (Māori King Movement) to publish its own newspaper, *Te Hokioi e Rere Atu-na* (literally, "the [mythical] bird flying there," hereafter referred to as *Te Hokioi*), to broadcast its own developing ideology and to counter the New Zealand government's own propaganda directed at Māori. For several years, until stopped by war, this *niupepa* (newspaper), under the editorship of the Māori king's cousin Wiremu Pātara Te Tuhi, opposed the dominant colonialist discourses being promulgated in Māori-language newspapers produced by Pākehā (white New Zealanders).

Te Hokioi was the first, and perhaps most radical, example of Indigenous media activism in New Zealand. In the early 1860s, its goal of a separate Māori state had real viability. This case study first describes the historical conditions that produced the Kīngitanga and *Te Hokioi*. It then looks at concepts of racial/ethnic difference and how the way Māori imagined themselves changed after European contact, including the visualization of a Māori nation. In particular this study investigates *Te Hokioi*'s articulation of ethnicity and the legitimization of power that it disseminated in support of the concept of an independent Māori nation.

Māori Desire for *Tino Rangatiratanga* (Autonomy)

Māori expectations of Pākehā colonization ushered in by the Treaty of Waitangi (here after referred to as "the Treaty") of 1840 were quite different from those of Pākehā and government officials. The Treaty, signed between Māori chiefs and a representative of the British Crown at Waitangi and then carried to other parts of the country for Māori signatures, was supposed to introduce a new and more "humane" method of British colonization.[2] Composed of three articles, the first

ushered in British government, the second guaranteed Māori land ownership, and the third gave Māori the rights of British citizenship. However, it was predicated on the understanding that Māori would be willing to sell large tracts of land to the Crown for settlement, take on European customs, and subject themselves to British law and government. Moreover the wording of *te Tiriti*, the Māori-language version of the Treaty discussed and signed by chiefs, is inconsistent with that of the English version. In particular, *te Tiriti* guaranteed Māori their *tino rangatiratanga*, their full chiefly rights, and did not spell out clearly the "sovereignty" being ceded to the Crown.[3] Indeed, in the first two decades of colonization most chiefs regarded the government more as the representatives of the white tribe rather than of their own. The government's authority was nominal at best outside of Pākehā settlements, and it lacked the necessary administrative and military resources to effectively impose its will on Māori.[4] The government's underlying goal (shared by Pākehā settlers), however, was to eventually gain total sovereignty. To achieve this necessitated the diminution of the *mana* (power and authority) and *tino rangatiratanga* that Māori still retained.

Without the necessary means to impose its will, the early colonial government instead sought to gain Māori acquiescence through persuasion and inducements. The governors were constrained both by a strong humanitarian sentiment prevalent in London, and by a paucity of officials and military forces, while Māori *hapū* and *iwi*[5] retained a strong military capability.[6] When the British Army did engage Māori forces during the mid-1840s, its achievements were less than decisive.[7] Instead, the government paid pensions or salaries to important chiefs to gain their support or protection. Through the 1840s and 1850s it also promulgated a twin discourse of Christianity and civilization to Māori, particularly through its Māori-language newspapers.[8] Naturally, the relinquishing of "waste" land for European settlement, and accepting the primacy of British sovereignty, state power, and English Law were important elements of this discourse.[9]

For both Māori and Pākehā of the nineteenth century, effective authority hinged on the control of land. Government pressure on Māori to sell land threatened tribal unity. As Pākehā settled on newly acquired land they demanded the protection of the state. Consequent government intrusion into Māori land inevitably impacted on *hapū* and *iwi* autonomy. In turn, it was encroachment upon Māori land that forced Māori leaders, particularly from the central North Island, to come together in the mid-1850s to conceptualize the Kīngitanga as a means of unifying Māori. However, those who supported the movement hoped that through strength of numbers they could hold on to their land and *mana*. The Kīngitanga was both an abstraction and a physical reality, representing the political will of independently minded Māori chiefs as well as the bulk of the central North Island, which was as yet unsold to the Crown. Pōtatau Te Wherowhero, an aged but influential Waikato chief, assumed the title of *kīngi* (king) in 1858 and was succeeded by his son Tāwhiao in 1860.

Although the Kīngitanga claimed a mandate to represent all Māori, and *Te Hokioi*, its newspaper, strove to show Māori unity in the face of the colonial state, not all chiefs and *iwi* aligned themselves to the movement. *Hapū* and *iwi* were political units based on close kin ties that guarded their independence. Thus, to come together as a confederation under one leader was a novelty not all could accept. At a debate at Kohanga in 1861 between the governor of New Zealand, Sir George Grey and Kīngitanga orators, the latter were at pains not to concede that, while the movement spoke for Māori, it could not claim authority over all Māori.[10] The strongest support (although not unanimous) came from the Waikato (the central-western part of the North Island and home of the kings) and some other areas of the North Island, such as Hauraki and what later became known as the "King Country." There was little support from *iwi* north of Auckland, and only mixed support in the east and south of the North Island. It was not that the nonsupporting *iwi* wanted government interference anymore than the Kīngitanga, but at the time they saw little threat to their *tino rangatiratanga* and distinct advantages in remaining on good terms with the government. Moreover, voluntarily ceding their *mana* to the chief of another *iwi* did not accord with a Māori episteme. While Māori at this time understood their societal divisions along genealogical lines, the colonial machine in interaction with colonial ideology from afar had already located Māori within discourses of race and nation.

Race, Nation, and Identity

Benedict Anderson suggests all communities where no individual can know all its members are imagined constructs, and Māori social structures are no exception.[11] Māori identity prior to contact with Europeans was based on genealogical links through which people formed *whānau* (extended families) within *hapū*. Although within these groups all members would have known each other, Māori also identified with the looser *iwi* confederations. The effective polity within Māori society, however, was the *hapū*, led by its chiefs, with its legitimacy based on *mana* and *rangatiratanga*, although a number of *hapū* might come together at times, particularly for war.[12] With all people sharing the same ethnicity and culture, concepts of group difference (other than genealogically based alterity) did not exist in any meaningful way. The advent of Pākehā meant Māori had another distinct group of people with different features, language, technology, and customs.

Post-Treaty colonialism introduced further ethnic division. As Frantz Fanon states, "The colonial world is a Manichaean world."[13] The colonialism Māori encountered was fundamentally just as racially dichotomous as in any other colony, despite Māori being told that "in the colonization of these Islands, by the British, the treatment of the aboriginal race has been regulated by humane and Christian principles,"[14] quite unlike Indigenous peoples elsewhere.[15] As betrayed by the slogan used by the government in its newspaper to Māori, "LET THE PAKEHA AND MAORI BE UNITED," the desired amalgamation of the two different ethnic groups in New Zealand was simply not the case.[16]

Figure 7.1. Wiremu Pātara Te Tuhi, Ngāti Mahuta (Tainui), chief and editor of *Te Hokioi e Rere Atu-na*. Photograph by Hardie Shaw Studios. Alexander Turnbull Library, Wellington, ref. no. F-91473-1/2.

As British subjects, Māori and Pākehā were supposedly politically equal, yet divisive racial discourses ensured that this was not the case: the term "Māori" was synonymous with "native" and linked to a plethora of uncivilized behaviors; Pākehā were *tuākana* (older siblings) to their Māori *tēina* (younger siblings); and the races were divided by color lines: Pākehā were *kiri mā* (white-skinned) and Māori were *kiri mangu* (black-skinned).[17] The discourse of the difference of race and culture was linked to power: the supposed superior cultural knowledge of Pākehā naturalized their right to manage and control the institutions of state political power.[18]

The Kīngitanga rejected this discourse and set about establishing its own Māori nation—but what form of "nationalism" was this to be? National feeling can derive from a number of factors perceived to be held in common, such as a language, culture, history, or love of the land, although theorists often expect certain political or social conditions to be present before a nation begins to emerge.[19] Certainly the Kīngitanga did not fit neatly into Anderson's precondition of print-capitalism,[20] or Ernest Gellner's industrial society.[21] The printed reading material (until *Te Hokioi*) to which Māori were exposed derived from missionaries, the government, or other Pākehā sources. However, such material was directed at Māori as a group who were largely literate, potentially creating "the embryo of the nationally imagined community."[22] Culture is always dynamic, but the unexpected arrival of Pākehā and subsequent colonization resulted in far-reaching change in Māori society, and encouraged Māori to envisage new possibilities. In the early colonial period, Māori society was largely pre-capitalist and pre-industrial, but many *iwi* began engaging in the market economy, albeit mainly as food producers. Moreover, by the mid-1850s, Māori had largely converted to Christianity, which had broken down some of the traditional *iwi* enmities that had divided them. The most important factor, however, was that colonization defined Māori as a distinct and separate people, thus encouraging them to imagine themselves in this way, and different to Pākehā. Indeed, in its own discourses the Kīngitanga maintained the colonial *kiri mā/kiri mangu* dichotomy in order to accentuate racial difference.[23] Thus the Kīngitanga's nationalism was a response to colonization, and was underpinned by the colonizer's own racialized discourses.

In order to promote its own concept of an ethnically based Māori nation, for example, *Te Hokioi* developed an association with the plight of black peoples. In a case study on the Haitian revolt in which black slaves overthrew their French masters to establish their own state, the original Indigenous people as well as the black slaves are constructed as both *māori* (native) and *kiri mangu*, while the Spanish and French were both *kiri mā*, creating a construction that clearly divides the colonial world into black and white.[24]

> Let the [Kīngitanga's] councils work peacefully, wait and perhaps the independence of this island will be like Haiti's, possessing wealth, power, law: because we are striving for a just cause, God will perhaps protect his black-skinned children living in Aotearoa.[25]

Significantly, the text uses *rangatiratanga* to define Māori independence. This was a term that in the nineteenth century possessed multiple meanings, although all related to power. It was used to mean "independence" when Northern Māori met in 1835 to issue a Declaration of Independence, and the Crown employed it to translate land ownership in the 1840 Treaty. Once colonization began in earnest, missionaries and government interpreters usurped the word to describe the European civilization and customs they expected Māori to adopt. In contrast the Kīngitanga text above effectively reasserts the link between chiefliness and Māori self-determination, guaranteed in *te Tiriti* (even if not intended by the translators) but under threat from the government's goal of substantive British sovereignty.

Denying Crown Legitimacy through *Te Hokioi*

The Kīngitanga was aware that its Māori nationalism stood in opposition to British rule, and therefore argued against the notion of Crown legitimacy through its key ideological device, *Te Hokioi*. Before 1840 no "state," in the modern sense, existed in New Zealand. Therefore, for Māori, any such institution that might emerge was new and lacked legitimacy through historical longevity. Despite the British Resident collecting signatures in 1835 for the Declaration of Independence, and providing a flag for the United Tribes of New Zealand, there is little evidence of any actual state emerging. When the British government sought Māori acquiescence to its gaining sovereignty in 1840, and thus legitimacy to govern, it did so through the Treaty. Despite some important chiefs refusing to sign, and large areas not having been visited, Governor Hobson declared British sovereignty over the whole country. Given the less than complete Māori acquiescence, Jock Brookfield describes this move as an "imperial seizure of power" and "revolution."[26] Nevertheless, the Crown asserted its exclusive right to govern through the Treaty. For example, with the Taranaki War at its height in 1860, Governor Browne warned Māori chiefs at Kohimarama that Māori who did not acknowledge Crown sovereignty risked the loss of their land, "and the destruction through which [they] will disappear."[27]

In relation to this context, by the early 1860s, the Kīngitanga was seeking to establish a state separate from that of the governor. As *Te Hokioi* stated, "let the King Pōtatau's *mana* stand upon the places of New Zealand that we still hold, and let the *mana* of Queen [Victoria] stand in the places she has obtained."[28] In theory, any land still held by Māori would make up the Māori nation. This potentially included most of the North Island south of Auckland, except for Wellington, Wairarapa, and Southern Hawke's Bay. The king's capital sat at Ngāruawāhia, at the meeting points of the Waikato and Waipā Rivers about a hundred kilometers by river from the coast.

Te Hokioi sought to discredit the Crown's legitimacy by attacking the validity and relevance of the Treaty to all Māori. This was necessary because, in the 1860s, the Crown's conception of the Māori citizen/subject was based on its interpretation of the

English-language Treaty. *Te Hokioi* countered this by arguing that "it is not good for [the allegiance of] many chiefs to be obtained on the acceptance of one chief,"[29] that is, despite many chiefs having signed, the Treaty possessed no validity for those chiefs who did not sign it. Similarly, it asserted that the governor had no right to send his gunboats up the Waikato River to Ngāruawāhia[30] and beyond, because the river did not belong to the Crown.

> The Waikato River does not belong to the Queen but to the Māori only. . . . The word of our mother, the Queen, to those chiefs is clear indeed, that is: if the people of New Zealand don't wish to cede the *mana* of their lands, their rivers and their fisheries to me, that is fine; let them keep the *mana*: so this is one of our rivers we are keeping to ourselves.[31]

The newspaper, in general, was thus critiquing the Crown's assertion that its sovereignty sat over the whole of New Zealand. The above quote in particular is significant for several reasons. The sovereignty of Queen Victoria (referred to with heavy irony as "our mother") rested only on land ceded willingly to her. This refers to Hobson's instructions that he was to obtain full and informed consent from Māori before declaring British sovereignty, when it was clear that Waikato (and other) *iwi* had refused to sign. However, the newspaper asserted that the river now belonged to "the Māori" rather than just to the Waikato *iwi*, a sentiment in line with advocating for a pan-Māori nation. The text also refers to "rivers and fisheries." This phrase is absent from the Māori Tiriti, where *taonga*, a vaguer but more inclusive term meaning "possessions" or "treasures," defines Māori ownership and asserts Māori rights in terms of *mana,* that is, traditional *iwi* control. Thus, the newspaper utilizes the English Treaty text to support Māori ownership of the river, while negating any notion of the limited ownership (under Queen Victoria's sovereignty) that would otherwise be implied.

Te Hokioi also sought to show that Pākehā had maliciously tricked the many chiefs who had signed the Treaty. For example, *the newspaper* outlines that when the Treaty came to the mouth of the Waikato River some chiefs were bribed with blankets, "not knowing there was a hook inside."[32] Manipulating the Crown's own terminology, which described the Treaty as a "covenant" between Māori and Queen Victoria, the newspaper described it as "the covenant of blindness." In its argument it also exploited, to its own advantage, the contemporary metaphor that equated uncivilized behavior with that of animals.

> I say it is the covenant of the blind, because the people of that time lived as animals, without human thoughts, like a dog shown some nice looking food. When it sees it, it rushes to eat, thinking that food to be very fine. When it eats it, it sticks in its throat, and then it knows that something is wrong. Then his owner arrives, and sees a bone stuck in its throat. He removes it, and health returns to it [the dog] . . . so in your opinion, is it the dog that did wrong? No, the person that erred is the one who knew.[33]

By accentuating Māori unawareness in 1840, the newspaper magnified the wrongdoing of Pākehā for the willful duping of Māori. In the allegory, the Treaty is the bone stuck in the throat of the (Māori) dog. *Te Hokioi* thus effectively dismissed the validity of any Treaty obligations for those Māori who had signed it.

The newspaper also attacked the government's credibility through its unequal treatment of Māori. The government pursued a policy of "amalgamation" toward Māori, which was translated into Māori as *iwi kotahi* (one people). Based on the notion of legal equality for Māori and Pākehā, the policy was designed to eventually bring Māori within governmental control. However, discriminatory laws did exist, which *Te Hokioi* gleefully pointed out.

> In the time before the Kīngitanga, the governors stated that Māori and Pākehā were as one people, or so their mouths said. [But] the Māori went to buy guns and powder, and it wasn't forthcoming. The Māori sold land to the governor, but for a pittance. Where is the truth in these words that said that there was one people and one law?[34]

This text highlights two serious Māori grievances: that they were unable to legally buy guns and gunpowder; and that the government had an exclusive right to purchase Māori land, on-selling it to settlers at a great profit. *Te Hokioi*'s arguments against the

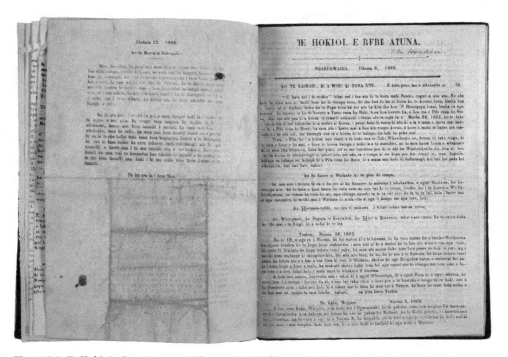

Figure 7.2. *Te Hokioi e Rere Atu-na*, 8 Tihema 1862. Williams 337. Hocken Collections, Uare Taoka o Hākena, University of Otago, Dunedin, N.Z.

Treaty, both moral and legalistic, as well as the accusation that the Crown had not lived up to its promises were designed to negate the legitimacy of the Crown's sovereignty over unwilling Māori. The Kīngitanga's opposition to the Crown was couched in ideological terms, and the movement's newspaper was central to promulgating these ideas to its Māori readership.

Defining Kīngitanga Legitimacy and *Te Hokioi*

Although *Te Hokioi* directly attacked the government's legitimacy to rule, support for the Māori kingdom was not universal, as noted earlier. Most Māori north of Auckland and in the South Island did not support the movement. Even within *iwi* of the central North Island, different factions might align with the king or the queen, and chiefs' "loyalty" to one or the other sovereign might fluctuate depending on circumstances. Even in the Waikato, the heart of the Kīngitanga, influential Tainui chiefs such as Te Wheoro and Te Awaitaia allied themselves with the government. The Kīngitanga suffered from one enormous disadvantage in asserting itself: that Māori *hapū* and *iwi* had always been separate and independent polities. Māori had never had their own central authority or leader, a point stressed by both the government and Māori who opposed the movement.[35]

Te Hokioi was thus at pains to show that the Māori king was indeed the legitimate custodian of the *mana* of collective *iwi*. In one article, it listed important chiefs from around the island who had expressed an interest in holding the land back from sale, and the various meetings held over several years leading up to the selection of Pōtatau as king in 1858. The piece concludes with the words, "and all the chiefs came from each place to honour the king, and to bring their lands under him. Some of the lands were ceded by letter."[36] *Te Hokioi* then appended a number of these letters in which chiefs gave their allegiance by placing the *mana* of their lands under Pōtatau.[37] That the king's *mana* derived from the freely given support of chiefs who held the *mana* of their *iwi* gave a deeper legitimacy to a movement portrayed by its detractors as a novelty. Several months later, the newspaper named a number of *iwi* that had sought the king's flag as their symbol, including Taranaki prior to the war there in 1860–61.[38] The Crown had attempted to purchase from a small *tuku whenua* (land-selling) group 600 acres at the mouth of the Waitara River in opposition to the majority of the *iwi*, Te Āti Awa. The newspaper's position was important as the government had accused Kīngitanga warriors who had gone south to fight the British Army as interfering in a dispute that did not concern them. By demonstrating that Te Āti Awa had already accepted the king's flag, the newspaper was vindicating the action of the warriors defending land already pledged to the Kīngitanga.

Some within the Kīngitanga, such as Wiremu Tamihana Tarapīpipi, the chief whose energy helped push the movement into existence, employed scripture to justify the Māori kingdom. Particularly appealing was God's injunction to the Hebrews that "one

from among thy brethren shalt thou set king over thee: thou mayest not set a stranger over thee, which is not thy brother,"[39] resulting in Saul's selection as king of the Jews.[40] *Te Hokioi* did not employ scriptural justifications, yet it was prepared to critique the government's *Te Pihoihoi* assertion that the Kīngitanga was counter to God's wishes.

> My friend, your words "God does not like the division of men, what God wants is that all races of the world be united, whether Pākehā or Māori, with one law." All I have to say to you about what you said is that you ask the many Pākehā peoples of Europe (from where came Religion and a great many things) why they are deaf to what God wants, in that those white-skinned races are all divided.[41]

That is, if Christianity was meant to unite different peoples, why was not all Christian Europe one state? If this was the case, how could the government assert that the Kīngitanga was going against God by wanting to establish a separate nation? Thus, although *Te Hokioi* did not directly use scripture to justify the Māori kingdom as others within the movement had, it was prepared to point out its opponent's biblical inconsistencies.

Asserting Kīngitanga Legitimacy

Te Hokioi was central to the Kīngitanga's political purposes, not just in defining the sources of the Kīngitanga's *mana,* but also in asserting its right to exercise it. Keeping its citizens secure by maintaining law and order is a fundamental responsibility of the state, one that the British government was unable or unwilling to exercise on behalf of Māori. Some Pākehā commentators at the time believed that the Kīngitanga had risen out of the government's inactivity in Māori districts, "not in what we had done, but what we had left undone," and that "under a rude form of government of their own invention they had done more for themselves than we had ever done for them."[42] Historian Keith Sinclair rejects this view, suggesting Māori no longer saw much benefit in colonization and "if the government had interfered more with the Māoris, the reaction probably would have been greater."[43] However, it was a convenient justification for the Kīngitanga at the time that they needed to establish the Māori king to suppress lawlessness in Māori districts.

The Kīngitanga attempted to address the issue of lawlessness that had arisen because customary control mechanisms had broken down. Internal *iwi* divisions were particularly prevalent where government pressure to sell land divided *iwi* and *hapū* into *pupuri whenua* (land-holding) and *tuku whenua* camps. The problem existed as much for *hapū* that supported the government as those that did not,[44] despite the government newspaper's assertions that the Māori king was unable to restrain his followers.[45] The Kīngitanga aim to lock away Māori land from purchase was designed to eliminate the main cause of murder and the inter-Māori warfare that resulted, and to establish its own system of justice. It wanted "to hold back the strong arm of the man

eager to engage in war over his land or wife, to leave for a court to seek a remedy for those offences, to stop the transference of the guilt of one man onto the many," that is, to stop disputes escalating.[46]

Te Hokioi was at pains to show that the Kīngitanga had instituted a legal system and was effectively administering the law. It published the names of its magistrates and the areas they were appointed to. In some places, such as Ōtaki [settlement on southern east coast of the North Island], the appointees would have struggled to administer law effectively given the divisions between the pro- and anti-Kīngitanga factions.[47] Despite the difficulties the Kīngitanga magistrates may have faced, *Te Hokioi* published some of the judgments in order to show the system working,[48] although a plea from one magistrate for Māori to take issues to a judge rather than take the law into their own hands shows that the adherence to the law was by no means universal.[49]

The situation changed for the Kīngitanga in 1861 after Sir George Grey, described by historian Ranginui Walker as "the hitman of colonisation,"[50] was recalled as governor after the inconclusive first Taranaki War. Grey stopped the plans of his predecessor Browne to invade the Waikato but continued the military buildup. He also sought to marginalize the Kīngitanga by setting up a local Māori self-government with paid Māori officials, but with limited autonomy, in districts where he was able.[51] Grey took an aggressive approach to his dealings with the Kīngitanga, which included sending his own magistrate, John Gorst, to Te Awamutu deep within the Kīngitanga territory as a symbol of governmental control. Gorst attempted to run his courthouse, which the local people steadfastly ignored.

Gorst's presence in the kingdom sparked a brief newspaper war. In 1862, *Te Hokioi* published one of Gorst's letters in which he complained about a Māori who had absconded from his court. The newspaper was happy to print this letter, in order to argue against government intrusion. It responded by arguing that since the governor had forbidden the Kīngitanga from interfering with unwilling *iwi*, then it was only fair that the governor should not meddle with the king's *iwi*. It added that "it is not right for you [Gorst] to come among the Kīngitanga tribes to live."[52] The following year, in order to challenge *Te Hokioi*'s successful propaganda, Gorst established his own newspaper, *Te Pihoihoi Mokemoke,*[53] which opened with a heavy-hitting article assailing the Māori king's ability to govern his people. The two newspapers sparred briefly, attacking statements from each other's articles. It is clear that the print media was of immense importance at this time: before *Te Pihoihoi*'s fifth issue could be distributed to interested readers within the Kīngitanga, Ngāti Maniapoto (mid-western North Island *iwi*) warriors descended on Gorst's establishment, removed the press, and gave the magistrate three weeks to return to Auckland if he wanted to live.[54]

The government took an aggressive and provocative line of action with the Kīngitanga, to which the movement and *Te Hokioi* responded according to its own nationalist ideology. As part of his military buildup, Governor Grey continued building the Great South Road directly toward the Waikato.[55] This the Kīngitanga had to endure:

Mundy, Photo. Christchurch. N.Z.

Figure 7.3. Sir George Grey, governor of New Zealand 1845–53 and 1861–68. Photograph by
Daniel Louis Mundy. Alexander Turnbull Library, Wellington, ref. no. F-91983-1/2.

their own rhetoric maintained that the governor had no rights on "Māori land" but could govern on land already sold to the Crown. It included the building of roads, even when designed for military purposes. However, when the government provocatively began to erect a building that looked suspiciously like a military blockhouse within the Kīngitanga boundary at the small village of Te Kohekohe, the king's supporters felt compelled to act. Despite Te Wheoro, the local chief, having consented to the government's plans, a Kīngitanga group seized the timber and floated it back onto government land. Their actions demonstrate that the Kīngitanga considered first that it had the right to deny the local chief authority over what would happen on his own land, and second that it had the right to eject such a government intrusion from Māori land. A short article on the incident appeared in the March 1863 issue of *Te Hokioi* but a much more extensive article appeared the following month, which began by describing the suspicious nature of the building. Its military appearance was thus a justification for its removal.

> Concerning the character of that building, it was said before that it would be as the church at Te Kohekohe, as a courthouse there, and as police school. At the time that the boards were stacked there, we really understood that the character of that building had changed, that it would stand surrounded [by defensive walls], and that it looked at the start like the soldiers' barracks at Te Ruatō.[56]

Unlike the government newspaper account, which portrays the Kīngitanga actions as violent and aggressive,[57] the article is at pains to show Wiremu Kūmete, the group's leader, as a reasonable man faced with the obstinacy of Te Wheoro at Te Kohekohe, but who ensures that the timber is safely returned downstream to government land. The article also includes dialogue between Kūmete and Gorst demonstrating Gorst's intransigence in refusing to stop the building. By the time this issue appeared Gorst had already been expelled, so the article concluded with a justification for this action.

> That night, [the group] thought over Gorst's misdeeds: his pulling up of Neri's [boundary] post at Mangatāwhiri; his quarrelling with *Te Hokioi*, that is his unacceptable words criticizing the King; his insisting on the erection of the building at Te Kohekohe to stir up trouble for us, the people; his not allowing the timbers, and the carpenters, to be returned to Te Ia.[58]

Te Hokioi thus asserted the Kīngitanga's right to act in its own interests against the provocative and illegitimate actions of the government.

The Demise of *Te Hokioi*

Te Hokioi's final arguments concerned the renewal of hostilities in Taranaki. The uneasy truce following the first Taranaki War was broken when government forces in March 1863 occupied the Tataraimāka Block. Taranaki Māori had been occupying this

land, previously sold to settlers, until the government restored the 600 disputed acres of land at Waitara. Māori waited for Grey to return to Waitara as he had intimated, but after a month of waiting Taranaki Māori killed a group of soldiers at Ōākura who were taking supplies to the British force at Tataraimāka. In May *Te Hokioi* published a letter from the minister of native affairs, F. D. Bell, accusing the Taranaki warriors of having murdered the soldiers in the name of the Māori king and advising the Kīngitanga to abandon those responsible as "all people who befriend such murderers the governor deems also to be murderers: people should calmly and deliberately determine which side they are on."[59] As the government was aware, if the Kīngitanga discarded its supporters, however militant, the movement would inevitably crumble as its underlying rationale was based on a pan-Māori identity and unity, and resistance to governmental authority.

Te Hokioi did not counter Bell's arguments directly, but printed a letter from Mataitawa chiefs in Taranaki giving their side of the story. This first discussed the governor's aggressive attitude at Tataraimāka and other places, then gave an account of the Ōākura incident, in which the Māori warriors pleaded with the soldiers not to proceed. However, due to the soldiers' belligerent stance, a battle commenced in which the British soldiers were killed. The letter ended with a plea for the Kīngitanga to come to Taranaki again to assist.[60] That *Te Hokioi* juxtaposed these two letters without comment shows that attitudes among the Kīngitanga had hardened. For the Māori readers, Bell's letter was plainly another governmental attack on the integrity of the movement, and the Mataitawa letter demonstrated Māori resistance to governmental aggression. *Te Hokioi* did not need to explain the letters' meanings to its readers.

War brought about the demise of the Kīngitanga newspaper, as well as the viability of the Māori nation. Grey had been assiduously preparing for war, but rather than engage Kīngitanga warriors in Taranaki as had happened in 1860–61, he decided to attack the movement directly by invading the Waikato River basin. With war against the Crown imminent, the Kīngitanga sent its printing press upstream for safekeeping although it was later discarded in the chaos of war.[61] During the Waikato campaign (July 1863–March 1864) the British Army pushed the Kīngitanga forces out of Waikato into Ngāti Maniapoto territory, allowing the government to confiscate the occupied Waikato land for Pākehā settlement. The Kīngitanga continued as a separate, but smaller, state in the "King Country," hostile to Pākehā intrusion until the early 1880s. The movement's newspaper had been silenced by force, but re-emerged in a different colonial environment in 1892 as *Te Paki o Matariki*.[62]

Conclusion

The Kīngitanga may have been lucky to have obtained a printing press, but having done so it established *Te Hokioi* to challenge the government's propaganda, and the dominant colonial discourse of power. Unlike the government discourse that New

Zealand would comprise one united people made up of Māori and Pākehā, the Kīngi-tanga was predicated on resisting subsumption by creating a Māori nation physically separate from Pākehā settlements. *Te Hokioi* was therefore prepared to convert the existing contemporary colonial discourse of cultural racial difference into one of political difference, of the binary opposites of black skin and white skin. This racial differentiation allowed for an ethnically based nationality.

Unfortunately for the Kīngitanga, serious problems existed. First, many Māori collectives preferred, whether through fear, self-interest, or genuine sentiment, to imagine themselves as autonomous entities within the emerging New Zealand nation-state rather than a Māori one. Second, the movement's rhetoric that the government could govern the land it had bought meant that the potential Māori state could shrink but never grow. Third, by the 1860s the government was aggressively pursuing a policy not only of acquiring Māori land but also extending its effective sovereignty as best it could. This included, in 1863, sending the British Army into the Waikato, which effectively limited the Kīngitanga's viability, and snuffed out the first example of Indigenous resistance through the use of media.

Te Hokioi's main purpose was to legitimize the Kīngitanga and the notion of a separate Māori state. Prior to Pākehā colonization, Māori had imagined themselves as members of kin-based groups. Therefore, both the new New Zealand state created through the Treaty in 1840 and the Kīngitanga itself eighteen years later, were new concepts without any long-standing authenticity. *Te Hokioi* sought to discredit the Crown's legitimacy by attacking the Treaty, arguing that many chiefs had not signed it and that those who had had been duped. While it acknowledged that the Crown could exercise its authority where it had bought land from Māori, it maintained that the Māori king should hold the *mana* over land that Māori still held. The newspaper also sought to demonstrate the legitimacy of the Kīngitanga by showing the broad support it held from *iwi* whose *mana*, in Māori terms, was indeed long-standing and authentic. In the face of government criticism that the Kīngitanga was unable to govern effectively, *Te Hokioi* stressed the efficacy of the Kīngitanga's legal system. The newspaper also justified the Kīngitanga resistance to government intrusion, including the magistrate Gorst, and the attempt to construct a fortified position within Kīngitanga territory.

Te Hokioi was published over only a relatively short space of time, yet the newspaper stands out not only as New Zealand's first example of Indigenous media, but also as one of its most radical. That is, its message of resistance sought to displace the encroaching colonial state as rightful sovereigns and to establish Indigenous political validity via Māori unity or what now might be considered "Māori nationalism." Since its demise, New Zealand has never seen Indigenous media of its like return, as the realpolitik of Pākehā demographic and military ascendency demanded more pragmatic responses. After *Te Hokioi* ceased to exist and into the twentieth century, a number of Māori-run newspapers appeared (including from the 1890s, the Kīngitanga's *Te Paki o Matariki*), some of which did seek to maintain or regain Māori *mana* and *tino*

rangatiratanga, yet such sentiments were always framed within the constraints of the wider New Zealand nation-state. That is, rather than challenge that state's right to exist, these newspapers sought rights based on 1840 Crown promises. Of all the newspapers, only *Te Hokioi* refuted the Crown's right to govern Māori, and advanced the notion of a united independent Māori state.

Notes

1. Anne Morrell, "Wiremu Toetoe Tumohe and Te Hemara Rerehau Paraone: Two Māori in Vienna," Working Papers of the Research Centre for Germanic Connections with New Zealand and the Pacific, no. 2 (University of Auckland, Department of Germanic Languages and Literature and Slavonic Studies, 2002); Helen Hogan, *Bravo, Neu Zeeland: Two Māori in Vienna 1859–1860* (Christchurch, N.Z.: Clerestory Press, 2003).

2. For example, see *Te Karere Māori,* July 14, 1860, 3.

3. Ruth Ross, "The Treaty of Waitangi: Texts and Interpretations," *New Zealand Journal of History* 6, no. 2 (1972): 129–57. For a more extensive discussion of the Treaty of Waitangi, see Claudia Orange, *The Treaty of Waitangi* (Wellington: Bridget Williams Books, 1987), 145. The term "*rangatiratanga*" possessed a number of different meanings in the nineteenth century depending on the context in which it was used. For further discussion, see Lachy Paterson, "Te Whakamahi i te Kupu Rangatiratanga i te Tekau mā Waru o ngā Rautau," *He Pukenga Korero: A Journal of Māori Studies* 10, no. 1 (2011): 15–22.

4. James Belich, *The New Zealand Wars and the Victorian Interpretation of Racial Conflict* (Auckland: Penguin Books, 1986), 20–21.

5. "*Hapū*" is a term for the kin-grouping that formed the primary social, political, and economic unit of precontact Māori society. A number of *hapū,* connected through *whakapapa* (genealogical links) composed an *iwi* (people). A large *hapū* in time could become an *iwi* in its own right. One of the consequences of colonialism is that *iwi* as political units became more important, partly because Māori could present a more united voice to government, and partly due to government preferring to deal with larger Māori entities. See Angela Ballara, *Iwi: The Dynamics of Māori Tribal Organisation from c.1769 to c.1945* (Wellington: Victoria University Press, 1998).

6. Maurice P. K. Sorrenson, "Māori and Pakeha," in *The Oxford History of New Zealand,* 2nd ed., ed. Geoffrey Rice (Auckland: Oxford University Press, 1992), 149; Matthew Wright, *Two Peoples, One Land: The New Zealand Wars* (Auckland: Reed, 2006), 26–27.

7. Belich, *The New Zealand Wars,* 64–70; Nigel Prickett, *Landscapes of Conflict: A Field Guide to the New Zealand Wars* (Auckland: Random House, 2002), 47.

8. *Te Karere O Nui Tireni* (1842–46); *The Māori Messenger–Ko te Karere Māori* (1849–54); *The Māori Messenger–Ko te Karere Māori* (1855–60); *Te Manuhiri Tuarangi–Māori Intelligencer* (1861); *Te Karere Māori–Māori Messenger* (1861–63); *Te Pihoihoi Mokemoke* (1863). These were supplemented by other newspapers produced by Pākehā. Walter Buller, government interpreter and son of a missionary, published *Te Karere o Poneke* (1857–58). Charles Davis, while not employed in the Native Office, produced *Te Waka o Te Iwi* (1857), *Te Whetu O Te Tau* (1858), and *Aotearoa–Māori Recorder* (1861–62). Rev. Thomas Buddle of the Wesleyan Church published *Te Haeata* (1859–62). For an analysis of Māori newspapers of this time, see Lachy Paterson, *Colonial Discourses: Niupepa Māori 1855–1863* (Dunedin, N.Z.: Otago University Press, 2006).

9. Lachy Paterson, "Māori Conversion to the Rule of Law and Nineteenth-Century Imperial Loyalties," *Journal of Religious History* 32, no. 2 (2008): 255.

10. *Te Karere Māori,* March 5, 1862, 2–4.

11. Benedict Anderson, *Imagined Communities: Reflections on the Origin and Spread of Nationalism,* rev. ed. (London: Verso, 1991), 6. See also Lachy Paterson, "Print Culture and the Collective Māori Consciousness," *Journal of New Zealand Studies* 28, no. 2 (2010): 105–29.

12. See Angela Ballara, *Taua, "Musket Wars," "Land Wars" or Tikanga? Warfare in Māori Society in the Early Nineteenth Century* (Auckland: Penguin Books, 2003), 122–26.

13. Frantz Fanon, *The Wretched of the Earth* (1963; repr., London: Penguin Books, 1990), 31.

14. *Te Karere Māori,* July 14, 1860, 2–3: "He tikanga atawhai ki te Māori nga tikanga i nohoia ai e te Pakeha; no te orokotimatanga mai ano taea noatia tenei, ko aua tikanga i mau tonu, ko a te atawhai, ko a te whakapono." (English translation from source document.)

15. *Te Karere Māori,* July 14, 1860, 8.

16. This slogan appeared on the first pages of issues of the government's bilingual *Maori Intelligencer: Te Manuhiri Tuarangi,* first in Māori as "Kia whakakotahitia te Maori me te Pakeha," then in Māori and English atop the first bilingual columns. This newspaper appeared sixteen times between March and November 1861. The slogan was kept for the first seven issues of its replacement, *The Maori Messenger: Te Karere Maori* (December 1861–March 1862).

17. See Lachy Paterson, "Kiri Mā, Kiri Mangu: The Terminology of Race and Civilisation in the Mid-nineteenth Century Māori-Language Newspapers," in *Rere atu, Taku Manu! Discovering History, Language and Politics in the Māori-language Newspapers,* ed. Jenifer Curnow, Ngapare Hopa, and Jane McRae (Auckland: University of Auckland Press, 2002), 78–97.

18. Paterson, *Colonial Discourses,* 134–35.

19. Boyd C. Shafer, *Nationalism: Myth and Reality* (London: Victor Gollanz, 1955), 7–10, 44–51.

20. See Anderson, *Imagined Communities,* 18, 33–45.

21. Ernest Gellner, *Nations and Nationalism* (Oxford: Basil Blackwood, 1983), 35.

22. Anderson, *Imagined Communities,* 44.

23. *Te Hokioi,* January 15, 1863: 1: "*nga kiri mangu katoa, ahakoa i te taha Kuini, kingi ranei.*"

24. See Lachy Paterson, "Haiti and the Māori King Movement," *History Now: Te Pae Tawhito o te Wā* 8, no. 1 (February 2002): 18–22.

25. *Te Hokioi,* April 26, 1863: 2: "Waiho marire ki a mahi nga runanga, taihoa pea ka rite te Rangatiratanga o te motu nei ki to Haiti, whai taonga, whai mana, whai ture, ta te mea e tohe ana matou ki te taha tika, tera pea te Atua e tiaki i ona tamariki kiri mangu, e noho ana ki Aotearoa."

26. F. M. (Jock) Brookfield, *Waitangi and Indigenous Rights: Revolution, Law and Legitimation* (Auckland: Auckland University Press, 1999), 105, 108.

27. *Te Karere Māori,* July 14, 1860, 10: "a, te ngaromanga e ngaro rawa ai"; "which must necessarily entail upon them evils ending only in their ruin as a race." See also Lachy Paterson, "The Kohimārama Conference of 1860: A Contextual Reading," *Journal of New Zealand Studies* no. 12 (2011): 33.

28. *Te Hokioi,* December 8, 1862, 2: "me tu te mana o kingi potatau ki runga i nga wahi o Nui tireni e mau nei ki a tatou, me tu te mana o kuini ki runga i nga wahi kua riro atu ki a ia." (All translations from *Te Hokioi* are by the author.)

29. *Te Hokioi,* December 8, 1862, 3: "e kore e pai ki a riro nga rangatira tokomaha i te whakaetanga o te rangatira kotahi."

30. Depending on the weather and river flows, the Waikato and Waipā Rivers were navigable well past Ngāruawāhia. Māori concerns were quite valid. The Crown utilized armed steamers in its invasion of the Waikato in 1863. See Richard J. Taylor, "British Logistics in the New Zealand Wars, 1845–66" (PhD thesis, Massey University, Palmerston North, N.Z., 2004), 130, 136–37, 142–43.

31. *Te Hokioi*, February 15, 1862, 1: "Ehara a Waikato awa i a te Kuini, e rangi no nga Maori anake . . . he kupu marama ano te kupu a to tatou whaea a te Kuini, i kii mai ai ki aua rangatira, i mea: Ki te kore nga tangata o Nui-Tireni e pai ki te tuku mai i te mana [o] o ratou whenua, o a ratou awa, o a ratou hianga ika ki au, e pai ana; waiho kia ratou ano te mana; na ko tetehi tenei o a matou awa e kaiponuhia nei e matou."

32. Ibid., 2: "kaore i mohio he matika kei roto."

33. *Te Hokioi*, December 8, 1862, 3: "i kiia ai e au ko te kawenata o te matapo, te mea e noho kuri ana nga tangata o taua takiwa, ka ore he whakaaro tangata, e penei ana me te kuri e whaka aria atu nei ki te kai pai te kitenga mai rere tonu mai ki te kai, ka hua he tino pai taua kai; no tana kainga ka mau i tona kaki katahi ka mohio e hemate tenei, ka tae atu tona ariki, ka kitea, he wheua e mau ana i tona kaki ka tahi ka tangohia ka riro na ka hoki mai te wai ora ki a ia . . . tena ki ta koutou whakaaro koia ko te kuri ihe, kao ko te tangata ano ihe ko te mea whai mahara."

34. *Te Hokioi*, February 15, 1863, 2: "i te takiwa i mua atu ote Kingitanga, ka mea nga Kawana, hei iwi kotahi te Maori, te pakeha, e ai ki te hamumu a o ratou waha haere atu ana nga Maori, ki te hoko pu; paura, kaore e ma kere mai, hokona atu e nga Maori; tewhenua ki a Kawana, he i ti te utu, – kei whea te tikanga o nga kupu i kia nei he iwi kotahi, he ture kotahi?"

35. For example, *Te Karere Māori*, September 30, 1857, 6; *Te Karere Māori*, July 31, 1860, 54.

36. *Te Hokioi*, June 15, 1862, 3.

37. Ibid., 4.

38. *Te Hokioi*, December 8, 1862, 2.

39. "Further Papers Relative to the Native Insurrection," *Appendices to the Journal of the House of Representatives* [AJHR] (1861), E1-B, 15, *AtoJsOnline*, http://atojs.natlib.govt.nz/cgi-bin/atojs/; "Return of the Correspondence Signed or Purported to be Signed by William Thompson Te Waharoa, etc.," *AJHR* (1865), E11, 6, ibid. The scripture quoted is from Deuteronomy 17:15.

40. *Te Haeata*, April 1, 1861, 3.

41. *Te Hokioi*, April 26, 1863, 2: "tau kupu ra, e hoa: 'Kaore te Atua e pai ki te wehetangata, ko ta te Atua i pai ai he whakakotahi i nga iwi katoa o tenei ao, ahakoa pakeha, Maori ranei, ki a kotahi ture.' Heoi ano taku hamumu ki a koe mo tau korero, mau e pataia atu ki nga iwi pakeha maha noa atu ki Uropi, (no reira ano te Whakaponotanga me nga tini mea katoa) moteaha i turi ai ratou ki ta te Atua i wehe ke ai era iwi kiri ma."

42. John Eldon Gorst, *The Maori King* (London: Macmillan, 1864; repr., Auckland: Reed, 2001), 2, 6. Citations refer to the Reed edition.

43. Keith Sinclair, "Māori Nationalism and the European Economy, 1850–60," *Historical Studies: Australia and New Zealand* 5 (1951–53): 119; Keith Sinclair, *The Origin of the Māori Wars* (Wellington: New Zealand University Press, 1961), 78.

44. John Eldon Gorst, *New Zealand Revisited: Recollections of the Days of My Youth* (London: Sir Isaac Pitman and Sons, 1908), 207, 209.

45. *Te Pihoihoi*, February 2, 1863, 3; *Te Pihoihoi*, March 9, 1863, 17; *Te Karere Māori*, April 20, 1863, 3–4.

46. *Te Hokioi*, December 8, 1862, 2: "Kia purutia te ringa kaha o te tangata e tohe nei kitehapai pakanga, mo tana oneone mo tana wahine hoki, ki a waiho ma te Whakawa e rapu he ritenga mo era hara, kia kati te whakaeke i te hara o te tangata kotahi ki runga i te tokomaha."

47. *Te Karere Māori*, November 30, 1857, 12–13; *Te Karere o Poneke*, November 12, 1857, 2–4; *Te Karere o Poneke*, December 3, 1857, 2; *Te Karere o Poneke*, September 27, 1858, 2–3.

48. *Te Hokioi*, January 15, 1863, 4; *Te Hokioi*, February 15, 1863, 2.

49. *Te Hokioi*, January 15, 1863, 4: "Na, e hoa ma ki te mea ka kite koutou i te hara, korerotia ki te kaiwhakawa, ki te Monita ranei: kaua tetahi tangata e paatu ki a ia kei hinga atu te ture ki a ia."

50. Ranginui Walker, *Ka Whawhai Tonu Mātou: Struggle without End* (Auckland: Penguin Books, 2004), 103.

51. *Te Karere Māori,* December 16, 1861, 5–8.

52. *Te Hokioi,* June 15, 1862, 1.

53. Its full name, *Te Pihoihoi Mokemoke i Runga i te Tuanui,* is taken from Psalm 102:7, "[I am] a sparrow alone upon the house top," a line followed by "Mine enemies reproach me all the day; and they that are mad against me are sworn against me." The title, known to Māori well versed in the Bible, was used as a metaphor for Gorst's isolated position as the government's magistrate within the hostile Kīngitanga area. The first issue played on the metaphor, suggesting that the *Pīhoihoi* would continue to "sing" the truth even if its enemies, such as Rewi Maniapoto, came to throw stones at it.

54. Gorst, *Maori King,* 140–43.

55. Ibid., 92–93.

56. *Te Hokioi,* April 26, 1863, 3: "ko te ahua o taua whare i karangatia ai i mua hei whare karakia ki te kohekohe Hei whare whakawa ki reira hei whare kura, pirihimana hoki. I te wa i whakarapopototia ai nga papa, ka tino matau matou, kua rereke te ahua o taua whare. Kua tua karapoti nei, koia ano, he ahua no te timatanga o te pa Hoia ki te Ruato."

57. "Native Affairs. Despatches from the Secretary of State and the Governor of New Zealand," *AJHR* (1863) E3-1, 18–19.

58. *Te Hokioi,* April 26, 1863, 4: "I taua po, ka whakaarohia nga heote kohi, ko tana unuhanga i te pou a Neri, i Mangatawhiri, ko tana whakatete kia te Hokioi, ara, i ana kupu pokanoa ki te whakahe ki te kingi[,] ko tana tohe ki te whakatu i te whare hei whakatari kino ki te kohekohe, ki te iwi hoki, ko taua, kore e rongo ki te whakahoki i nga Papa ki te Ia, me nga kamura."

59. *Te Hokioi,* May 21, 1863, 1: "ko nga tangata katoa e whakahoa ana ki aua kai kohuru ka kiia e te Kawana he kohuru tahi ratou: me ata hurihuri marire te tangata, ko tehea taha ranei tana e pai ai."

60. Ibid., 2.

61. *Te Awamutu Courier,* August 26, 1949, quoted in *Journal of the Te Awamutu Historical Society* 6, no. 1 (1971): 26. The remains of *Te Hokioi* press were recovered from a farmer's field and are currently exhibited in the Te Awamutu Museum.

62. The title of the Kīngitanga's newspaper, *Te Paki o Matariki,* literally means "The widespread clam of the Pleiades," which traditionally referred to fine weather and was a metaphor for peace. The newspaper bore King Tāwhiao's coat of arms, also known as "Te Paki o Matariki." For more details, see Carmen Kirkwood, *Tawhiao: King or Prophet* (Huntly, N.Z.: MAI Systems, 2000), 109–10.

8. *Barry Barclay's* Te Rua

The Unmanned Camera and Māori Political Activism

APRIL STRICKLAND

.

I am cinema-eye—I am a mechanical eye. I, a machine, show a world such as only
I can see.

—Dziga Vertov, *Kino-Pravda*

IN THE FIRST SCENE OF *TE RUA*—Barry Barclay's seminal 1991 film about Māori
rights and responsibilities—a man in a trench coat walks on a beach, away from the
camera and toward the water. It is a gray rainy day, and his body is obscured by the
inclement weather. He turns and addresses the camera. "Ready?" he asks. He then
takes a few more steps toward the water, turns to the camera once again, and says, "Is
it okay?" The film cuts to an unmanned camera. Rain and heavy mist blow past it. An
umbrella has been set up next to the camera, presumably to protect it from the ele-
ments. The film then cuts back to the man. He strides toward the camera, then stops
and asks, "Are you rolling?" The film slowly zooms in on the unmanned camera. It
stands there alone, with no one to guide it. The vocals from a Māori *haka* (posture
dance) are soon heard, quietly at first, then steadily louder. In the next shot, we see the
man in the trench coat standing in front of a group of Māori men. They are dressed in
ceremonial costumes and performing a *haka*. The man stands perfectly still as they
move and chant behind him. The film cuts to an extreme close-up of the unmanned
camera. It lingers on that image. Even up close its workings are impenetrable.

As one of the first Indigenous feature films produced in New Zealand, and by Bar-
clay's count,[1] one of only five such productions in all, *Te Rua* has been influential in the
development of Māori media and self-perception. At the level of plot, the politics of
the film are quite clear: a group of Māori activists are struggling for the repatriation of
three ancestral carvings taken from their community in the 1880s and sold to a Ger-
man collector. Now, more than a hundred years later, the carvings are held in the store-
room of a Berlin museum. Māori activists, both in New Zealand and abroad, work to
have these carvings—their de facto ancestors—returned to their community. This
repatriation effort drives the film's narrative.[2]

Yet, the film is more than a critique of the appropriation of cultural property, a polarized tale of bad Europeans and good Māori, or a morality play about colonial arrogance and Indigenous righteousness. Instead, it presents a vision of a restored Māori community and testifies to the efficaciousness of certain forms of Indigenous political activism. But it is strangely silent about Māori production of media, let alone its possible roles in this utopian vision. What kind of model and message does *Te Rua* offer when the Indigenous production process of images is shown to happen, as it were, all by itself? Why are we repeatedly shown images of an unmanned camera with no one behind it? If Māori activists are to be in control of their own "image destiny," to use Barclay's words,[3] why is no one from the Māori community shown to be in control of the camera?

This chapter tracks the notion of the unmanned camera in relation to Indigenous media, and my use of it as a heuristic for understanding the composite vision of Māori activism presented in *Te Rua*; how Barclay's representation of the camera and its inter-locutors is dependent on his notion of "talking in" and "talking out"; Barclay's conception of the "marae" and the "invisible marae," and the ways these serve to consolidate Māori community and suture past wounds; the role of technology and media in *Te Rua*'s depiction of community; and the proposed idea of "spiritual ownership" as an antidote to the commodification of Māori cultural property.

The Unmanned Camera

After the opening scene, Taki Ruru (the man in the trench coat) provides the historical context for the story. He stands in front of the unmanned camera and talks directly to the viewer. "Only our Nanny knows," he says, "where the man is buried. His own brother threw him out. That was on the day he heard what he and the German had done with the carvings." The film then cuts to a shot of an ancestral carving being pried off the wall of a *whare whakairo* (ancestral meeting house). "The man," Taki continues,

> I don't want to say his name, took shelter in that shed. That one over there, *te rua*, the store-house. It was built for sweet potatoes. We never go in there now. On the day he was thrown out, the man lived like a scavenging pig. And at the beginning of winter, he shot himself in the chest. No one would pick up the body. After ten days, a Pākehā came, went down into the shed and collected what was left of him. And he buried the remains someplace we don't know. Only Nanny knows.[4]

The viewer now understands that it was a collaborative effort on the part of a capital-izing German collector and a rogue Māori individual.

In this scene, the unmanned camera plays an active role. It is frequently shown onscreen as it silently records Taki's monologue. In doing so, the film acknowledges its technological artifice and calls attention to its immanent presence. Rather than

"breaking the fourth wall," whereby an actor directly addresses the audience and calls attention to the fictional artifice set before the spectator, here the physical presence of the camera compromises realism. The onscreen camera is on, yet it is not actually recording Taki Ruru's monologue. It is only a token, an icon.

Televisual images, as Barry Dornfeld suggests, emerge "from the variety of social interactions that occur in its making, guided through all production stages by interpretative and evaluative acts, constrained and steered by the field of production within which the work is embedded."[5] Yet, the image of the unmanned camera here confounds the spectator who implicitly knows that films do not self-manifest. This scene was not the result of an unmanned camera set up on a beach. It is not a spontaneous home movie soliloquy. It is a scripted dialogue but where is the field of production within this scene?

To answer this question, I asked the Māori artist and political activist George Nuku, who worked on music production for *Te Rua*. Nuku believes that this scene is a commentary on the lack of a Māori presence in the media, both onscreen and off. By his account, since there were no Indigenous people working in the film industry in New Zealand, "there might as well not be anyone there at all."[6] When Indigenous people were filmed, the final product was not the result of collaboration between filmmaker and subject. There was only the filmmaker's view of Māori. Images were being taken, not given or shared.[7] From Nuku's perspective, the unmanned camera in this scene is a commentary on such exclusionary cinematic practices. Rather than staging a process of mutual participation and exchange between filmmaker and subject, the scene places the Māori subject in full control. Following Maureen Mahon,[8] this scene could be read as a public and visible process where Barclay "self-consciously uses the media and artistic forms to critique the social terrain [Māori] inhabit and the social verities they inherit." For instance, while the speeches that characters utter to the unmanned camera may be the most obvious presentation of resistance in *Te Rua*, there are also visual and narrative forms of resistance. Characters adopt physical stances taken from Māori ritual performance, and clearly enter into a formalized performance space outside of the realm of so-called naturalized acting that the rest of the film inhabits.

The unmanned camera appears again later in the film, after the viewer has been introduced to the central characters and the main storyline. The Māori activists in Berlin are now starting to gather support for their cause. Again, a single individual addresses the unmanned camera, which once again appears alone on a beach. This time, however, the individual is a young Māori woman, Mare Marangai, the protagonist's daughter. Other women stand on the beach behind her. All are dressed in wetsuits and carry masks and snorkels. They appear to have been gathering food in the waters near shore. She stands rigidly and states, "It's a game to them, those people in Europe. . . . They draw us into their plans and we get trapped. They don't give a damn about us. Farmers and fishermen, that's what we are. Why? Why do they try to trap us all the time?" Beyond cinematic practices, this monologue contests repressive political processes.

The unmanned camera also appears to break the narrative flow. While the rest of the film functions in a typically Aristotelian manner of linear narrative development, the temporal and conceptual relation of these scenes to the other events in the film is unclear. They are neither flashbacks nor flash-forwards. Yet, these visual and narrative breaks in the story serve to create an informed commentary on the proceedings of the rest of the film. In many ways, these scenes are reminiscent of on-location news bulletins, though the background visuals are less a visual supplement to the narration than a kind of visual testimony authorizing the Indigenous pedigree of the "number."[9] While such a reading makes sense in the scene with Taki and the *haka,* it is less clear whether Māori women with wetsuits, masks, and snorkels have a similar authorizing gravitas— either for a Māori or non-Māori audience. Nevertheless, these tableaux do signal to the viewer that the actors are in a different kind of space, that they are no longer just acting within the film but solemnly commenting upon it, and this form of visual resistance makes the narrative resistance of the speeches all the more compelling.

Whakapapa, "Talking In," and "Talking Out"

While these tableaux presented to the unmanned camera can be appreciated by a non-Māori audience, the film also presents scenes that can only be understood (and perhaps only appreciated) by an audience with intimate knowledge of Māori culture. Moreover, little if any attempt is made to explain the significance of these scenes to a more general audience. The most conspicuous of such scenes involves *whakapapa* (genealogy). For instance, when the international businessman and protagonist Rewi Marangai returns home to New Zealand, he finds that his wife has gone to work shearing sheep in a local factory. Rewi walks up to her, hands her a wrapped gift, then walks over to another man in the factory. They shake hands, then *hongi* (share breath by pressing noses together).[10] Rewi says to the man, "Your grandfather on your mother's side was Hepi Ropata." The man nods. Rewi continues: "Hepi's father was Rewi Marangai, my name. Your brother Stevie shifts fish for the Gisborne fisheries." A slight nod. "He sleeps with my wife." Rewi walks out of the factory.

For those unfamiliar with Māori culture, this scene is slightly mystifying. The viewer knows that Rewi has announced his presence in his home community and presented himself as knowledgeable of certain personal events that have transpired in his absence. What may not be evident to a non-Māori audience is that Rewi employed *whakapapa* to make his point. Barclay writes,

> Rewi did not need to punch Steven Ropata's brother, William. He simply reminded him of their blood connections and, given the circumstances, that would be humiliating enough. He drove the knife deeper by reminding the offending family that a common ancestor carried his name, Rewi [Marangai]. By mentioning whakapapa and a shared name in front of others, Rewi made his feelings clear to the others much more effectively than if he had resorted to some gross physical attack.[11]

My sample Māori audience chuckles at what Rewi does.[12] He manipulates the use of whakapapa in a way that is both unconventional and conventional. It is unconventional in that he uses it in public to put his wife and her new man in their places, and it is conventional in that the citing of whakapapa is often used to assert legitimate status.[13]

In this scene, a high degree of cultural literacy is required to comprehend both the conventional and unconventional use of *whakapapa.*

Barclay, sensing the debate that this scene and others like it in *Te Rua* might cause, preempts his potential detractors. In *Our Own Image* he writes,

Perhaps you have similar traditions [to *whakapapa*] within your own culture and no doubt other cultures have such traditions too. But from where I am sitting, I can imagine some debate coming up about this scene and others like it. "OK. I accept that what Rewi does is culturally accurate, but how do you expect the rest of us to understand that? You will have to put in more explanation, give more background, or you are going to alienate your audience." My only defense against that valid observation is rather a high-handed response: "Well, I am not writing for you. I am writing for a Māori audience. They will understand what the scene means."[14]

Barclay describes this strategy as "talking in" rather than "talking out."[15] "Talking in" refers to a method of presentation that draws upon and speaks to those with intimate knowledge of a culture, while resisting an assumed synthesis of Indigenous cultures into Western frames of understanding. "Talking out" on the other hand is complicit with explaining the workings of culture to an outside audience and is positioned in relation to market demands. Rangihiroa Panoho describes this terminology of "in" and "out" as a binary between privacy and revelation. According to Panoho, Barclay's films are positioned as

facing inwards into its own parent cultural space yet transparently allowing external cultural observation, gaze and etic participation. He sees the former term as the more appropriate approach and a necessary answer to the dilemma of constantly "talking out" to meet the demands of the market. The filmmaker infers this process as one that almost overcompensates for the intention and meaning of the work not being understood by those simply passively observing and being fed the culture on screen.[16]

While Barclay had attempted to "talk out" in earlier projects, he ultimately found this to be an unrewarding strategy, as he explains,

The "talk out" approach has been tried, not only in film-making, but in many other areas too—in education, public broadcasting and publishing. By and large, the approach has failed. The majority culture seems to have ears like a sponge: you can talk your tongue off, year after year; the ears flap, but in the end you feel you have spent your life speaking to a great sponge which does not seem to learn, but which is ever eager to absorb more.[17]

The *Marae*: Balancing Hospitality and Interiority

For Barclay, the resolution to the problem of tokenized absorbtion, that is, where one is willing to absorb culture by merely synthesizing it into one's own, while foregoing the will to "learn," involves the creation of an "invisible marae." "The marae," Panoho explains,[18] "is a space which brings people together and provides a context and occasion in which they might practice their values, conduct their protocols, enact their ceremonies, and celebrate their taonga [valued things]." "When you enter this space," Barclay writes,[19] "you will hear our people talking in their own way to their own people." Though the invisible *marae* is not signposted, one finds there the same qualities, values, and protocol associated with a visible *marae*. It is these qualities, and not just four walls, that Barclay argues make "a marae a marae."[20]

Following this model, Barclay stakes out a new theoretical position where a *marae* need not "abandon or compromise its key values so that another culture might better understand the Indigenous culture. It is not the role of film, Barclay asserts, for example, to educate Pākehā [white New Zealanders] about Māori."[21] Pākehā, should they want to know about Māori epistemic knowledge, will need to invest time and energy. The invisible *marae*, Panoho writes, is "not open to those incapable or unwilling to accommodate the differing Māori concerns and value systems which clarify it. Everything of deeper and more abiding value in the Māori world takes time, relationships, and a commitment to realise."[22] To be an active audience participant, one must be willing to learn, as well as visually familiar with the cinematic grammar that Barclay employs.

Like the protagonists in the film, the ideal audience is situated locally but is savvy to the world abroad. This viewer should have knowledge of both customary culture and contemporary visual media. The ideal viewer then is a Māori fluent in *te ao Māori* (the Māori world) who can also make sense of popular cinema. Yet, this is not divisive, although dominant cultures seem to see recourses to alterity as inherently so. While *marae*—both cinematic and architectural—are created for and maintained by Māori communities, they welcome visitors. According to Barclay,[23] hospitality is an essential quality of a *marae*, and without it, a *marae* will not survive:

> A marae has another quality that tempers what, at first glance, might seem to be exclusiveness. The whole conduct on a marae is aimed at making people from other areas welcome and comfortable. No matter how steeped in tradition a marae is, and no matter how piously the local people invoke those traditions, if visitors feel they have not been brought in warmly and treated well, then the marae will be considered hollow and will die. When creating a communications marae,[24] I think we must be conscious of that duty to offer suitable hospitality. You must not insult your guests, or let them feel they are being left on the outer. If we do not respect that most basic of marae rules, the communications marae we have striven so hard to set up will be rejected, not only by the majority culture, but by our own people—and indeed, by them first.[25]

The invisible *marae* is a way of balancing film's public nature with Indigenous responsibilities and values, while maintaining cultural integrity.[26] As Panoho explains, "The filmmaker sees the marae form as keeping itself open to the world while still maintaining its *manawa* (heart) area intact and unpolluted."[27]

When Trauma Leads to Action

The acknowledgment of a contemporary Indigenous audience in New Zealand is an overt political move. Barclay has non-Māori audiences, but first and foremost he is an Indigenous filmmaker creating films for his own community.[28] Like Inuit filmmaker Zacharias Kunuk, Native American filmmakers Sherman Alexie and Chris Eyre, and Australian Aboriginal filmmaker Rachel Perkins, Barclay uses media technology to create an argument for Indigenous self-determination.[29] Placing these forms of Indigenous entertainment in circulation inserts an Indigenous voice into dominant and counter "public spheres."[30]

In films such as *Ngati* (1987) and *Te Rua*, Barclay appears to be making a similar argument for the value of Māori lifestyles in New Zealand. Yet, Barclay also recognizes that these "everyday lives" are not without contradiction and complexity. The characters in *Te Rua* are not without fault. This is true of characters onscreen and offscreen, in the narrative past as well as the present. In fact, the central narrative of the film involves the treacherous acts of a community leader in the nineteenth century who performed an act of "symbolic violence" against his own community.[31] This film, like other de-romanticizing Indigenous films, is not "based on some retrieval of an idealized past, but create[s] and assert[s] a position for the present that attempts to accommodate the inconsistencies and contradictions of contemporary life."[32]

At the end of the film, for example, after the ancestral carvings have been repatriated, the matriarchal character, Nanny Matai, stands before the assembled community. She speaks in Māori, but a younger woman, Rewi's ex-wife Helen, translates her words and explains her actions: "She's standing at the gravesite of the man who helped steal the carvings . . . and now she's going through the genealogies showing we're all related to the man buried there." The history of the carvings' expropriation is a part of a collective history, and this fact is acknowledged rather than denied or elided. It is deliberately remembered, so that it will be preserved in the collective memory.

Though this story is fictional, it exemplifies a trend Faye Ginsburg has identified as "screen memories," where communities need to remember the traumatic and the damaging as well as the victorious and the triumphant.[33] Indigenous peoples, Ginsburg writes, "are using screen media not to mask but to recuperate their own collective stories and histories—some of them traumatic—that have been erased in the national narratives of the dominant culture and are in danger of being forgotten within local worlds as well."[34] In *Te Rua*, it is precisely these traumatic memories that generate social action. They are the catalyst. Māori have been directly involved in creating the

problems that face their communities, and now they must be directly involved in creating solutions. The Māori community in *Te Rua* loudly and actively agitates for its rights. This advocacy occurs domestically and abroad, in Māori and in English, in traditional and modern venues, and at the local and translocal levels.

In a direct effort to suture the traumatic wounds caused by the loss of their ancestors, Māori activists in *Te Rua* converge in Germany. From a public park in Berlin, they abduct the marble busts of three ancient Roman figures—Caesar, Pompeia, and Nero—and hold them captive in an abandoned warehouse. The parallels to the abduction in New Zealand of the three Māori ancestral carvings are overt. Just as three carvings of Māori ancestors had been seized and placed under German custodianship, three carvings of ancient Roman figures, the ancestors of contemporary Western culture, are abducted and placed under Māori custodianship. The intended critique of expropriation and custodianship is clear. A female Māori activist is shown speaking on the phone, presumably to the German police or a media source, and she says, "The point is, why can't we look after a few German artifacts? The experts in Berlin are looking after our work. Can't they trust us to be conscientious curators of their treasures? Are we inferior to them or something?"

Yet, the Māori activists do more than just create an uncomfortable homology between their proprietorship of German artifacts and German proprietorship of their artifacts. In an effort to reinstate the dignity of their community as well as repatriate their ancestral carvings, these Māori activists rig the ancestral statues in their control with explosives and hold them hostage. The police soon arrive and assemble outside the abandoned warehouse. The viewer sees Rewi Marangai casually walking out toward the police. Despite the presence of several heavily armed policemen, he appears calm and unshaken. He walks up to the police negotiator and says, "We are ready to make our first demands. We want a stepladder, right here where I'm standing. And a megaphone." The police officer, puzzled, answers, "That's all?" "For now, yes," Rewi says, then turns and walks inside.

A few scenes later, Rewi appears atop the stepladder, megaphone in hand. He addresses the assembled crowd: "The days when Indigenous people were talked at or down to have gone. Henceforth, all communication will be done from an appropriate height and with suitable instruments." Later, once again standing atop the stepladder and speaking through the megaphone, he makes his next demands: "A word processor. We need a word processor. Why should Indigenous people have to look after our treasures without the sort of technological support you people have enjoyed for years?"

Megaphone Diplomacy

Rather than represent themselves as noble savages victimized by "technologically more advanced powers,"[35] Rewi Marangai and his cohorts advocate for a Māori place

within the modern world. Though the use of technology by Indigenous people "may be limited by the political economy, ideological factors, and institutional constraints that marginalize the producers,"[36] this does not imply an inability to learn and make use of technological forms. In the stepladder scenes, for instance, Rewi appropriates a megaphone—a device that the viewer would expect to be used by the police to address the hostage-takers inside, not the other way around. As a wry political subversion, Barclay heralds a Māori voice, which is demanding and political—it is strong, loud, and heard by all, rather than elided, obscured, or silenced.

In many films, the police or other state security forces use megaphones to bark out orders to those who have transgressed the law. Here, however, it is the state that is being accused of being a transgressor. And it is doubly charged. Indigenous people have been deprived of treasures to look after—whether their own or others—and they have not enjoyed "technological support." Regardless of any claims that Rewi might make, just by speaking through a megaphone at an elevated height Rewi makes sure that as a Māori he is no longer simply "talked at or down to."

Rewi makes a number of megaphoned speeches from the top of the ladder. For example, when Dr. Sattler, the museum director, approaches the activists to negotiate, he is directed to a stepladder. Rewi, just a few yards away, stands atop his own stepladder, megaphone in hand. The museum director begins speaking, softly in an unmediated voice:

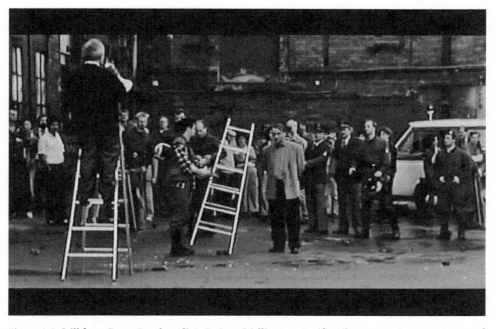

Figure 8.1. Still from Barry Barclay (dir.), *Te Rua* (Wellington: Pacific Films, 1991). Image courtesy of Pacific Films.

REWI: Stop. On the ladder please, Dr. Sattler, so we can be on equal footing. On the ladder please. (He pauses while the museum director climbs to his post on the ladder.)

REWI: We have been told you will return our ancestors.

MUSEUM DIRECTOR: Well haven't you been told the conditions?

REWI: Oh yes. No publicity. This gentleman has told us, away from the light of day, that our ancestors will be returned—quietly, like thieves released from prison. No publicity. They will be returned only when we give up our freedom, like burglars caught in the act. Dr. Sattler, our ancestors were crept out in the darkness. One hundred years later, I will not be party to creeping them home again. I reject your offer.

Though giving Dr. Sattler the chance to be on equal footing, Rewi nevertheless does not negotiate. Instead, he dictates the terms of the situation, both physically and discursively. This is an act of "megaphone diplomacy"—"the making of public statements regarding a matter of dispute, rather than negotiating directly."[37] While Dr. Sattler is given a stepladder, he is not given a megaphone; likewise, the police negotiator is given a megaphone but no stepladder. Rewi seems to be ensuring that he will always have the upper hand.

"Don't Just Think We're a Bunch of Country Bumpkins"

While Rewi dictates his terms in Berlin, Rewi's daughter dictates her own terms in New Zealand. Here, however, the conflict is not performed *through* a mediating device, but *over* a mediating technology. To protest the carvings' museum internment, Nanny Matai, the matriarchal figure of the community, has gone on a hunger strike in the local *marae*. A white news team soon appears to film her story for a local news program. As they are setting up their camera, Rewi's daughter Mare comes marching out of the *marae* and angrily approaches the news team. She knocks their camera over and begins to walk back to the *marae*. The head of the news team shouts out to her: "It's a public story." She replies, "It's our story." "It's news," he counters. "Tough," she says, "we have our own way with news." The reporter continues to argue with her: "The old lady says she won't eat until the carvings are returned. She'll starve to death. That's of national interest." Again she counters his argument: "We'll give you the news when it's our news. You can do whatever you like with your news." She begins to walk away, then turns and says, "And don't just think we're a bunch of country bumpkins, either. We know how to use you people, but we'll choose our time, thank you."

While the Māori community may not have its own news team to cover these events, they nevertheless portray themselves as media savvy. They appear to be knowledgeable of mediated representations and their circulation, and to be capable of controlling a media event so that it meets their goals. Their claims to such a highly sophisticated form of self-representation bespeak a mastery over a domain far more complex than the technological world of the megaphone and word processor. Media savvy

requires political acumen if not political influence, and Rewi's daughter seems to boast of having all three.

This scene also continues to redefine the *marae* as a space of political activism, while preserving its identity as an abode of Māori culture. Much like Chandra Talpade Mohanty's observation about feminist domestic space, the *marae* here can perhaps be seen as "an imaginative, politically-charged space where the familiarity and sense of affection and commitment lay in shared collective analysis of social injustice, as well as a vision of radical transformation."[38] The *marae* is not just a site of tradition, a place where deceased ancestors still live, but an active place where generations can come together and work together to bring about a vision of a thriving Māori community.

By taking up residence in the *wharenui* (carved meeting house), Nanny has taken the place of "Granny"—one of the missing carvings—as a representative ancestor. Her hunger strike is an effort to force the return of the ancestors (i.e., Granny and the other carvings) whose place she now inhabits. In a song that she repeatedly sings in the *wharenui,* she laments in Māori, "You came like the gull shredding open my womb. Now you've taken my children and they ride the wind with you." The solution to this problem requires her to intervene in a variety of ways. First, she directs Rewi to go to Berlin to reclaim the dignity of the ancestors. As one of Rewi's daughters tells him, "Nanny told you to go. You've got no option, you know." Second, Nanny takes herself hostage in the *wharenui,* not unlike what Rewi and the other activists do in Berlin. An ancestor's fate has been placed in the hands of a Māori activist, though in this case the ancestor and the Māori activist are one and the same. Lastly, Nanny works together with Rewi's daughter—the former makes the news and the latter speaks of controlling it. The *marae,* in short, is a place where custom, community, imagination, and politics all come together.

Activism and Ownership

The larger argument in these scenes and in *Te Rua* as a whole concerns political activism—what it means to work toward a healthy and sustainable community, and the challenges involved in this process. In this respect, the film is intended to be an instructional document for Māori activists advocating for the return of cultural property. *Te Rua,* Barclay writes,

> is also (in fact, primarily) an activist film on Māori conduct. Frankly, it is intended mostly as a document for Māori and other Indigenous people—this is what is likely to happen when you attempt to get your treasures back. Many of the messages (in particular, the idea of *mana tuturu* or Māori spiritual guardianship) are directed at Māori. We can get carried away being angry and active, and, along the way, forget the basics of the culture. In this respect the making of the film is a Māori activist camera "speaking in". It is speaking in also about what it's like to be speaking out.[39]

In *Te Rua*, however, the return of cultural property does not necessitate a physical return of expropriated objects, only a metaphysical return. At stake is the "spiritual ownership"[40] of property and the claim that certain highly valued objects in Indigenous communities, though recognized abroad as "art," can be treated as commodities—alienable possessions able to be bought and sold.

Ownership, when prefaced by the word "spiritual," does not necessarily refer to the materiality of the carvings, their commercial ownership, or their legal copyright, though these may be of significant value. Instead, it places these carvings into a different scheme of value where interior systems of meaning are privileged over exterior form. This idea of spiritual ownership brings to mind Marcel Mauss's notion that objects can possess, in part, the spirit of a person—for example, a gift is imbued in part with the spirit of its donor. [41] Here the carvings are not gifts, nor are they commodities. They are inalienable possessions.[42] Yet, they are very much imbued with spirits: the spirits of the ancestors. One of the carvings, in fact, is "Granny," and she is not for sale. Though she may have an outer value, what might be termed "commercial value," she has a far greater inner value, a "spiritual value." This inner value is the object of "spiritual ownership," and the deed or title of this ownership cannot be transferred.

In *Te Rua*, a New Zealand copyright lawyer, an African diplomat, and German political activists work together to create a legal document to be presented to the museum officials in Berlin. This document asserts that while existing copyright laws can stay in place, spiritual ownership of Indigenous "art" will be the right of the community that created it. When presented with this document, the director of the museum rebuffs it. Then the following exchange occurs between the museum director and the African diplomat:

> MUSEUM DIRECTOR: It's a blackmail document, Mr. Mbuya. Ownership.
> AFRICAN DIPLOMAT: Spiritual ownership.
> MUSEUM DIRECTOR: And copyright? And previous contracts?
> NEW ZEALAND LAWYER: They can stay in place.
> MUSEUM DIRECTOR: You're playing with words.
> AFRICAN DIPLOMAT: These people are asking for the dignity of their work to be recognized. And for that to happen, you and people like you must acknowledge the spiritual guardianship.
> MUSEUM DIRECTOR: But we own them, Mr. Mbuya.
> AFRICAN DIPLOMAT: You might own the outside, for the time being, doctor, but you will never own what's inside.

These words are prescient. In a later scene, the chairman of the museum, Dr. Biederstadt, is shown sitting pensively at his desk, pondering the contested document. Then, with an aria coming to a crescendo in the background, he signs the document and tells the activists waiting in his study, "I feel so much younger now." He has unburdened himself of the ancestors in his care. Though the museum's collection will remain much

the same, it will no longer be a spiritual prison for Indigenous ancestors. With this acknowledgment of spiritual ownership, even if the ancestral carvings are not physically returned to *Te Rua*'s Māori community, they will be returned in essence. And this, *Te Rua* argues, is what is most important. The film closes with the Māori community standing on the beach, one man again talking to the unmanned camera. Taki, the first character to have appeared on the screen, states, "We have our Granny back. . . . The others have gone to prison. But that's how it is. But the thing is, we have our Granny back. Know what that means? We're all together now."

The Unmanned Camera Reconsidered—Where Is Barry Barclay?

As I have argued, *Te Rua* makes a strong case for the efficacy of Māori activism in a variety of social and political contexts. Yet, why—to return once again to the image of the unmanned camera—is there no director shown onscreen who controls the camera and the images it records? Why create an illusion for the viewer that elides and simplifies the production of images, as if filmmaking could just happen on its own? How can the Māori community control the representation of itself if it is not working to produce its own images? Where is the director? Where is Barry Barclay?

In developing this chapter, I posed a series of such questions concerning the unmanned camera to Barry Barclay via e-mail. In one reply, he wrote,

> There simply weren't Māori media activists who might have been portrayed in *Te Rua*, not without inventing the breed for the sake of the drama. There were activists, of course, but not people skilled in making use of the now-usual tools. (Don't forget many of the tools were new then, or not available to the common citizen.)[43]

Barclay had expressed a similar sentiment previously about the relative paucity of Māori skilled in media production. As a result of receiving a substantial grant from the New Zealand Film Commission, Barclay writes,

> I ran a training course [in filmmaking], one of the first of its kind here, I guess. It was a four-week short, sharp exercise and fairly ineffective, except for its symbolic value in signaling to both Māori and Pākehā communities that something along these lines had to be done.[44]

While Barclay is probably right that an onscreen representation of skilled Māori media practitioners would have required "inventing the breed," I find it odd that in a film with so much wishful thinking about the Māori community, Barclay is so literally minded when it comes to representing those who share his profession. In a film where Indigenous treasures in a German museum are spiritually repatriated worldwide, why is it such a conceptual leap to place an Indigenous filmmaker behind the camera?

Barclay recognizes the "symbolic value" for the Māori community of training Māori in film production, even if such efforts were "fairly ineffective," yet he does not seem to

acknowledge the symbolic value of representing Māori filmmakers. While it is not the case that creating a particular symbolic world necessarily transforms the material world as desired or envisioned, changes at the symbolic level do generate "dispositions"[45] that may incline individuals to think and act in certain ways. So why not present Māori with the visual opportunity to recognize in themselves the possibility of their future as filmmakers? Why not offer Māori the chance to be "interpellated,"[46] the chance to be hailed visually to the calling of media production?

Considering that *Te Rua* was written and directed by Barclay, it is peculiar that he has created an alternate vision of the present in which Māori activists are extraordinarily effective in transforming the social worlds of Indigenous people worldwide, yet among these Māori activists there is no filmmaker. Seemingly every member in the Māori community joins together in political solidarity, yet no filmmaker is visibly present. While a German film crew comes to document the kidnapping perpetrated by the Māori activists in Berlin and a Pākehā film crew comes to document Nanny Matai's hunger strike on the *marae,* there is no Māori film crew in *Te Rua* to document anything. Regardless of whether this is humility, self-abnegation, or denial, Barclay's onscreen counterpart is conspicuous in his absence.

What is missing is not just a director to man the unmanned camera or a camera operator in a news crew, but an activist filmmaker like Barclay himself who works *with* Māori communities to get their interests represented and circulated in the media. In his documentary work for the *Tangata Whenua* series in the 1970s, for instance, Barclay recorded footage of rural Māori communities and elders talking about Māori customs and ways of life. Why then is there not an onscreen counterpart of Barclay in this role? Why place an unmanned camera on the beach to record Māori rituals, protests, and oral histories instead of an activist filmmaker who works *with* Māori to produce images of social and political import? Why does Barclay not preach what he practices?

As Barclay explained in our e-mail correspondence, however, the unmanned camera is not a commentary on the production of Indigenous images or the role of Māori filmmakers; instead, it is a visual metaphor concerning the circulation of images. While Māori may control the production and circulation of events on the *marae,* they do not control the reception, representation, or circulation of these events beyond the *marae.* According to Barclay,

> One sort of law prevails on one side of the marae boundary fence, another on the other side. The unmanned camera is "out there," on the other side of the boundary. It stands there from time to time. You don't know who the people are who man it; you don't know what they are going to do with your image once they take the camera away. . . . For the community performing to and declaring to the spooky unmanned camera at the opening and end of the film—this camera is just THE CAMERA. It's cold, mechanical; real humans (Māori or non-Māori) do not operate it; where the image that it takes goes is beyond your control. It's the camera cold from hell. You assemble and gather, you talk and gesture together and present

to this camera with every ounce of pride and dignity you can muster, but do not expect it to do anything other than stare back at you without feeling.[47]

Though the majority of *Te Rua* involves "talking in" the "invisible marae," the scenes with the unmanned camera are explicit instances of "talking out" to Pākehā "on the other side of the boundary." As I explained previously, Barclay argues that "talking in" is more effective than "talking out"—addressing one's own community in a controlled way, with its language and stories, is a more effective strategy of political activism than "talking out" to those willing to assimilate but not to learn. As a means and method of political expediency, "talking out," Barclay notes,[48] "by and large . . . has failed." Why then talk out to the unmanned camera? And if one does do so, how should it be done and to what end? According to Barclay,

> you present yourself in certain ways to this outsider unmanned camera. You may line up as a group; you will probably have a spokesperson to speak for you. The open and closing state-ments of the film (made to the unmanned camera) are "public statement", made for the whole wide world to hear—making the end statement of *Te Rua*, by the way, a pretty solid clue as to what the film as a whole might have been about.[49]

What are the "certain ways" in which one presents one's community to an outside community quite likely to misunderstand the message (if not the medium)? Are the "public statements" in *Te Rua*, which are "made for the whole wide world to hear," meant to be understood by the Pākehā public or are they really "numbers"—spectacles meant less to educate than to captivate?

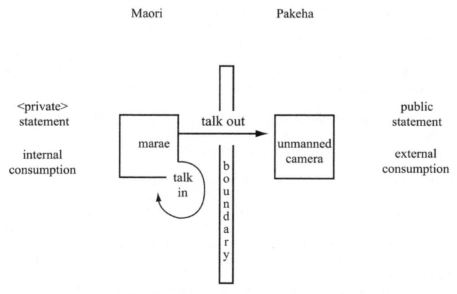

Figure 8.2. Author's illustration of the cinematic situation "talking in" and "talking out."

One way of making sense of this cinematic situation of "talking in" and "talking out" would be through the rubric of spiritual ownership. Certain objects, as I described earlier, can be said to have an inner value and an outer value—glossed previously as a "spiritual value" and a "commercial value"—and while the latter is an alienable possession, the former cannot be sold or transferred. Perhaps in *Te Rua*, then, it is more important to create an event for Māori consumption—to manufacture its content—than to try and control its technological mediation or social circulation outside the invisible *marae*.

Following this logic, "talking in" within the *marae* can be said to belong to the community, much in the same way that an object such as "Granny" belongs to the community, but once it leaves the *marae* its outer form can be manipulated. Likewise, when "talking out" in a public statement to the unmanned camera it is less important to lecture, for one knows that the external form will be manipulated and the internal form obscured or elided. Instead, one should try to *move* the Pākehā viewer, quite literally, across the boundary and into the invisible *marae* so one is "talking in" to them. Perhaps this is the function of the tableaux I discussed previously. These narrative ruptures, rather than functioning discursively, are affective stimuli. In this way, political transformation occurs not by "talking out" to Pākehā and educating them, but by attracting them so that they too can inhabit and expand the invisible *marae*.

Notes

1. Barry Barclay, "Celebrating Fourth Cinema," *Illusions* 35 (Winter 2003): 7.
2. In *Te Rua*, Barclay addressed the questions of repatriation of Māori cultural property and anticipated many of the discussions that would occur between Māori and museums about the proper custodianship of Māori cultural property—particularly the holding of Māori human remains in museum collections—in the decades to come.
3. Barry Barclay, "Housing Our Image Destiny," *Illusions* 17 (Spring 1991): 39–42.
4. Barry Barclay (dir.), *Te Rua* (Wellington: Pacific Films, 1991).
5. Barry Dornfeld, *Producing Public Television, Producing Public Culture* (Princeton, N.J.: Princeton University Press, 1998), 19. Though Dornfeld refers to television documentaries, his analysis here can be extended to other forms of media production, such as feature films.
6. Personal communication, 2004.
7. Compare Barry Barclay, *Our Own Image* (Auckland: Longman Paul, 1990) and Barry Barclay, *Mana Tuturu* (Honolulu: University of Hawai'i Press, 2005).
8. Maureen Mahon, "The Visible Evidence of Cultural Producers," *Annual Review of Anthropology* 29 (2000): 474.
9. Linda Williams emphasizes a structural contrast—common to movie musicals and pornography (as well as kung fu films)—between *narrative* and *number* (Linda Williams, *Hard Core: Power, Pleasure, and the "Frenzy of the Visible"* [Berkeley: University of California Press, 1989]). Commenting on Williams's work, William Elison explains, "Stag flicks and early musicals of the Busby Berkeley type (and, to a lesser extent, the latter-day counterparts of both) share the practice of rupturing narrative diegesis with spectacular tableaus—numbers—that revert to conventions of exhibition and address established by their theatrical antecedents" (William Elison, "Prisoners of Filmistan: Framing, Myth, and Ways of Seeing in Indian Film Culture" (PhD dissertation, University of Chicago, 2007).

10. The exchange of breath is central to the *hongi,* for it symbolizes the sharing of one's life force *(mauri)* with another. Epistemologically, it recalls the creation of Hine-ahu-one by Tane-nui-a-Rangi and Io.

11. Barclay, *Our Own Image,* 52.

12. This comment refers to the reception of the screenplay of *Te Rua,* not to the movie itself.

13. Barclay, *Our Own Image,* 52–53.

14. Ibid., 52.

15. Ibid., 76–79.

16. Rangihiroa Panoho, "Kei Hea Te Ngākau Māori? Locating the Heart, Shona Rapira-Davies and Reading Māori Art," *He Pukenga Kōrero* 7, no. 2 (2004): 4.

17. Barclay, *Our Own Image,* 76.

18. Panoho, "Kei Hea Te Ngākau Māori?," 3.

19. Barclay, *Our Own Image,* 77.

20. Ibid., 76. Barclay, in his invocation of the term, uses *marae* to denote the total *marae* complex (including structures and boundaries) as well as the proper protocol between *tangata whenua* (hosts) and *manuhiri* (guests). Through following these ritual protocols, from welcoming speeches to the sharing of breath, the friendship between these two groups is enacted and activated. For more on ceremonial protocol on the *marae,* see Anne Salmond, *Hui: A Study of Māori Ceremonial Greetings* (1976; repr., Auckland: Reed Publishing, 2006).

21. Panoho, "Kei Hea Te Ngākau Māori?," 4.

22. Ibid.

23. Barclay, *Our Own Image,* 78.

24. Barclay in *Our Own Image* uses the terms "invisible marae" and "communications marae"—the former more frequently than the latter—but he does not specify the relationship between the two.

25. Ibid., 78–79.

26. Much like the Native American photographs described by Lucy Lippard ("Introduction," in *Partial Recall: Photographs of Native North Americans,* ed. Lucy Lippard [New York: The New Press, 1992], 23), *Te Rua* "is valued for what it portrays. Losing its modernist identity as an image and its postmodernist identity as a reflection, it works in relation to another value system."

27. Panoho, "Kei Hea Te Ngākau Māori?," 4–5.

28. Barclay, *Our Own Image*; Barclay, "Housing Our Image Destiny": 39–42; Barclay, "Celebrating Fourth Cinema," 7–11.

29. Cf. Barclay, "Celebrating Fourth Cinema"; M. Durie, *Te Mana Te Kāwanatanga: The Politics of Māori Self-Determination* (Auckland: Oxford University Press, 1998); Faye Ginsburg, "Indigenous Media: Global Village or Faustian Contract?," *Cultural Anthropology* 6 (1991): 92–112; Faye Ginsburg, "Screen Memories," in *Media Worlds,* ed. Faye Ginsburg, Lila Abu-Lughod, and Brian Larkin (Berkeley: University of California Press, 2002), 39–57. Though I concentrate on Indigenous filmmakers who create fictional films, many others are working with similar goals to produce documentary films and television programs for Indigenous communities worldwide. Some of these initiatives, such as the Warlpiri Media Association in Australia (see Eric Michaels, *The Aboriginal Invention of Television in Central Australia 1982–1986* [Canberra: Australian Institute of Aboriginal Studies, 1986]; Eric Michaels, "Hollywood Iconography: A Warlpiri Reading," in his *Bad Aboriginal Art* [Minneapolis: University of Minnesota Press, 1993]); the Video in the Villages Project (see Vincent Carelli, "Video in the Villages: Utilization of Video Tapes as an Instrument of Ethnic Affirmation among Brazilian Indian Groups," *Commission on Visual Anthropology Bulletin* [May 1988]: 10–15); and the Kayapo Video Project in Brazil (see Terence Turner, "Defiant Images: The Kayapo Appropriation of Video," *Anthropology Today* 8, no. 6 [1992]: 5–16; Terence Turner, "Representation,

Politics, and Cultural Imagination in Indigenous Video: General Points and Kayapo Examples," in *Media Worlds*, ed. Faye Ginsburg, Lila Abu-Lughod, and Brian Larkin [Berkeley: University of California Press, 2002]) document the collaboration between outside researchers, filmmakers, and Indigenous peoples to gain funding, provide training, support production, and promote these projects. Other Indigenous media projects, such as the Aboriginal Peoples Television Network in Canada and the Māori Television Service in New Zealand, have been the products of native activism, state agencies, and media professionals partnering to create and institutionalize Indigenous television networks (see Sigurjon Baldur Hafsteinsson, *Unmasking Deep Democracy: Aboriginal Peoples Television Network and Cultural Production* [Philadelphia: Temple University Press, 2007]; Lorna Roth, *There's Something New in the Air: The Story of First Peoples Television Broadcasting in Canada* [Montreal: McGill–Queen's University Press, 2005]).

30. Jürgen Habermas, *The Structural Transformation of the Public Sphere: An Inquiry into a Category of Bourgeois Society*, trans. Thomas Burger with the assistance of Frederick Lawrence (Cambridge, Mass.: MIT Press, 1989). The first Māori television station in Aotearoa New Zealand began broadcasting in early 2004. Though one of the station's primary aims is the revitalization of the Māori language, it is too early to fully gauge the political consequences of this project. For a sample of academic investigation on Māori televised media, compare Sue Abel, "The Public's Right to Know: Television's Coverage of the Ngāpuhi Media Ban," *New Zealand Journal of Media Studies* 9, no. 2 (2006): 17; Jo Smith, "Parallel Quotidian Flows: MTS on Air," *New Zealand Journal of Media Studies* 9, no. 2 (2006): 28; Jo Smith and Sue Abel, "Three Years On: Māori Television," *Take: The SDGNZ Film and Television Quarterly* 48 (Spring 2007): 16–19; Faye D. Ginsburg and April Strickland, "The Latest in Reality TV? Māori Television Stakes a Claim on the World Stage," *Flow* 2, no. 9, posted 22 July 2005, http://flowtv.org/2005/07/maori-television-global-television-first-peoples-television/.

31. Pierre Bourdieu, *Pascalian Meditations*, trans. Richard Nice (Stanford: Stanford University Press, 2000).

32. Ginsburg, "Indigenous Media," 105.

33. Ginsburg, "Screen Memories." This type of acknowledgment allows for onscreen acceptance of a community's multifaceted past, yet avoids what Harald Prins refers to as the "primitivist perplex"—the adoption of oppressive and romanticizing images as an Indigenous strategy of self-representation. Prins explains that this method of representation has counterhegemonic potential, but in the end is a "Faustian deal." Harald Prins, "Visual Media and the Primitivist Perplex," in *Media Worlds*, ed. Faye Ginsburg, Lila Abu-Lughod, and Brian Larkin (Berkeley: University of California Press, 2002), 58–74.

34. Ginsburg, "Screen Memories," 40.

35. Prins, "Visual Media and the Primitivist Perplex," 72.

36. Mahon, "The Visible Evidence of Cultural Producers," 474.

37. Panoho also views this scene as an example of Duchampian cynical mimicry (2004, personal communication).

38. Chandra Talpade Mohanty, "Under Western Eyes: Feminist Scholarship and Colonial Discourses," *Boundary* 2, no. 13 (1984): 353; cited in Purnima Mankekar, *Screening Culture, Viewing Politics* (Durham, N.C.: Duke University Press, 1999), 31.

39. Personal communication, 2004.

40. In *Te Rua*, there is a shift between the terms "spiritual ownership" and "spiritual guardianship." In his writings after the release of *Te Rua*, Barclay primarily employs the term "spiritual guardianship" or its Māori equivalent *mana tūturu*.

41. Marcel Mauss, *The Gift*, trans. William D. Halls (London: W. W. Norton & Company, 1990).

42. Compare Annette Weiner, *Inalienable Possessions: The Paradox of Keeping-While-Giving* (Berkeley: University of California Press, 1992).

43. Personal communication, 2004.

44. Barclay, *Our Own Image*, 32–33.

45. Bourdieu, *Pascalian Meditations*, 158–93, 247–79.

46. Louis Althusser, *Lenin and Philosophy*, trans. Ben Brewster (London: New Left Books, 1971), 127–84.

47. Personal communication, 2004.

48. Barclay, *Our Own Image*, 76.

49. Personal communication, 2004.

9. *Reflections on Barry Barclay and Fourth Cinema*

STEPHEN TURNER

BARRY BARCLAY was a rare filmmaker, writer, and thinker. His filmwork, writings, and talks can hardly be conceived independently, so I will address the thinking that coheres in all his activity. Due to his seminal filmwork, notably the made-for-television *Tangata Whenua* series (1974) and the world's first Indigenous "feature," *Ngati* (1987), and to his book *Our Own Image*,[1] Barclay is a founding figure of Indigenous cinema. There are other substantial films, *The Neglected Miracle* (1985), *Te Rua* (1991), *Feathers of Peace* (2000), and *The Kaipara Affair* (2005), and an important later book, *Mana Tuturu: Maori Intellectual Treasures and Property Rights*.[2] Barclay died suddenly, and unreasonably, in February 2008, while engaged in new film, book, and community projects. He leaves behind a radical and positive view of the future of New Zealand, couched as was his habit in filmic terms. It is not just the critical energy and exuberance that will be missed by those who knew him. He was a philosopher of place, rare in a new country. Philosophically minded types may not be the kind of people you need to build a new society, but it is the kind of people you need if that society is going to offer the different people in it the freedom to flourish.

In another country Barclay might be a leading public intellectual, though the term does not describe very well his community activism and capacious network of conversation partners. He is nowhere nearly as well known to middle New Zealand as historian Michael King, whom Barclay worked with on the *Tangata Whenua* series. This may be because Barclay, unlike King, has much to say that is unpalatable to middle New Zealand. More strongly, it is because his view of New Zealand is impossible to grasp from that middle place. He offers a heretical intellectuality oriented around the public interest, both first and second peoples, that is, Indigenous and settler, but he also reconceives the very idea of the public, or the public domain, in terms of a longer history than that of non-Māori in New Zealand. Barclay offers a radical idea of democracy-in-community, rooted in the longer local Māori history, which is also inclusive of later-comers. The idea of place as a living knowledge of its long history was for Barclay quite literally a matter of vision. Film was his medium and the means for seeing people and place differently.[3]

Fourth Cinema is the eye of a Fourth World of history. It is a portal to another world, *Te Ao Māori* (the Māori world) in New Zealand. Fourth Cinema, my co-teacher Charise Schwalger at the University of Auckland told me, is not an essence, simple category, or object of definition. It is a *taniwha* (water spirit, monster, chief, something or some-one awesome), so Barclay entitles a section of *Mana Tuturu* ("Nga Taniwha"). The shape-shifting quality of this spirit creature,[4] often associated with water and danger, suggests to me a limit-point to settler vision and sense of place. Where the short his-tory of national orthodoxy shades into long history, the shape of place shifts. The dread of this moment for non-Māori—where am I now?—makes the *taniwha* apposite, and makes Fourth Cinema a switch point. A cinema that engages me brings into view a world of long history, which distorts the framing of my own shorter history here, and challenges my sense of self and place. That is the switch. The dread, for Pākehā (white New Zealanders) at least, is the seeming lack of definition, not seeing clearly and need-ing to know. Given that the lens of settler-seeing is the settler state of their own inva-sion, based on their own shorter history in the same place as Māori, I will avoid defini-tion of Indigenous media in national terms—the challenge of the *taniwha*—as much as I can.

The issues raised by Fourth Cinema are not simply "film" issues. They are, more deeply, issues of law, knowledge, and property. Any discussion of Fourth Cinema is also a question of knowing and seeing. This is because a quite different place hoves into view once the full human history of that place is acknowledged, and embraced. In this chapter I will consider the prospect or outlook of Fourth Cinema—the future past of place—as a radical rethinking of law, knowledge, and property in terms of the long history of first peoples. I will focus on New Zealand and Barclay's work in that context. His own underexamined films, alongside those of Merata Mita, establish a template for thinking about Fourth Cinema as a distinct filmic mode of address. I also write in the spirit of my own conversation with Barclay. I have tried to note his original con-cepts at every point, but the generative nature of conversation with him means that it is not easy to say at what point his ideas become my own or other people's. Better to say that the origin of an idea is a conversation, real or imagined.

Fourth Cinema

So what is Fourth Cinema? Following film criticism, Barclay describes first cinema as "Hollywood," "second" as art house or festival circuit, and "third" as cinema of the Third World.[5] But this does not cover all filmmaking. Barclay was looking for a term that might offer film critics, who like to organize materials in categorical terms, a way of talking about a kind of film that remains little talked about in the university and film-journal world. It was impressive to me, when I was constructing a university course on "Fourth Cinema," to discover just how little has actually been written about the seminal works of Barclay and Mita. Criticism of world cinema is otherwise

voluminous. This gaping deficit is somewhat redressed by Stuart Murray's fine new book on Barclay.[6] As far as the lack of older commentary is concerned, a short and not very satisfactory response is that critics at the time lacked the vocabulary, wherewithal, and will to talk about these films in any way that was adequate to them. In this regard, the category of Fourth Cinema might help, despite obvious objections. Producer-director Tainui Stephens comments in *Storytellers in Motion* (2007), the television series on Indigenous cinema directed by Jeff Bear and Marianne Jones, that Māori have always been subjected to categories. The legal administration of Indigenous peoples in the North American context according to settler-mandated "blood quantum" bears this out. Barclay, I am sure, would agree about categories. On a good day he would put "categories" in a fire with copyright release forms and the claims to place of second peoples, and happily set them all alight.[7] But Indigenous film looks and does not look like other kinds of film. It behaves differently. The inseparable historical, political, and aesthetic properties of Indigenous cinema make it different in kind.

There is by now some amount of writing on Indigenous cinema, which has emerged from the ethnographic cinema of visual anthropology by contesting its object. In the ground-breaking work of critics such as Marcia Langton, Ella Shohat, and Faye Ginsburg, Indigenous media turns against and overturns, or turns around, an objectifying ethnographic gaze.[8] The problem of essentializing culture is hardly confined to ethnographic film. Separating out "culture" from contact and colonized history, and making an anthropological object of its constitutive elements, namely kinship, ritual, and religion, has not helped Indigenous peoples. In Australia, for instance, claims made under native title legislation, strongly informed by anthropology, became impossible to support.[9] A history broken by the coming of second peoples, involving displacement and absorption, where not genocide, makes it impossible to fulfill the criteria of "traditional culture" determining Aboriginality. For Langton, "'Aboriginality' only has meaning when understood in terms of intersubjectivity, when both the Aboriginal and the non-Aboriginal are subjects, not objects."[10] For her, Aboriginality refers to the intersubjective relationship of first and second peoples, and not to the objectification of the first by the second. The anti-ethnographic thrust of Fourth Cinema runs against rigid definitions, including the non-Indigenous worry about what is and is not Indigenous.

The view of Indigenous media, where it is concerned with non-Indigenous peoples, looks back at those who have long looked at the indigene, and poses the reverse question: And who, exactly, are you? The enormous amount of talk that the coming of strangers must have generated among first peoples is little represented in film. This is partly because there are so few Indigenous features. Imagining the category for himself of Fourth Cinema in 2003, Barclay counted just "five Indigenous features completed in this country, and six completed abroad."[11] Fourth Cinema has since expanded[12] and also crosses into other media forms (see *Storytellers in Motion*), but Barclay's point is that "we are looking at a very slim body of work [and that] we will

always be looking at a relatively small body of work."[13] This is not his only point. For him the shared characteristics of Indigenous feature films cannot be simply identified. "Surface features" or "accidents" merely make up the "exteriority," for example "rituals, the language, the posturing, the décor, the use of elders, the presence of children, attitudes to land, the rituals of a spirit world."[14] The "interiority" that actually distinguishes this mode of cinema is a force or presence of long history. It is a prior history and a sense of place and being that also infuses other media, particularly Indigenous documentary and television work, which therefore comes within the ambit of Fourth Cinema. I do not separate out Indigenous cinema and other Indigenous media, except in terms of generic characteristics of the feature genre. "Fourth Cinema," then, is a term for a force or presence that animates Indigenous media more generally. It is this force or presence, rooted in the myriad particularity of Indigenous cultures, which I consider here, rather than the externalities of Indigenous film. If it is not possible to describe in any deep and unifying way the wealth and diversity of Indigenous peoples expressed in the films Barclay mentions, it is still possible, I think, to describe the animating source of Indigenous film. At least this is what I attempt here, with reference in the main to Aotearoa New Zealand.

On one view "indigeneity" follows the invasion of place by second-comers, which defines, as a result, the peoples already there as "first people." This political definition of Indigenous peoples in the context of second settlement works well enough where claims to priority involving *taonga* (treasures) such as lands, language, and law are being made. Yet, Indigenous peoples are Indigenous (more accurately *tangata whenua*) whether others are settlers or visitors. In this deeper sense *tangata whenua* are not beholden to definition by second peoples at all. Māori would like to have the freedom, says Linda Smith, to be "self-defining and self-naming . . . to be free, to escape definition, to be complicated, to develop and change and be regarded as fully human."[15] In the context of long history and "other ways of being, of knowing, and relating to the world," Māori want to be free to "choose to 'live as Māori,'" while being "able to live as citizens of New Zealand, as citizens of the world and enjoy the benefits of good health and wellbeing."[16] In this view Māori can be neither defined in postcontact nor precontact terms (Smith questions the desire itself to know and define the other). The long history of Māori does not oppose but overlaps with and encompasses the shorter history of second settlement, making Māori equally "modern." This relationship opens out the public domain of second peoples to the long, or longer, history in the same place of the first, and forms the basis of a future Indigenous or indigenized state.

I contrast the short or shorter history of second peoples in the place with the long, or longer history of Māori inhabitation. Māori claims to place are based in the anteriority of long history, or being-before, an encounter with place, and other Māori of it, that is prior to the encounter with Pākehā. This earlier encounter is the basis of relations among people and place that are different in kind to those of the second-comers. It is

the basis of the "spirituality," Barclay wearily notes, that others like to attribute to first peoples, a sense of "an interconnectedess between the animate and the inanimate, the born and the yet to be born."[17] That earlier encounter makes Māori being, or being Māori, part of something living, older, and larger than the individual person. The connectedness of long history can only make sense to second-comers if they admit the full meaning of *tangata whenua*. More strongly than the "people of the place," *tangata whenua* means the "people-place." The shorter history of Pākehā, by contrast, means that they cannot be people of the place in this sense. Pākehā may claim indigeneity in New Zealand today,[18] but being "Indigenous," if this is what Pākehā now want to be too, does not mean anything if first and second peoples are Indigenous alike.

The being of people of long history is at one level the basis of resistance to second settlers. But at a deeper level it is a matter of insistence[19] and assertion—in Barclay's terms a joyful energy and cause for celebration (a published talk, first given by Barclay at the University of Auckland's Film, Television and Media Studies Department on September 17, 2002, is called "Celebrating Fourth Cinema"). What is asserted is the living knowledge of a long history of inhabitation. The properties of Fourth Cinema thus express properties, or attributes, of place. If *tangata whenua* means people-place, making people an expression of the historical being of the land, and not simply the people of it, then land, forest, and waters also have agency. These interconnected elements are historical actors in Fourth Cinema. They need to be understood as foreground and not as background or context. In Mita's *Mauri* (1988), the hill from which the *kuia* (old woman) Kara leaves for Hawaiki (spiritual homeland for Māori) toward the end of the film is the vehicle for the education of her *mokopuna* (grandchildren), and our own, and serves as the real basis of her future. In this film about the severe consequences of breaking *whakapapa* (geneaology)—a man who has taken another's identity to escape a police hunt becomes ill—the hill restores the continuity of being between the future and past of place, broken by white invasion and appropriation of Māori land.

The hill, put simply, has filmic agency. I see it as a central figure and actor, and the vehicle for the "*mauri*" (the principle or force of life) of the film's title. So properties of place in Fourth Cinema become properties of film. Fourth Cinema is a medium through which things pass, enabling people and place to be recollected and connected in the viewing experience. Says Kara:

> That's the way we come when we go back to Hawaiki. I'll pass over that hill on my way north. I'm very fond of that hill. It's where my grandmother has her little thatched *whare* [house]. She left so much of herself in that spot. That's why it's so full of peace. *Kei reira tonu tōna wairua. Tino marino ana tenei whenua* [Her spirit is still there. The land is so full of peace].[20]

Mauri is central to the relationships between the living and the dead, the human and natural environment. Thus properties of place, conceived as attributes of film,

reenvision the future of the country by recalling the long-standing relationship to it of Māori.

National Orthodoxy

The perspective to which first peoples are subject in settler societies is what Barclay calls the "national orthodoxy." This is a view of New Zealand, and of Māori themselves, framed by the short history of second settlement. The national orthodoxy is premised on the "good" grounds of the settlement of the country, which is to say the unquestionable value of its improvement thanks to second settlers. The national orthodoxy is by definition majoritarian and mainstream, that is, predominantly non-Māori, and is maintained by big media, whether film, television, or Internet (at least corporate or government sites). It is a prescriptive view of the new country that promulgates the national agenda of continuous improvement, in the first instance so that the "new" country would fulfill its promise for second-comers and reward their investment in it. In media terms, this agenda can today be understood as a countrywide program, or countrywide programming. Needless to say, Fourth Cinema does not subscribe to the script of national media. In his own filmwork Barclay avoided the forced story, the "Māori" script mandated by national funding bodies, and strove to elicit the unbidden, local, and Māori (a word that originally meant "ordinary"). In typically mocking terms he described the national orthodoxy of big media, which shapes everyday news and events, as "objectivity ha ha" (i.e., a mock or mocking objectivity).[21]

An example can help elucidate what is usually described as a media beat-up. When the Waitangi Tribunal visited Tūhoe (central to eastern North Island *iwi*) country in 2005 to hear the Tūhoe claim before that government body, all that New Zealanders saw of the event on national television at the time was images of the wild party of Tūhoe that greeted the tribunal, many riding about on horses, eyeballs rolling (*pūkana*) and tongues protruding (*whētero*), others painted in mud baring their backsides,[22] all the while engaged in a fierce *haka* (posture dance). The media image par excellence, for many New Zealanders, a visual summation of Tūhoe, showed well-known spokesman, activist, and artist Tame Iti shooting a New Zealand flag on the *marae ātea* (courtyard in front of the meeting house) in front of the seated tribunal members. While national media sensationalized the event, Robert Pouwhare's studied and knowledgeable documentary, *Tūhoe: A History of Resistance* (2005) gives it full historical context. Within the short history of second settlement that constitutes the film frame of national orthodoxy, the event merely confirms historical preconceptions of Māori savagery and the good grounds that settlers must have had for occupying the country and "civilizing the natives." The film's explanation, on the other hand, of the reenactment of Tūhoe history that was taking place, which includes the invasion, confiscation, and encircling of Tūhoe lands in the nineteenth century, puts the short history of second settlers in the context of the long history of Tūhoe inhabitation and

ownership of the land. For Barclay providing context, or "contexting," is what Fourth Cinema does (see also chapter 1).

Considered within the short history that forms the basis of the national orthodoxy, Fourth Cinema is by definition a heretical media. It exposes the contradictory nature of an orthodoxy that seems like common sense to the majority of people who live in the country. Slavoj Žižek, in typically counterintuitive terms, describes heresy as that which follows official rules too literally, and thereby reveals the bad or "ill" logic of law. Following the letter of the law reveals its impoverished human spirit. Žižek gives the example of St. Francis of Assisi, who took the vow of poverty so literally that the church authorities became worried about the implications of his "good" work for the feudal structure of property relations, within which the Church, of course, was fully embedded.[23] For many New Zealanders official biculturalism resolves, or ought to have resolved, the historical question of the relationship between Māori and Pākehā. The official doctrine expresses New Zealand's much-touted, world-excellent race relations. But if I were to take biculturalism too literally, I might, from a Tūhoe point of view, embrace their idea of themselves as Tūhoe and not as New Zealanders, their law as Tūhoetanga and not national law (Crown law), and their place as their own domain and not as part of New Zealand. Taken too literally, official policy in this case leads to binationalism, or multinationalism. This means that a national body could not decide upon or dictate an official doctrine that applies to Tūhoe, because biculturalism means that national policy cannot not apply to Tūhoe unless they agree that it does. What this contradiction reveals is that official biculturalism requires Tūhoe to be Māori for the nation's sake, so that everyone can be at home thanks to the participation of Māori in the national polity. It does not mean that Māori can be Māori for Māori sake, for instance Tūhoe. That is, Māori cannot be *tangata whenua* with continuing *tino rangatiratanga* (self-determination). This is one definition of national orthodoxy.

The events of October 2007, when Tūhoe lands were invaded by paramilitary police on the basis of alleged terrorist activity, show that Tūhoe have long faced the problem of talking to another party whose pistol lies on the negotiating table between them (see also chapter 1). "A Pistol on the Table" is the title of a report Barclay wrote to the Prime Minister's Office and the board of New Zealand on Air in 2006[24] about the national system of film funding. The title refers to a story that Barclay heard from the Iraqi poet Emad Jabbar who features in *The Kaipara Affair*. In the weeks leading up to another birthday of Saddam Hussein, Jabbar was asked by an old professor of his what he was going to contribute to mark the occasion. Apparently this was customary for established poets. While Jabbar thought about the request the professor's pistol lay on the table between them.

The immediate cause for Barclay's report was the editing of *The Kaipara Affair* for television without Barclay's knowledge, and the removal of a good deal of context, which in his view reduced the voice of the community in this film. The central concern of the film was, after all, the common cause shown between Māori and Pākehā over the depletion of fishing stocks in the Kaipara, and their efforts to assert local control

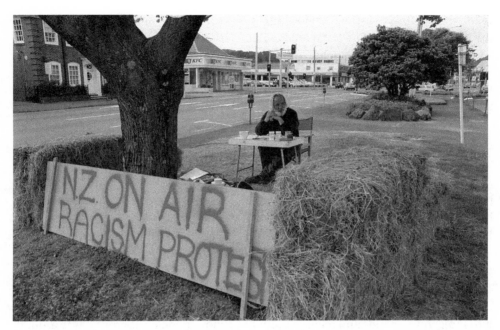

Figure 9.1. Barry Barclay encamped in Kent and Cambridge Terraces, Wellington, protesting against racism outside the office of New Zealand on Air, December 16, 1996. Photograph by Philip Reid. Dominion Post Collection, Alexander Turnbull Library, Wellington, ref. no. EP/1996/3620/7.

over the resource. For Barclay the lack of interest of Television New Zealand and New Zealand on Air in the original agreement between director and producer, which was made under *tikanga* (Māori customary procedure) to safeguard the community, betrays a fundamental element of documentary ("be true to the brief"). While both agencies regarded the matter as an unfortunate dispute between director and producer, Barclay saw the new edit as a typical talking-heads "issues" documentary that sidelines a central figure, Mikaera Miru, makes another, Raewyn McDonald, almost disappear, and altogether "makes ho-hum the *national* significance of what was really going on in the Tinopai 'uprising.' "[25] Remarkably, a de facto *rāhui* (temporary prohibition) against in-shore fishing instigated by the local community had taken on real legal force. For Barclay, the community had "combined under two laws: under the general law of the land, and under *tikanga* as law, rather than lore."[26] The attempt to curtail this kind of vision marks the systemic function of the national orthodoxy. With "this sort of collusion," Barclay remarks, "who needs a State Censor and Gulag?"[27]

Image-Sovereignty

The matter of *tikanga,* for Barclay, is one of trust, which goes to the very basis of community. Observing *tikanga* in filmmaking generates trust, and ensures that the purpose of the camera serves its subjects, which constitute the sovereign community. In

moments of "objectivity ha ha," however, it is the other way around: the event serves the prewritten script of national media. But relating right to people and place is *tika,* which means "correct" or "right" in the sense of the right way. *Tikanga,* given a prior history of settlement, also means a right-of-way. This sense of right infuses works of Fourth Cinema. Making films that utilize *tikanga* in every aspect of production both secures and expresses the Māori world. In *Our Own Image* Barclay describes the attention paid to *tikanga* in the making of *Ngati.* Māori principles and values are not then merely content, something talked about, or worse, explained as an object of anthropology; they are actually constitutive of Fourth Cinema. The film expresses the self-sovereignty of Māori community because community values are part of the film's making. How local people go about the place is not just described but enacted. This is law of Māori making. Barclay titled one of his last talks, "The Law Is My Breathing."[28] For Barclay, the "second" law of national orthodoxy can have no traction if it does not acknowledge independence, prior right, and existing law, understood as *tikanga,* of first peoples.

Fourth Cinema begs further questions of knowledge and property, or what Barclay has called "image sovereignty." Knowledge of Indigenous matters requires entering into Indigenous worlds and relations with Indigenous people—there's no way around it. "Knowledge" is not then an object but rather the experience and expression of a relationship, hence a *living knowledge.* There is of course an "object"-oriented knowledge as well, which is to do with the technology that mediates human relationships. The question is whether the technology, in this case film technology, serves the purpose of human community, or whether community is made the "object" of technological imperatives. The subjection of people to a technological mandate or drive, such as the continuous improvement of a new country, makes them the objects of programming (in the context of a "new country" one can ask whether its continuous improvement was actually a choice for peoples already living there). In this regard, Fourth Cinema concerns the making of media, and how you go about it rightly, in a way that generates trust and thereby creates community. The participation of people in making images of themselves that others will see goes against the pre-scripted imperatives of national programming. In the first instance, their say in the making of an image defines image sovereignty. For Barclay, the sovereign community is ultimately what the Indigenous image expresses.

The image-sovereignty of film is best enacted in image-*hui* (gatherings), where films are watched in an Indigenous setting. Barclay asks: Why do we make people pay? What would happen if film was something you gave to an audience? "If this means shaping a whole other kind of cinema," he says, "then so be it."[29] This idea is utopian, given the cost of making film and television, but it challenges our idea of these media. It questions the extent to which image conventions—what we take film or television to be—are almost entirely conceived in terms of commercial exchange. Rather than asking an audience to pay, and having to satisfy the expectations this generates of

Figure 9.2. Barry Barclay with Nissie Herewini on the set of *Te Rua*, 1991. Reproduced with permission of the *Dominion Post*.

entertainment worth the price of entry, Barclay would pay people to come (being himself always as poor as a monk, he would provide the most exuberant monastic hospitality). The particular rhythm and pattern of Hollywood film, from the construction of a problem, its complication, climax, and denouement, would be challenged. The unlikely and unscripted would be welcome. So "the film space may be made *stage* space—perhaps comic, perhaps fringe, perhaps lyric, perhaps humpty-dumpty—where dramatic, unexpected and playful rhetoric and gesture will not only be legitimate but encouraged."[30] The film as gift changes expectations, opening out an audience to their own unorthodoxy.

Fourth Cinema is not film, in the first instance, of oneself for others. Vilisoni Hereniko has described the very different experience of watching the Rotuman feature he directed, *Pear ta ma'on maf/The Land Has Eyes*, in Rotuma.[31] The living knowledge of the watching community—many acted in the film—formed the basis of excited reaction and discussion. Image-*hui* (gatherings) at Wairoa or Hokianga in New Zealand are different in this regard from the metropolitan mega-complex or film festival.

"Image sovereignty" thus questions the protocols and practices that govern the making, distribution, reception, and storage of Indigenous media (for instance in libraries and information systems). Ultimately, it questions whether human community is enhanced or diminished by its imaging and archiving, or whether the

imperative of imaging and archiving makes an inert object of human community for others (scholars and strangers). In his earlier book, Barclay was concerned about the making of film in "our image," as opposed to being subjected to images made of one-self by others. In his later book, *Mana Tuturu,* the question of image sovereignty has become more explicitly a rethinking of image sovereignty in terms of local law and living knowledge. For Barclay, national law is big "L" law.[32] It does not appear a made thing, a tool of human purposes, but something that came before us and sits above us, on high. We are subjected to it willy-nilly. While big "L" national law has worked to alienate and corrode Indigenous community, and most especially, the capacity to make law, Māori law or *tikanga* by contrast generates trust in and though protocol and practice. It is made law whose processes include its remaking. A camera too is a tool of our purposes. In the right hands, held the right way, it generates trust.

In *Mana Tuturu,* Barclay's more particular subject is the emerging international regime of intellectual property rights (IPR). Indigenous relationships, in his view, cannot be understood as property relations in any Western sense of the word. These are not relationships over which one can assert ownership. The knowledge of the properties of a forest and all it contains is not something that is strictly own-able. For *tangata whenua* are another one of those elements, understood in terms of long-standing relationships. In Rachel Perkins's stunning *One Night the Moon* (2003) contrasting attitudes to property are expressed in the theme song, jointly sung by white and Aboriginal antagonists: "this land is mine/this land is me." Insofar as Fourth Cinema expresses the interrelatedness of an Indigenous lifeworld—and it is Fourth Cinema to the degree that it does—it cannot be divorced or detached from those relationships and remain what it is. Hence the danger to the Indigenous world, in Barclay's view, of IPR.

Knowledge as property, something owned by an individual or institution or archive, is reenvisioned by Fourth Cinema. The image cannot be isolated from living relations in terms of which it makes sense and has value. It cannot be rendered inert, stored away, a matter of ownership or copyright. In current archiving or library storage, knowledge becomes the living expression of historical community. Its use will depend on the assent of the community in a local forum of appropriate weight and serious-ness. Indigenous media expresses a set of relationships that consolidates a living knowledge system. New media issues of archiving and access, as far as Indigenous material is concerned, must then be considered in terms of the protocols and prac-tices of the community whose knowledge it is. Fourth Cinema cannot, for example, be the simple object of university-based knowledge. The "knowledge" generated by a course I conducted, with the help of many others,[33] in Fourth Cinema at the University of Auckland, could not be the property of the university, much less myself, as someone who is not Māori and yet "supposed to know." It belongs to the peoples whose history and being this media expresses. As the properties or attributes of film express living relations, so Fourth Cinema becomes a form of encounter.

Our course involved taking an Inuit film about the coming of strangers and Christianity and the loss of old ways, *The Journals of Knud Rasmussen*,[34] to Te Hikutu of Moria *marae* (the land and buildings that Māori affiliate with genealogically) at Whirinaki in the Hokianga. How could it possibly be said that non-Māori "know" this story? Pākehā are necessarily outsiders to their own coming to Māori. They can tell the offshore but not the onshore story (a distinction made by Barclay in the first chapter of *Mana Tuturu*). The implications of this film could only be properly grasped, or at least addressed, I felt, in an Indigenous setting (ideally an Inuit one). The *marae* was for that time the "university," and was rightly referred to as such. What the class learnt in the course, and what I myself learnt, was the nature of a relationship with the people of Te Hikutu that the class and Te Hikutu collectively constructed in and through their coming together. That is, we were accepted into a community of living knowledge. The extraordinary grace of the *kaumātua* (elders) and *kuia* of Moria, the hospitality of the *marae*, the work of Heather Randerson, who arranged for members of the local community to talk to the group about history at significant local sites, left an imprint on the group as indelible as that of the land on Te Hikutu themselves. In the university context Fourth Cinema is at once a way of seeing—a re-vision of knowledge—and active pedagogy. It concerns relationships that Indigenous film enables in and through its viewing. For this reason, Fourth Cinema cannot be owned by any university, program of study, anthology, or "expert." That "knowledge" is enacted in real situations of Indigenous viewing and talk, and not, I think, in any other place.

Living Knowledge

Properties of place considered as living knowledge—a system of elements human and natural—form what I call correspondences, where place is understood in terms of long-existing and evolved relationships among people and place. So the place now is conceived in terms of the people of its earlier time, however much colonialism has created a broken history. Correspondences of time and place relate the short history of second peoples and the longer histories of its Māori inhabitation, and suggest the basis of a reconstructed public domain and national law. The land itself is a participant in this reconceived commons, or public domain. It has rights in people, rather than people simply having rights in it (for *tangata whenua*, being an element of the land, there are not so much rights over the land as a right way to go about in it). Right is vested in properties of place, a living knowledge of long history, and not simply in the sense of place that the majority of people now living in it happen to have.

Barclay's own filmwork is sensitive to properties of place: land, forest, and waters constitute a visceral and material element of his filmmaking from *Ngati* to *The Kaipara Affair*. He is alert to the behavior of people and elements of place that enter the lens without his bidding. For him, the magical "singular incident"[35] of documentary film occurs when what is front of the camera speaks for itself, rather than the apparatus

of the filmmaker speaking for it (the bundle of director-producer-script-funder). Such precious moments crystallize the community of relationships that were always Barclay's subject. I take such moments to characterize the vital force of Fourth Cinema. In a passing moment of *The Journals of Knud Rasmussen* a child goes to sleep in the hood of her mother's anorak, an incident that has no apparent plot function yet resonates powerfully with the joy and intimacy of community, and the palpable threat to it, shown in this story. The main actor in this film, again, is the landscape, which fills out the screen at every moment, last of all in the departing shot of a an Inuit group shrinking in size as the camera backtracks to reveal the white expanse surrounding them. In Fourth Cinema properties of place are properties or attributes of film; the land has agency ("the land has eyes, and teeth too," says a character in Hereniko's film).

A more recent Māori-Pākehā work starkly illustrates the different sense of property at stake in a public domain reconceived by Fourth Cinema. *Restoring the Mauri of Lake Omapere*[36] (dir. Simon Marler, 2007) concerns the jewel of Ngā Puhi (northern North Island *iwi*), the lake at its heart, which has become sick through abuse and misuse. One view of restoring the lake to health is that its waters should be returned to the level of the early 1920s, when they were lowered 4.5 feet to create more land for returned servicemen (the film tells the story of the legal machinations that prevented a legal determination of Māori ownership at the time from taking effect). The lake has since served many purposes and users: it has been water for drinking and swimming, water for agriculture (stock use) and the public utilities of nearby Kaikohe, and water for commercial fishing. It is also water that has long absorbed fertilizer and land runoff, creating extensive mud banks, due to land clearance for farming and the removal of lakeside kauri forest through the nineteenth century. It has as a result become literally poisonous through increased nitrogen content and the growth of toxic algae bloom. The lake, however, has its own being—the taniwha Takauere—whose viewpoint one might take of its degradation.

While acknowledging the difficulty of challenging individual property rights, local elder John Klarecich offers a different vision of the relationships between the lake, its properties, and the surrounding community. For Barclay, this is a system of living knowledge whose properties and attributes are greater than the sum of its parts. I paraphrase the problem of ownership that Klarecich states in the film as follows: the lakeside farmer will say that the land at the edge of the lake is his own property; that, as a result of working it, the land is productive, and that all New Zealanders benefit from his contribution to the economy. His sense of property is possessive and individualist. From the point of view of the lake, however, its properties or attributes are enjoyed by many different people, who constitute a public interest that is wider, richer, and more inclusive than the farmer's interest in the land as his possession. The lakeside land in question, from the point of view of the lake's well-being, is actually water. The properties of the lake, which cannot be anyone's simple possession, suggest a collective and common interest. With regard to this lakeside land, the question is whether you see land or water, whether you take the view of short or long history. In

any case, there is too much talk in this film, academic and lawyer Nin Tomas told my class: the *wairua* (spiritual essence) lies with the eel, the sacred and purifying *kiriko-puni* (eel), which appears and reappears as a central character in the film, and it is the eel that we should follow. Its presence and movement in the lake, which intimate the health of the lake, and the need to make its lifeways viable again, expresses the interiority that characterizes Fourth Cinema for Barclay.

Before his death Barclay was himself engaged in a film project ("The Isosceles Triangle") about the centrality of water to community. In a synopsis of the living knowledge system at this film's core, Barclay says that we "glimpse, time and again, people under great pressure helping one another to seek out new arrangements, new systems, something beyond the tools so beloved by homo economicus, beloved by the modern nation state as well, and the military that serve them so faithfully. I am not talking [he says] of some new ethanol wonder-mix, some ultra-light solar panel, some glistening ship run on cow dung. I am talking ways of organising ourselves in community, as community."[37] Long local history, for Barclay, was not a past made redundant by modern things, but the basis of new ways of organizing and conceiving life.

Living in the Hokianga prior to his death, Barclay always regarded himself as an outsider to the area. He would with some deliberation describe local matters as the business of local people, and carefully defer to the way they went about that business. Any solution to local issues, or a local initiative, could not be imposed and be long-lasting without the full participation of the long-established people of the area. Ngāwhā springs, which adjoin and feed Lake Ōmapere, remains a site of radical energy and protest due to the ill-fated decision to situate a prison there, given local opposition to the idea. Such correspondences, or hotspots of long history, for lack of greater knowledge in mainstream New Zealand, erupt within and disrupt the national orthodoxy, making places such as Ngāwhā flashpoints of Māori opinion and opposition. The "resistance," however, may be more deeply understood as a matter of insistence—the very life force of springs. The energy of springs, unless altogether capped, manifests an insistence on land as law. It is around the land, and the long inhabitation of it of Māori, that settler society needs to rethink and shape itself, if it is to claim legitimacy in the long run. For New Zealand will always be that older place too.

Notes

1. Barry Barclay, *Our Own Image* (Auckland: Longman Paul, 1990).

2. Barry Barclay, *Mana Tuturu: Maori Intellectual Treasures and Property Rights* (Honolulu: University of Hawai'i Press, 2005).

3. Barclay's work resonates, I think, with the call by Roger Maaka and Augie Fleras in *The Politics of Indigeneity: Challenging the State in Canada and Aotearoa New Zealand* (Dunedin, N.Z.: Otago University Press, 2005) for "living together differently."

4. Māori Marsden offers this broader and more detailed definition: "These dragon-like creatures dwelt in certain localities and could be independent and unattached to the local tribe. As such they were devourers of men. But where they were attached to the local tribe, they acted as

guardians and manifested themselves as animals, fish, birds or reptiles. Strictly speaking, these were not spirits but occult powers created by the psychic force of ancient tribal tohunga and by the mana of their creative word, given form and delegated as guardians of the tribe." "God, Man and Universe: A Māori View," in *Te Ao Hurihuri: Aspects of Māoritanga,* ed. Michael King (Auckland: Reed, 1992), 133.

5. In "Exploring Fourth Cinema," a talk given by Barclay in Hawai'i as part of the Summer School lectures entitled "Re-Imagining Indigenous Cultures: The Pacific Islands," for the National Endowment for the Humanities, Summer Institute, July 2003.

6. Stuart Murray, *Images of Dignity: Barry Barclay and Fourth Cinema* (Wellington: Huia Press, 2008).

7. Barclay describes one such day in *Mana Tuturu,* 67.

8. Steps have been made in visual anthropology in significant anthologies and monographs, namely, Peter Ian Crawford and David Turton, eds., *Film as Ethnography* (Manchester: Manchester University Press, 1992); Karen Jennings, *Sites of Difference: Cinematic Representations of Aboriginality and Gender* (South Melbourne: Australian Film Institute, Research and Information Centre, 1993); Karl G. Heider, *Seeing Anthropology: Cultural Anthropology through Film,* 3rd ed. (Boston: Allyn and Bacon, 2004); David MacDougall, *Transcultural Cinema* (Princeton, N.J: Princeton University Press, 1998); Fatimah Tobing Rony, *The Third Eye: Race, Cinema and Ethnographic Spectacle* (Durham, N.C.: Duke University Press, 1996); and Heather Norris Nicholson, ed., *Screening Culture: Constructing Image and Identity* (Lanham, Md.: Lexington Books, 2003). Despite the fundamentally anti-ethnographic thrust of Fourth Cinema, however, much of this work remains enclosed by the "ethnographic paradigm." An exception is the writings of Faye Ginsburg, who has been formative in breaking with the ethnographic basis of "looking at" rather than "looking out of" Indigenous film. See "Indigenous Media: Faustian Contract or Global Village?," in *Rereading Cultural Anthropology,* ed. G. E. Marcus (Durham, N.C.: Duke University Press, 1993), 356–75; "Mediating Culture: Indigenous Media, Ethnographic Film, and the Production of Identity," in *Fields of Vision: Essays in Film Studies, Visual Anthropology and Photography,* ed. Leslie Devereaux and Roger Hillman (Berkeley: University of California Press, 1995), 256–91; "The Parallax Effect: The Impact of Indigenous Media on Ethnographic Film," in *Collecting Visible Evidence,* ed. Jane M. Gaines and Michael Renov (Minneapolis: University of Minnesota Press, 1999), 156–75; and "Screen Memories and Entangled Technologies: Resignifying Indigenous Lives," in *Multiculturalism, Postcoloniality, and Transnational Media,* ed. Ella Shohat and Robert Stam (New Brunswick, N.J.: Rutgers University Press, 2003), 77–98. See also the more recent works by Sacha Clelland-Stokes, *Representing Aboriginality* (Hojbjerg, Denmark: Intervention Press, 2007); Faye Ginsburg, Lila Abu-Lughood, and Brian Larkin, eds., *Media Worlds: Anthropology on New Terrain* (Berkeley: University of California Press, 2002); and Houston Wood, ed., *Native Features: Indigenous Films from Around the World* (Honolulu: Hawai'i Pacific University Press, 2008).

9. See Patrick Wolfe, "Nation and Miscegenation: Discursive Continuity in the Post-Mabo Era," *Social Analysis* 36 (October 1994): 93–152.

10. Marcia Langton, *"Well, I Heard It on the Radio and I Saw It on the Television": An Essay for the Australian Film Commission on the Politics and Aesthetics of Filmmaking by and about Aboriginal People and Things* (North Sydney: Australian Film Commission, 1993), 32.

11. Namely Nils Gaup (dir.), *Pathfinder* [Ofelas] (Norway: Filmkameratene A/S/Mayco/Norsk film/ Norway Film Development, 1987); Tracey Moffat (dir.), *Bedevil* (Australia: Southern Star entertainment, 1993); Chris Eyre (dir.), *Smoke Signals* (Canada/USA: ShadowCatcher Entertainment/ Welb Film Pursuits Ltd., 1998); Zacharias Kunuk (dir.), *Atanarjuat: The Fast Runner* (Canada: Canada Television and Cable Production Fund License Program (CTCPF)/Canadian Film or

Video Production Tax Credit (CPTC)/Canadian Government/Canadian Television (CTV)/Channel 24 Igloolik/Igloolik Isuma Productions Inc./National Film Board of Canada (NFB)/Telefilms Equity Investment Program/Vision Television, 2001); Ivan Sen (dir.), *Beneath Clouds* (Australia: Australian Film Finance Corporation (AFFC)/Autumn Films/Axiom Films, 2002); Sherman Alexie (dir.), *Business of Fancy Dancing* (New York: FallsApart Production, 2002); Vilisoni Hereniko (dir.), *Pear ta ma 'on maf/The Land Has Eyes* (USA/Fiji: Te Maka Productions, 2004). And in New Zealand, Barry Barclay (dir.), *Ngati* (New Zealand: New Zealand Film Commission/Pacific Films, 1987); Merata Mita (dir.), *Mauri* (New Zealand: Awatea Films/NZ Film Commission, 1987); Barry Barclay (dir.), *Te Rua* (New Zealand/Germany: Pacific Films, 1991); Lee Tamahori (dir.), *Once Were Warriors* (Culver City, Calif.: Columbia Tristar Home Video, 1994); Don Selwyn (dir.), *Te Tangata Whai Rawa O Weneti/The Māori Merchant of Venice* (New Zealand: He Taonga Films, 2001). See "Celebrating Fourth Cinema," talk given by Barclay to the Department of Film, Television and Media Studies [hereafter DFTMS], University of Auckland [hereafter UoA], September 17, 2002, reproduced in *Illusions,* no. 53 (Winter 2003): 7–11.

12. See Wood, *Native Features.*

13. Barclay, "Celebrating Fourth Cinema," *Illusions* 35 (2003): 7.

14. Ibid.

15. Linda Smith, "Neoliberalism and Endangered Authenticities," in *Indigenous Experience Today,* ed. Marisol de la Cadena and Orin Starn (Oxford: Berg, 2007), 349.

16. Ibid., 350.

17. Barclay, *Mana Tuturu,* 87.

18. So Trevor Mallard declared in his first major speech as Co-ordinating Minister for Race Relations (to the Stout Research Centre for New Zealand Studies, July 28, 2004).

19. This was the central theme of a talk by Amanda MacDonald at a conference on "Settler Colonialism," University of Chicago, April 24–25, 2008.

20. For all their help with this essay, and with this reading of *Mauri* in particular, many thanks to Scott Wilson and Charles Koroneho.

21. This theme was the subject of a talk given by Barclay to DFTMS students at UoA, May 6, 2006.

22. *Pūkana* refers to dilation of the eyes "by both genders when performing haka and waiata to emphasise particular words," maoridictionary.co.nz. *Whētero* refers to the protrusion of the tongue but is performed by men only, also to give weight to certain words or phrases. Baring one's backside is considered an insult to the other party.

23. In Slavoj Žižek's words: "Recall the fate of Saint Francis: by insisting on the vow of poverty of the true Christian, by refusing integration into the existing social edifice, he came very close to being excommunicated—he was embraced by the Church only after the necessary 'rearrangements' were made, which flattened this edge that posed a threat to the existing feudal relations" (*On Belief* [London: Routledge], 2001, 8).

24. Barry Barclay, "A Pistol on the Table: One Film-maker's Report to the Prime Minister's Office and the Board of NZ on Air" (unpublished report, 2006).

25. Ibid., 16.

26. Ibid.

27. Ibid., 17.

28. At the symposium "One Country, Two Laws," held in Old Government House, UoA, June 2005.

29. Barclay, *Mana Tuturu,* 237.

30. A talk given by Barclay to DFTMS students at the UoA, May 6, 2006.

31. Reaghan Tarbell, "Interview with Vilisoni Hereniko," Native Networks website, http://www.nativenetworks.si.edu/frameset_html.html.

32. See my own review of this book, "Living Law," in *Landfall,* no. 212 (Spring 2006): 128–41. Rosemary Coombe sets out the terms of the academic debate in *The Cultural Life of Intellectual Properties: Authorship, Appropriation and the Law* (Durham, N.C.: Duke University Press, 1998). For further views see also Robert Sullivan, "Indigenous Cultural and Intellectual Property Rights," *D-Lib Magazine* 8, no. 5 (May 2002) and Leonie Pihama and Cheryl Waerea-i-te-Rangi, *Cultural and Intellectual Property Rights: A Series of Readers Examining Critical Issues in Contemporary Māori Society* (Auckland: Moko Productions, 1997).

33. The course was "co-authored" by Barry Barclay, Jo Smith, Charise Schwalger, Kathryn Lehmann, Geraldene Peters, and the people of Te Hikitu.

34. Norman Cohn and Zacharias Kunuk (dirs.), *The Journals of Knud Rasmussen* (Canada, Denmark, Greenland: Igloolik Isuma Productions Inc./Kunuk Cohn Productions/Barok Film A/S/Téléfilm Canada/SODEC/Canadian Television Fund/Quebec Film and Television Tax Credit/Det Danske Filminstitut/Canadian Film or Video Production Tax Credit (CPTC)/Government of Nunavut–Nunavut Film/Nordisk Film- & TV-Fond /Greenland Home Rule/Nuna Fonden/Danmarks Radio (DR)/Nunavut Independent TV Network, 2006).

35. Barclay, "A Pistol on the Table," 14.

36. Simon Marler (dir.), *Restoring the Mauri of Lake Omapere* (New Zealand: Maringi Noa o te Manawa Trust, 2007).

37. Synopsis of "The Isosceles Triangle," a proposed feature film, sent to me by Barclay in early 2008.

Māori Television:
Nation, Culture, and Identity

10. The Māori Television Service and Questions of Culture

CHRIS PRENTICE

THE ADVENT IN 2004 of the free-to-air Māori Television Service (MTS) channel in New Zealand marked an important development in Māori cultural politics and in the bicultural nation's televisual democracy. While Māori constitute around 15 percent (and growing) of the population, more compelling than the statistical argument for greater representation in broadcast media has been the notion of "partnership" of Māori and Pākehā (white New Zealanders) under the auspices of the Treaty of Waitangi (1840, referred to hereafter as "the Treaty") and its revival as a basis for appeals against historical and continuing (post)colonial injustice in the 1975 Treaty of Waitangi Act and 1985 Treaty of Waitangi Amendment Act. Invoked with the institutionalization of statutory biculturalism in the mid-1980s, the notion of Treaty "partnership" implies an ideal of equality, so that the "fifteen hours per week (including repeats!)" of Māori content on mainstream broadcast channels was justly decried by Tainui Stephens, shortly before the arrival of MTS, as "a disgracefully small amount of media time for the television needs of a people who are ostensibly equal partners in Aotearoa Te Wai Pounamu [New Zealand, constituted as Aotearoa, the North Island and Te Waipounamu, the South Island]."[1] Stephens's comment bears witness to the complexities and contradictions of struggle within ostensible biculturalism: continued de facto Māori disadvantage within statutory (Treaty) equality reveals the Treaty's "promise of power sharing between Treaty partners" as "an incomplete project."[2] MTS therefore offers an opportunity for examining what Rey Chow refers to as "the vicissitudes of cross-ethnic representational politics."[3]

First mooted in 1973, the channel was conceived as an initiative in promoting and revitalizing *te reo Māori* (the Māori language) and *tikanga* Māori (Māori customary lore) or culture more generally. By 1973, New Zealand was acknowledging and beginning to address its colonial past, the impact of its early-to-mid-twentieth-century policy of assimilation of Māori into the hegemonic British-descended settler culture, and the implications of its Pacific location and relations. Britain—to which New Zealand had been tied politically, economically, culturally, and affectively since its nineteenth-century colonial settlement—joined the European Economic Community, in practical

terms forcing New Zealand to find new export markets, but also to come to terms with
the wider implications of a loosening of (post)colonial ties. Locally, the Māori political
and cultural renaissance was emerging, and this was the year that Ngā Tamatoa, a
group of young Māori activists, presented a petition to Parliament calling for the intro-
duction of Māori language into the nation's primary and secondary schools,[4] putting
the revitalization of *te reo Māori* squarely on the agenda. The country was also attend-
ing to the increasing centrality of broadcasting, and in particular television, as sites of
cultural negotiation and exchange. While there was still only one television channel
available (color television was introduced that year; a second channel arrived in
1975), by the 1970s the vast majority of New Zealand households had television,[5]
reinforcing its ability to function as a "national" forum,[6] and thus also reinforcing the
stakes of Māori representation, as a means of intervention into a settler-culture
hegemony.

The decades that followed saw further efforts to secure Māori televisual represen-
tation.[7] Ranginui Walker discusses the 1985 bid by the Aotearoa Broadcasting Trust for
the country's third television channel. Such a channel was proposed as furthering the
fulfillment of section 3 of the 1976 Broadcasting Act concerning the broadcasting sys-
tem's obligation to reflect and develop New Zealand's culture and identity, as it largely
neglected Māori culture. The bid failed for lack of funding support, a failure "likened to
the original betrayal of the Treaty," as such a channel "would have provided employ-
ment and an economic base, as well as an outlet for the expression of Māori culture."[8]
In 1986, a claim was brought before the Waitangi Tribunal (see the Introduction) argu-
ing that the Māori language was a *taonga* (treasure, prized possession or article) that
warranted Crown protection through, among other things, presence in national
broadcasting. However, in 1989, in the context of the country's neoliberal economic
reforms and widespread deregulation, Radio New Zealand Ltd. and Television New
Zealand Ltd. were established as "state-owned enterprises." The New Zealand Māori
Council and Ngā Kaiwhakapūmau i te Reo (Custodians of the Language) applied to the
Court of Appeal in 1992 citing the threat to Treaty obligations in a deregulated media-
sphere, and in 1993 took the appeal to the Privy Council in London. Although the
appeal was dismissed, the council's judgment stressed the Crown's previous undertak-
ings in regard to preservation of Māori language though both radio and television
broadcasting. The 1993 Broadcasting Amendment Act paved the way for the establish-
ment in 1994 of Te Māngai Paho, an agency charged with allocating funds for Māori
language and cultural representation. However, the beginnings of a separate channel
did not eventuate until the experimental establishment of the Aotearoa Television
Network in 1996 as a pilot scheme for such a channel, running in the Auckland region
on a UHF frequency for thirteen weeks, until its collapse in 1997 in the midst of finan-
cial troubles. As Jo Smith and Sue Abel point out, "Many commentators have sug-
gested that it was also set up to fail because of the time frame and the budget allowed,"
and that its "very publicized" troubles and closure "ultimately tainted the reputation

of Māori programme makers,"[9] placing further hurdles in the way of attempts to establish a Māori television channel.

MTS was eventually founded, thirty years after it was first mooted, under the 2003 Māori Television Service Act (Te Aratuku Whakaata Irirangi Māori) that established it as a statutory corporation. Its arrival constitutes a belated achievement by and for Māori in the politics of representation, understood as that cathected space at the intersection of the two senses of the term representation itself: the sense of delegated voice that is associated with democracy and attendant notions of rights and citizenship, access and equity, of participation in the public sphere of political, social, and cultural decision-making—politicized as questions of who speaks as and for whom, and how; and the sense of the verbal or visual images that circulate in subjective and social space—the politics of images, including both their content and the processes of image-making and circulation.[10] The channel provides a source of employment and professionalization in the contemporary postindustrial (cultural) economy, in a context where predominantly agricultural and industrial sources of Māori employment have been severely impacted by the realignment of the national economy toward globalization in the 1980s and 1990s.

Stephens's account of Māori television, as articulated just prior to the advent of MTS itself, implicitly affirms the significance of such a channel in terms of the politics of representation. Its success in realizing "the dream that many of us now hold" for such a service lies,[11] for him, in the way it is oriented to, and exemplifies, Māori as agents of televisual production, as creative drivers of televisual (self)representation, committed to Māori cultural practices and protocols *(tikanga)* behind the camera and onscreen.[12] In this way, MTS provides broadcast space for the coverage of Māori issues and concerns both to a fuller extent than the mainstream national media have done, and from a Māori, rather than hegemonic nationalist, perspective.[13] Such a perspective shifts the representation from that of a "window on the Māori world" to one of a "mirror" in which Māori may see themselves reflected.[14] Stephens further cites the ability of technology to produce and maintain an "audiovisual archive" of cultural figures and knowledge, while the variety of programming on the channel is able to offer perspectives on "what it means to be a Māori in modern New Zealand."[15]

This emphasis on the politics of representation, characteristic of policy and promotional accounts of MTS, and of critical responses to the channel, nevertheless presents a range of problems and pitfalls precisely at the cathected intersection, to which I have alluded, of delegated voice and invested image, for which a shorthand term might be "identity politics." My argument is not that representation, or even identity politics, are inherently or inevitably—essentially—problematic. Rather, I suggest that they call for an examination of their effects in relation to the broader context of their articulation. In other words, the significance of acts of (self)representation or articulations of identity politics are inseparable from the wider political economy, and its onto-epistemological predicates, within which they take place. Further, in asking

how the cultural aspirations to which the channel has been attached from its inception shape, and are shaped by the social, political, and economic conditions into which it has emerged, I contend that television is really only an epiphenomenon of a larger set of challenges for postcolonial Māori culture. Nevertheless, even as "hard-" and "software" (or technological and semiological) manifestation of such challenges, it also presents its own potentialities within a reconceived politics of "representation."

Two descriptive statements serve to reveal the political—"representational"— complexity of the moment into which MTS has emerged. The home page of the channel's website opens with the following assertion:

> The Māori language is the cornerstone of Māori culture. It provides a platform for Māori cultural development and supports a unique New Zealand identity within a global society. It is a taonga (treasure) at the very heart of Māori culture and identity, and for that reason alone it must be preserved and fostered.[16]

Describing the channel as "New Zealand's national Indigenous broadcaster," the website explains that MTS aims "to promote and revitalise the Māori language . . . and culture that is the birthright of every Māori and the heritage of every New Zealander." By the time of the channel's inception, therefore, the notion of Māori inclusion and agency within a national mediascape is dispersed across the values of Māori cultural identity, the politics and condition of indigeneity, a unique New Zealand (national) identity, and their shared participation in a global society. Māori language and culture are central not only to Māori identity, but to New Zealand's heritage and its unique place within globalization. The very entity that was challenged and petitioned to recognize its history of suppression of Māori language and culture, and to redress its settler/Pākehā monoculturalism, is now supported, its position strengthened, by its Māori linguistic and cultural heritage. My point is not that this is necessarily a bad thing, a negative outcome for Māori; rather, I suggest that it is important to mark a political shift from one of challenge, protest, and petition—the political charge of the call for representation, inclusion, agency from a position "outside" the system being called on—to one of institutional(ized) participation of Māori language and culture in the fortunes of the nation, and of both of these in the context of a global cultural economy. If the latter thrives on expansion through diversity, the question remains open as to the significance of Māori postcolonial cultural agency.[17]

A history of colonial suppression and oppression casts the mission of "fostering," "promoting" and "revitalizing" the Māori language in the light of postcolonial healing and (re)affirmation, restoring the status of a language that was denigrated and suppressed—further signified in the implications of organic continuity in the website's use of such terms as *"taonga,"* "heart," "birthright," and "heritage" to be "fostered" and "preserved." However, the culture is also to be "promoted," in the cause of "development," where both terms accrue a range of significations, with the advent of the global

cultural economy, that cannot be separated from culture's instrumentalization as a resource and a commodity. As such, culture—in the senses of both collective identity and the creative expressions of that identity—may be mobilized in the political demands of marginalized groups, but these demands will inevitably cast culture as a "value"—literally or metaphorically a commodity—in the circulation of capital, perhaps all the more "valuable" for being identified as "marginal" (exotic) in an economy perpetually seeking sustenance through "difference." Such is not only the fate of colonized, Indigenous, minority or otherwise oppressed "cultures"; one could clearly make the same argument regarding "national cultures," or "cultural identities" such as New Zealand's.

A similar rhetoric of protection and promotion informed the nation's Broadcasting Charter with its mission to put "New Zealand on Air" at the very point where neoliberal economic reforms had opened the country up to global economic and cultural exchange.[18] This "coincidence," I suggest, is less a problem of contradiction between the discourse of protection and the conditions of market exposure; rather, it is a matter of the market motivating and shaping, even generating, the culture to be "protected" and "promoted." However, my concern is with the implications for Indigenous peoples, such as Māori, for whom "culture" has become the basis and medium of political projects of decolonization. From that point of view, in technological terms television is ideally suited to the signification of Māori culture *(tikanga)* for broadcast throughout and beyond the nation, to affirm and celebrate the diversity of Māori lives, history, and creativity, to enable Māori direction of the televisual gaze on the world, and to develop Māori professional status and skills. However, what could it mean to undertake and affirm the "development" and "promotion" of *taonga,* heart, birthright, and heritage other than translating these into terms, values, significations to be circulated and exchanged on the cultural market? Further, if culture connotes varying forms of attachment, as collectivity, commitment, identity, or property, what is the fate of culture and cultural politics in a deregulated neoliberal economic market? These questions arise from my contention that there is something specific about the way television produces culture (a semio-technological issue), and that television's relation to the cultural market subsumes culture under the overarching market logic that constitutes its own economy (an institutional issue). Like the two senses of representation, these technological and institutional issues of course ultimately articulate one another, however it is useful at this point to signal their specificities, before rearticulating them in my argument that the pitfalls and potentialities of MTS must be situated within the contextual political economy of its moment of advent.

This brings us to the second statement that invokes the politics of representation, while gesturing toward the need to reexamine the contemporary nature of representation itself. Smith observes that "MTS is an initiative driven by the tenets of equal representation, democracy and Treaty partnership, and the focus on media industries highlights the increasingly central role that audiovisual culture plays in the negotiation of community relationships, social power and cultural survival."[19] Without

minimizing their import in the wake of a history of colonial suppression and persistent social, economic, and cultural inequities, the references to equal representation, democracy, and Treaty partnership are consistent with the conventional arguments for Māori television as outlined above. Like all bids for representation, the emphasis of these terms is both discursively and substantively on the politics of inclusion and participation as agents within the overarching framework of the system being petitioned, accepting its terms and insisting on their extension to include Māori. Yet, the identity of that system itself remains ambiguous here, and opens on to a set of further considerations in the politics of Māori televisual representation. On the one hand, it appears to refer to the nation-state of New Zealand, a statutorily bicultural democracy that has not fully achieved its own Treaty-based commitment to such a status. On the other hand, the reference to a "focus on media industries" could render the media industries themselves the governing system, within which Māori seek equality of representation, democracy, and Treaty partnership. This possibility, supported by the further reference to the centrality of "audiovisual culture" in negotiating the stakes in such equality of representation ("community relationships, social power and cultural survival"), marks a shift with important implications for the cultural politics of MTS, and for MTS's role in contemporary Māori cultural politics.

It might seem that television functions as a medium, in the sense of an instrument, in the (re)assertion and (re)affirmation of Māori culture in relation to the mainstream settler-national culture of New Zealand, whether that relation is one of sovereign partnership or shared heritage and point of distinction or difference in the global arena. MTS has generally been viewed in terms of the relation of Māori language and culture to the national New Zealand culture and context, whether as critical intervention, "disrupting the hegemony of New Zealand settler society," offering "potential circuit breakers in the common narratives of nationhood" by presenting "indigenised" versions of familiar formats such as reality television to assert "another economy of belonging to landscape and resources," or as cultural complement, signifying "progress toward a more egalitarian and bicultural society that may affirm Māori cultural identity," appropriable as "bicultural branding."[20] However, Smith's reference to audiovisual culture draws attention to the culture of television itself, and the audiovisual realm more generally. It complicates not only "representation" but "culture," now simultaneously suggesting—to simplify and schematize for the sake of brevity—a group identity forged in the colonial crucible turned to positive articulation of collectivity; a postcolonial nation-state in the process of self-legitimation and international assertion; a technological apparatus and the institutional agencies and means/resources that sustain it; and a set of onto-epistemological assumptions, discourses, and practices for the production and exchange of meanings. While there is something isomorphic about Māori culture in relation to national culture (in that their relations may be cast as historically shaped and hierarchically positioned within an overarching notion of collectivities of peoples), the relation of Māori culture to televisual or audiovisual culture poses quite different questions and problems.

To return to the notion of representation, cultural critics have both acknowledged and problematized the role of audiovisual media in the struggles of oppressed or minority groups for equality of representation. As Peggy Phelan has noted, there is "a deeply ethical appeal in the desire for a more inclusive representational landscape," but she warns that a "much more nuanced relationship to the power of visibility needs to be pursued"[21] to intervene critically in "implicit assumptions about connections between representational visibility and political power"[22] that have dominated cultural theory. Something of this is exemplified in Smith's concern that "the State can exploit" an initiative like MTS "while maintaining other institutional practices that deny Māori agency,"[23] harnessing "MTS images of Māori empowerment as symbols of a healthy bicultural nation-state at the same time as it resists challenges to its policies in other forums."[24] Clearly such "images of Māori empowerment" risk being circumscribed within the realms of televisuality itself, with little or no referential reach to wider Māori social, economic, or political strength. In this case, the images stand in for an implicit extra-televisual referent, displacing and replacing it with aesthetic assurances of well-being. However, I would argue that intervention into the assumptions that inform the pursuit of "visibility," or representation within audiovisual media, must address (audio)visuality itself, the very forms and practices of representation in visual media.

Marcia Langton's observations regarding Aboriginal television and other broadcast media point toward the problem in these terms, when she writes that "During the 1970s and 1980s, the Aboriginal response to racist representation, especially in the large urban centres, was to demand control of representation,"[25] but that "Rather than demanding an impossibility, it would be more useful to identify the points where it is possible to control the *means* of production and make our own self-representations."[26] Langton's point draws attention to the problems of attempting to limit or prescribe the circulation of images (verbal or visual, imaginary or material), and instead advocates Aboriginal agency in producing the positive images that might contest or even prevail over racist ones. However, when it comes to self-representation, for example through television, I am reminded of Barbara Kirshenblatt-Gimblett's caution, in another context, that "Much is made of the traditions themselves as if the instruments for presenting them were invisible or inconsequential."[27] In other words, Indigenous cultural workers may gain and exercise agency in the production of televisual self-representation, and in that way intervene in and contest the hegemonic (inter)national cultural mainstream images and narratives. Yet, such self-representation depends upon investing in the semiological or significatory and technological-institutional parameters of audiovisual culture itself. Clearly even self-representations do not escape the shaping force of the media themselves. As Smith acknowledges, "Māori Television can claim a sense of achievement in its ability to set an agenda and disseminate viewpoints that promote indigenous knowledges, investments, language, and aesthetic practices. Yet these indigenous articulations circulate within a larger social and political context that helps shape their meanings and effects."[28] Thus, when

Victoria Grace contends that "The source of wealth has shifted from control of the means of production to a mastery of the process of signification,"[29] she invokes the shift of the dynamics of global capital toward the postindustrial cultural/knowledge economy—where I would reiterate the importance of MTS as a step in Māori agency within such an economy. At the same time, though, she points to a shift from the notion of control, with its connotations of the ability to limit as much as to generate from a sovereign autonomous position of agency, to one of mastery, which connotes an ability or facility with(in) the system, in this case the code of signification, rather than ontological autonomy from it. A focus on television as a medium oriented to the transmission of visual images serves to draw out the implications of the larger arena of "visibility" politics, an inflection of the politics of representation that casts the emphasis on the production and circulation of images.

Representation, whether in political or aesthetic contexts,[30] requires and articulates reified, positive, terms. It implies there is a(n absent) "presence" for which it substitutes, an idea or object or entity whose existence is prior to and ontologically distinct from the representation itself, and which is "signified" by the representation, which is materialized in the "signifier." Together, the signifier and the signified constitute the sign, so that representation may be seen as the production and exchange of signs. Signs are exchanged for one another, and for their referents, according to a principle of equivalence, which entails both accuracy/identity and adequacy. On MTS, for example, the "signified" might be, in general terms, "Māori culture," or the "Māori world"; more specifically, it might be an event of significance for Māori, a Māori person or group, Māori places, objects, narratives, and so on. These must first be reified, conceptually, as distinct and finite existents or presences in the world, able to be represented, and then be materialized, as signifiers—images, words, sounds—that call up the signifieds they represent, and in turn refer to the existence of these signifieds in the world. This simple account of representation as the production and exchange of signs has a number of implications, however, that bear on a television channel committed to the preservation and revitalization of an historically colonized and marginalized culture.

The semiological representation of culture or identity (or event or object) constitutes these through the semiotic code itself, the code that divides into signified and signifier before rearticulating their relation as sign in terms of reference according to the principle of equivalence referred to above. This code is indifferent to the content of its significations. Māori culture—or to that extent *iwi* (peoples) cultures, since in this context unity or plurality of culture(s) is not the issue—signify in the same way as Pākehā, British, New Zealand, or any other cultural representation. The difference of Māori culture(s), like any culture, is reducible to the semiotic code or system itself, and in that sense offers diversity within the significatory system, rather than an intervention into it. A concern with the reduction of MTS to a channel for cultural differences— the basis of the very bid for Māori televisual representation—within the larger national

mediasphere is evinced in Smith's concession that "MTS broadcasts a communication system shaped by *te ao Māori* [the Māori world] and Indigenous interests, creating an Indigenous public sphere that *parallels* that of the mainstream,"[31] an observation that stands in tension with her affirmation of the channel's ability to *intervene* into the mainstream, unless that intervention is understood in terms of addition, and at the level of content alone. As Phelan has noted, "Visibility politics are additive rather than transformational. . . . Visibility politics are compatible with capitalism's relentless appetite for new markets. . . . The production and reproduction of visibility are part of the labor of the reproduction of capitalism,"[32] a point that recalls Chow's argument concerning the "protestant ethnic" noted above.

The conceptual reification of culture, or cultural qualities, is the precondition of their status of, or as having, "value," which in turn circulates by way of the medium of representation (semiotic and/or technological). Moreover, this economic circulation of value(s)—in materialized abstraction as signs—is precisely what enables the state to harness and appropriate such value(s) for its own self-legitimation as bicultural, or indeed for the global market in cultural goods to appropriate the signs of Māori identity as experiential, intellectual, or material commodities. Smith and Abel point out that "Māori Television functions within a wider mediascape where Māori differences have often sustained, enhanced and demarcated the national difference of New Zealand on the global market."[33] In this way, Māori culture is "promoted" and "developed," but in the sense of objectifying and instrumentalizing it within the logic of capitalist expansion and consumption. Further, Smith poses the important question, "how might Māori Television address [the] issue of *self-exploitation* in a context where the embeddedness of indigenous ways of knowing can be picked up, processed, and then circulated for the sake of the bi- or multi-cultural nation?"[34] My concern here, though, is primarily with the impacts and implications of this process of reification as value(s) for Māori cultural revitalization, and the role of MTS in both. If the semiotic code underpins culture's reification in representation generally, television as a technology encodes and signifies culture in its own specific ways. As an audiovisual medium, it is obviously constrained to the requirements of audiovisualization, but as a cultural institution contemporarily situated within a broader (inter)national neoliberal market economy, its requirements and accountabilities are geared to the political economy of image production and circulation in this context. The MTS website's homepage clearly outlines that for all its commitment to Māori cultural revitalization, it is required to fulfill its accountabilities to the Crown and Te Pūtahi Pāoho (the Māori Electoral College) through "a Statement of Intent provided annually to the House of Representatives; output agreements and quarterly progress reports to the stakeholders; an annual report; regular audits via the Office of the Auditor General, and compliance with the Official Information Act." The English-language account of its vision statement casts MTS as "a world-class Indigenous broadcaster," while its mission reads, "To make a significant contribution to the revitalization of *tikanga Māori* and *reo Māori* by being an

independent, secure and successful Māori television broadcaster." In other words, the role of MTS in the revitalization of Māori language and culture is shaped by its political and economic accountabilities, subject to reportage and audit, and the requirement to reach "output" targets, to become and remain economically secure and successful (itself cast as a measure of Māori cultural revitalization), while in professional terms there are national and international broadcasting protocols and standards to which the channel is just as accountable, and against which it agrees to measure itself.

In more practical terms, as Smith observes, MTS "participates in a form of identity politics designed to celebrate its culture, but it does so with the eye firmly on the market,"[35] and this entails that its "mandate to revitalise *te reo* and Māori *tikanga* is pitched at an audience that is not exclusively Māori."[36] This is because, as Smith and Abel note, "Māori television must also attract a broader audience that might be attracted to the language and/or culture,"[37] to expand its market share. There are various programming implications of this attention to the market; indeed, if the pursuit of political representation looks to participant/audiences as constituencies, then the contemporary pursuit of televisual representation constitutes participant/audiences as markets. Smith and Abel register concern at the reduction of cultural difference to "just another demographic difference such as that between old and young,"[38] and indeed at the intersection of a market-driven televisual economy, the age demographic is itself shaping the priorities and emphases in MTS's representation of Māori language and culture. A preponderant and growing youth demographic characterizing the Māori population has seen an emphasis on children's and youth programming, while youth themselves are constituted as markets as much as audiences, constituencies, or cultural subjects. On the one hand, the culture and language are "marketed" to children and young people—Māori and Pākehā[39]—appealing through a global youth idiom. Stephens refers to the program philosophy of *Mai Time*, a "series [that] presents music videos, celebrity insights, and the happenings of young people in a bi-cultural, bilingual and bi-funky mix," that "it is cool to be Māori."[40] He refers to children's series in which "presenters have become stars and role models for their eager audiences,"[41] and to these audiences as "'screenagers' . . . avidly scrutinising the world and the opportunities it offers."[42] On the other hand, such marketing has had some ramifications for the channel's ability to foreground *te reo Māori* itself. Smith and Abel observe:

> Māori Television's ratings success to date has been because, as Māori Television's G[eneral] M[anager] Programming Larry Parr has pointed out, "the channel has attracted disenfranchised viewers from the mainstream channels, who like Māori television because of its public service broadcasting and minimal advertising." This, he says, "has come at the expense of our own rangatahi [youth]."[43]

The logic of market expansion or extension is thus in tension with that of cultural fostering and preservation, as the latter faces pressures of the reach from the "cultural

inside" out to the wider global cultural market, and of the entry of the "cultural out-side" into an arena seeking to define itself with reference to language and cultural specificity. The advent, in 2009, of *Te Reo*, a channel broadcasting for a limited period each day on the new digital platform, wholly in *te reo Māori*, testifies both to the complexities of negotiating culture and the market, and to a technological development—digital television—that is in many ways enabling, but that nevertheless increases the "presence" of Māori television at the very moment when broadcasting itself is quickly giving way to narrowcasting, to niche viewerships/markets.

The notion of audience as market, or as niche market, shifts emphasis from representation in its "political" sense of delegated voice to representation in its "aesthetic" sense of the production and content of images (remembering their inseparability, and thus that one cannot replace the other), with implications for representational politics themselves. John Hartley and Alan McKee argue that "new notions of citizenship have arisen that stress culture, identity, and voluntary belonging over previous definitions based on rights and obligations to a state."[44] If it might seem that citizenship that stresses, rather than blinds itself to, culture and identity (and thus emphasizes difference over sameness) is a positive move for members of an Indigenous culture within a majority settler-(post)colonial state, the notion of "voluntary belonging" points to the inflection of citizenship through "lifestyle," and by extension through the commercial exercise of preferences rather than the political exercise of rights. Indeed, Hartley and McKee continue:

> Public participation is much higher and more enthusiastic in "commercial democracy" than in the formal mechanics of representative politics. Economic activity is most heated . . . in new areas of culture, knowledge, information and "identity" consumerism, from tourism to fashion. The media are no longer explained as a secondary institution. . . . Media are the primary and central institutions of politics and of idea-formation; they are the locus of the public sphere.[45]

The clear corollary of the orientation of economic activity to, broadly speaking, culture is that culture (along with knowledge, information, and identity) is an economic object, amenable to being measured, weighed, accorded more or less value, accrued as property, or exchanged for some available equivalent. More to the point of this argument, the recognition of media as primary rather than secondary calls for a radical reconsideration of the role of television in the politics of representation, indeed in the notion of representation itself.[46]

When Langton expresses the concern that there is a need for Indigenous control of media to enable the production of self-representations, where " 'what's on' creates the context for what is known, and hence finally for what 'is,' "[47] she alludes to television's role as a primary producer rather than mediator (medium) of knowledge, meanings, truth, reality. We are no doubt familiar with the notion that what is presented as

television "news," and how it is presented, relates fundamentally to the capacities and requirements of television—the ability of the technology and reporters to reach locations or events and transmit; their specific audiovisual framing of them *as* events; the market/ratings-driven assessment of audience concern with them as events (newsworthiness); the programming schedule's influence on the amount of time spent "covering" any particular event or prioritizing what will and will not be covered, and when; the institutional perspectives, often shaped by the channel's political and economic stakeholders, through which the events are presented; and so on. This overdetermination of television as window on or even mirror to the world is also familiar in the "representation" of televised sport, where examples abound of the primacy of television, from the orientation of ceremonial openings and closings to televisual transmission to the adaptation of the sporting codes, their rules, and periods of play to be televisually appealing and to fit with the relativities of play/broadcast and advertising time. In other words, the game itself—along with any ceremony—becomes a televisual production, rather than television being the medium that broadcasts the game. What, then, of the role of television in the broadcast of a cultural world? What, even, of television's role in broadcasting (in) and thus revitalizing a particular language? Can it be any more neutral, regarded simply as a medium transmitting these things without fundamentally producing them in its own technical and institutional registers or likeness? The "audiovisual archive"[48] that Stephens envisaged is an entirely valid aspiration for MTS, bearing in mind that it will be an archive of the tele-audiovisualization of Māori knowledge, traditions, perspectives, and creativity. Certainly all practices and contexts of recording or transmission shape the materials they encompass; the point is to remain cognizant of the qualities, capacities, and limits of television as such. To reiterate Kirshenblatt-Gimblett's point, "Much is made of the traditions themselves as if the instruments for presenting them were invisible or inconsequential."[49]

It is entirely understandable that much concern with the politics of representation for Indigenous peoples, those who have been colonized and/or experience minority status within larger nation-states (hardly a matter of the "voluntary belonging" to which Hartley and McKee refer), has been with the problems of under- or misrepresentation, problems with the accuracy and adequacy of representation. Indeed, such concerns often gesture further toward the force of such misrepresentation as precisely the installation of false, limiting, or otherwise destructive or oppressive norms. While racist or negatively stereotypical representations are obviously problems that can generate real effects for their objects, it can be just as problematic when such representations are cast in the positive or affirmative. Smith points to the "burden of representation" borne by MTS as a national Indigenous broadcaster, where the channel "risks quantifying and standardising the many life-worlds that constitute te ao Māori,"[50] even coming to express "regulatory force."[51] Smith and Abel develop this to specify the problem of the channel "producing a pan-Māori identity at the expense of different *iwi*."[52] While I agree that these observations are important, I would argue that the

problems are not fundamentally addressed by pursuing wider, fuller, more diverse—quantitatively and qualitatively *more* accurate and adequate—representations, or in other words differences rather than difference. Indeed, this may only serve to further obscure the problem, even obliterate the possibility, of space between a revitalized, living Māori cultural world and its televisual representation.

Smith's ambivalence toward MTS as a channel committed to the revitalization of Māori language and culture is implicit in the tension between her affirmation of its ability to signify "Indigenous values," or (Māori) indigeneity, in contestation of mainstream cultural narratives, while also registering the concern noted above that this in turn risks becoming a totalizing discourse. She affirms MTS's "refashioning of tried and tested TV genres,"[53] such as reality television, its "indigenisation" of such formats, drawing attention to how *DIY Marae,* for example, "offers a point of difference to the makeover genre that depicts, and accordingly normalises, marae lifestyle on TV"[54]—where it hardly needs spelling out that this casts the *marae* (land and buildings of genealogical significance) very much in a consumerist discourse precisely as "lifestyle"—primarily through its (putative) contestation of the usual makeover genre's focus on individualism and consumption. This contestation implies that indigeneity may be encoded as a set of characteristics, qualities, or values, and takes the form of the televisual assertion of "another economy of belonging to landscape and resources,"[55] through an emphasis on location, history, and community. Smith goes on to acknowledge that "By rewriting these familiar TV narratives, MTS produces a palimpsest text where commercial imperatives and cultural knowledge mesh, a risky mesh that contains peril as much as potential for Indigenous agency."[56] However, where she sees the conflict *between* cultural knowledge and commercial imperatives, I would suggest that television promotes the reification of culture as cultural knowledge in a manner that is consistent with the economic foundations of signified "value(s)."

Culture, rendered as cultural knowledge, may be signified through such values as community, history, tradition, and belonging, or aestheticized through the signification of Māori cultural values or protocols *(kawa)* in the ethos or presentation of programs, schedules, flows. Stephens has pointed to Māori cultural aesthetics, arguing that "Extended 'talking heads' sequences, or pithy visual/audio metaphors are examples of the techniques that help to define truly Māori television."[57] I do not want to suggest that these qualities do *not* accord with a Māori cultural or aesthetic sensibility; rather, I am concerned that functioning as *signs* of indigeneity, they are susceptible both to decontextualization and appropriation, and to their decontextualized installation as stereotypes, or simulation models for the (re)production of Indigenous "authenticity." Whereas "Representation stems from the principle of the equivalence of the sign and of the real (even if this equivalence is utopian, it is a fundamental axiom),"[58] and the politics of representation could be seen as being concerned with the pursuit of that utopian equivalence, simulation, by contrast, "is the generation by

models of a real without origin or reality: a hyperreal."[59] Thus "Simulation is character-
ized by a *precession of the model*."[60] Further, although they may be signs whose the-
matic content contests the political economy of the capitalist-consumerist nation-
state, they are ironically complicit in that political economy through their "additive"
contribution of signs according to a logic of diversity. It is for this reason that while the
notion of (more adequate and accurate) representation of *iwi* differences breaks open
that of pan-Māori identity, each of those differences signified only expands the system
of signification.[61]

The ambivalence Smith registers culminates in her reference to MTS's potential
role in "staging cultural identity," in "visualising . . . cultural differences onscreen,"
resulting in "empty televisual representation."[62] Here she approaches the crux of the
argument toward which I have been heading. I take her reference to "empty" represen-
tation to mean its lack of an external referent, its status as the product of televisual
codes of production and circulation (including consumption) themselves. This is the
condition of simulation—the copy or image with no original, or referent, in the real
world, but rather, "already inscribed in the decoding and orchestration rituals of the
media, anticipated in their presentation and possible consequences . . . where they
function as a group of signs dedicated exclusively to their recurrence as signs."[63] Per-
haps because of its popular connotations of inauthenticity, neither Smith nor Abel
refer explicitly to simulation as the nature or name of many of the "risks" they identify
with and for MTS. However, the development and increasing centrality of audiovisual
technologies in contemporary cultural life have not only borne witness to, but also
intensified the impossibility of drawing a line of demarcation between authenticity
and inauthenticity. To produce images and meanings through the significatory code is
to produce simulacra; to signify the world is to simulate it in signs. Thus, representa-
tion is ultimately itself simulation, though its invocation of an external referent to
which it is bound means it is a "lower" order of simulation, which characterizes the
ability, in contemporary audiovisual culture, to produce images (and meanings)
through manipulation of the semiotic and technological instruments themselves,
with no necessary attachment to an external referent.[64] Thus in simulation, signs cir-
culate freely and independently of attachment to any referent, their value/meaning
"floating" on the market in differences (from one another). In other words, the notion
of representational adequacy is not tied to the sign's identity with, or equivalence to, its
referent, but to its identity with itself, and its difference from other signs that confers
that identity. To bring this back to more specific terms, when Langton invokes the situ-
ation where "what's on" television comes to determine "what is," we see the televisual
production of reality, rather than its representation of it. Such a reality is thus a televi-
sual simulation, which does not make it any less real or authentic in the sense of being
lived; rather it is a different "order" or ontology of the real. Similarly, when Smith refers
to the "regulatory force" of televisual "representations" of the Māori world, she invokes
their ability to shape that world "beyond" television, though this "beyond" is

inseparable from a televisual onto-epistemology, and again no less real as "lived," for all that.[65] This also raises the important point that the opposition of active/passive also collapses in the face of simulation. If my characterization of television, and MTS, has focused on the production side at the expense of consumption, seemingly overlooking the recognition that viewers are not passive consumers of televisual representation but active in responding, engaging, choosing, contesting, transforming, and even creating their own cultural texts from the materials it offers, I would argue that this in no sense contradicts the contention that "the real," encompassing the lived activities and experiences of viewers, is shaped by television, programmed or encoded by the "medium." Indeed, "The medium itself is no longer identifiable as such. . . . There is no longer a medium in the literal sense: it is now intangible, diffused and diffracted in the real."[66] In other words, wherever "the distinction between [the] two poles [beginning/end; here/there; cause/effect; true/false; active/passive] can no longer be maintained, one enters into simulation, and thus into absolute manipulation—not into passivity, but into *the indifferentiation of the active and the passive*."[67] The "relation" to the media is thus "neither more nor less active or passive than a living substance vis-à-vis its molecular code."[68] The questions that follow from this are: To what extent do the capacities and limits, requirements of, and on, television as a technological (non) medium and an institution in the (hyperreal) political economy (of culture), shape the Māori language and culture being revitalized, and the manner of its revitalization? And what are the gains and losses for the project of cultural revitalization in television's signification of Māori language and culture?

A television channel committed to cultural revitalization risks reducing culture to signification through its reification and fixity as signs or images of identities, meanings, events, and processes. Television can signify/simulate what is, what has been, what might or will be; but can it encompass the dimensions of reversion, nonidentity, the radical ambivalence of subject/object/meaning, the singularity of gestural exchange before or beyond representation? In short, can it encompass "symbolic exchange"—where "reversibility, cyclical reversal and annulment put an end to the linearity of time, language, economic exchange, accumulation and power"[69]—other than through their production in or reduction to positivist signification?[70] The singularity of culture, which is its irreducibility to signification or representation, to appropriation and commodification, lies in its gestural spatiotemporality alone, which is the spatio-temporality of symbolic exchange. In symbolic exchange, "an outline of social relations emerges, based on the extermination of values,"[71] in the sense that the term (the identity) as terminal, is ex-*term*inated, its status as term(inal) reversed back into radical ambivalence, noncapture by identity. Positing that identity may be revealed as harboring its own oppressive, even deadly, demands, Jean Baudrillard insists, "The symbolic demands meticulous reversibility. *Ex-terminate* every *term*, abolish value in the term's revolution against itself: that is the only symbolic violence equivalent to and triumphant over the structural violence of the code."[72] If there is anything in this

evocation of the symbolic, whose structural exclusion haunts the production of Māori culture as televisual signification, then the limits of television's role in cultural preservation and revitalization are revealed.

I have suggested that the best response to inadequate and inaccurate representation today may not be the attempt to close the gap between reality and representation through more and better images. The reason for this is that the very closure of that gap has emerged contemporarily as the condition of simulation and its hyperreality in saturated televisual/audiovisual space. Yet, if Baudrillard is right that "We will never defeat the system on the plane of the *real* . . . which is always *the reality of the system*," then reversibility, as the law of the symbolic, might point precisely to the production of images *beyond* the representational imperative, to where "challenge, reversal and overbidding are the law."[73] Thus, it might be more strategically canny to acknowledge and celebrate television *as* a "simulation machine," and indeed to celebrate MTS's advent as a significant step in Māori participation in this very order of simulation, going further than the system's—that of the structural law of value and its encoding of the real—own simulation of "Māori culture" under the sign of "the real." Rather than pursuing truth, adequacy, and wholeness of cultural (self)representation, it might be better to play the game of appearances, images, a game that would collapse the very opposition of truth/appearance, and allow each to allude to and reverse the other in a continual and unarrestable cycle. After all, contemporary viewers of television barely credit, let alone expect, anything as weighty and earnest as Truth-in-representation. Viewership has developed enough sophistication to appreciate the construction of news, the generic characteristics of programs, the formats syndicated around the world, while further developments in audiovisual culture, such as the DVD, in fact commodify their own processes of construction for further consumption, and "reality television" exemplifies the dissolution of the gap between the production and consumption, activity and passivity, of televisual representation. It would be rather poignant to pretend that there can be a zone of televisual representation exempt from this context, left alone to attempt to proffer its faithful depictions of a sovereign cultural world in the belief that it is mounting a transformative political intervention. Gestures in this direction would constitute a simulated politics. I began by referring to the advent of MTS as an important moment in Māori cultural politics. I conclude with the suggestion that it is precisely as *audiovisual* politics that Māori have achieved the opportunity to engage, and that what is now at stake is the politics of simulation—the politics of (dis)appearances. By engaging television—or audiovisual culture more generally—*as* simulation, it may even reopen the space between audiovisual culture and the symbolic quality of singularity—unrepresentability—that would sustain *te ao Māori* beyond its equivalence to, difference from, or in general comparability with, the national and global political economy of culture.

Notes

1. Tainui Stephens, "Māori Television," in *Television in New Zealand: Programming the Nation*, ed. Roger Horrocks and Nick Perry (Melbourne: Oxford University Press, 2004), 108.

2. Jo Smith and Sue Abel, "Ka Whawhai Tonu Mātou: Indigenous Television in Aotearoa/New Zealand," *New Zealand Journal of Media Studies* 11, no. 1 (2008): 2.

3. Rey Chow, *The Protestant Ethnic and the Spirit of Capitalism* (New York: Columbia University Press, 2002), viii.

4. Ranginui Walker, *Ka Whawhai Tonu Mātou: Struggle without End* (Auckland: Penguin Books, 1990), 210–11.

5. Roger Horrocks, "The History of New Zealand Television: 'An Expensive Medium for a Small Country,'" in *Television in New Zealand: Programming the Nation*, ed. Roger Horrocks and Nick Perry (Melbourne: Oxford University Press, 2004), 21.

6. Ibid., 22.

7. The development of wider Māori broadcast initiatives and platforms, including radio, is beyond the scope of this chapter. See, for example, Donna Beatson, "A Genealogy of Māori Broadcasting: The Development of Māori Radio," *Continuum: Journal of Media and Cultural Studies* 10, no. 1 (1996): 76–93.

8. Walker, *Ka Whawhai Tonu Mātou*, 272; see ibid., 270–73.

9. Smith and Abel, "Ka Whawhai Tonu Mātou," 3.

10. This distinction of the two senses of representation, in order to examine their (re)articulation, has been made by Gayatri Spivak in "Can the Subaltern Speak?" (see Gayatri Chakravorty Spivak, "Can the Subaltern Speak?," in *Marxism and the Interpretation of Culture*, ed. Cary Nelson and Lawrence Grossberg (Urbana: University of Illinois Press, 1988), 271–313; esp. 274–80). Spivak invokes the German words *Vertretung* and *Darstellung*, which she explains in the interview "Practical Politics of the Open End" as signifying representation as "stepping in someone's place" or "to tread in someone's shoes," and "placing there," respectively (Gayatri Chakravorty Spivak, "Practical Politics of the Open End," in *The Postcolonial Critic: Interviews, Strategies, Dialogues*, ed. Sarah Harasym (New York: Routledge, 1990), 95–112, 108. She continues: "Representing: proxy and portrait . . . Now the thing to remember is that in the act of representing politically, you actually represent yourself and your constituency in the portrait sense, as well" (ibid.). Similarly, Edward Said points to representation as referring to "an isolated cultural sphere, believed to be freely and unconditionally available to weightless theoretical speculation and investigation," and to "a debased political sphere, where the real struggle between interests is supposed to occur" (Edward Said, *Culture and Imperialism* [London: Vintage, 1994], 66). Said argues that while it is often "accepted that the two spheres are separated," they are in fact "not only connected but ultimately the same" (ibid., 67).

11. Stephens, "Māori Television," 113.

12. Ibid., 110–11.

13. Ibid., 107–8, 113.

14. Ibid., 109.

15. Ibid., 109, 111. My discussion neither concerns nor indeed contests the channel's success and distinctiveness in the national mediascape as a broadcaster of children's and young people's programs, with their emphasis often on language acquisition, news, sports, lifestyle programs, entertainment shows, movies, and documentaries, the last two further distinctive for their inclusion of Indigenous materials from around the world. My focus is on the question of the role of television in the stated project of language and cultural revitalization.

16. Māori Television Service home page: http://www.maoritelevision.com/Default.aspx?tabid=227.

17. The shift I refer to should also be seen in the context of Chow's argument concerning the "protestant ethnic," and "the ways in which [the politics of ethnicity] partakes of the Protestant work ethic that Max Weber identified as the spiritual side of capitalism's commodifying rationale." Using the term "protestant" in its wider sense of "pertaining to one who protests," Chow maintains that the "protestant ethnic" results from the collaboration of "the power of subjective belief (in salvation) [and which I would gloss as "liberation" into "representation"] as found in modern, secularized society and capitalist economism's ways of hailing, disciplining, and rewarding identities constituted by certain forms of labor" (Chow, *Protestant Ethnic*, viii). She includes in her call to "chart the complex genealogical affinities among ethnicity, capitalist commodification, and the spiritual culture of protest" (32) the need to consider ethnicity itself in terms of how it would be understood "structurally, as part of a biopoliticized economic relation, whereby the very humanity attributed to ethnics is itself firmly subsumed under the process of commodification and its asymmetrical distribution of power rather than outside them" (ibid.). Thus, it is vital to consider how "ethnics have been subjected to and continue to 'resist' their dehumanizing objectification, but also the psychological mechanism of 'calling' (sense of vocation)—what Max Weber calls a 'work ethic'—that gives rise, certainly, to compelling feelings of individual resistance but is, arguably, already a dynamic built into the rationalist process of commodification" (33). It is therefore not a matter of valorizing protest; however Jean Baudrillard might argue further for the need to take account of how labor itself is transformed in a society that has moved from an economic rationale of production to one of consumption. Rather than alienated, labor is integrated: "the structure of absorption is total. Labour power is no longer brutally bought and sold, it is designed, marketed and turned into a commodity" (Jean Baudrillard, *Symbolic Exchange and Death*, trans. Iain Hamilton Grant [London: Sage, 1993], 15).

18. The Government Broadcasting Policy Statement of Objectives (July 2000) identifies state interest in broadcasting in "public service" terms as promoting "New Zealand culture and identity," "participatory democracy," and protection of "local content" against market forces. Marian Hobbs, "Broadcasting Policy: Objectives and Delivery Mechanisms," http://www.beehive.govt .nz/feature/towards-broadcasting-policy. This website is archived, but subsequent broadcasting charter statements are similarly concerned with television's role in identifying "what it means to be a New Zealander."

19. Jo Smith, "Parallel Quotidian Flows: Māori Television on Air," *New Zealand Journal of Media Studies* 9, no. 2 (2006): 27.

20. Ibid., 27, 35, 32, 28.

21. Peggy Phelan, "Broken Symmetries: Memory, Sight, Love," in *The Feminism and Visual Culture Reader,* ed. Amelia Jones (London: Routledge, 2003), 110.

22. Ibid., 106.

23. Smith, "Parallel Quotidian Flows," 28.

24. Ibid., 33.

25. Marcia Langton, *"Well, I Heard It on the Radio and I Saw It on the Television": An Essay for the Australian Film Commission on the Politics and Aesthetics of Filmmaking by and About Aboriginal People and Things* (North Sydney: Australian Film Commission, 1993), 9.

26. Ibid., 10.

27. Barbara Kirshenblatt-Gimblett, *Destination Culture: Tourism, Museums and Heritage* (London: University of California Press, 1998), 156.

28. Jo Smith, "Postcolonial Māori Television? The Dirty Politics of Indigenous Cultural Production," *Continuum: Journal of Media and Cultural Studies* 25, no. 5 (2011): 722.

29. Victoria Grace, *Baudrillard's Challenge: A Feminist Reading* (London: Routledge, 2000), 113.

30. Again, this is an artificial separation of terms that are ultimately interdependent: political representation requires and mobilizes implicit images of its constituency; aesthetic images stand in for, delegate for, a presumed referent, a "presence" (marking its absence).

31. Smith, "Parallel Quotidian Flows," 28; emphasis added.

32. Phelan, "Broken Symmetries," 112.

33. Smith and Abel, "Ka Whawhai Tonu Mātou," 6.

34. Smith, "Postcolonial Māori Television?," 724; emphasis added.

35. Smith, "Parallel Quotidian Flows," 33.

36. Ibid., 23.

37. Smith and Abel, "Ka Whawhai Tonu Mātou," 5.

38. Ibid., 8.

39. See Stephens, "Māori Television," 111.

40. Ibid.

41. Ibid.

42. Ibid. These comments about particular programs predate the arrival of MTS itself, but while some have subsequently screened on the channel, others serve to illustrate the larger role of television in the process of marketing Māori language and culture to young people. Note, too, that the term "screenagers" foregrounds the screen as the cultural milieu of significance for young people, whether Māori or non-Māori.

43. Smith and Abel, "Ka Whawhai Tonu Mātou," 6.

44. John Hartley and Alan McKee, *The Aboriginal Public Sphere: The Reporting and Reception of Indigenous Issues in the Australian Media 1994–1997* (Oxford: Oxford University Press, 2000), 4.

45. Ibid.

46. Smith gestures beyond the terms of representation when she argues that "If Māori are allowed restricted access to the institutional processes surrounding Māori broadcasting, the excessive meanings generated by television *as a medium* certainly open it up to other avenues and pathways of social mobility that have not yet been defined in institutional terms" ("Postcolonial Māori Television?," 726). However, while I agree with this point, it defers ("not yet") rather than displaces the representational process (being "defined in institutional terms").

47. Langton, *"Well, I Heard It on the Radio,"* 5.

48. Stephens, "Māori Television," 109.

49. Kirshenblatt-Gimblett, *Destination Culture,* 156.

50. Smith, "Parallel Quotidian Flows," 28.

51. Ibid., 34.

52. Smith and Abel, "Ka Whawhai Tonu Mātou," 6.

53. Smith, "Parallel Quotidian Flows," 32.

54. Ibid.

55. Ibid.

56. Ibid.

57. Stephens, "Māori Television," 110.

58. Jean Baudrillard, *Simulacra and Simulation* (Ann Arbor: University of Michigan Press, 1994), 6.

59. Ibid., 1.

60. Ibid., 16.

61. Chow has made the further observation that it is problematic "to conflate the mobility or instability of the sign with existential freedom" (Chow, *Protestant Ethnic,* ix).

62. Smith, "Parallel Quotidian Flows," 34.

63. Baudrillard, *Simulacra and Simulation*, 21. The fact that Baudrillard is making this point with reference to such events as bank holdups and airplane hijackings does not disqualify its resonance with less visibly catastrophic instances of the encoded nature of the simulated real, or hyperreal, such as cultural identity.

64. Baudrillard distinguishes between "the law [as] a simulacrum of the second order, whereas simulation is of the third order, beyond true and false, beyond equivalences" (ibid.). In *Symbolic Exchange and Death*, he glosses the second order as that pertaining to the era of industrial production, of the market law of equivalence—and thus of representation—and the third order as code-governed, according to the structural law of value, relating only to the difference/identity of the sign in the system of signification itself (50–60).

65. The notion that things happen because of television, rather than television as a medium broadcasting things that happen, is illustrated in the October 2009 U.S. case of the "boy in the balloon," a hoax that was perpetrated by his family seeking its own reality television show; and indeed media coverage of it kept television viewers transfixed to what they responded to as a true crisis and real danger to the boy, while the emergency services also responded in the full belief that it was real. Although the boy was finally discovered not to be in the balloon at all, emergency services, the media, and viewers engaged with the event—contrived for television itself—in a way indistinguishable from if he had been. The line between what was authentic and inauthentic in this "event" is thus significantly blurred. Baudrillard cites the early example of the TV verité experiment that filmed a Californian family, the Louds, documenting "its dramas, its joys, its unexpected events, non-stop," during which the family "fell apart . . . a crisis erupted, the Louds separated, etc. Whence that insoluble controversy: was TV itself responsible? What would have happened if TV hadn't been there?" (Baudrillard, *Simulacra and Simulation*, 27–28). More to the point, he asks of such TV verité—which could be aligned with the pursuit of absolute truth of representation such as that of "cultural identity" politics—"does it refer to the truth of this family or to the truth of TV? In fact, it is TV that is the truth of the Louds" (ibid., 28–29).

66. Baudrillard, *Simulacra and Simulation*, 30.

67. Ibid., 31.

68. Ibid., 32.

69. Baudrillard, *Symbolic Exchange and Death*, 2.

70. It is not uncommon to find cultural texts signifying "cyclical time" or other nonlinear, nonaccumulative modes, as part of their formal organization or aesthetic, or even thematic discourse. This, however, is not the same as the gestural action of these qualities in "social space," and in fact contributes to their status as simulacra of cultural identity.

71. Baudrillard, *Symbolic Exchange and Death*, 1.

72. Ibid., 5.

73. Ibid., 36.

11. *Māori Television, Anzac Day, and Constructing "Nationhood"*

SUE ABEL

The eleven years which have elapsed since the Hokowhitu a Tu sailed from these shores for Egypt and Gallipoli have given us the length and breadth of vision needful to estimate at its full value not only the service which our Māori people gave to their country and to their allies but also the reflex of that service on the position of the Māori as a social and political entity in the life of New Zealand.

> —Māui Pōmare, in James Cowan, *The Maoris in the Great War* (1926)

ANZAC Day is often referred to as NZ's "coming of age," well in my mind ANZAC Day 2007 was Māori TV's coming of age. Well done. Kia Kaha [be strong].

> —"John Smith" who self-defines as "born and bred very proud
> Kiwi, however unfortunately with no Māori blood,"e-mail
> to Māori Television, 2007

THESE TWO QUOTATIONS, from very different eras in New Zealand's history and from different ethnic groups, nevertheless resonate with each other in a way that provides a useful starting point for an examination of the role that Māori Television's annual coverage of Anzac Day plays both in the establishment of Māori Television as an integral part of the New Zealand mediascape and in the ongoing construction of what it means to be a "New Zealander." This examination is based on an analysis of the Anzac Day coverage in 2007, and of 312 responses that were posted to the channel's website or emailed to the channel on Anzac Day or immediately following.[1]

Anzac Day is a national day of remembrance held on April 25 every year in Australia and New Zealand. It marks the anniversary of the ill-fated landing of the Australian and New Zealand Army Corps (ANZAC) at Gallipoli in the Ottoman Empire on April 25, 1915. The Gallipoli campaign was the first major battle undertaken by the Australian and New Zealand Army Corps, and is often considered to mark the birth of national consciousness in both of these countries. When Anzac Day started in 1916, the first anniversary of the Gallipoli Campaign, a half-holiday was gazetted as a day of remembrance to acknowledge the sacrifice of that campaign, and to support grieving families.[2]

Over the years, however, its function has changed. Stephen Clarke, a historian for the Returned Servicemen's Association, says that Anzac Day today is "first and foremost about a search for identity as New Zealanders." Official websites set this out clearly: "Anzac Day enjoys unusual reverence in a country where emotional public rituals are otherwise absent. The day still has a traditional commemorative function, but for more people it is also becoming an opportunity to talk about what it may mean to be a New Zealander."[3] And further:

> Today, at a time when it seems New Zealanders are increasingly keen to assert and celebrate a unique identity, we recognise Anzac Day as a central marker of our nationhood. . . . Anzac Day now promotes a sense of unity, perhaps more effectively than any other day on the national calendar. People whose politics, beliefs and aspirations are widely different can nevertheless share a genuine sorrow at the loss of so many lives in war, and a real respect for those who have endured warfare on behalf of the country we live in.[4]

Many of the soldiers who fought (and died) at Gallipoli and in other battles in World Wars I and II were Māori. Māori members of Parliament Māui Pōmare and Āpirana Ngata, from different sides of the House, joined forces during World War I to encourage Māori to join the armed forces. They both believed that by participating strongly in the war and fighting to defend the country, Māori would demonstrate to Pākehā (white New Zealanders)[5] that they were full citizens.[6]

It is very tempting to take the excerpt from Pōmare's preface to James Cowan's 1926 book *The Maoris in the Great War* cited above and make a neat correlation between Māori service in World War I as leading to a Māori coming of age in New Zealand society, just as Māori Television's Anzac Day coverage is seen, like "John Smith" suggests, as the channel's coming of age. But on closer and critical examination, there are, as always, other stories to be told. Pōmare's statement glosses over the widespread Māori resistance to fighting what was seen as a white man's war, and fighting for the British who had confiscated so much Māori land.[7] Subsequent history also tells us that service in World War I did not automatically result in greater citizenship for Māori. For example, Māori soldiers who returned from World War I were not eligible for rehabilitation funding as were Pākehā soldiers.[8]

"John Smith'"s congratulatory remarks were posted to Māori Television's website on Anzac Day 2007, and reflect the tone of many of the other postings and e-mails of that time. These responses offer a picture of "progress to date" in the continuing search for identity as New Zealanders—a picture that suggests some hope for a more bicultural identity than has previously been the case. At the same time, however, we need to go back to "John Smith"'s endorsement and ask, "Coming of age for whom?" By April 2007, Māori Television had been broadcasting for three years. I am uneasy at the implication here that it "comes of age" when it attracts and satisfies a non-Māori audience. In both these quotations, then, there is an unnamed dominant culture that decides what "coming of age" means, and when Māori will have reached this stage. This raises questions about the role of Māori, *te reo Māori* (Māori language), *tikanga* Māori (Māori

customary lore) and, eventually, Māori Television in the domain of nationhood, New Zealand's national identity, where nations are made, not born. As Philip Rosen puts it, "to exist they must be made and remade, figured and refigured, constantly defining and perpetuating themselves. . . . Nations are cultural, discursive fields."[9] In other words, we are talking here about "nation-building," a term much loved by New Zealand politicians and bureaucrats.

The establishment of Māori Television, and its first four years of Anzac Day coverage, took place while the Labour-led government was in power.[10] This is significant because of the priority Labour gave to national identity, naming it in 2006 as one of their three key themes for the next decade. The Ministry of Culture and Heritage's *Statement of Intent for 2006–2010* states:

> Symbols can highlight very powerful features of our understanding of our nation and its culture. They provide moments of shared national connection. Examples include the Tomb of the Unknown Warrior and other memorials, Anzac Day, and the National flag and anthems. . . . Such symbols of nationhood are seen to play an important role as formal markers of our sense of heritage and identity in a time of considerable cultural diversity.[11]

The *Statement of Intent* also states: "Culture and heritage activities enhance how we are seen by the world. They assist in the recognition of New Zealand as a distinctive, creative and savvy nation; this has clear benefits in such fields as diplomacy, trade and tourism."[12] There are suggestions here of nation-branding, a concept I feel uneasy about, because it often involves the appropriation of Māori culture at the same time that the role of *tikanga* and Māori ritual in the wider public arena are acrimoniously debated, and Māori self-determination is a phrase still guaranteed to scare a majority of non-Māori New Zealand citizens.

The then Labour-led government's emphasis on culture, heritage, nation-building, and national identity played out in the legislation that established Māori Television:

> The principal function of the Service is to promote te reo Māori me ngā tikanga Māori through the provision of a high quality, cost-effective Māori television service, in both Māori and English, that informs, educates, and entertains a broad viewing audience, and, in doing so, enriches New Zealand's society, culture, and heritage.[13]

Two issues are particularly noteworthy here. The first is the tension between targeting a Māori audience and "informing, educating and entertaining a broad viewing audience while at the same time enriching New Zealand's society, culture and heritage." I discuss the implications of this below. The second is that what actually constitutes culture and heritage, and following from this, national identity, is not named here, or in any of the Ministry of Culture and Heritage publications, nor is it named in any of Māori Television's *public* documents. Following the requirements of the legislation as set out above, Māori Television set as a "Strategy Priority" in its 2007 annual report's goals such as "Focus will remain on providing quality public service broadcasting, in

both *reo* Māori and English, which contributes to national identity and pride,"[14] while in its statements of intent it has listed as a factor that impacts on its delivery of outcomes, "Broad acceptance that te reo and tikanga Māori are integral to New Zealand's national heritage and identity."[15] Similarly, Te Puni Kōkiri (the Ministry of Māori Development), Te Māngai Pāho (the funding agency for Māori broadcasting) and Te Taura Whiri i te Reo (the Māori Language Commission) all argue for the retention and development of *reo* Māori as an intrinsic part of New Zealand's (undefined) national identity and heritage (an objective that, on the one hand can be seen as worthy, but on the other as not unexpected coming from institutions with a vested interest in continued government support of *te reo*). While it is easy to understand how support for *te reo* can contribute to an *iwi* (peoples) or a wider Māori identity, it is not as easy to understand how this will contribute to national identity, unless it is taken up more widely and more seriously by non-Māori.

Also at play here (and elsewhere) is a slippage between the concepts of "nationhood" and "national identity." It is beyond the bounds of this chapter to enter fully into the intricacies and cultural politics involved in this slippage. Here "nationhood" is defined as that synthesizing force of national unity. This second definition is particularly appropriate to Māori Television's interpellation of its viewers on Anzac Day—as people of different ethnicities, who come together as one, on this occasion at least.

The situation where "national identity" is ill defined is not specific just to New Zealand, but it can be argued that in this country it means that the role Māori play in national identity and in the nation-state has been able to be safely obfuscated. The power to identify with the nation is not necessarily equally distributed among its members, especially where national difference is delineated to a globalized world, that is, as part of nation-branding. In reality, New Zealand's national identity has been largely a Pākehā construct in which aspects of Māori culture deemed acceptable to the "white majoritarian public"[16] have been inserted, to provide a sense of difference for both individual New Zealanders, and for the nation on the global stage. Parekura Horomia, the then minister of Māori affairs, inadvertently pointed to the value of this when he told the Ngā Aho Whakaari Conference in 2007, "When we celebrate our national identity, we simply cannot bypass the fact that Māori people provide the 'X-factor' that makes us unique in the world."[17] While Horomia may celebrate this, as long as the power to decide which aspects of *te ao Māori* (the Māori world) are part of "our national identity" lies beyond the control of Indigenous hands, the "X-factor" is likely to be tokenistic.

Apart from the undefined references to "national identity" by official Māori institutions, there is a decided lack of writing by Māori about "national identity," which suggests that as a concept it is seen as less relevant than "Māori identity" or "*iwi* identity." In an interview with renowned Māori historian Ranginui Walker arranged to discuss this issue, he told me, "Nationhood is a work in progress, and we have made great progress in the last 15–20 years. Once Pākehā recognize Māori as social and intellectual equals we'll be getting there."[18] While slippage occurs between "national

identity" and "nationhood," Walker's implicit definition of nationhood resonates with Māori Television's Anzac Day coverage and the responses to it. Māori Television, not surprisingly, consistently assumes that Māori are the social and intellectual equals of Pākehā. The media is, of course, a key player in transmitting ideas both about Māori social and intellectual inferiority, and about national identity. Vanessa Poihipi has connected these two sets of ideas in a discussion of mainstream broadcasting when she argues that "one way of disguising monoculturalism [is] by giving audiences the impression that we are a nation which is homogenous and egalitarian; irrespective of our cultural and ethnic differences there are commonalities which connect us all as *New Zealanders.*"[19] Anzac Day has always been one of these commonalities, and Poihipi reminds us that the rhetoric of nationhood, unity, and pride, such as that historically heard on Anzac Day, does not guarantee all our nation's members equal rights as citizens.

As with Anzac Day, Māori Television since its inception has been a key site for the construction of nationhood, nation-building, and national identity. Speaking at the first World Indigenous Broadcasters Conference held at Auckland in 2008, Waitangi Tribunal chairperson Joe Williams said:

> The demographic changes over the next generation and a half, maybe two generations mean that national identity, the success of the national project as well as the Māori project will depend on Māori broadcasting operations like Māori Television and Māori radio succeeding in being the facilitator of the interdependence between the Māori community and the wider community, being the platform on which that discussion is able to take place.[20]

Māori Television's role here, however, is not unproblematic, and we need to consider the political economy that the organization sits within. Two factors are of key importance. The first is that Māori Television was established, not out of beneficence from the government, but as a result of more than three decades of Māori agitation. Even when the then Labour-led government agreed that a Māori television station could be established, the battle was not over. Walker, in his book *Ka Whawhai Tonu Mātou*, has documented both the bureaucratic impediments and the ill will from a considerable section of the non-Māori public.[21] This ill will was fueled by continual critical scrutiny of Māori media initiatives by mainstream media, drawing on and furthering a long-established discourse of Māori inability to manage institutions and their finances, resulting in "a waste of taxpayers' money." At the same time, the opposition National Party[22] made it clear that they did not support the establishment of Māori Television, and would disestablish it when they came to power. Given such a threat and the fact that National did come into power in 2008, Māori Television has had to for its own survival establish itself as a financially viable "good citizen," and has adopted specific strategies to proffer political and public goodwill.

The second and overlapping factor is the then government's commitment to "nation-building." As noted above, Māori Television is required through its enabling

legislation to "inform, educate and entertain" a broad viewing audience and to "enrich New Zealand's society, culture and heritage" as well as meeting the needs of a Māori audience. Given Māori Television is a state-funded body, the question could be posed, what choice did Māori have in these mandates? Jo Smith has coined the term "benevolent biculturalism" to suggest the manner in which the state kindly, beneficently "gives" money to Māori Television—money that can presumably just as easily be denied if the channel does not perform in a way that pleases the state, and/or if public and political goodwill toward the channel significantly decreases.[23]

There are also questions to be asked about the extent to which Māori Television is constructing a version of nationhood that pleases its funder, the state, but that papers over past and present issues of colonialism and its legacy. Smith and I have argued elsewhere that while it is very easy to adopt a celebratory tone when talking about Māori Television, we also question, for example, to what extent might there be subtle pressures on Māori Television to present itself as "Good Māori" in order to create a sense of harmonious nationhood and sustain its own viability?[24] This is not to suggest that Māori Television is completely submissive to the state or sets out to "please" them,[25] yet at a fundamental level they are accountable to the state and thus there is an ongoing tension here. Some Māori have asked whether Māori Television should be acting as an agent of decolonization for Māori, or providing a channel for middle-class Pākehā who feel increasingly disenfranchised by the commercialism of other broadcasters, and who enjoy Māori Television's independent films, documentaries, and comparative lack of advertising.

Māori Television's coverage of Anzac Day plays a pivotal role in sustaining its viability as a "good citizen." The idea for producing all-day coverage of Anzac Day came in 2005 from Larry Parr, at that time head of Māori programming. The original plan had been to run all-day coverage of Waitangi Day, but this was rejected because Waitangi Day was seen as "quite divisive" (see chapter 9, especially Barry Barclay's notion of "contexting").[26] The rejection of Waitangi Day suggests the selection of Anzac Day was clearly intended as something that would unite audiences. Parr comments here that Māori Television was not consciously chasing a non-Māori audience, but that they definitely wanted to be inclusive. He notes that despite the fact that most Māori advances have been as a result of political or legal responses to Māori agitation, the position that Māori Television took in its programming and its promoting of the coverage was one of "being inclusive, of holding out a hand." The then prime minister, Helen Clark, visited Māori Television on Anzac Day in 2006, and Parr quotes her as saying: "Congratulations, you've done more for race relations in this country than anything I can think of in the last 20 years."[27]

Parr also comments that Māori Television "caught a tide-shift," picking up on the idea that New Zealanders had shown increasing ambivalence toward the sacrifice made by those who took part in the world wars. At the same time, he sees the Anzac Day coverage in 2006 giving Māori Television, and thus Māori, so much credibility that it basically secured the organization's position in the broadcasting landscape.[28] This is

a view supported by others. NZ on Screen, for example, states, "Māori Television has staked such a claim on Anzac Day coverage that the two have almost become synonymous."[29] Māori Television's Anzac Day coverage is now such a prominent fixture in its programming that a team is employed all year round compiling the interviews and documentaries that make up much of the day. The channel offers a text message wakeup service so that people can be up at 5:45 a.m. to catch the dawn service.

I noted above that there are tensions among Māori about what is Māori Television's primary role. For instance, at the World Indigenous Broadcasters Conference in Auckland in 2008, which I attended and took notes at, Michael Cullen, in his roles as minister of finance and minister of Treaty negotiations, addressed the topic of "what governments who invest in Indigenous broadcasting should expect from their broadcasters." Here Cullen implies that the relationship between the government and Māori Television is of a master/servant nature. There was no suggestion that Māori Television might be seen as a Treaty right for *tangata whenua* (Indigenous people of New Zealand) and a form of recompense for the role the state has played in the loss of Māori culture. One of the expectations Cullen set out was that Māori broadcasters "play a role in helping New Zealand define itself as a unified, diverse and thriving nation." The examples he gave were the *tangi* (funeral) of Te Arikinui Dame Te Atairangikaahu (the Māori queen) in 2006, and the coverage of Anzac Day.

Jim Mather, Māori Television's CEO, addressed the conference later and spoke in terms of "offering a window into the Māori world," of building an "inclusive brand," of "promoting understanding and building nationhood." Such an approach can be interpreted as providing for a Pākehā gaze, with no mention of Māori viewing and representing their world for their own sake. Later in a panel discussion Mather said, "We've gained political capital because of how inclusive we've been, and we've brought people along on the journey." This rhetoric was challenged several times, particularly by Tahu Pōtiki, former CEO of Ngāi Tahu (a South Island *iwi*), and now on the board of Māori Television. Summing up at the end of one of the days, he asked the following question, "Borne out of struggle and activism, what responsibility do Indigenous broadcasters have to remain activist, or alternatively take on the role of nation-building?" The next day, Leigh Comer, chief executive of Te Puni Kōkiri, argued: "The work Māori Television has done on Anzac Day etc. means that no political party will disestablish them."

Leaving aside for the moment the voices questioning the role of Māori Television (and implicitly, its Anzac Day coverage), what is it about this coverage that elicits such approval? Perhaps surprisingly, it is not "more of the same." The sense of national identity that has conventionally been associated with Anzac Day is based on New Zealand breaking away from an identity dependent on the imperial "motherland" and establishing a new, stronger, and independent sense of nationhood in an international arena. I want to argue here, however, that conventional forms of remembering Anzac Day, especially broadcast forms, have been predominantly Pākehā. The presence of Māori has been restricted to the occasional, too often mangled, formal address in

Māori at the beginning of a speech in English, and, of course, reference to the Māori Battalion in their role as "warriors."[30] I am not meaning to demean this role here—merely to point out the limited nature of Māori representation and involvement in conventional Anzac Day remembrances. This was especially evident in the 2007 Dawn Parade at the Auckland Cenotaph, where the only acknowledgment of Māori came when Dick Hubbard, the then mayor of Auckland, stumbled through a small *mihi* (greeting) to veterans.

Māori Television's coverage of Anzac Day constructs a very different national identity. It is also one that breaks from former colonial masters—but in this case it is *within* the nation-state. Faye Ginsburg argues that Indigenous media offers Indigenous peoples the opportunity for "the insertion of their histories into national imaginaries."[31] Māori Television inserted not only Māori histories but also *te reo Māori* and *tikanga* into its Anzac Day coverage. In 2007, as in other years, the Anzac Day coverage ran from 5:30 a.m. until concluding addresses at 11:30 p.m. Māori Television's audience ratings for the day jumped 550 percent. Responses from viewers tell of individuals and families spending all day in front of their televisions, demonstrating an overwhelming goodwill toward Māori Television and wide acceptance of the story of Anzac Day and New Zealand identity, with its strong emphasis on Māori presence, participation, and *tikanga* that was constructed in their broadcast.

A Māori presence was established from the very beginning of the day's coverage. Rather than report live from the Dawn Service at the Auckland Cenotaph, the service that conventionally takes precedence over others in broadcasting terms, Māori Television prioritized the Dawn Service at Te Papaiouru Marae[32] in Rotorua, where the service was led by the Te Arawa (a central North Island *iwi*) Returned Services League. Only after this was finished did we get a prerecorded broadcast of the Dawn Service at the Auckland Cenotaph. A Māori presence was also evident through the use of *te reo*. Co-presenter Julian Wilcox spoke in Māori as often as he did in English, and his English was usually an addition to, rather than a translation of, his address in *te reo*. A Māori presence was also foregrounded in the wide use of Māori sources telling Anzac Day stories. When such sources spoke in *te reo,* English subtitles were not always provided.

A Māori history was included not only through the comparatively large number of stories about the Māori Battalion in World War II, but also stories about Te Hokowhitu-ā-Tū, the World War I Māori contingent who were present at Gallipoli. Other stories were told by the descendants of Māori soldiers, who talked about seeing their fathers off, and what life was like at home without them. Stories like this were accompanied by footage of Māori families at the docks at Wellington farewelling their soldiers, and Māori soldiers climbing onboard ships. I do not remember seeing footage of Māori soldiers leaving before, let alone their families farewelling them. The images I had seen of Māori soldiers previously had been of the Māori Battalion at war, with the emphasis on their role as "good soldiers," indeed, as "warriors"—certainly not as members of a *whānau* (family) or *iwi*. Images of dutiful families waving goodbye to the brave husband and father were reserved for Pākehā. A continuing segment during the day's coverage was *He Tuku*

Figure 11.1. Anzac Day poster, 2007. Image courtesy of Māori Television.

Whakaaro (Letters Home), in which we saw a Māori soldier in the desert writing a letter. Each segment had a voiceover reading an excerpt from a different letter sent home by a named Māori soldier. Again, Māori soldiers are depicted in opposition to the dominant discourse, as having a personal life outside the warrior role.

I am reminded here of two observations. The first comes from Irihapeti Ramsden, who said in reference to Alan Duff's novel *Once Were Warriors*:[33] "Once were gardeners, once were astronomers, once were philosophers, once were lovers."[34] In other words, there is much more to Māori than the archetypal warrior image. The second is Stuart Hall's observation that "the 'white eye' is always outside the frame—but seeing and positioning everything within it."[35] What Māori Television provided on many occasions was a "brown eye" outside the frame, selecting and editing images. But this was not a brown eye that excluded or marginalized non-Māori, as the slogan for the day, "Nā Rātou mo Tātou" ("From them, for all of us"), suggests. This slogan is an example of both an inclusive approach and representative of a bicultural nationhood, typically absent in mainstream media. The Māori language has two different words to express different senses of "us." "*Mātou*" means "us, but not you." "*Tātou*," however, places the emphasis on "all of us"—"you and me and those over there."

One example of a Māori worldview was a dramatized insert before the screening of the Dawn Service at the Auckland Cenotaph. Two teenage Māori boys are seen kicking a ball in the concreted area around the cenotaph. An old *kaumātua* (elder) comes along and gently reproaches them. He explains that the ground around the cenotaph is *wāhi tapu* (a sacred place), that the whole area is like a *marae* with the museum behind the cenotaph seen as a meeting house. Instead of carvings, however, there are inscriptions. He reminds them that the *marae ātea* (the open area in front of a meeting house) is the realm of Tūmatauenga, the god of war.

More often, however, a Māori worldview was implicit in the tone of the coverage, especially in terms of drawing on the importance that remembering the dead plays in *te ao Māori*. As early as 1994, Patrick Day wrote in his history of broadcasting in New Zealand, "The argument for Maori broadcasting is not just about programming: it is an argument for a changed understanding of what it is to be a New Zealander."[36] One might ask, of course, a changed understanding on whose part? Again, in a classic example of the invisibility of whiteness, reference to the dominant culture is left out. Nevertheless, the 312 responses to Māori Television's Anzac Day coverage I had accessed demonstrated that Day's argument was prophetic.

Some of these responses suggested the potential of Māori Television's coverage to improve the attitudes of the dominant group toward Māori:

> I am encouraged to write to you from all of us at work. We believe that the coverage would have touched so many people and one thing that we all spoke of (in common) was how this would change the attitude of non-Māori to Māori. It can only be positive!
>
> Most of all—I was impressed with the mana [power and authority] of your presenters and your inclusion of all New Zealanders. It was this inclusion of Māori perspective, reo and tikanga that left me with a tremendous sense of pride in Aotearoa. If every New Zealander could have watched your coverage—all of it—we would all be living in a better land.

There were some who specifically nominated the Māori content ("We enjoyed the Māori content of the program") but as with the presence of *te reo*, the most significant factor here was the number who talked of the coverage as reflecting a national identity without any reference to the strong Māori presence normally absent in mainstream broadcasting. There were numerous variations on the statement "You have made me feel so proud to be a New Zealander/Kiwi." Others expanded on this:

> I saw New Zealand through my fellow countrymen's eyes and was able to better appreciate who I am and where I come from. It is with great pride that I am a New Zealander and have a wonderful heritage.
>
> It was very inclusive, very entertaining, very emotional and created a strong sense of national identity. . . . As a New Zealander it made me proud and carried me along with it.
>
> The stories were real NZ community stories and the way they were presented reflected what we are as New Zealanders.

I would argue that it is because a strong Māori presence has become more normalized, which allows these viewers to refer to national sentiment without referring to the non-discursive Māori content. Day's argument for Māori broadcasting as allowing for a changed understanding of what it is to be a New Zealander seems to be coming to pass, as these responses suggest that to some extent at least, an Indigenous voice, Indigenous history and Indigenous *tikanga* have been inserted into the national imaginary.

Given the high proportion of *te reo* in the coverage, I found it surprising that so few responses commented on this. Here is a typical example of the few who did: "I'm a 5th generation Pākehā and while at times subtitles would have been appreciated, I can understand that you wish to build your identity and preserve the Māori language." The absence of any comment about the substantial use of *te reo* in the rest of the responses, particularly among those who identified themselves as Pākehā and/or as first-time viewers, is very significant. Māori Television executives have stated that one of their objectives is to normalize and naturalize the use of *te reo*, and that certainly seems to be the case with these viewers.

Conclusion

But—and there is of course a final "but"—Māori Television's Anzac Day coverage does not mention that Māori soldiers returned home to a continuing position of inequality. For example, my Pākehā father was able to get a "rehab" farm through a government ballot after World War II, yet this option was not available for Māori ex-servicemen. While on one or two occasions the question "Why should our men go off to fight another man's battle?" was raised in the coverage, there was no discussion of this. As for other wars involving Māori and Pākehā soldiers—those that took place on our own soil—these were not mentioned. Subhabrata Banerjee and Goldie Osuri, writing in

2000 about the "whiting out" of Aboriginality in making news and making history in Australia, have said:

> Representation of the past can take many forms: narratives, monuments, commemoration, museums, coins, to name a few. Monuments to the Australian soldier, the iconographic "digger", can be seen all over the country, generally accompanied by the grateful thanks of a nation in an inscription that reads "Lest we Forget." Recent setbacks to Aboriginal land rights and the Australian government's staunch refusal to apologize to Aboriginal peoples for past injustices appear to suggest . . . that "best we forget" is a more appropriate directive when it comes to representing Aboriginal histories.[37]

In New Zealand, the prominence of Anzac Day and the strategic forgetting of the Land Wars suggest another "Lest we Forget/best we forget" scenario. Clarke has suggested that perhaps when we are mature enough as a nation we will be able to commemorate our own battles, and make pilgrimages to sites such as Rangiriri.[38] Here another "coming of age" quotation is appropriate, this time from historian Danny Keenan: "New Zealand did not come of age on the beaches of Gallipoli; it came of age on our own battlefields, like Rangiriri. The war that mattered—that forged the nation we are today—was fought on our own soil."[39] It seems, however, that these are issues that remain to confront Pākehā, and hamper a "unified nation" the state expects Māori Television to replicate. There is still, then, some way to go, more change needed in the understanding of what it is to be a New Zealander. This does not mean that Māori Television will not have a role to play here. Williams argues:

> The demographic changes over the next generation and a half, maybe two generations mean that national identity, the success of the national project as well as the Māori project will depend on Māori broadcasting operations like Māori Television and Māori radio succeeding in being the facilitator of the interdependence between the Māori community and the wider community.[40]

Williams assumes here that Māori Television will still be around in two decades to be such a facilitator. In the meantime, while Pākehā are still the dominant demographic, political, and economic group, Māori Television's Anzac Day coverage, limited as it is to foreign wars, still plays a dual role of providing the channel with political capital and of contributing to a changing sense of "being a New Zealander."

Notes

First epigraph: The name Te Hokowhitu-ā-Tu literally refers to the 140 warriors of the Māori war god, Tū-mata-uenga, but was applied to the Native Contingent who served in World War I. This group of Māori soldiers later became the famous Māori Battalion.

1. I wish to acknowledge my gratitude to Sonya Haggie, general manager of sales, marketing, and communication at Māori Television at the time of writing, for giving me access to these responses.

2. Stephen Clarke, personal communication, May 7, 2007.

3. http://www.nzhistory.net.nz/war/modern-anzac-day.

4. http://www.anzac.govt.nz/today/index.html.

5. "Pākehā" is a term used to refer to the descendants of white settlers in New Zealand. It can be controversial, with many white New Zealanders preferring to call themselves "New Zealanders" or "Kiwis." For an excellent discussion of this issue, see Avril Bell, "'We're Just New Zealanders': Pākehā Identity Politics," in *Nga Patai: Racism and Ethnic Relations in Aotearoa/New Zealand*, ed. Paul Spoonley, David Pearson, and Cluny Macpherson (Palmerston North, N.Z.: The Dunmore Press, 1996), 144–58.

6. European settlers brought with them to New Zealand an assumed superiority that led to the marginalization of Māori people, Māori culture, and Māori epistemologies, as well as "a structural relationship of Pākehā dominance and Māori subjection." Ranginui Walker, *Ka Whawhai Tonu Mātou: Struggle without End* (Auckland: Penguin Books, 1990), 10.

7. Kingitanga (the King Movement) leader Te Kirihaehae "Te Puea" Hērangi maintained that her grandfather, Tūkaroto Matutaera Pōtatau Te Wherowhero Tāwhiao, had forbidden Māori who lived in the Waikato region where the Kingitanga is centered to take up arms again when he made peace with the Crown in 1881. She was determined to uphold his call to Waikato to "lie down" and "not allow blood to flow from this time on." Te Puea maintained that Waikato had "its own King" and didn't need to "fight for the British King." If land that had been confiscated was returned, then perhaps Waikato might reconsider its position (http://www.nzhistory.net.nz/war/first-world-war/conscientious-objection/maori-objection). Tūhoe prophet Rua Kēnana was arrested for sedition for his opposition to Māori conscription in World War I in 1916. Rua's "seditious" argument was that Māori should not fight for a Pākehā king and country when Māori ancestral lands had been taken by a Pākehā government fifty years before in the confiscations in Taranaki, Waikato, and Bay of Plenty that followed the New Zealand Wars (see also chapters 4 and 7).

8. Ranginui Walker, *He Tipua: The Life and Times of Sir Apirana Ngata* (Auckland: Penguin Books, 2002), 190.

9. Philip Rosen, "Making a Nation in Sembene's Ceddo," *Quarterly Review of Film and Video* 13, nos. 1–3 (1991): 147.

10. The Labour Party is one of New Zealand's two major political parties; the other being the National Party.

11. Ministry of Culture and Heritage, *Statement of Intent for 2006–2010* (Wellington: Ministry of Culture and Heritage, 2006), 7.

12. Ibid., 9.

13. Section 8 of the Māori Television Service Te Araratuku Whakaata Irirangi Māori Act (2003).

14. Māori Television, *Annual Report* (2007), http://corporate.maoritelevision.com/LinkClick.aspx?fileticket=_kkKiSBhXmc%3d&tabid=170.

15. Ministry of Culture and Heritage, *Statement of Intent*, 8.

16. Stephen Turner, Lecture on Barry Barclay in "Māori and Media" course, Māori Studies, University of Auckland, 2009.

17. Parekura Horomia, speaking at the Ngā Aho Whakaari National Conference at Rotorua, March 23. 2007, http://www.scoop.co.nz/stories/PA0703/S00510/horomia-nga-aho-whakaari-2007-national-conference.htm.

18. Ranginui Walker, personal interview, February 23, 2009.

19. Vanessa Poihipi, "The Impact of Māori Television on Being Māori: A Geographical Approach," *MAI Review* 1 (2007): 1–21.

20. Joe Williams, "Opening Address," World Indigenous Broadcasters Conference, Auckland, March 26–28, 2008.

21. Walker, *Ka Whawhai Tonu Mātou*, 370–77.

22. The National Party supports center-right policies.

23. Jo Smith, "Everyday Insurgencies: Māori TV and Benevolent Biculturalism," address given at the Economies of Culture/Cultures of Economy Symposium, University of Auckland, November 2006.

24. Jo Smith and Sue Abel, "Ka Whawhai Tonu Mātou: Indigenous Television in Aotearoa/New Zealand," *Journal of New Zealand Studies* 11, no. 1 (2008): 1–14.

25. Sonya Haggie, Māori Television's general manager of sales, marketing, and communication, took umbrage at the implication in a conference paper that preceded this chapter that this might be the case.

26. Larry Parr, personal interview, June 10, 2009. Waitangi Day is commemorated in New Zealand every year on February 6 to commemorate the signing of the Treaty of Waitangi between the Crown and Māori in 1840. The occasion is often marked by protest from groups of Māori (and non-Māori allies) who wish to draw attention to the fact that many of the breaches of the Treaty by the Crown have not been addressed.

27. Without wanting to read too much into a passing comment reported secondhand, I would like to draw attention here to two matters. The first is that the notion of "good race relations" is more about tolerance than it is about equality and equity. The second is that such a comment seems particularly ironic coming from the leader of a government that passed the Foreshore and Seabed Act (2004).

28. Māori Television was successful in its bid (with funding from Te Puni Kōkiri) for the rights to broadcast the Rugby World Cup. An editorial in the *New Zealand Herald* on October 4, 2009, supported this bid, partly on the basis of the wide acclaim the channel received for its coverage of Anzac Day.

29. NZ on Screen is a website that makes available a wide range of New Zealand television programs and films. It is funded by New Zealand on Air, which also funds television programming with local content. http://www.nzonscreen.com.

30. The notion of Māori as warriors is ambivalent. On the one hand, it is generally acknowledged that Māori excelled as warriors both in inter-*iwi* warfare and later as part of the Māori Battalion in the two world wars. On the other hand, it is argued by some that Māori have a "warrior gene" that makes them more susceptible to violence than non-Māori.

31. Faye Ginsburg, "Embedded Aesthetics: Creating a Discursive Space for Indigenous Media," in *Planet TV: A Global Television Reader*, ed. Lisa Parks and Shanti Kumar (New York: New York University Press, 2003), 315.

32. A *marae* is an area of land and buildings (meeting house, dining hall, and forecourt for orators) typically owned by a *whānau* (family in the widest sense) or *iwi* (people). It is the most common place for Māori gatherings to take place.

33. *Once Were Warriors* is the bestselling first novel of New Zealand author Alan Duff. Published in 1990, it tells the story of an urban Māori family, the Hekes, and portrays the reality of domestic violence in the Heke family. Although his mother is Māori, Duff and his book are both seen as anti-Māori by many. Duff has said that he wants to "push both Maori and Pakeha liberals into shaming Maoris into taking responsibility for their own actions and own families." http://quote unquotenz.blogspot.co.nz/2010_07_01_archive.html.

34. Taonui, Rawiri. "Ngā tuakiri hou—new Māori identities—Urban identifiers," *Te Ara*—the Encyclopedia of New Zealand, http://www.TeAra.govt.nz/en/nga-tuakiri-hou-new-maori-identities/page-2.

35. Stuart Hall, "The Whites of Their Eyes: Racist Ideologies and the Media," in *Gender, Race and Class in Media: A Text-Reader*, ed. Gail Hines and Jean Humez (Thousand Oaks, Calif.: Sage, 2003), 92.

36. Patrick Day, *Voice and Vision: A History of Broadcasting in New Zealand* (Auckland: Auckland University Press, 1994), 272.

37. S. B. Banerjee and G. Osuri, "Silences of the Media: Whiting Out Aboriginality in Making News and Making History," *Media, Culture & Society* 22, no. 3 (2000): 263–84.

38. Clarke, e-mail communication, May 7, 2006. Rangiriri was a key battle site during the New Zealand Land Wars (1840s through to the 1870s). The Māori pa (fortified village) at Rangiriri incorporated many innovative techniques, and its skillful engineering made a strong defensive line that physically blocked the advance into the Waikato area by British forces on November 20, 1863. While Māori fared better than the British in the actual fighting, both sides suffered heavy casualties and Māori in the end lost the battle because they were outnumbered three to one. There is now a Heritage Centre at the site.

39. Danny Keenan, "We Came of Age on Battlefields of New Zealand," *New Zealand Herald,* http://www.nzherald.co.nz/nz/news/article.cfm?c_id=1&objectid=10378631.

40. Williams, "Opening Address."

12. Indigeneity and Cultural Belonging in Survivor-*Styled Reality Television from New Zealand*

JO SMITH AND JOOST DE BRUIN

THIS CHAPTER EXAMINES the different ways in which two recent New Zealand television programs draw upon global reality television formats to articulate discourses of indigeneity and cultural belonging in New Zealand. By examining how the TV3 outdoor challenge program *The Summit* and Māori Television's language competition program *Waka Reo* share aspects of the American reality television show *Survivor,* this chapter investigates the ways in which global television formatting can illuminate the specificities of local discourses of indigeneity. As this chapter demonstrates, claims to indigeneity remain a contested terrain, due to the usurpation of *iwi* (tribes) Māori settlement by processes of British colonization. If, as Laura Hubbard and Kathryn Mathers argue, "*Survivor* moves across the globe, dropping Americans into differing geographies and carefully teaching them how to 'be' in relationship to themselves and the world,"[1] then what kind of lesson in cultural belonging and cross-cultural encounter does *Survivor*-styled reality television from a contemporary settler nation offer? In this chapter we argue that the contrasting style and themes of *The Summit* (a program made for a general audience) and *Waka Reo* (a show dedicated to promoting *te reo Māori*—the Māori language) reveal the intranational tensions of a nation where claims to belonging and indigeneity remain a fraught affair.

In a country where the British colonial project has given way to new forms of neo-colonization, claims to an Indigenous national identity open to all (usually framed as "Kiwi") often conflict with alternate claims to Indigenous sovereignty made by *iwi* Māori.[2] Comparing and contrasting *The Summit* with *Waka Reo* in light of the global format of *Survivor* reveals the constitutive role that global audiovisual culture plays in the production of discourses of indigeneity, localness, and New Zealand national identity. By acknowledging the productive nature of reality television (as a genre that produces, regulates, and intervenes in reality as much as it reflects existing sociocultural phenomena), this chapter identifies the mobile and mutable nature of discourses of indigeneity at play in New Zealand.

The Cultural Politics of *Survivor*-Styled Reality Television

The global dissemination of television program formatting is a key characteristic of contemporary television industries with the U.S. program *Survivor* perhaps one of the keenest examples of how a television format can proliferate and be dispersed across the globe.[3] Discussing recent developments in television, Silvio Waisbord suggests that two trends characterize contemporary conditions and involve "the globalization of the business model of television and the efforts of international and domestic companies to deal with the resilience of national cultures."[4] Waisbord's subsequent discussion highlights the ways in which global and national media interact in complex and contradictory ways. Noting how contemporary television brings questions of economics into close proximity with questions of cultural and national identity, Waisbord argues:

> Contemporary television is a Janus-faced industry that in the name of profitability needs to commodify real and imagined nations while being open to global flows of ideas and money. . . . Formats reflect the globalization of the economics of the television industry and the persistence of national cultures in a networked world. They make it possible to adapt successful programs to national cultures.[5]

For Waisbord, global television formats are the perfect vehicles for disseminating cultural values that transcend the national (for example, consumer culture) while at the same time provide generic features that can become "customized to domestic cultures." As we shall see, critiques of the *Survivor* television format have focused on its commodification of local and national cultures and the program's celebration of the global project of capitalism. However, Waisbord's attention to the diverse flows between economics and culture and between global and local dynamics complicate any one-way approach to the power dynamics of this program. That is to say, we are mindful of the easy critique of U.S. imperialism that one could make of Mark Burnett's *Survivor* and of how less attention is paid to the ways in which local uses of a global format might reveal differing power formations such as those that perpetuate and resist other forms of neocolonialism. We will, therefore, investigate how two reality television programs from New Zealand "splice together" aspects of the *Survivor* format in ways that reveal the push/pull power dynamics of contemporary television.[6]

The *Survivor* format involves selecting a range of competitors who will provide good televisual drama and spectacle. These competitors are placed in a foreign environment, divided into two tribes (the names of which utilize local knowledges), and asked to perform particular challenges and trials. The aim of the game is encapsulated in the show's slogan, "Outwit, Outplay, Outlast," and contestants compete to win USD$1 million. The "survival" theme of the series echoes the castaway narratives of books such as *Treasure Island* and *Swiss Family Robinson,* and critics have identified the ways in

which the program reiterates forms of nineteenth-century travel writing and colonial fiction[7] as much as the "survival of the fittest" ideologies that are so in keeping with U.S. cultural celebrations of the individual.[8] To maintain these castaway narratives of being lost in the realm of nature, the *Survivor* crew must clear away unwanted signs of habitation (culture) in order to render the landscape as pristine and uncontaminated. As such, the depiction of landscape and nature in *Survivor* is a crucial signature of the show as underscored by the opening of the episodes and the often-utilized cut-away shots to crawling insects or predatory beasts that are used as visual cues to emphasize the drama between contestants. Accordingly, some critics are interested in the way in which the popularity of *Survivor* (the series is now into its twenty-fourth season) reveals something about the nature of contemporary forms of U.S. imperialism.

Anyone viewing *Survivor* for the first time would be struck by the way a group of U.S. citizens get to play "native" on a game show dedicated to capitalist outcomes (the prize of USD$1 million dollars). From the faux "tribal councils" where contestants get to vote each other out, to the tribal names assigned each group and the competitions that draw on Indigenous practices, *Survivor* incorporates local cultural characteristics into its televisual system to act as the exotic mise-en-scène for the different cycles of the show. The rules of the format (participants interpolated as castaways and therefore exposed to a landscape made "natural" by technological intervention) produce the U.S. subject as "native" by simultaneously invoking and then modulating all signs of the local. This process of incorporation is made manifest in the aesthetic dimensions of each show. As Kathleen Riley notes,

> island crafts and cultural practices were belittled as they were used essentially as props in contest "challenges" and that tribal chants were synthesised into background music on *Survivor: Marquesas*. Their presence was manipulated to meet the needs of programme-makers to such an extent that even the landscape was digitally remastered to obscure signs of prior human occupation.[9]

Due to these techniques that remaster (digitally or otherwise) the local landscape and cultural practices, much has been made of the U.S.-centric nature of the series. Discussing *Survivor Vanuatu,* its titillating reference to the history of cannibalism in Ni-Vanuatu, and its dressing up of local people to look savage, Lamont Lindstrom argues that *Survivor* speaks to a U.S. audience and to U.S. cultural themes where the "survival of the fittest" discourse must be understood in the context of neoconservative U.S. politics. As such, cultural imperialism is valorized in the show.[10] While these critiques offer up an analysis of how Western imperialism is repackaged and reproduced under contemporary conditions, such approaches risk overlooking the ways in which global television formats are also shaped by "the pull of local and national cultures."[11] What of the complex and contradictory movements of power noted by Waisbord as characteristic of contemporary television culture? How does one offer up a critique of

Survivor-styled television that looks at how local uses of the format might express and enable other forms of cultural negotiation?

Better Living through Reality TV goes some way toward offering an analysis of the complex power dynamics of contemporary television. In this book Laurie Ouellette and James Hay treat reality television as a cultural technology that provides a potential map or set of rules, relations, and constraints through which we can learn to conduct ourselves as productive and useful citizens in a neoliberal economy.[12] Focusing on U.S. reality television, the authors state, "We examine reality TV's relationship to ideals of 'governing at a distance' and consider how reality TV simultaneously diffuses and amplifies the government of everyday life, utilizing the cultural power of television."[13] For Ouellette and Hay, reality television functions as a "civic laboratory" where the experimentation with rules and regulations as much as the expression of norms are a salient aspect of the televisual system. As such, their book seeks to understand the conditions of reality television that test and demonstrate "the government of the self in relation to current political rationalities."[14]

Discussing *Survivor* specifically, Ouellette and Hay label it a reality television program dedicated to "group governance," a form of television that exploits the productive tensions between a group-directed ethos and "effective self-actualization" to reveal the contemporary conditions of U.S. society as well as a larger global economy.[15] The key trick (or conduct) for any *Survivor* contestant is to balance out participation as a group member of the various collectives with exceptional individual prowess, which will ultimately convince their peers that they are worthy of the financial reward at the end of the game. This is the crucial tension of the *Survivor* show, but also a valuable quality for any neoliberal citizen.[16]

Ouellette and Hay's approach to reality television as a "civic laboratory" offers us a way of critiquing *Survivor* that is based on an analysis of the microlevels of power and the pedagogical dimensions of the show's format (its DNA, if you will).[17] As such, Ouellete and Hay's approach demonstrates how the power relations of U.S. cultural imperialism are distributed across a range of fields and flow in diverse directions. Once the DNA of the *Survivor* format (its peculiar style of governmentality) is recombined by a national television producer, we have the opportunity to examine how a global television format is transformed by the pull of the national and how "the government of the self" operates in relation to the "current political rationalities" of a contemporary settler nation.

Survivor-Styled Neoliberalism and Settler Governmentality in *The Summit*

As Ouellette and Hay note, *Survivor* is a game of group governance that is performed far away from the participants' own neighborhood and is therefore an extreme metaphor of television's ability to govern at a distance.[18] We are reminded of Hubbard and Mathers's argument that *Survivor* teaches the United States "how to 'be' in relationship to themselves and the world."[19] Accordingly, *Survivor* can be seen as a lesson and

form of governmentality that disseminates a specifically U.S. neoliberal ethos in exotic locations. The task of this chapter is not to unpack how *Survivor* reveals the contradictions of U.S. global hegemony but rather to examine how New Zealand uses of *Survivor*'s format reveal peculiar forms of televisual governance.

Just as *Survivor* celebrates a particularly U.S. neoliberal subjectivity, so too New Zealand television content expresses a wider political and economic reality shaped and honed by neoliberalism. The New Zealand government's economic reforms of the 1980s have left an indelible mark on contemporary television culture.[20] New Zealand television broadcasters operate within an environment of competing claims that seek to balance out commercial imperatives with more culturally inflected requirements, such as the need to reflect the nation's identity via local content. Reality television provides a solution to these tensions by offering a proven television format tested on the global market, which can be customized for a national and local market.[21] Commenting on the early days of New Zealand reality television, Misha Kavka notes how the genre has been largely a *Pākehā* (white New Zealanders) dominated one.[22] Focusing in particular on the popularity of real estate reality programs such as *Location, Location, Location* (1999), Kavka suggests that reality television is a ratings success due to its ability to offer a strong sense of cultural place to a national audience.[23] According to Kavka, this early period of reality television in New Zealand offers a sense of cultural belonging that perpetuates "the white reconstruction of nation and the naturalisation of habitat."[24] Kavka's claims derive from the "make-over" logic of these reality programs, and their valorization of physical and creative labor, "Kiwi" ingenuity and the quarter-acre myth of New Zealand land ownership. Kavka, along with Stephen Turner, extends the "make-over" and "do-it-up" logic of contemporary settler identity in a discussion of Peter Jackson's *Lord of the Rings* trilogy. Discussing the use of prosthetics, digitally enhanced landscapes, and the double-branding of New Zealand as Middle-Earth, and Middle-Earth as New Zealand, Turner and Kavka argue that settler identity has always been based on a "make-over" logic that refuses to acknowledge an Indigenous presence, a presence subsequently displaced by colonization:

> This fundamental and originary misrecognition is the historical basis of a political economy of [settler] identity. For the ideal condition of a viable economy in this part of the world is a place and history that can be made-over, reconstructed at will, to meet the demands of larger markets. The real place and real peoples that settlers encountered had to be misrecognised for their settlement to take place, so that the place could be made available for the investment of others' interest in it.[25]

Taking Turner and Kavka's critique seriously, reality shows such as *Mitre 10 Dream Home* (a home renovation show) and *My House, My Castle* (a show addressing issues of home ownership) can be understood as televisual forms of settler governmentality that attempt to naturalize (we could say, indigenize) the Pākehā settler subject within

the nation's landscape, a process of naturalization that privileges a settler-styled ethos at the expense of other ways of knowing, being, or becoming *within* the nation.[26] Perhaps we can see this settler ethos most dramatically in those New Zealand reality television shows that borrow from the *Survivor* format. That is to say, the makeover logic of settler identity finds its echo in the "going-native" techniques of the *Survivor* format that simultaneously invoke and erase signs of the local or Indigenous presence in order to secure the participants' involvement in the game. New Zealand reality television programs such as *The Summit* share a similar "going-native" logic to that of *Survivor* in their use of the local landscape as a backdrop for defining the New Zealand national subject, thereby carving out a space for an Indigenous national identity open to Pākehā New Zealanders. The tension between group governance and individualism is also a key feature of *The Summit* and perhaps provides an opportunity to examine a particularly settler-styled neoliberal logic at play in the contemporary settler nation. After completing our analysis of *The Summit,* we will turn to Māori Television's *Waka Reo* to explore how Indigenous cultural producers have drawn on the *Survivor* format to articulate quite different claims to indigeneity.

The TV3 series *The Summit* (2005) is one part *Survivor,* one part *Fear Factor,* and one part *The Amazing Race. The Summit* is set in the landscapes of the South Island of New Zealand. The narrative of the show revolves around a series of mental and physical challenges. Similar to *Survivor,* participants live, eat, and sleep together at a base camp, which is located on the shores of an alpine lake. Over the course of the ten episodes contestants face a series of orchestrated challenges, endure adverse weather conditions, and are voted out one by one. The sole survivor wins an all-terrain car (supplied by one of the sponsors of the show) by being the first to reach the summit. As in *Survivor,* and comparable to *Waka Reo* as we will discuss later, narrative tension is structured around contestants conducting themselves simultaneously as members of a community *and* as individual contestants bent on winning the competition.[27] While the challenges require group collaboration, James Gemmel, the host of the show, reminds us in every episode: "Only one can reach the summit." As a "better guide to living" (in Ouellette and Hay's terms), we could say that *The Summit* has a neoliberal ethos similar to that of *Survivor,* where the tensions between community and individualism must be constantly negotiated and yet where individualism wins out in the end. There are crucial differences between the two shows, however.

Where *Survivor* is a game of group governance that is performed offshore from the United States (and coming soon to a location near you), *The Summit* features local participants who are "cast away" *within* their home nation. According to promotions for the show, participants are "real New Zealanders" as well as "men and women from all over the country and from all walks of life." As with most reality television programming, *The Summit* emphasizes the participants' "knowability" as citizens. The sense of belonging to a generic sense of "nation" is underscored when regional and ethnic

identities are elided in the individual introductions to each contestant, with only their name, age, and profession mentioned explicitly. Accordingly, this notion of "real New Zealanders" is strictly orchestrated, regulated, and deployed along the lines of established myths of New Zealand settler identity. One such myth is that of the South Island, a rural and alpine landscape that is consistently invoked in advertising campaigns selling New Zealand to international markets as well as to New Zealanders at home.[28] One could say then, that where *Survivor* throws its participants into a highly mediated and technologized "natural" environment, *The Summit* confronts its contestants with their own mythology of national identity. Cast away, within the alpine interiors of the nation's South Island space, these "real" New Zealanders must face a landscape that is framed as foreign, adverse, and alienating.

The South Island landscape in *The Summit* is presented as vast, daunting, and empty.[29] In episode one, it is referred to as "an alien environment" that the contestants will come to know well. In promotion material for the series it is referred to as "the most rugged and spectacular terrain that New Zealand has to offer" and also "somewhere between heaven and hell." As if to underscore the sublime, spectacular, and inhuman dimensions of this landscape, each episode begins with speed-ramped shots of the mountain ranges, valleys, and open spaces upon which contestants will test their limits. Apart from a freight train running through the landscape (itself a symbol of colonial development) and a road, there are no visible signs of human presence in these opening shots. The only people visible are the ones participating in the show. A sense of emptiness is reinforced by, for example, footage shot from a plane flying over the landscape, images of the host of the show announcing the next challenge while standing in front of a vast and seemingly "empty" valley, and shots of the contestants in action in the rugged landscape. This sense of isolation plays a crucial role in underscoring the "castaway" elements of the show and in highlighting the necessary skills and courage that the contestants will need to "master" this environment. Not only relevant to the rules of the reality television game, the empty and alien South Island landscape (and the contestants' ability to "tame" this landscape) revisits common tropes of colonization (landscape as tabula rasa for ongoing acts of settler-styled indigenization) and national identity (the pioneering male spirit).[30] This representation of the South Island landscape is in direct dialogue with *Waka Reo,* as will become apparent below.

Jennifer Bowering Delisle points out that when *Survivor* contestants take on tribal names derived from the location of the shoot, when they interact with, and perform, local and Indigenous rituals, they take on the status of a new native; a nativity that can be located somewhere between that of a colonizer and the colonized.[31] Crucially, this native-status is manufactured, manipulated, and dependent upon the simultaneous invocation and erasure of prior Indigenous practices and people. In *The Summit,* the emphasis placed on an anonymous alpine landscape as the backdrop to the

competition denies the possibility of using Indigenous or tribal names to distinguish these teams of "real New Zealanders." To give these teams Indigenous names would be to acknowledge the presence of the South Island as an already peopled place (instead, the two teams are given the names "Taurus" and "Orion," which refer to constellations in the southern hemisphere). Rather than draw upon local *iwi* knowledge, the "local and Indigenous rituals" that *The Summit* offers come in the form of an outdoor sports expert, the "New Zealand multi-sport legend" Steve Gurney. Gurney is well known in New Zealand for winning the Coast to Coast race (a race from the West Coast to Christchurch on the east coast of the South Island that includes running, cycling, and kayaking) a record nine times. He embodies many of the traits seen as typical of Pākehā masculinity, such as humbleness, toughness, and "Kiwi" ingenuity. Throughout the show, Gurney introduces the tasks that the contestants have to compete in and explains the dangers at hand. He thereby reinforces the idea that conquering the landscape requires particular knowledge and skills. Gurney's national sport celebrity status, coupled with his obvious outdoor knowledge (which he makes a point of conveying to the show's audience) underscores the pedagogical dimensions of *The Summit*. To be at home in this landscape—to confront and conquer these physical and mental challenges—one must tool-up, so to speak, on settler myths of national belonging that valorize a combative relationship to the landscape, an ability to manage a group, and the individual resilience to prevail in the end. Yet, perhaps this is an unconvincing lesson for subjects of the contemporary settler nation?

Landscape in *The Summit* plays a central role in consolidating the rules of engagement that have become a generic aspect of *Survivor*-styled programming. At the same time, this treatment of landscape makes a direct appeal to the mainstream New Zealand audience and its knowledge of national myths of belonging; an appeal that perhaps ultimately fails. That is to say, the contestants are asked to physically inhabit a landscape whose image has been overdetermined by the early New Zealand film industry, the publicity films of the New Zealand government, and the ongoing international advertising campaigns that promote New Zealand's natural resources. The program draws heavily on Gurney's embodiment of Pākehā masculinity in preparing the audience for an encounter with an alpine wilderness. His direct-to-camera addresses dwell on the specialized skills one needs to survive in this difficult environment. One can perhaps foresee then that this encounter between "real New Zealanders" and established myths of the nation is doomed to fail. In the final episode of *The Summit*, it is clear that the remaining contestants are very happy to leave base camp to go home to their families and enjoy the comforts of middle-class life. Most of them seem worn out by the landscape they were meant to have conquered. Unlike most *Survivor* contestants, the people participating in *The Summit* do not seem very confident about their efforts. The runner-up of the contest talks repeatedly about how bad he is at the assigned tasks. In the end the logic of *The Summit* is one in which all the participants, except one, are set up to fail

at the central premise, which is conquering the land. After the contest is finished contestants are expelled from the spectacular scenery that surrounds them and the land is left seemingly empty—empty, that is, if we follow a settler-styled approach to the landscape.[32]

If, as Waisbord argues, contemporary television is a "janus-faced industry" that commodifies "real and imagined nations" at the same time as incorporating "global flows of ideas," then *The Summit* reveals an imagined community no longer convinced by its own mythologies. As a guide to "better living" for those members of a contemporary settler society, *The Summit* provides a lesson in cultural commodification; a lesson that underscores the need for ever newer and improved forms of imagined communities that take into account contemporary conditions of cultural belonging. Coming as it did, one year after the launch of the Indigenous Māori broadcaster, Māori Television, one could say that *The Summit* offers a nostalgic form of national belonging superseded by other forms of televisual governance.

Indigenous Television and Emerging Forms of Televisual Governmentality

Since Kavka's 2004 analysis of New Zealand reality television programming there has been a boom in Māori reality television initiated by the emergence of New Zealand's first Indigenous television broadcaster, Māori Television. As a new broadcaster that must build an audience, reworking established global television formats is a pragmatic technique. The popular *Kai Ora* (healthy food) and *Kai Time on the Road* rework the cooking show genre to showcase Indigenous resources and ways of sharing food. For those of the right generation, the Māori agony-aunt program *Ask Your Aunty* (and its twin, the agony-uncle show *Whatukura*) can be seen as an Indigenous echo of the much earlier *Beauty and the Beast* hosted by well-known New Zealand media celebrity Selwyn Toogood. In terms of the reality television genre, *Mitre 10 DIY Marae* is perhaps the best example of how an Indigenous cultural producer reworks mainstream "realty" shows (to quote Kavka) to reveal the rules and regulations that inform a sense of place and identity. *Mitre 10 DIY Marae* involves a makeover of a *marae* (the land and buildings that a Māori affiliates with genealogically), its stated purpose being to achieve the *marae*'s five-year development plan in a few days. While *Mitre 10 DIY Marae* follows the format of a home renovation series, *Waka Reo* has become the most prominent example of a reality show influenced by the *Survivor* format.

Perhaps trading on the global popularity of *Survivor,* the producers of *Waka Reo,* Ngāi Tahu Communications (Ngāi Tahu, or Kāi Tahu in southern dialect, is a South Island *iwi*), used *Survivor*-styled formatting to attract its target *rangatahi* (youth) audience.[33] In the first season (the series ran between 2005 and 2008) fourteen contestants are "stranded at a remote South Island marae" where they must battle to be the best at learning *te reo Māori* (the Māori language) and thus win NZD$10,000.[34] There are

physical challenges as well as language-based competitions that test the participants' learning abilities. Isolation and the need to learn to live with others are constant themes in *Waka Reo* that echo those of the *Survivor* series. Yet, as with *The Summit*, both shows inflect these global format techniques of isolation and discomfort with local characteristics. In the promotional material circulated to encourage young executives to sign up for the lifestyle challenges of the fourth *Waka Reo* season, the following pitch drew on common tropes about New Zealand's outdoor culture as a site of simplicity, endurance, and down-to-earth values: "There's no flash office or funky cafe to brainstorm in, no designer gear to impress, no gyms to unwind in—and definitely no sushi or flat whites. Instead, there are anoraks, mattresses, sleeping bags, home-cooking, living with strangers—and lots of reo Māori."[35] Instead of a group of young executives, the fourth season resulted in a somewhat different line-up of contestants (see below); yet there is no mistaking Māori Television's use of common understandings of urban/rural divisions to appeal to its potential demograph.[36] If we follow the lead of Ouellette and Hay and treat reality television as a cultural technology that provides a potential map for "better living," what form of governance or "better living" does *Waka Reo* provide for Māori and non-Māori subjects of a contemporary settler nation? To answer this question, we need to provide an outline of the conditions surrounding the program's production.

Figure 12.1. Still from *Waka Reo* (Christchurch: Ngāi Tahu Communications Ltd., 2007). Reproduced with permission of Ngāi Tahu Communications Ltd.

A 2003 Act of Parliament established Māori Television and sets out its core objectives, which are, among others, to promote the cultural revitalization of *te reo* and *tikanga Māori* (Māori customary lore). The Act states:

> The principal function of Māori Television is to promote te reo Māori me ngā tikanga Māori through the provision of a high quality, cost-effective Māori television service, in both Māori and English, that informs, educates and entertains a broad viewing audience, and, in doing so, enriches New Zealand's society, culture and heritage.[37]

The outcome of years of political activism for Māori to gain access to media systems of representation, Māori Television represents a bicultural system of governance that recognizes the rights of Māori as enshrined in the 1840 Treaty of Waitangi.[38] As such, state-sanctioned systems of governance regulate the core objectives of Māori Television, while the broadcaster remains a powerful vehicle for depicting and disseminating an Indigenous view of the world.[39] As the 2003 Act overtly states, Māori Television is to be an educator and entertainer of a broad range of citizens, and reality television programming on Māori Television helps to diffuse and amplify (in Oulette and Hay's words) "the government of everyday life."[40] The cultural power of Māori Television operates in a complex range of ways including a dual address to the nation that recognizes the need for group empowerment (the promotion of Māori language and culture) at the same time as it responds pragmatically to New Zealand's neoliberal economic climate and the role of the individual and processes of self-empowerment. *Waka Reo* best encapsulates these tensions.

There can be no doubt that *Waka Reo* is a provocative project, one initiated by one of the most prominent *iwi* in New Zealand.[41] The objectives of Māori Television are to promote Māori language and culture; a project of group empowerment. *Waka Reo* pursues these group-oriented objectives using a *Survivor*-styled format based on a "survival of the fittest" logic. Commentary surrounding *Survivor,* as we have outlined earlier, also charges the show with perpetuating U.S. imperialism and impacting negatively on the native environments it comes into contact with. Accordingly, how does *Waka Reo* rework a U.S.-centric global television format in ways that advance the mandate of Indigenous cultural revitalization? We would suggest that the show exploits the contradictions of the U.S. show (the tension between group governance and self-empowerment) to formulate a *Survivor*-styled reality show that still advances the cultural aims of Māori Television. We can see this in *Waka Reo*'s treatment of the landscape, in the central role of language in linking land and people together, and in *Waka Reo*'s dual address to the nation as a whole as well as to Kāi Tahu specifically.

Promotional discourses surrounding *Waka Reo* draw on assumptions surrounding the New Zealand nation including the settler myth of the South Island sublime (for example, the website descriptor of contestants "stranded at a remote South Island marae"). In the quote above, the cold climate of the South Island is again invoked by

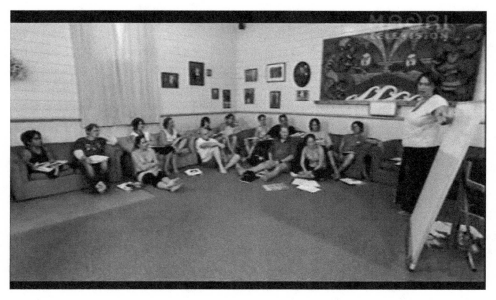

Figure 12.2. Still from *Waka Reo* (Christchurch: Ngāi Tahu Communications Ltd., 2007). Reproduced with permission of Ngāi Tahu Communications Ltd.

the reference to anoraks, and the structural paragraph distinction between urban pleasures and rural hardships ("flat whites"—a type of coffee—and "sleeping bags") suggests an implicit separation between the urban areas of New Zealand (most often North Island cities, such as Auckland) and the rural wilds of the South Island.

One might argue that there is a dimension of ironic self-reflectivity in the reference to being "stranded at a remote South Island marae" that implicitly criticizes North Island *iwi* stereotypes of Kāi Tahu. However, the use of national and settler-styled images and ideas about New Zealand are given prominence, with the emphasis placed on how contestants must live with strangers for the duration of the competition. Rather than accentuate the cultural dimensions of life on a *marae* (where the ritual of encounter between *tangata whenua* [hosts] and *manuhiri* [visitors] takes place), this promotion accentuates the separation and isolation one might feel by having the chance to live in simple conditions (on mattresses, in sleeping bags) among strangers. In this generic address to potential contestants, one witnesses the nation-building agenda of Māori Television and Ngāi Tahu Communications where it is not only Māori who are invited to participate in *Waka Reo* and the onscreen life of Māori Television, but New Zealanders in general. This general appeal was pushed to its limits when the fourth season of *Waka Reo* included Nur/Koa and David/Kaha, both of whom are migrants to New Zealand and who speak English as a second language.[42] In a sense then, *Waka Reo*'s use of settler mythology in its promotional discourses produces a broad appeal that reveals something about the cultural power (television as a cultural technology) behind *Waka Reo*.

While the promotional discourses surrounding *Waka Reo* may draw on national myths of the South Island sublime, the actual content of the series treats the landscape in ways significantly different from that of *Survivor* or *The Summit*. Indeed, *Waka Reo* can be read as a specifically Kāi Tahu epistemic expression; an initiative that speaks back to the common misconceptions surrounding the South Island as a non-Māori space.[43] To underscore the importance of Kāi Tahu places and people, the first episode of each new series presents the ritual of encounter and welcome between contestants and *tangata whenua*.[44] Along with this technique, which promotes Kāi Tahu *marae* and local people, the competitions and language tests undertaken by contestants include details of the local environment as well as local place names. Given the dearth of representations of specifically Kāi Tahu ways of being on television, the importance of screening South Island *marae* and Kāi Tahu locations cannot be underestimated. Indeed, *Waka Reo*'s original producer Whetū Fala notes that "*Waka Reo* was deliberately set in Te Waipounamu [South Island] and on [Kāi] Tahu marae to be a 'visual postcard of home' for [Kāi] Tahu who live outside of the rohe [place]. The creation of jobs for local people has also been a consideration."[45] This emphasis on *Waka Reo* as a "visual postcard of home" suggests that televisual representation (and the work that goes on behind the onscreen space) offers a productive form of cultural revitalization for Kāi Tahu and that this positive effect occurs alongside—and even in spite of—the successes and failures of the onscreen contestants.

Influenced as it is by the *Survivor* format, *Waka Reo*'s form of televisual cultural revitalization attempts an uneasy balance between individual competition and the more group-oriented norms of a communally based culture. Perhaps the most contentious aspect of *Waka Reo* is its prize of NZD$10,000, a goal that promotes individual competitiveness above the cultural value of *whakawhanaungatanga* (building familial relationships) and *manaakitanga* (hospitality, kindness), which are values that underpin other Māori language-learning systems.[46] In the fourth season, the tension between group empowerment and individuality became a drama point when one contestant (the sole remaining girl, Rongo (a.k.a. Kelly Barry) helped her classmates with their language learning only to get third place in the physical challenge and thus be nominated for elimination. Rongo subsequently withdrew her support for the others and concentrated on winning the prize money. Yet, the language strategies underpinning *Waka Reo* are based on a pragmatic understanding of the world in which *rangatahi* must participate; a world where NZD$10,000 is an attractive prospect and something that can jumpstart careers, families, or education. At the time of writing, the winners of the first three seasons all have *iwi* alliances and all continue to use the language in their everyday lives. Two of the finalists are involved in the education system.[47] The pedagogical function of *Waka Reo* is not restricted to the winners of each season, as Fala notes when she writes, "By the end of the third series we had achieved the following: 39 Māori rangatahi, 1 German, 1 Englishman and 1 Samoan had participated in the show and had learnt te reo."[48] Fala also reminds us that Ngāi Tahu Com-

munication's television language-learning system feeds in to a larger and longer language strategy developed by the *iwi*:

> Waka Reo was created for [Kāi] Tahu rangatahi to have aspirations to learn Te Reo and to use it as an everyday language. Te Reo used as an everyday language is key to its survival. It is encapsulated in the Tahu reo strategy of "Kotahi Mano Kaika, Kotahi Mano Wawata" in which they hope to have 1,000 Kai Tahu homes speaking te reo by the year 2025.[49]

More than a teaching tool for the participants alone, the cultural power of *Waka Reo*, as televisual practice, brings the challenge of learning a new language and the challenge of living with others into the homes of a variety of citizens. If *Survivor* teaches the United States how to "'be' in relationship to themselves and the world"[50] then *Waka Reo*, as *Survivor*-styled Indigenous television, demonstrates the rules of a social system informed by not only *matauranga Māori* (Māori knowledge), and in particular Ngāi Tahutanga (Kāi Tahu lore) but also the current political and economic realities of postcolonial Aotearoa/New Zealand. By demonstrating these tensions onscreen, *Waka Reo* raises some interesting questions about the future shape and contour of New Zealand cultural politics.

Conclusions

If the producers of *Survivor* throw their U.S. contestants into exotic locations throughout the globe, participants of *The Summit* are cast away *within* their home nation. Where *Survivor* constructs a mythic and highly mediated world of untouched and exotic nature, *The Summit* confronts its participants and television audience with a highly mediated myth of New Zealand national identity, one that privileges the South Island as an unoccupied landscape where settler myths of ingenuity, physical toughness, and "expert" outdoor knowledge can be tested. *The Summit* thus perpetuates a myth of the settler subject as a new native: a subject who is neither colonizer or colonized but one born of the encounter with a foreign, and now conquered, landscape. Yet, the saliency of this mythmaking project is challenged by the sense of defeat and exhaustion expressed in the final episodes of the series—an exhaustion also registered in the fact that *The Summit* only ran for one season. The power of the myth of the settler as new native is also challenged by other television offerings, including Māori Television's *Waka Reo,* a show that expresses Indigenous strategies of cultural revitalization. If, as Turner and Kavka have argued, the latex-logic of settler identity is based upon a fundamental misrecognition of "the real place and real peoples that settlers encountered," then *Waka Reo* performs a pedagogical function when it films the South Island landscape through *iwi* eyes.

Seen through the lens of televisual governmentality, *Waka Reo* offers the settler subject (as new native), as much as Māori, a guide to "better" living within a

postcolonial nation such as New Zealand. Treating the television series as a "visual postcard" of a South Island *iwi* presence, *Waka Reo* reminds the new native subject of the longer history of settlement and of the palimpsest nature of the New Zealand landscape. More than this, *Waka Reo*'s emphasis on prize money and individual competition dramatizes the necessity of conducting forms of cultural revitalization that address the neoliberal consciousness underpinning this society, a consciousness that affects both Māori and non-Māori. Set alongside *The Summit, Waka Reo* highlights the need for new images of national belonging based upon forms of cohabitation that register this shared predicament.

Notes

1. Laura Hubbard and Kathryn Mathers, "Surviving American Empire in Africa: The Anthropology of Reality Television," *International Journal of Cultural Studies* 7 (2004): 444.
2. Stephen Turner offers a fruitful overview of "Kiwi"-styled cultural interpellations in his essay " 'Inclusive Exclusion': Managing Identity for the Nation's Sake in Aotearoa/New Zealand," *Arena* 28 (2007): 87–106.
3. While the original format was developed in the United Kingdom and first licensed and adapted in Sweden as *Expedition: Robinson,* Mark Burnett's U.S. version of the format (licensed by the CBS network) is perhaps the best-known adaptation.
4. See Silvio Waisbord, "McTV," *Television and New Media* 5, no. 4 (2004): 360.
5. Ibid., 368.
6. We treat the *Survivor*-styled texts discussed in this chapter as "recombinant" texts rather than pure adaptations of the global format. We draw the term "recombinant" from the work of Todd Gitlin who describes the contemporary conditions of television production in the following way: "The logic of maximizing the quick payoff has produced that very Hollywood hybrid, the recombinant form, which assumes that selected features of recent hits can be spliced together to make an eugenic success" (Todd Gitlin, *Inside Prime Time* [New York: Pantheon], 1983, 64).
7. Hubbard and Mathers, "Surviving American Empire in Africa"; Jennifer Bowering Delisle, "Surviving American Cultural Imperialism: Survivor and Traditions in Nineteenth-Century Colonial Fiction," *Journal of American Culture* 26, no. 1 (2003): 42–55.
8. Gray Cavender, "In Search of Community on Reality TV: America's Most Wanted and Survivor," in *Understanding Reality Television,* ed. Su Holmes and Deborah Jermyn (London: Routledge, 2004).
9. Ibid., 168.
10. Lamont Lindstrom, "Survivor Vanuatu: Myths of Matriarchy Revisited," *Contemporary Pacific* 19, no. 1 (2007): 162.
11. Waisbord, "McTV," 360.
12. Laurie Ouellette and James Hay, *Better Living through Reality TV: Television and Post-Welfare Citizenship* (Malden, Mass.: Blackwell Publishing, 2008), 2.
13. Ibid.
14. Ibid., 16.
15. Ibid., 187.
16. Ouellette and Hay's definition of television's role in a neoliberal economy draws from the following observation: "As the State entrusts private entities (including television) to operate as social

service providers, conflict mediators, and support networks, popular reality TV does more than entertain—it becomes a resource for inventing, managing and caring for, and protecting ourselves as citizens" (ibid., 4).

17. By referring to the norms and regulations of the *Survivor* format as DNA we take our cue from Waisbord, who suggests that, "The DNA of formats is rooted in cultural values that transcend the national" (Waisbord, "McTV," 368).

18. Ouelette and Hay, *Better Living through Reality TV*, 186.

19. Hubbard and Mathers, "Surviving American Empire in Africa," 444.

20. For an overview of the history of New Zealand television see Trisha Dunleavy's *Ourselves in Primetime: A History of New Zealand Television Drama* (Auckland: Auckland University Press, 2005).

21. As Waisbord argues, "What is British about *Who Wants to Be a Millionaire?* Because formats explicitly empty out signs of the national, they can become nationalized—that is, customized to domestic cultures" (Waisbord, "McTV," 368).

22. See Misha Kavka's chapter "Reality Estate: Locating New Zealand Reality Television," in *Television in New Zealand,* ed. Roger Horrocks and Nick Perry (Melbourne: Oxford University Press, 2004), 222–39.

23. Ibid., 223.

24. Ibid., 231.

25. Stephen Turner and Misha Kavka, "This Is Not New Zealand: An Exercise in the Political Economy of Identity," in *Studying the Event Film:* The Lord of the Rings, ed. Sean Cubitt, Thiery Juttel, and Harriet Margolis (Manchester: Manchester University Press, 2008), 235–36.

26. For a "reverse shot" of makeover reality television programming see *Mitre 10 DIY Marae,* a show screened on Māori Television. For a discussion of this program see Jo Smith, "Parallel Quotidian Flows: MTS On Air," *New Zealand Journal of Media Studies* 9, no. 2 (2006): 27–35.

27. The challenges are meant to push the contestants to their limits and one of the consequences is that contestants in *The Summit,* just like in *Survivor,* spend a lot of time arguing with each other. Over the course of the ten episodes competition intensifies and the sense of community within the group is in decline. Contestants scheme against one another and form alliances to vote particular people out. The logic of the show is an individualistic and competitive struggle over negotiating the landscape.

28. For discussions of the role of the landscape in the manufacturing of a national identity see Thierry Jutel's "*Lord of the Rings*: Landscape, Transformation and the Geography of the Virtual," in *Cultural Studies in Aotearoa New Zealand: Identity, Space and Place*, ed. Claudia Bell and Steve Matthewman (Melbourne: Oxford University Press, 2004), 54–65.

29. For footage shot in mid-Canterbury for the opening sequence see http://www.timelapse.co.nz /t12/archive/The-Summit.html-5,2.

30. In his useful article "Colonialism above the Snowline," John Newton traces the emergence of a dominant settler imaginary within mid-century Pākehā nationalism centred on the South Island. Drawing attention to common tropes in early New Zealand literature, Newton notes, "New Zealand is constructed on the model of the South Island, whose regional topography is deployed in a rationalization of regional history. In styling that landscape as bare and inimical . . . the Caxton poets rewrite as geographical destiny the comparative ease and efficiency with which settler domination was achieved in the South." See his essay in *Journal of Commonwealth Literature* 34, no. 2 (1999): 85–96.

31. Bowering Delisle, "Surviving American Cultural Imperialism," 49.

32. While this phrasing ("settler-styled approach") risks homogenizing the settler subject, we use it in keeping with Barry Barclay's polemical move when he describes the relationship between

non-Māori and the New Zealand landscape as one based upon the rules of property and commodification. See his publications *Our Own Image* (Auckland: Longman Paul, 1990) and *Mana Tuturu* (Auckland: Auckland University Press, 2005). (See also chapters 8 and 9 in this volume.)

33. Ngāi Tahu Communications is the media arm of the South Island *iwi* Kāi Tahu and oversees the running of the *iwi* radio station Tahu FM, the *iwi* magazine *Te Karaka* and a number of other interests.

34. http://www.throng.co.nz/tag/waka-reo/.

35. http://www.throng.co.nz/2007/03/business-hotshots-wanted-for-reality-tv-show/.

36. This rural/urban dimension must also be contextualized in terms of the Māori urban drift of the 1950s through the 1970s, a time of intranational migration that is commonly blamed for the undermining of tribal structures and local, regional, and general Māori culture. *Waka Reo*'s use of the rural setting to base a language revitalization program might suggest that the show reinscribes a form of "rural" festishization that consolidates a romantic notion of Māori as having to return to the rural in order to become authentically Māori, however *Waka Reo*'s appeal to urban-based executives overtly acknowledges the realities of contemporary *iwi* existence. In addition, one cannot overlook the televisual novelty of having rural-based Kāi Tahu *marae* on primetime television; a depiction of Māori life that broadens the typically North Island–based representations of Māori culture.

37. Māori Television Service (Te Aratuku Whakaata Irirangi Māori) Act (2003), no. 21, Public Act, section 8 (October 25, 2006): 11.

38. For a discussion of television and Māori prior to the establishment of Māori Television, see Tainui Stephens, "Māori Television," in *Television in New Zealand: Programming the Nation*, ed. Roger Horrocks and Nick Perry (Melbourne: Oxford University Press, 2004), 113.

39. The emergence of this Indigenous broadcaster has stimulated the growth in Māori production companies. It has increased the local content of New Zealand programming and now attracts a monthly audience of approximately 695,000 on average. For an overview of the emergence of Māori Television, see Jo Smith and Sue Abel's articles "Three Years On: Māori Television," *Take: The SDGNZ Film and Television Quarterly* 48 (Spring 2007): 16–19, and "Ka Whawhai Tonu Mātou: Indigenous Television in Aotearoa/New Zealand," in *Reverse Shots: Indigenous Film and Media in an International Context*, ed. Wendy Pearson and Susan Knabe (Wilfrid Laurier University Press, forthcoming).

40. Ouellette and Hay, *Better Living through Reality TV*, 2.

41. In 1998, Kāi Tahu, the largest Māori *iwi* of the South Island, was one of the first *iwi* to settle with the New Zealand Crown. Kāi Tahu's history of legal action against the Crown was long and persistent—its first court case was in 1868. The formal offer of settlement to Kāi Tahu included a formal apology by the Crown, the return of the mountain Aoraki (a significant marker of *iwi* identity), a cash payout of NZD$170 million, the right of first refusal to Crown assets, and a relativity clause related to the government's fiscal envelope. *Te Karaka* 40 (Spring 2008): 24.

42. The dual names are a feature of Waka Reo as all contestants must choose a Māori name on entering the series. David chose "Kaha" as it means strength while Nur chose "Koa" for its reference to happiness (and because it contained the same number of letters as her original name). These naming practices echo those of *Survivor* where tribal names are drawn from languages native to that season's location.

43. This history of this misconception is a long and varied one and has a racial basis. For a discussion of Kāi Tahu identity see Hana O'Regan's invaluable *Ko Tahu, Ko Au: Kāi Tahu Tribal Identity* (Christchurch, N.Z.: Horomaka Publishing, 2001).

44. The first season was based in Purau, the second in Koukourarata, the third in Raapaki, and the most recent at the Te Tauraka Waka a Māui, Te Rūnanga o Makaawhio.
45. Whetū Fala, personal communication.
46. For example, the Te Ataarangi Māori language-learning system is one where the total group values the progress of every student. See http://www.teataarangi.org.nz/our-vision.html.
47. Peara won the first season and is now a bilingual teacher; Manawa (winner of season two) is studying *te reo* at tertiary level; and Te Iti Kahurangi (a season three finalist) performs in the historical reenactment of the Musket Wars.
48. Whetū Fala, personal communication.
49. Ibid.
50. Hubbard and Mathers, "Surviving American Empire in Africa," 444.

Acknowledgments

E koekoe te tūī, e ketekete te kākā, e kūkū te kererū.

We began conceiving the idea for this book some years ago; we discussed it with colleagues, friends, and *whānau* before committing ourselves to it. We found it urgent to bring together a variety of voices to interrogate the complex and intricate relationship between the Indigenous peoples in Aotearoa/New Zealand and the media.

Numerous people and institutions have, in one way or another, contributed to writing this book. It is to them that the book owes its intellectual debt. We extend our thanks and gratitude, first and foremost, to Dr. Anna Petersen, whose dedication, persistence, wealth of editorial experience, and patience were invaluable to seeing this book to its eventual end. Thank you, Anna, for your fine work and commitment to this project!

From the University of Minnesota Press, we thank senior acquisitions editor Jason Weidemann, whose guidance was crucial to the project's fruition; series editor Professor Robert Warrior, who encouraged the project and made interventions at significant stages to enable the collection to reach its potential; editorial assistant Danielle Kasprzak, for her readiness to support; and the Press's faculty board, for encouragement and endorsement of the project.

Within the University of Otago, our thanks go to the Division of Humanities, which provided two publishing grants toward the completion of this book; Erica Newman (Te Tumu, School of Māori, Pacific, and Indigenous Studies) and Maureen Lloyd (Department of Media, Film, and Communication Studies), for their administrative assistance; and Lachy Paterson, for providing an apposite and poignant dedication.

Given the collection's subject material, Indigenous media, the illustrations are vital to the animation of the book and its argument. Our appreciation goes to Clare Barker, Marino Harker Smith, and Tuvae Siaosi (Māori Television); Arran Birchenough (Getty Images); Sam Bonwick and Gillian Cardinal (Oxford University Press); Anna Cable (Auckland War Memorial Museum and Robin Morrison Estate); Richard Cornell (Designer Headstones); Russell Garbutt and Blade Jones (Ngāi Tahu Communications

235

Ltd.); Janine Kapa (University of Otago); Mary Lewis and Aleisha Blake (Hocken Collections); Jasmin McSweeney, Faith Dennis, and Robin Laing (NZ Film); Georgina McWhirter (Otago University Press); Debra Millar (Penguin Group [NZ]); Alexandra Nation *(Dominion Post)*; David Retter (Alexander Turnbull Library); Jo Scully (Bridget Williams Books); Aaron Smale, Rick Spurway, and Steve Thompson (Brandspank); Juley Van Der Reyden *(New Zealand Herald)*; Craig Walters (Pacific Films); Vincent Ward *(Rain of the Children)*; Mere Wilson Tuala-Fata (Auahi Kore); Errol Wright and Abi King-Jones *(Operation 8)*; and Te Maari Wright (Te Puni Kōkiri).

Particular thanks to all those scholars who silently contributed to the quality of this collection by acting as anonymous readers and to Faye Ginsburg, leading global scholar on Indigenous media, for her insightful comments on the project and her endorsement of the book. Finally, Brendan and Vijay thank all the contributors for their scholarship and for their patience as the process determined its own meandering course: the errors that remain in this book are, of course, our own responsibility.

Brendan acknowledges his immediate *whānau* for their love and support: Nālani, TJ, Riley, Kaliko, and Tai. *E iti noa ana, nā te aroha.*

Vijay recognizes the support of his *whānau* and deeply thanks Rakhee Chatbar for her patience, encouragement, and inspiration.

Contributors

SUE ABEL is senior lecturer at the University of Auckland, where she is employed by the Department of Māori Studies and the Department of Film, Television, and Media Studies. Her key research interest is indigeneity and media, with a focus on Māori and media. With another contributor to this book, Jo Smith, she recently secured a research grant to write a book about Māori television.

JOOST DE BRUIN is senior lecturer in media studies at Victoria University of Wellington. He teaches in the areas of popular culture, audience studies, and television studies, and his research interests include global television formats, media audiences, and young people and media.

VIJAY DEVADAS is senior lecturer in the Department of Media, Film, and Communication at the University of Otago. His research interests include postcolonial theory, critical theory, and cultural studies. He has published on cinema, print, broadcast, and new media; his recent work is on media and the war on terror, new media and democracy, and Tamil cinema and migrant workers. He is on the editorial collective of the international journal *borderlands* and is a founding member of the Postcolonial Studies Research Network at Otago.

SUZANNE DUNCAN is an academic in Te Tumu, School of Māori, Pacific, and Indigenous Studies at the University of Otago. She traces her genealogy to the Te Rarawa and Te Aupouri tribes of New Zealand. Her research explores the interface between colonial economies and indigenous worldviews. She is completing her doctoral thesis, which investigates the cultural values of the indigenous Māori family and its involvement in the economy as a family business.

KEVIN FISHER is senior lecturer in the Department of Media, Film, and Communication at the University of Otago. His research interests include phenomenology, documentary, digital special effects, and audiovisual analysis. His essays have been

published in the anthologies *Cinephilia in the Age of Digital Reproduction, Studying the Event Film:* The Lord of the Rings, and *Meta-Morphing* (University of Minnesota Press, 2000) and in journals such as *Science Fiction Film and Television* and *The New Review of Film and Television*. He is writing a book manuscript on altered states of consciousness in post–World War II American cinema.

BRENDAN HOKOWHITU is of Ngāti Pukenga descent, an iwi (people) from Aotearoa New Zealand. He is Dean and Professor of the Faculty of Native Studies at the University of Alberta, Edmonton, Canada. He previously was senior lecturer, associate professor, and associate dean (Māori) in Te Tumu, the School of Māori, Pacific, and Indigenous Studies at the University of Otago. He has published across a number of disciplines, including indigenous critical theory, masculinity, media, and sport. He is the lead editor of *Indigenous Identity and Resistance: Researching the Diversity of Knowledge*.

ALLEN MEEK is senior lecturer in the School of English and Media Studies at Massey University, New Zealand. He is researching trauma studies and biopolitics and is the author of *Trauma and Media*.

LACHY PATERSON is senior lecturer in Te Tumu, School of Māori, Pacific, and Indigenous Studies at the University of Otago, with research interests in Māori-language print culture and Māori history. His publications include a monograph on mid-nineteenth-century Māori-language newspapers, *Colonial Discourses: Niupepa Māori 1855–1863*. He is working on several historical projects that investigate Māori textual culture, as well as ongoing research into Māori religious history.

CHRIS PRENTICE is senior lecturer at the University of Otago, where she teaches New Zealand and postcolonial literatures and postcolonial theory. She convenes the Postcolonial Studies Research Network that has held annual symposia and master classes on postcolonial themes since 2005. Her research focuses on "culture" in contemporary negotiations of settler–Indigenous relations in settler postcolonial societies. She has published in *Ariel, New Literatures Review, Modern Fiction Studies,* and *Continuum: Journal of Media and Cultural Studies*. She coedited *Cultural Transformations: Perspectives on Translocation in a Global Age* and is editing a volume on postcolonial exoticism after globalization.

JAY SCHERER is associate professor in the Faculty of Physical Education and Recreation at the University of Alberta. His research interests include globalization, sport and public policy, and cultural studies of sport and leisure. He is coauthor (with Steve Jackson) of *Globalization, Sport, and Corporate Nationalism: The New Cultural Economy of the New Zealand All Blacks* and coeditor (with David Rowe) of *Sport, Public*

Broadcasting, and Cultural Citizenship: Signal Lost? He has contributed articles to many scholarly journals, including *Sociology, Media, Culture & Society, New Media & Society, Cultural Studies ↔ Critical Methodologies, Policy Sciences,* and *Sociology of Sport Journal.*

JO SMITH (Kāi Tahu, Kāti Māmoe, Waitaha) is senior lecturer in the Media Studies Programme at Victoria University of Wellington. Her research examines the sociopolitical power of media technologies with a focus on how colonial histories inform contemporary media practices. With another contributor to this book, Sue Abel, she recently secured a research grant to write a book about Māori television.

APRIL STRICKLAND is a documentary filmmaker and PhD candidate in the anthropology department at New York University. Her dissertation considers how sites of Māori media production in New Zealand create, negotiate, and sustain Indigenous subject formation, reclaim Māori political and cultural agency, and contest state-legislated identities.

STEPHEN TURNER is senior lecturer in the English department of the University of Auckland. He has published on the settlement and history of Aotearoa New Zealand and the politics of indigeneity. With Sean Sturm, he writes about writing pedagogy and the idea of the university. He is working on a manuscript about Indigenous law and settler society.

Index